First Edition

The Secret To Their Success

How 33 Women Made Their Dreams Come True

Edited by Emily A. Colin

Carolina
Women's Press

The Secret To Their Success How 33 Women Made Their Dreams Come True

Edited by Emily A. Colin

*Carolina
Women's Press*

An Imprint of:

Coastal Carolina Press

4709 College Acres Drive, Suite 1

Wilmington, NC 28403 U.S.A.

www.coastalcarolinapress.org

First Edition 2000

Book design by Maximum Design & Advertising, Inc.

Cover artwork by Alisha Kerlin

Printed in the United States of America

Applied for Library of Congress Cataloging - in - Publication Data

ISBN 1-928556-20-5

For Bryan, who taught me the true meaning of courage, and convinced me that anything is possible.

Table of Contents

Acknowledgements

The Secret to Their Success: How 33 Women Made Their Dreams Come True and *The Long Way Around: How 34 Women Found the Lives They Love* are sister volumes. When I began the project of telling North Carolina women's stories, I didn't anticipate the compilation of two separate books; but to my surprise and delight—and, initially, to my bewilderment—the response to my inquiries proved overwhelmingly positive. So many women were interested in participating that I had to restructure my ideas about what, precisely, this venture would entail. I must say that I am very happy with the result; I have learned a great deal from the women featured in these pages, and I hope that readers will, as well.

Needless to say, it would have been impossible for me to organize and compile these fine volumes without the help of a number of talented individuals. I owe substantial debts of gratitude to Heather Folan and Nikki Smith, for countless hours spent transcribing, entering edits, scanning photos, offering suggestions, and otherwise being of invaluable assistance; to Doris Elliott, for easing the transcription load; to Susan Comer, for lending her fantastic journalistic skills to this project, and for being so reliable; to Amy, Kelly, and Alex at Maximum Design & Advertising for another job well done—and for letting Stanley and me languish on their floor; to Alisha Kerlin, for painting an amazing cover, and for being the most talented eighteen-year-old I know; to Emily Herring Wilson and Doris Betts, for their valuable advice and for writing fantastic introductions; to Dan Levy at the Mia Hamm Foundation, for taking time out of his busy schedule to speak with me; to Ms. Berry at Dr. Maya Angelou's office, for her patience and persistence; to Ellyn Bache and Julie Tetel Andresen, both contributors, for encouraging and supporting me in so many ways; to Georgeann Eubanks, Jean O'Barr, and Lynn Salsi, for their positive attitude and enthusiasm regarding this project; to the North Carolina Writers' Network, for providing much-needed information at a crucial juncture; to Celia Rivenbark, for her prestidigitation regarding our title search; to Bryan, for his constant words of encouragement, and my parents, for their continued support of this and other endeavors; to Ellen Rickert, for the conversation that birthed this project; to Dorothy Gallagher, Gil Brady, and Chris Compton for playing the name-this-book game (and further thanks to Dorothy for her patience with the graphically impaired); to Tony Norris, for listening to me talk about both books (and little else) for five months straight, and for aiding and abetting throughout their evolution; to Andy Scott, for taking a chance on me; to Zoë, Quinn, Niko, Sox, and Gray Cat for providing me with companionship, entertainment, and much-needed distractions; and, of course, to all of the women who so graciously and freely contributed to both of these fantastic volumes. I couldn't have done it without you!

Preface

The stories in this volume speak for themselves. They are mute only on one issue: their geographic relationship. The women featured here are from all over this country, and some are from another nation entirely. All have one thing in common: they have chosen North Carolina as the arena where they live, work, or play. Some, of course, were born here; but I did not make that the criteria for participation. I wanted, instead, to discover the twenty-first-century North Carolina woman.

This is what she looks like: dark-skinned, short, full-figured. This is what she looks like: pale, blonde, tall. This is what she looks like: voluptuous, rail-thin, stocky, muscular, blue-eyed, brown-haired, freckled, full-lipped. English may be her second language. She has started her own business, raised five children, written books, taught classes, counseled people in need, taken award-winning photographs, sold real estate, painted incredible pictures. She is Asian-American, Latina, African-American; she is Jewish, Buddhist, Christian, Muslim. She is gay and she is straight. She is from everywhere, and her story is every woman's story.

Emily A. Oz

Introduction Doris Betts

"I long to speak out the intense inspiration that comes to me
from the lives of strong women."
— Ruth Benedict

As students, we learned that *vocation* and *vocal* were words from the same Latin source—and believed that as we grew older and luckier, we might receive a "calling" to a particular career or lifetime service for which our heretofore unrecognized talents had been mysteriously preparing us. This vocabulary lesson served to turn one part of the high school curriculum into an oxymoron, for how could "Vocational Training" function, except to sharpen the ear toward some inner or outer voice?

None of us girl students were being hollered at in any case. For centuries and years, if a girl was said to "have a vocation," it meant that the whisper of God had clarified her limited choices. Mary Ambrose made this clear when quoted in *Life* magazine in 1963: "The true vocation (of a nun) is settled on the day the girl looks around her and sees a young woman her own age in pretty clothes wheeling a baby carriage by the convent. Then her heart takes an awful flop and she knows what it is God really is asking of her."

Apart from the cloister, females were thought to have an automatic calling, as much from the ovary as from the heart, and while spinsters might become nannies, governesses, later schoolteachers and secretaries, and then nurses, most families—especially Southern families—were like my own in not yet realizing that World War II had shattered that presumption forever. Rosie the Riveter was no temp who gladly hurried home in peacetime to fold pastry; besides assembling aircraft carriers, she had begun early construction on what later became the women's movement and feminism.

These 33 women are Rosie's spiritual daughters and granddaughters—though Ann Jennings is a grandmother herself. Their lives began in many different places and circumstances; North Carolina is often their chosen rather than native state. Both men and women have been their most admired mentors and role models. They have become successful coaches, photographers, editors, athletes, actresses, farm wives, filmmakers, businesswomen, artists. One is a cardiologist, one a MacArthur Fellow, one the first female Secretary of Commerce for North Carolina, another is the state's Secretary of Cultural Resources. Most have married, many of these more happily the second time, and have children—of whom they are very proud—but not one claims it's easy to balance home and work. They don't hate men. Many are involved

in volunteer or non-profit organizations for idealistic reasons, doing wildlife management and marine biology, directing a rape crisis center or community development projects, taking the arts into hospitals, leading church projects.

And surprisingly enough, in these times when every unhappy neurotic wails on television and one-by-one shows the public every psychic scar, there's not an unhappy woman in the crowd.

Yet "happy" may seem too easy and superficial a description. Their own essays and interviews say honestly they've come through problems, admit making poor choices. But these are Horatio Alger stories for women, women who pulled themselves up by their own sandal straps.

In their interviews, Emily Colin and Susan Comer have always asked what advice each woman would give to a younger one contemplating her own future; in their essays, other women answer the implicit question by the details and memories they volunteer. Almost with one voice, they advise their younger daughters and granddaughters to be free to choose any vocation they feel called to try, but the means to this end is down-home practicality:

> *"Take risks; follow your bliss—and you gotta work at it; do those things that will make you feel proud of yourself; push beyond your comfort zone; roll the dice and go for it; work hard and work smart; be willing to change; be open to what comes to you; take care to do something well..."*

Clichés? Or, to use a distinction I've preferred since I once heard a UNC professor make it, "the great commonplaces." As Charlotte Perkins Gilman said,"find your real job and do it."

And these women revitalize common-sense advice while also adding new meaning to "vocational training," since these pages record years and years of their stubborn practice and hard work as well as ultimate rewards of creativity and delight. Writes one, "I believe God really does have a plan for your life if you'll just let it unfold," but as you read on you see her helping God out with a lot of sweaty unfolding on her own. Another suggests that doors indeed will "open for you," but "sometimes you have got to force the doors yourself; other times people help open them up. But you have to get to the doors."

These women heard their own "call," got themselves to the doors, opened them, moved in and through and onward, did their own "vocational training," and each has a clear view of where she's come from and where she's going.

It's a long view, though. Editor and publisher Shannon Ravenel notes that it took her 40 years to discover a bestseller, but she seems to have cherished every other quality book that bears the Algonquin imprint. A Charlotte native, she ends her own essay remembering strong women in her family. Her grandmother, for example, ran the Camden (S.C.) Water and Light Department,

and walked to work every morning with her pet retriever walking in front of her carrying her purse in his mouth.

That dog, she writes, "symbolizes the fun—the joy even—of doing what we can do, doing it where it suits us, and doing it well."

Motherly Angst Goes To The Movies Ellyn Bache

When Susan Sarandon said yes, I knew it was going to happen.

My novel, *Safe Passage,* would be made into a film for the same reason it was published in the first place. Maternal guilt. That awful feeling you are doing too much for yourself and not enough for your kids. And that you are going to pay for it. And how.

Except for that, *Safe Passage* is not the kind of book that becomes a major motion picture. It is barely TV-movie fare. Ditzy Mag Singer has spent most of her forty-three years raising seven sons she loves but never wanted. Now she's glad they're mostly grown so she can pursue a longed-for career. But in the pre-dawn hours of an October morning, she awakens with an all-too-familiar premonition, only to learn that her troubled middle son, Percival—the one who ran off to join the Marines—may have been stationed in the building in Beirut that's just been blown up by terrorists. For three days, the family doesn't know what's happened to him. Unable to bear the thought of Percival buried under the rubble, nevertheless Mag is convinced the sins of the fathers (in this case, the mother) may well be visited on her sons. She was never a good mother. There was so much she could have

done. If Percival suffers a terrible fate, it will be her fault.

After all, she finished college instead of volunteering at school. She took jobs while Percival was skipping class. She lamented her lack of a true career and blamed it on domestic duties. Every moment she took for herself was stolen from her children. She has been waiting for the punishment. Maybe this is it.

If this sounds familiar, you must be a mom.

People always think a fictional character is a thinly-veiled version of her author. In my case that's not exactly true…or exactly false, either. Unlike Mag, I married at twenty-seven (considered quite old in those days). I had a master's degree. I had always wanted a family. But once I became the mother of four, oh my.

Much as I loved my children, I was also ambitious. I didn't like playing kiddy games with preschoolers or hosting their neighborhood friends. I wanted to write. Working part-time at a newspaper, publishing stories in women's magazines, I longed for large blocks of time to begin a novel and resented that I didn't have them. No matter that most women didn't have the luxury of working at home, of taking off if someone had a strep throat, still I was

greedy for more. Once I stayed home from a parents' school visitation in order to finish an article, only to have my distraught oldest son rush in from kindergarten, sobbing that he was the *only one* who had to take the bus at the end of the day. When the youngest was four and wanted to read like his sister and brothers, I shamelessly bribed him. We could practice the "b" sound and the "oy" sound for as long as he wanted if he would leave me alone at my desk until lunch. When he finally went to school all day, other women dabbed at tears as their offspring boarded the bus wearing new sneakers and brave expressions of hope. Not me. I could barely suppress my smile.

Is this the profile of a selfish woman? Oh, yes.

My children ranged from six to fourteen when I finally began *Safe Passage*. Maybe I wrote it partly to expiate my sins; or maybe out of the superstitious belief that if you think of the worst, if you confront it, it won't actually happen. My husband had survived Vietnam. I feared that my sons would also become Marines, would also go to war. I feared they might not be as lucky as their father. In the book, Mag thinks the only thing you can do for your children is wish them safe passage through their lives. I hoped that wasn't so. I hoped writing the novel— taking on the nightmares before they came true—would somehow ward them off, inadequate mother though I was.

It was a great relief, afterwards, to discover other mothers,

even far more "successful" ones than I, shared my same doubts and fears. The literary agent who handled the novel turned out to be the only man involved in all the things that happened next. He sent the book to an editor who "sort of" liked it. She was twenty-something and childless. Mag didn't need seven children, she said. I should take out the twins. Five kids would be enough. I knew, heart and gut, that she was wrong. Four kids—even five— didn't push you far enough. I might dream about spraying lawn-killer on a neighbor's yard after she insulted my son, but I didn't actually do it, as Mag does. Nor had I kicked my unruly ten-year-old out of the car to make his own way home. You needed at least seven children to do that. I told the editor no.

A few months later, *Safe Passage* was bought by an editor who had recently given birth to a set of twins. I suspect she felt guilty leaving them home in Brooklyn while she worked in glamorous Manhattan, securing her place in the heady world of publishing. The Hollywood film agent, Lynn, had a daughter, an only child. It could be a lonely life, without any brothers or sisters. No doubt Lynn felt guilty about the long hours she spent at work. She loved the book.

So did Deena, the screenwriter, who pitched the novel to thirteen different production companies in hopes of being hired to write the script. This is almost never done. Usually the production companies see the novel first. Deena got the job, though

I'm sure she felt guilty spending all that time away from her child, talking to producers.

The movie deal fell apart several times. I was told that Kathy Bates was interested; I was told that Brenda Fricker had been approached, the actress who played the mother in *My Left Foot*. I couldn't see either of these big solid women playing spacey Mag. When my daughter brought home the tape of *The Rocky Horror Picture Show*, I commented that Susan Sarandon had exactly the flighty quality I imagined in Mag, and that Susan (who was not so famous in those days before *Thelma and Louise*) would be just Mag's age by now and perfect for the part. It was an offhand comment. My literary agent said that books were often optioned, rarely produced. But when producer Gale Anne Hurd got Susan involved, I knew the film was as good as wrapped. Unlike Mag, I had few premonitions, and mine were often happy ones. Gale Anne Hurd, best known for producing action/adventure films like *Aliens*, was a woman with a daughter. How guilty she must feel, jetting back and forth across the country, spending so much time away from her child. Of course she had to make the movie! And she did.

Susan Sarandon was more proactive. She agreed to do the picture, I was told, only under certain terms. The film must be shot in New York City so she could go home to her family at night. It must be shot only five days a week (instead of the six standard in the industry) so she could have a normal family week-end. The project must be finished by spring break so she could go on vacation with her brood. I loved the idea of *Safe Passage* coming to the screen under conditions dictated by a mom with the interests of her children in mind. When we went to visit the set, Susan's dressing room was scattered with toys, and her babysitter brought her two-year-old over every day after his nap.

I wish I could say the film was a big commercial success. It wasn't. It got nice reviews, spent a couple of months in theaters, and pretty soon was out on videotape and being shown on T.V. But for me, it was wonderful all the same. I learned I wasn't the only mother out there thinking thoughts that had nothing to do with her children, certain her mental treachery was putting them in peril. It made me feel less lonely. It was a mighty nice thing to know.

That said, I still believe the selfish choices mothers make may have hurtful consequences, if not always the dire ones we fear. I'm not sorry my house was always a mess, not sorry that in the contest between the vacuum and the typewriter, the typewriter always won. But it gives me a twinge when my grown children remind me that, even though I was able to stay home and offer the physical presence I thought so important, they always knew I wasn't completely "there." I wish I had been. I think they would have liked it a lot.

Even so, I'm glad I wrote. Overwhelming and all-consuming

as children are—the best thing you ever had, the people you will always love the most—they grow up. They leave you. And when they are gone, off to the independent lives you always hoped for them, you miss them every day of your life.

So you better have a life to lead without them.

I'm awfully glad I do.

Gray Wells

Ellyn *Bache*

"*I learned I wasn't the only mother out there thinking thoughts that had nothing to do with her children, certain her mental treachery was putting them in peril.*"

Ellyn Bache

Ellyn Bache is the author of three novels for adults, a teen novel that was a finalist for *Foreword Magazine's* Book of the Year Award, a collection of short stories that won the Willa Cather Fiction Prize, and a nonfiction journal about sponsoring Vietnamese refugees. She and her husband, Terry, have four grown children.

Weathering Hurricanes Clay Carmichael

When writers and artists talk about the people and things that influence their work, they often mention teachers who have fostered their fledgling abilities. I have a broad view of teaching and learning. Simply put, it's that everybody teaches and that everything that happens is an opportunity to learn. For this artist, the considerable difficulty of getting a first book published, a divorce, and a hurricane became teachers, though they didn't teach me the hard lessons you might expect. They taught me about hope, resilience and joy.

In January 1995, ten days before the text and illustrations for my first picture book, *Bear at the Beach*, were due in New York, my marriage, a relationship of twenty years, came apart. I have my theories about why this happened, most having to do with how life teaches us whatever we need to learn whether we want to learn it or not. But I also have an ongoing gripe with the Deity about why these lessons have to hurt so much. Why can't learning be easy and intensely pleasurable? If it were, wouldn't we soak up lessons like sponges? The Deity and I have regular discussions

about this, though maybe discussion is the wrong word, as so far our talks are strictly one-sided. Or are they? I wonder. Hurricane Fran made me wonder.

My books' main character, Bear, is drawn from a real bear of my childhood. I still have him. He sits on the high side of my drawing board every day and I still hug him hard occasionally, especially during hurricanes. The end of my marriage and Fran were not the first storms we'd weathered together. When I was a child, my mother became seriously ill and remained so until I was grown. Fortunately, my grandmother lived next door in a big and mysterious old house, very like the sort Hollywood dreams up for children's movies. There were two child-sized rooms over the kitchen used for storage and my grandmother's struggling African violets. The sunnier of these two rooms had a big table made from two empty drums topped by a sheet of plywood. We grandchildren claimed it, and because of a set of old paints and some Matisse-y efforts of my uncle's tacked to the walls, we called it the art room. There I learned that drawing and painting could

take my mind off my maternal troubles for hours at a time, and that when I wasn't happy with the world I lived in I could rearrange its raw materials to create a new one.

My other paradise was the library downstairs. It had been my grandfather's study before he died. It was small and intimate, scented by the cedar paneling. A feather-stuffed couch covered with worn velveteen cooled the skin on hot summer days. There was one huge overstuffed chair, an oriental rug, a working fireplace, and over the couch an ornate family tree, suspiciously heavy with European royalty. Best of all were the books: beautiful books, lovingly made, many with color pictures. Dickens and Twain had whole shelves of their own. Conrad, less prolific, took up only half. I still have many of them, including *Treasure Island*, with N.C. Wyeth's pirates still looking villainous and bloodthirsty, even in this age of "The Terminator;" and ten extraordinary illustrated volumes for children called *Journeys Through Bookland*. The covers of these last volumes are stamped in gold with five of the most beautiful words in English: Imagination. Wisdom. Character. Truth. Beauty. Inside were child-sized portions of Homer, Virgil, Cervantes, Blake, Shakespeare, Poe, Barrett Browning, Stevenson, Keats and many more.

My favorite book was *Robin Hood*. I read it again and again and lived vicariously through the adventures of Robin's band depicted in the color plates. From Robin Hood I learned that kings and other adults in power often did questionable, self-serving things: and that when they did, good people sometimes had to become outlaws and take to the trees. That book taught me life-long lessons about the importance of reading and thinking for one's self; about the necessity of vigilance, taking personal risks and questioning the status quo—lessons that seem to me even more urgent today, because as far as I can see the world hasn't changed much since the materialistic and power-hungry times of Robin Hood. Good people must still take to the trees, even if Sherwood Forest is only their bookstore or library. Trees are, after all, what books are made of. I also began to write in those days, mostly in journals. My writing was so awful I cringe to remember it, though at the time I was sure I was writing *War and Peace*. But as awful as my writing was then, and continued to be for a long time, I learned two big artistic lessons: First, always write from deep feeling, from the heart; and second, revise like crazy.

School on the whole was a painful experience. I was an overweight, nearsighted and bookish child, things that don't make a girl popular with her peers. But a few good teachers looked past my appearance and my mostly overwrought prose and saw some-

thing they encouraged. I remember writing a lurid horror story for one high school creative writing class which ended at the climax with: "Cut! " cried the director, "that wraps up our episode of Supernatural Stories for today!" My teacher, the sainted Jean Ferguson, praised my descriptive abilities and said nothing about my lazy ending. To this day, I think that praising what's good and ignoring the rest is the best thing any teacher can do.

In college I studied English literature, but fell in love with García Márquez, Borges and other Latin American writers. I read *The Odyssey, The Aeneid, The Divine Comedy* and Tolkien's *Lord of the Rings Trilogy* in a course called The Heroic Journey, which made me begin to think of life in the same way. I studied prose writing with the novelist and short story writer, Max Steele, who was head of the Creative Writing Program at UNC-Chapel Hill. At the end of the semester, Max told us we were the laziest class he had ever had. Then he looked at me and said, 'I think you're a poet. I'm sending you to Kirkpatrick."

Robert Kirkpatrick still teaches at UNC and sits, deservedly, in the Bowman Gray Chair. His gift was to draw out the very best in each and every one of us. I suspected he was telepathic, because he always knew when I could do better, which was most of the time. When he liked a line or a poem I'd written, he rolled his eyes heavenward and sucked in his breath as though inhaling rarefied air. What he didn't like, he politely ignored or passed over

as kindly and quickly as he could, confirming my belief that silence is the best critic. "Be gentle with one another's efforts," said Malcolm Cowley. "Be kind and considerate with your criticism. Always remember that it's just as hard to write a bad book as it is to write a good book."

Another teacher who taught me about the bones of good writing was Jim Shumaker. He and my father were friends, and I had known him since I was a child. Crusty, direct, obscene, he still teaches in the UNC School of Journalism and the comic strip *Shoe* is named after him. "Sentences should be twelve words or less," Shumaker told us. "Never use a two-syllable word when a one-syllable word will do." The first day of class he wrote Mark Twain's golden rule of writing on the blackboard and I have tried to follow it ever since: "The right word is to the almost right word, as lightning is to the lightning bug."

Useful as all these influences were, none of them came to anything until my father became ill. Craft is all well and good, but how well you say something doesn't mean anything unless you have something to say and a good heart to say it with. I hadn't had much to speak of until then. But my father and I had been close and his illness affected me profoundly. He was very sick, wasting away little by little from a rare brain disease, and every time I visited him a bit more of him was gone. "Have you seen my father?" the question my character Bear asks again and

again, was a question the child in my heart asked her father every visiting day. And then one Sunday I came home so full of sadness that it spilled out onto a page in both words and pictures, and became what is still the heart of my first book. It came out, to my surprise, in a child's voice and a child's pictures. And that is how I began to write and illustrate books for children.

But though the heart of what is now *Bear at the Beach* was written then, and many of the present pictures followed, the story was framed very differently when I began to send it out in September of 1990. HBJ, Harpercollins, Greenwillow, Farrar, Straus & Giroux, Candlewick, Crown, Houghton Mifflin, and Orchard all rejected *Bear* and my other manuscripts, but I viewed this time as my apprenticeship and diligently revised and persevered until June of 1993. Then my natural pragmatism took over and I decided it was time to stop kidding myself and admit I wasn't good enough. I sent *Bear* to one last publisher whose new catalog welcomed unsolicited manuscripts. This never happens. At best, publishers tolerate unsolicited manuscripts, collectively called "the slush pile," so you know what they're really thinking. It's hard to blame them. My colleague Jackie Ogburn once told me that when she was a children's book editor, she received two hundred unsolicited manuscripts a week.

Even so, I take a Robin Hood-ish attitude toward publishing practices such as their use of the word *slush* to refer to the pile my hard work goes in, or their other common practice of taking six months to a year to decide if they want your slush or not. (One editor at Random House, who had kept my MS for more than a year, told me, "Clay, it's not personal." I said, "I'm a person. Of course it's personal.") But this time *Bear* landed on the desk of Julie Amper, a patient, warm-hearted editor, who called me within two weeks to tell me that the New York publisher she worked for wanted my book.

At Julie's encouragement, I jettisoned the outer framework of *Bear* and developed its heartfelt core. "That's the real story," Julie said. "Write about *that*." We worked together for eight months, I revising, Julie commenting and suggesting. Finally she was satisfied that I had written *Bear* as best I could and tentatively offered me a contract. My success lasted less than a day. The next morning she called back to say that after eight months her boss had suddenly decided that she didn't like my art work after all and wondered could I possibly execute all the art in a different style and a different medium? I told Julie that her boss might as well have asked me to change the color of my skin. Julie said she was sorry, there was nothing she could do, and she and I said very sad good-byes. I had come to like her and trust her instincts and I would miss working with her. I hung up the phone and decided that this was a sign that I should stop writing and illustrating for good. But not long after, Julie called again. She was having lunch

with her friend Marc Cheshire, the publisher at North-South Books in New York. Would I mind if she showed *Bear* to him?

Of course not, I told her, but by this time I wasn't optimistic. Three years of rejections and set-backs had taught me not to get my hopes up. But Marc liked *Bear* and called to tell me so on a day when I was rearranging all the furniture in my studio so that I couldn't put my hands on so much as a pencil to take notes. Marc is a lovely person, but he always calls at such times. We talked, as I remember, for almost an hour, but he still wouldn't commit to the book. We'll talk again, was all he said.

Seven months later, after I had sent him a number of letters and faxes and left more than a few phone messages, Bear and I were still waiting for him to call. One day I reached my limit. That day, I called New York and politely asked the secretary to tell Marc that I was angry and upset at his refusal to return my phone calls or my work and that I needed to hear from him *that day*. I hung up, sure that I had burned that bridge. I walked out into my yard—my personal Sherwood Forest—and told a friend of mine that I had decided to give up children's books, go back school and study the other subject that had interested me all my life. "I'm going to medical school," I told her. "It's easier."

When I came back inside, there was a diplomatic message from Marc on my answering machine. He still loved *Bear*. He still wanted to publish it. He would call the next day and offer me a contract. Which he did.

The following morning at the YMCA, I told my friend Jean how I had lost my temper and gotten a book contract. Jean lifted an eyebrow and said, "There's a lesson there somewhere."

Risk. The writer Annie Dillard says to spend it all every day, shoot it all, hold nothing back. I was learning to take chances in my work and in my life. One day, when I was anguishing over another career risk I was taking, a wise older woman at the YMCA said to me, "All my life, I never risked anything. I always did the safe thing. I never took risks and so I never gained anything. I watch you gain because you take risks." Then she smiled and said: "Keep it up."

In the weeks after my marriage ended, I painted the final illustrations for *Bear at the Beach*. I wasn't sure if painting them would make me crazy or keep me sane. Among other things, *Bear* is about loss; the empty place the absence or loss of a loved one can create in a life. I didn't need reminding about that. But it's also about the power of love to fill empty places and overcome the losses, and the great joy of appreciating the good things you have. I got through those exquisitely painful days by drawing one line and painting one wash at a time, by returning, with Bear, to the art room that had healed and comforted me as a child.

During that time, I also read and reread many books that I love. Patricia MacLachlan's *Baby*. Marcel Pagnol's *Memories of Child-*

hood. *A Story Like the Wind* and *A Far Off Place* by the great South African soul Laurens van der Post. Madeleine L'Engle's *Crosswick Journals*. Rosemary Wells' consoling *Bunny Planet Trilogy*. William Maxwell's early and, I think, best novel, *They Came Like Swallows*, a book written for adults but which describes, better than any book I have ever read, exactly how it *feels* to be a child. And many nights before I went to bed, I read the newly arrived color proofs of *Bear at the Beach*, the book I had written to comfort myself.

Wonderful colleagues, family and friends took care of me and made sure that I, like the bear in my story, was safe and cared for and loved. Those really are the important things, no matter how old you are. Good things began to happen. Julie, my faithful editor, wised up and went to work for Marc. *Bear* went to press in Belgium. *Bear* returned beautifully printed in English and to everyone's surprise, North-South's European office had published a Dutch edition as well. An early review called it "simple, yet powerful" and "a treasure." I signed two new book contracts with North-South. I received word that *Bear* would be translated into Japanese and that a national parenting group had awarded it a gold medal as one of the best books of the year.

Little by little, I cleared away the debris and clutter of my old life. This is the natural purpose of hurricanes, as a friend reminded me. My new life became focused and lean. I was clearer about what really mattered to me, and about the difference between what I wanted and what I truly needed. Both the artist and the person in me thrived on the spare and disciplined life. I began to write and illustrate my second book. I got up every day before dawn, swam a mile in the YMCA pool, then put my head down and worked hard at my two professions: writing and illustrating for children, and graphic design which paid the bills.

But the night of Hurricane Fran I was sure my new luck had turned. Hurricanes come with the territory in North Carolina—though, 180 miles inland, we in the Triangle are often spared the brunt. Fran made straight for us. Her wind-force bowed the oldest trees, pounded the window glass, and tossed trash cans and lawn furniture like tumbleweeds. It rained horizontally. The house strained and vibrated, seeming as flimsy as the taped-together houses I'd made with my father's shirt cardboard as a child. During that long, scary night I thought a lot about Dorothy and Toto and wondered if Bear and I would wake up witch-killers in Munchkinland.

I got up in the pitch dark of the truly powerless and waited more anxiously for first light than I had in years. The radio declared a disaster. Trees and

power lines were down everywhere; roads were impassable, cars and houses crushed. Authorities urged us to boil tap water and warned that hundreds of thousands of us might be without phone, water, or power for weeks. I prepared myself as best I could for the personal and financial fallout of another hard year.

But the sun rose. And though the lights were out and the yard was a mess, Sherwood Forest was still standing. I thanked the Deity for sparing me two hurricanes in as many years. Then, a little warily, I went out and thanked every tree.

I thought then about what has long been one of my favorite passages in all literature, about another forest and another Bear, which happens to be from children's literature:

"The wind was against them now, and Piglet's ears streamed behind him like banners as he fought his way along, and it seemed hours before he got them into the shelter of the Hundred Acre Wood and they stood up straight again, to listen, a little nervously, to the roaring of the gale among the tree-tops.

'Supposing a tree fell down, Pooh, when we were underneath it?'

'Supposing it didn't,' said Pooh after careful thought.

Piglet was comforted by this."*

And so was I.

*From "A Very Grand Thing," *The House At Pooh Corner* (Dutton) by A.A. Milne; pp 132-133.

Clay **Carmichael**

 Clay Carmichael is an artist, writer and teacher from Chapel Hill, North Carolina. Her picture books *Bear at the Beach, Used-up Bear* and *Lonesome Bear* (North-South) have been translated into six languages. She also speaks about her work at K-12 schools and universities, and leads workshops on writing, illustrating and publishing for adults and children.

In the Kitchen Dorette E. Snover

In the Pennsylvania Dutch kitchen where I was born and raised, I learned how to bake shoofly pies, serve A.P. cakes to Grandpa Howard, and heard stories about my Prussian Princess great-grandmother Laura. They told me family secrets about her over plates of *Schnitz un Knepp*, a hearty German hodge-podge of ham and dried apples.

"She's crazy. Thanks be to God that you're adopted and have no blood of her in you. Child, pass the apple butter."

My brother Jeremy, was also adopted and was five days older than I. Our adoptive mother, Aileen, was a private practice physician schooled at Women's Medical College, later to become Hahneman University in Philadelphia. She doctored my biological mother, who died at twenty-nine from heart complications brought on by a bout with childhood rheumatic fever. My adoptive father, Warren, called Bud by everyone, was also my blood uncle. He was everyone's friend. He was the produce manager at Acme Markets, a well-known grocery store chain in the area.

They divorced when my brother and I were about a year old. I have very important memories with both of them separately, but none together. We would go on rounds at St. Joseph's Hospital in Reading with my mother and watch my father stock Smokehouse apples in the fall in the aisles at Acme. At some point my father remarried a saintly woman, Jackie, who often provided a safe place for Jeremy and I to be. When Jeremy and I would visit them on Sunday afternoons, Jackie would make spaghetti and meatballs and on our birthdays we would have huge horseshoe-shaped cakes baked and decorated with roses in pink, blue yellow and green. As a child I thought it was very exciting to have two houses in which to celebrate birthdays.

The needs of everyday life were secured by my grandmother. Her friends called her Dot or Dorothy. Or Nana. For reasons I didn't find out till much later, Mom decided to name me the French version of Dorothy, Dorette. On the eve of Fat Tuesday she placed a bowl of *fastnacht* doughnut dough to raise on a table in my bedroom, because the main heating vent lived there. I can still smell the warm, yeasty potato dough. My mother explained that I was given this room as I was quite sick during my first year.

"We didn't think you'd make it. You couldn't hardly hold any food down."

No one would believe that today. I remember December suppers when Nana, Jeremy, and I ate ketchup and butter sandwiches as the snow blew across the back porch. Nana was too poor for anything else. I didn't know that then, I just loved the grand

adventure of it all. And so I grew up watching carefully how food influenced all of us. Nana held court with potato filling and my mother, Aileen, shunned such simple roots and demanded that she cook citified Delmonico steaks.

When Mom would take us to New York City for Easter, we'd pack jars of pickled red beet eggs and pepper cabbage to eat on the drive through the Holland Tunnel and all the bridges. We'd pull up under the huge green awning at the Waldorf Astoria. She'd take us to Saks Fifth Avenue to buy yellow Easter suits, matching shoes and pocketbooks. I felt like a new baby duck when I walked down Fifth Avenue in the Easter Parade.

Jeremy and I were treated as twins, though we had different mothers (but perhaps the same father; I may never know). I remember gargantuan double birthday celebrations at a Greek restaurant on Penn Street in Reading called The Crystal. I waitressed there the summer I was eighteen. I always kept my tables laughing, but the day a birthday cake lit with sparklers slid off the platter onto the birthday boy, I wondered about making it my career. I cried my eyes out to the Puerto Rican salad maker in the kitchen I was so ashamed, but when I finally returned to the table the birthday boy, who was seventy, sat me on his lap and gave me a big kiss.

It wasn't until I was five that anyone learned my secret.

"Why doesn't she answer? Jeremy, what does she want?"

Jeremy spoke for me, as I was deaf in one ear. Maybe it was because of my hearing problem that as a little girl I spent a lot of times in dreams, listening to music, and dancing. I was actually set on being a ballerina. I wanted to live in New York City. I adored the French names for all the movements, the accessibility of the larger world through dancing and the framed Degas in the studio where I took lessons. My instructor, Pearl, was vivacious. I wanted more than anything to have pink satin toe shoes like she did. I didn't care if she was old. Occasionally I still dream of being a ballerina, but my knees can't take it like they once did.

When we went to New York, I was so excited! In the dining room at the Waldorf Astoria, our waiter pushed open the doors into the kitchen. I was sure the most important secrets in the world were hidden here. Who were those people? What were they doing? Where were they going? What was that smell? Did they get burned? My god, you could walk into a refrigerator and sit down in a bowl of whipped cream! When I peeked around the corner, a slab of beef was just hanging there. I was dizzy, it was a world beyond my comprehension.

But life pushed against my mother. She married for the second time but he was a horribly abusive man. To all of us. Things grew more and more complicated. She gave up her practice, had to go live in Philadelphia, and took a position with the Veteran's Administration working on the board with lawyers deciding

veteran's cases. First there were World War II vets and then, later, Vietnam vets. We only saw her on weekends. She became an alcoholic. Nana struggled to maintain some semblance of order. But it was insane. Bud and Jackie kept quiet, never wanting to incur her wrath, though we all did.

When Jeremy drowned at eighteen, it was a major blow to my triangle: Mom, Nana and myself. We were totally broken and never fully recovered. My father and Jackie suffered too. It was then that I felt a great tapestry spread out around me, swirled with tangerines, velvets, pink roses, and unraveling green threads. I expect one day I will know why I can understand life only as I wind across valleys, rivers, and up into cloud-shrouded mountains.

A fabulous circumstance was meeting my husband, Rich, when he was fifteen and I was sixteen. He was from a simple family. He had a real mother and a father. He had two brothers and a sister. He listened to me and laughed at me. I laughed at him. He enjoyed food. I understood him and felt like I had known him since I was a little girl. We were both working at Mr. Angus Steak Haus and immediately took up with each other. I won't say there haven't been ups and downs. But if it hadn't been for him, I would never have survived Jeremy's death. In his family I learned about *halushki* and *galumpki*. Poppyseed bread at Christmas and mincemeat cookies. He brings so much joy to everyday life.

We married in 1978 and moved to Boston for a year. The next August, we traded the inner and outer loops of Boston for the cattle ropes of Laramie, Wyoming. I learned that cattle were not the same beasts as cows. And that the winter wind can blow trains off tracks. I also discovered that even though I graduated from college with a degree in home ec ed, I preferred the kitchen. And so I pedaled from Married Student Housing, with yards full of prairie-dog towns, to the University of Wyoming bakery to make hundreds of doughnuts at five o'clock in the morning. After that I met a Swedish woman who told me I should come cook in the hospital. I thought it was a little strange, because my mother had always wanted me to be a doctor like her. She was not happy about this cooking thing. Not at all. But I wondered if maybe I could heal people by feeding them instead.

After the dietician would leave for the day, I would make changes in her recipes for the regular diet patients. It worried me a little, but the patients told me it tasted better with oregano and basil, something they didn't know too much about in Wyoming. Actually, at the time I wasn't worried—I was just frustrated.

In between all of this, Rich was studying electrical engineering and was learning to hunt. Life was different in Wyoming. It was our pioneer time; we were thrown back to a primitive state. We butchered and ate everything: Elk, deer, antelope, sage grouse.

After a particularly long day of antelope processing, I couldn't bear it any longer and wrapped up the legs and stuck them in the freezer.

It seemed only natural that I then went to cook at The Farmhouse Fraternity. I love big appetites. Big breads, big cuts of meat. Big ovens. Big pots, big pans. Big desserts. I love feeding hungry people.

I began dreaming about going to the Culinary Institute of America. I had read an article about it and remembered that when I was a waitress at the Sheraton in Boxborough, Massachusetts, I was more interested in talking to the chefs who had just graduated from the CIA then I was in getting back to my tables who had been waiting and waiting for their orders. But it is Rich who gets the credit for encouraging me to go.

A year or so before Rich and I married, Nana was diagnosed with breast cancer. She had a double mastectomy and was well enough by June to be at our wedding. About a year after Rich and I moved to Boston, my mother and Nana moved out to Mesa, Arizona. It was good therapy for both of them at first. But the desert heat baked everything to a crisp. It was Christmas of 1981 that I saw Nana last. I was in my second semester at CIA when she died. But how could I give up then? It was because I believed in the power of cooking and Nana that I went on. Mom abandoned me and everyone for alcohol.

Despite this, the two years I spent at the CIA in Hyde Park, New York were two of the best years of my life. I worked in the Katherine Angell Library and saw Rich at Christmas. We were together for the summer of my externship on Hilton Head Island. He worked at Dairy Queen. I worked at the Hilton Head Inn on Sea Pines Plantation. It was a starry steamy summer, filled with peanut butter parfaits, dirty rice, oyster roasts, low country shrimp, and she-crab soup. I adored working the sauté line, even though it was 120 degrees and I must have drunk three quarts of water every night during service. It was thrilling and exciting, and I felt good, like I was doing something important.

After graduation I was hired with a friend of mine, Mary Pat Kiernan, for a job as a private chef at a business retreat in the mountains near Almont, Colorado. Anne and Perkins Sams, from Midland Texas, were great fun and high on the list of quirky, but who am I to talk? After that summer job, Rich and I moved to Colorado Springs, where I found a similar position working for another Texas family who lived near the Broadmoor and owned an equestrian training center. In addition to cooking for them, I also cooked beef hearts for their dogs, made peanut butter cookies for their turtles and pineapple kebabs for their parrots. Believe me, I can tell you things that would curl your hair. It did mine.

When Erick and Jaryd came into our lives, Rich and I were determined to spend our time with them. Now they are almost

fourteen and eleven (and a half, okay Jaryd?) and I have never regretted a single minute. They are my two angels. And my two trouble-makers par excellence. But I have been fortunate enough to share an incredible journey, a child growing up. They have different interests. Karate. Alligators. Track. Drawing aliens. Vietnamese food. Brownies and chocolate fettucine. Of course it's not over yet.

When Erick was very small, I began writing restaurant reviews for a local business magazine. But it wasn't until we moved to Chapel Hill in 1990 that I realized there was almost as much freedom in the world of writing as in cooking. Today I also love feeding readers with words. Since living in the South, I have been lucky enough to write for local and national publications. And gain experience in food-styling for photography. I've learned to be fearless in submitting queries. What can they say but no? I've heard that before and I will hear it again. It's part of life.

Before I watched my mother die of pancreatic cancer in 1998, I consumed a great deal of time caring more about meeting everyone else's expectations. What did it mean to be a home economist, a chef, a food stylist, a food writer, and then a fiction writer? Since then, I have narrowed my gaze. I care only about my family and doing what I need to do. I have struggled with the fact that I never learned or paid attention in the traditional way. It was much to my detriment and to my growth as a person.

Perhaps I have spent too much time telling about my childhood. It cast a magic spell over me, although much of it was quite strange. I always felt as though I was walking through the looking glass.

But maybe that's the reason I take great pride in developing Kid-Chefs, my culinary camp for kids. I can't set the rest of the year's pace for the kids who come into my kitchen. But for one week, they can experience the world through smelling, tasting, touching, and creating. I feel it is imperative to share the special space of the kitchen with them. To honor them. What is more important than our children?

I divide my year between these very intense summers of Kid-Chefs in our home in Chapel Hill, and writing freelance food pieces and fiction. In between, Rich and I hold cooking workshops with our Tuscan wood-fired oven and are developing a program for using cooking as a means of corporate team-building. I love nothing more than to gather around the table teaching and sharing with friends, old and new, young and old, the magic that exists in the kitchen. The magic that can open hearts and doors for all of us.

I continue to be challenged by the novel I am revising, *Eleone*. It is totally self-driven and it has occupied the greater portion of my energies for the last five years. Many people said, don't bother, it can't be done. Why would you want to write about that? Those

kinds of challenges only make me want to overcome whatever stands in the way. After my mother died, it became even more important to me. It is the tale of a contemporary food stylist, Elyn, and her sixteenth century family in Gascony. It features a wood-fired bread oven in Southwest France and a tiny village there and how their lives revolve around the bread, among other things. When Elyn travels to Gascony to style the food for a movie being filmed, she makes discoveries beyond the periphery of the camera, which change her life.

My personal life and my career have really merged at this point. I write from home, teach from home, and live at home. What I live is what I do. It wasn't necessarily my plan, but it has been what I wanted all along. I relax by planting more basil for the deer, visiting friends from Armenia and Argentina, and writing stories about places like the 25 Hour Café. I am thinking of taking up archery. Again. I'd love to learn more about Mesopotamian food rituals and visit Tunisia.

When I have trouble achieving what I've envisioned, I look long and hard at Julia Child. She started late in life too, and has kept to what she believes. No Matter What. The very first time I met her was at Draper's, a café, at the Greenbrier in West Virginia. I'm sure she didn't understand a word I was saying, because I was just a blithering idiot. But Julia, thank you.

One day I'd like to return to an *auberge* on the banks of the Gelise River in Gascony, France and spend time with Rich there: baking bread, sautéeing foie gras and catching eels.

The greatest challenge is being my own boss. I have had to learn when to back off of a project, perhaps if there are differences with an editor that are hard won. And when to plunge ahead. The dare in doing what you love is the false notion that you should not be paid well. The convolution of doing what you love incurs some level of guilt, which defers payment. Some projects I take on for the equation of money and their simplicity. Others I do for the pure love and satisfaction in taking on the challenge in completing them. I know a great deal more about myself since I've been quiet inside than when I was driven by others' ideas of who I should be. I listen intensely to my gut feelings, to my husband Rich and to my sons, Erick and Jaryd.

At times it's been ridiculously cold and flooded by the river, wearing boots that were five inches too short, and at other times the sun has warmed the earth so much that roses emerge from every crevice. But I wouldn't change anything. I am thankful for both.

Dorette E. *Snover*

Influenced by French heritage and the food traditions of the Pennsylvania Dutch Country where she was born and raised, Dorette Snover graduated from the Culinary Institute of America in 1983. In Colorado she spent ten years as a private chef to the Rich and Strange. Since 1990, Dorette has pursued food styling and writing in Chapel Hill. Her food commentary has appeared in local media, WUNC Radio, and national media such as *Kitchen Garden, Fine Cooking, Selling Power,* and America Online's Food.com. She assisted Kate Hill with Culinary Adventures in Gascony, France during the summer of 1996.

In 1996 and 1997, she and her husband Rich rebuilt their kitchen, which was damaged by three confused oak trees during Hurricane Fran. She also co-produced culinary hysterics with Jean Almand on Raleigh's only television cooking show, *Tarheel Chefs.* Dorette also offers workshops in her Tuscan wood-fired oven. During the 1999 season of her culinary camp for kids, PBS's *Regina's Vegetarian Table* filmed a session in her kitchen. Between calzones, she is revising her first novel, *Eleone.*

Mary Best Ellis an interview

Suppose we start with where you grew up and where you went to school?

OK. I was born and raised in Greensboro. When I was growing up, I lived really in the country, but now it's like the center of Greensboro's most explosive growth. And I went to high school in Guilford County. I went to Chapel Hill to UNC for my freshman year of college, and for a variety of reasons that didn't really quite work out, I transferred to UNC-G where I graduated with a BA in English and history. Then I went on through the master's group program in history at UNC-G and got my MA in American intellectual history.

When you were a child, did you know that you wanted to study history? What did you dream of doing?

I was always interested in history and in writing. I have a great-aunt who was a writer, and I always kind of wanted to model myself after her. So, I had a neat mentor growing up. Her name was Nell Wachter, and she wrote *Taffy of Torpedo Junction* and a couple of other books. They were children's books. Also, my dad grew up on the coast. He was born and raised in a little town called Sunny Point, which is also where Nell was from, and so I always found it real romantic and really fascinating that he grew up on the coast in the 1920s and '30s. So, yes, I have always been real interested in history and biographies and people.

How did that, as you grew older, translate to your degree? When you got to college, did you start out studying English and history, or did you cast about for a while to figure it out?

When I was in high school, those were classes that I did real well in. It sort of reinforced my interest in them. My senior year in high school, our school had a scholars program with Guilford College, where about five or six high school seniors could take classes at Guilford in subjects that they were really interested in. I got chosen to take history, so I took an American history class there, which was really neat. It felt really special to get to take a class like that. So that really boosted my interest, I think, in history.

When I got to Carolina, initially I was pre-law. I took a variety of courses. Of course, I took several history classes and an English class. That pulled a lot of my interests together.

I really never studied English or history for any kind of vocational training. I studied it because I was really interested in it, and I really enjoyed it. I was afraid when I graduated that it might be a big mistake, because I wasn't sure exactly what I was going to do when I got out of school. I knew I wanted something related

to history and English and research, and the liberal arts. And I was real interested in publishing. But I didn't have anything specific in mind. As I have worked in the publishing industry, I realize that the liberal arts education that I got when I was in school has been just invaluable. Even all the skills that I learned, in terms of verbal skills, research, and learning how to analyze things and evaluate things, have been so helpful. So that whole intellectual training that I had in school has been something I would never want to go back and change.

Can you recount for me the path you took to get to where you are today?

Let's see. When I finished my course work in graduate school, I was maybe twenty-three or twenty-four, and I had absolutely no idea what I was going to do. For a long time I thought about going on and getting my Ph.D. But I had been in school my whole life, and I felt like it was time for me to learn how to take care of myself, and, you know, be on my own and become part of the real world. So, I applied for a job at Page Communication that summer, and I got it and started working in the fall of '86 at Page. I was an editor for *Pace Magazine*, which was Piedmont Airline's in-flight magazine. And I really liked that. It was a lot of fun, and the magazine was real interesting. It concentrated a lot of things in the Southeast; everything from destinations—obviously there were a lot of travel destinations, but you know a lot of

the out-of-the-way places—interesting restaurants and inns, and you know, a lot of that kind of more travel-oriented kind of stuff. I worked there on *Pace* until U.S. Air bought Piedmont, and then U.S. Air had a magazine. Page published it, but it was a whole different animal with a different staff. So, I started working on other projects at Page, which included a grocery trade magazine, and I did a golf magazine. I ended up doing a lot of special projects; working with the publisher trying to solicit new accounts. That was always very exciting, because as much as I liked the monthly routine of magazine publishing, doing special projects really gave me a chance to step outside the box. Creating new projects and new magazines, you can be very creative and very imaginative, and I liked that a lot.

I was there for six years. But in 1992, I decided I wanted to go back and get my Ph.D. So I quit, and I went back to school for a year at UNC-G in a cultural studies program. And then my husband and I moved to Oklahoma for a year. My husband is a professor of American Indian history, and he was offered a job in Oklahoma, so he taught there for a year. I taught freshman comp, which I am really glad I did, because you know, always thinking about getting your Ph.D. also means that you will teach in some capacity. After about the first five minutes in a classroom, I realized that I am definitely not a teacher.

How did you know?

It was very uncomfortable. I felt very, very awkward in front of a group of people. It's not that I am terrified of crowds, but I wasn't comfortable enough being in front of them to try to measure where they were intellectually, and I wasn't real sure how to meet them where they were. I mean, I enjoyed it, and I am glad I did it, but I have a whole new respect for people who teach, because I think that is extremely hard. And I think that my strengths lie more in things that require a little more solitude, like maybe writing. I think that's much more in the area of interest for me than trying to teach.

Anyway, we stayed there a year, and we moved back to Greensboro, and I started working for a company called GP Publications, which is now called Imagine Media, and we did a lot of computer magazines for computer gaming, computer entertainment magazines. I worked there for nine months, and the company moved to San Francisco. I moved to San Francisco for a few months to help launch a magazine on the Internet that we were working on. Then I moved back to Greensboro, and I started working for a company called Connors Publishing. I was a special projects editor there. It was sort of similar to what I was doing at Page in that we were creating new projects and new magazines and working on new web sites. And so that was interesting. I liked that. It was a lot of fun. People who were there

were really very talented and very bright, and I enjoyed working with them. But in December of '96, I heard that *Our State* had moved to Greensboro, and they were looking for an editor. And I had always wanted to work for *State* magazine when I was growing up. My parents got it, and I read it and thought it was really neat that it was about our state. My mom taught fourth grade, so I had a lot of background in North Carolina history. Since I had been in school, I had sent resumés periodically to *The State*—at the time, that was the name of it—but I never heard anything back. So, when I was in Greensboro, I sent in my resumé and had an interview, and I was hired. I loved every minute of it. It was great.

What do you think have been your greatest challenges along the way?

Gosh, that's hard. There are work-related things that I have found very challenging. One is learning how to delegate work. I think a lot of times, working with special projects, you are the only person who does it and you kind of do everything. Most of the companies I worked for had a fairly small staff. So that's one thing I really had to learn to do, try to build a staff, and I learned to build a team rather than trying to have one person with all the editorial, and one person with all the art, or whatever. That's real challenging for me, trying to manage a staff and a team. I am much better at managing a magazine than I am with people, I

think. I am really trying to learn how to build a staff of people that I don't have to manage. So that's been one real challenge for me.

I think the other challenge for me is on more of an intellectual basis, which is trying to make sure that the work that we do continues to be fresh, meets the interests and the needs of the readers, that it isn't too repetitious, or that it can find that balance between finding new stuff, new places, new things to write about, without neglecting sort of the foundations of North Carolina that people really love. So I think that is the biggest challenge with this magazine, with *Our State.*

What aspect of what you have done brings you the most joy?

I love putting a magazine together. I just love it. I love being in production. I love having concepts and ideas, and then working on that and working with people, and then having, at the end, a final product that you can actually hold and see, and touch, and that people find an enjoyment. And I like to write. But I think putting a magazine together, the whole package, is really what I enjoy the most.

Do you do any of your own writing?

Yes. I write a monthly column for *Our State,* and periodically I will write a short article here and there. I haven't really done

any big features or anything. But I get to do enough writing that it keeps me satisfied, and keeps me pretty interested in it.

You mentioned you had a husband. At what point did you meet him? Did you meet while you were in school?

Yes. We met in graduate school. Sure did. We met in a colonial American history class, which was pretty appropriate, I guess, given what we both do.

Did you know right away that he was the one for you?

Yes, I think so. He made me really nervous. The first weeks of school, we sat at this big square table. It was a graduate seminar, so there weren't that many people in it. And he has real, real intense blue eyes. Whenever I would say anything, and he would look at me, it would just make me stop in my tracks. I mean, I'd completely forget what I was trying to say. I felt like a complete idiot, you know. And then one day after class, he came up to me and referred to something that we had been talking about in class a couple days before, and he lent me a book that he had on the topic that we were talking about. So, I guess from then on I wasn't so terrified of him anymore, and we got to be real good friends, and that was nice.

Has it been a challenge for you to balance your family and your career?

Yes, it really has. I don't know how people with children do it. I don't have any children. I have three dogs, and I have a fairly large family that still lives in Greensboro. My parents live here, and my brothers, and my sister. And then, of course, I am married, and we have a house and all that stuff, and I find it extremely difficult to try to balance all that; to maintain a healthy relationship with my husband and with my family; to not be a workaholic, really. Because I really like what I do, and it is so easy when you are here for ten hours a day just to keep on living in this little world. It's hard for me to change gears sometimes. But then, when you go home and have a husband and three dogs and a house and a garden and all that fun stuff to work with—it takes me a little while, but I usually can shift gears. But for people who have children and have those responsibilities—I just don't see how people do it.

What are some ways that you relax when you come home?
I like to walk. Usually that is the first thing I do when I get home—I like to go for a long walk. I sort of unwind that way.

With your three dogs?
Sometimes.

I don't think I would be able to walk three dogs. I have two dogs, and I can't walk both of them at the same time.

Do you, really? The time that they are all three on the leash together is when I am taking them to the vet. Otherwise, I usually take one at a time. We have an older dog, who is twelve now, and it is a little harder for her to get around. But I like to take her out and play with her and exercise her. And I have this little dog; he would be a hoodlum if he were a person. Anyway, he would be hanging out in a back alley smoking and cutting up with friends.

What does he look like?
He is real small. He is part terrier, and he is real wiry-looking. He is just the sweetest little guy, but he hates just about everybody but me and my husband. But I like walking him. He is at a good age. He has a good pace, and I think it is good for him to get out and socialize a little bit; learn how to be around other dogs and people without having a nervous breakdown. And, then our other dog, Larry, is just the sweetest little guy. He is part Lab, and he is a real sweet dog. He is just a couple of years old. My husband and he are really good friends. My husband teaches at Elon College. He takes him to school a lot of times.

So aside from your dogs, what are your other personal interests?
I like to work in my garden. I have flowers. I like to work around the house. I am not real domestic, in terms of cooking

and that kind of thing. A lot of the stuff I like to do is to be outdoors. I like to read. I read a lot. One of my favorite things is to look at magazines. I always have a big stack of magazines with me that I am reading. But that doesn't feel work-related to me. That is a whole different way of getting my batteries charged. I like doing that a lot. Those are the main things.

Is there one way that you have evolved throughout the course of your life that makes you the proudest?

I think that the area that I am the most proud of, or maybe most satisfied with, is that I have learned over the past years to really learn to trust my instincts about things. I think everybody has those instincts. It's just that I always ignored them. I never really would listen to what was going on inside. If all my friends were going to go do something, and I didn't want to do it, I wouldn't listen to that. I would go do it anyway and be miserable. I mean that is a real shallow example, but professionally, I think that translates into things like getting a sense from somebody about something and not acting on it. If I sense that somebody is upset about something, or if they are happy about something, listening to that, and responding appropriately to it. With the magazine, I think that sort of works with creativity, and with going with my first basic instinct about what I think would work, or what I think wouldn't work.

Is there anything that you think you might do differently if you could turnback the clock?

Oh, yeah. I would do a lot of things differently, I think. I think the main thing would be to be able to maintain friendships and relationships that I have. I think that is a big thing. Again, I think there are times when my instincts have told me that I should do something, or go somewhere, or call somebody, and I haven't done it, and I really regret that. I think that there are going to be magazines around for a long time, but people I know and love are not going to be here forever, and if I could do things over again, I would make sure that I was more careful with those relationships.

Do you have dreams yourself that are yet to be realized, either personal or professional?

Yes, I think so. I think, personally, I want to be much more active in the community and feel like I am really contributing to the betterment of the community, be it working with a social group or a charity. I just feel like it is a responsibility of mine to try to make the world a better place. I think working with a magazine like *Our State* is a good way to do that, because I think that brings enjoyment to people, and it helps to make people proud of who they are, and I think that is real important. But I also think that there are a lot of other ways that we can create a safer and happier world, so that's one goal that I really hope that I can achieve. I

guess professionally, the main thing I want to do is to write a novel. I am not sure that I ever will be able to do that, but it is something that, at least, I really, really want to try and see how it goes. I may not ever let anybody read it, but I just want to see if I can do it.

What is it about writing a novel that is so special to you?

I think part of it is just growing up wanting to be a writer and having that tag on most of my life. I sort of have the social obligation to do it. I feel like that is what I am supposed to do, so I kind of have it in my head that I want to do it because of that. Also, I think the sense of accomplishment—you know, that's a hard thing to do. I think it takes a lot of dedication and a lot of patience. I think that would be a really good exercise for me. And also, I think that through the years I have created some characters in my head that I would like to bring to life in a written form, rather than just in my imagination.

What advice would you give young women who are just starting out in their career, or older women considering a career change?

Most people who are young professionals, or wanting to become professionals, and have graduated from college, or whatever—for the most part, they have things pretty much checked off. But, I think that we tend, as young professionals, to want to follow the leader, and that we don't allow our own individuality to come out very often. And I think that would be the one thing that I would say. Don't be afraid to let people know who you are. Don't be afraid to say what you have to contribute. If it's different, that's good.

People are different from each other, and that's what makes the world really interesting, especially in a profession as creative as publishing. Because it is all about ideas, you know. And I think having the confidence to believe in who you are and not being afraid to let other people know who you are is really important.

Interviewed by Emily A. Colin.

Mary Best *Ellis*

Mary Best Ellis has been the editor of *Our State: Down Home in North Carolina* since 1996. She holds a master of arts degree from the University of North Carolina-Greensboro, where her focus was on American intellectual and religious history. She has edited for numerous publications, including *Computer Entertainment News*, and served as launch editor for *The Net: Your Cyberspace Companion* and for *VISaVIS*, the monthly in-flight magazine of United Airlines, with more than fifty-seven million readers per year.

Mary lives in Greensboro, North Carolina with her husband and three dogs.

"Having the confidence to believe in who you are and not being afraid to let other people know who you are is really important."

Mary Best Ellis

Nothing Hick about Water and Light Shannon Ravenel

Although I was born in North Carolina—in Charlotte, where my father had a brief job as a stockbroker—I grew up in Charleston, South Carolina. And I spent all of my childhood summers with my mother's family in the South Carolina Piedmont. I went to college in Virginia (Hollins College, now known as Hollins University) and, when I graduated in 1960 with an AB in English Literature, I went straight to New York City with the dream of spending my life with books.

The specific inspiration for my career in book publishing was a movie, 'The Best of Everything,' that came out around 1959. Based on a novel by Rona Jaffe, and starring Hope Lange, Joan Crawford, and William Holden, it's about a smart college grad who goes job hunting in New York on a Monday, lands a secretarial job in a major publishing house on Tuesday (Joan Crawford plays her mean boss, a big-time editor), discovers a wonderful novel in the 'slush pile' on Wednesday, goes behind her boss's back to the CEO who signs the novel up on Thursday (it becomes a bestseller), meets and falls in love with the author (William Holden) on Friday.

'That's for us!' was how I persuaded my cousin to leave Charleston with me to seek our fortunes in the big city. My own career didn't follow that time frame very closely. It took me more than a week just to find a pretty menial first job and almost forty years to discover a bestseller (*Gap Creek*, by Robert Morgan, Algonquin Books, 1999), but here I am, still in book publishing, albeit not in New York City, a lot of years later.

I lasted in New York for only a year. My first publishing job involved writing direct mail advertising copy for high school textbooks such as Moon, Mann & Otto's *Modern Biology*. A lot less than what I'd imagined. And New York was way more than I had bargained for. Everybody but me was so beautifully dressed, so chic, so glamorous. I coveted with every cell in my underpaid body. So after a year of longing for everything I couldn't afford and embarrassed to be quitting for that petty reason, I told my boss I was going 'back to school' and fled to Boston, a much more manageable town whose women dressed for warmth and not style. In Boston, I lucked out and got the job Hope Lange had: secretary to the senior editor in a major trade editorial department. And in fact, that job sent me 'back to school' in the best possible way. My three years at Houghton Mifflin as Dorothy de

Santillana's secretary were the equivalent of at least a master's degree in fiction editing. I rose in the ranks to finally, after seven years, become a real, true editor with my own list of writers, including Pat Conroy, Jonathan Kozol, C.K. Williams, and Anne Sexton.

Marriage and motherhood intervened and the new family left Boston for two years in London where I read manuscripts for Macmillan for 'under the table' pay. After that, we spent a very long time in the publisher-less city of St. Louis. In 1978, Houghton Mifflin tracked me down to ask if I'd like to be the series editor for the venerable fiction anthology, *The Best American Short Stories*. I did indeed and I served as that for fourteen years, during which time my professor at Hollins had a brainstorm that turned into Algonquin Books of Chapel Hill. He invited me to join him in starting the house. And so by 1990, I was back down South and things had come full circle.

Although 'The Best of Everything' provided the initial push away from the South and into publishing, the much truer inspirations for my professional life were my maternal grandmother and unmarried aunt, both of whom lived their whole lives in the very small town of Camden, South Carolina. They were both early feminists, though when they were alive, the word had not been yet uttered in upcountry South Carolina. They put it this way: women should earn their own livings. My grandmother's first job was Housekeeper of the Camden Hospital. Later, she ran the town's Water and Light Department. For thirty-some years, she walked to work every weekday morning with one of a series of dogs who spent their days asleep under her desk. One of them, a big black retriever, walked in front of her carrying her purse in his mouth. Later, when my aunt Sal Lee had completed her Business Course in Newberry, South Carolina, she too joined the Water and Light Department. When my grandmother retired, Sal Lee took the reins.

I remember them best as they looked in the summertime, which was when I stayed with them in Camden. They dressed for work in starched cotton shirtwaist dresses and high-heeled 'spectator' pumps. In the hottest spells of summer, they wore leg makeup because their wartime rayon stockings were hot and saggy. They described themselves to me, when I was little, as Career Women. I realize that I am still in their thrall.

Why does the 1940s image of two small-town working women epitomize success for me? Partly, of course, it has to do with the business of perceiving the South as a backwater. True, their lives unfolded pretty far from the madding crowd. But that they weren't making any impression on the world beyond Camden meant nothing to them in terms of their innate dignity and professionalism. That they dressed up for their work, that they took all of it seriously enough to worry how their legs looked to the

sleeping dogs, that it didn't cross their minds to belittle either themselves or their jobs for being situated in an 'outland'—that made an impression on me, though I didn't know it at the time. Come to think of it now, there was nothing unessential about their jobs at the Water and Light Department. Water and light are essentials, wherever you live. There is nothing hick about water and light.

Would it be too much of a leap to suggest that the same thing is true of literature?

As for that dog with the purse? Well, he was a Carolina Piedmont dog, showing off, of course. He symbolizes the fun—the joy, even—of doing what we can do, doing it where it suits us, and doing it well.

"New York was way more than I bargained for. Everybody but me was so beautifully dressed, so chic, so glamorous."

Shannon Ravenel

Mark Katzen

Shannon Ravenel

Shannon Ravenel grew up in Charleston, South Carolina. She graduated from Hollins College in Virginia in 1960 and has worked in publishing, one way or another, ever since.

She was a member of Houghton Mifflin's trade editorial department for eleven years until she left Boston to follow her husband, neurobiologist Dale Purves, around the science circuit. When Martha Foley died in 1977, Ravenel accepted Houghton Mifflin's invitation to act as series editor of *The Best American Short Stories* and edited thirteen volumes of that anthology plus the retrospective *Best American Short Stories of the Eighties*.

In 1982, she joined her former teacher, Louis Rubin, to establish Algonquin Books of Chapel Hill (now a division of Workman Publishing) for which she serves as editorial director and under whose imprint she edits *New Stories from the South: The Year's Best*, now in its fourteenth year. Writers she has worked with include Pat Conroy, Anne Sexton, C.K. Williams, Jonathan Kozol, Larry Brown, Julia Alvarez, Jill McCorkle, A. J. Verdelle, Lewis Nordan and Clyde Edgerton.

Ravenel has been a juror and panelist for many organizations including the Rea Award for the Short Story, the National Endowment for the Arts, and DeWitt & Lila Wallace Literary Marketing Grants. In 1990, The Council of Literary Magazines and Presses gave her its Distinguished Achievement Award.

Shannon Ravenel lives in Chapel Hill, North Carolina, with her family.

Bridgette Lacy an interview

Let's just start by your telling me where you grew up and where you went to school.

OK. I grew up in Washington, D.C., and I went to public school there and then I went to Howard University, which is an historically black institution in Washington. My major was broadcast journalism and my minor was political science.

What career dreams did you have as a child?

Well...(*laughs*). At first I wanted to be a singer. I loved Gladys Knight and the Pips. I just *loved* Gladys Knight's voice. I loved *Midnight Train To Georgia*. Everybody in my household knew the words to that song. But as I grew older I really fell in love with writing—especially by the time I got to high school. They had a journalism program there. I was the feature editor for our newspaper, which is called *The Beacon*. I believe I'm just a person with kind of a creative bent, in that I've always loved different kinds of music and art and writing. So writing, in a way, seems like a natural progression. My voice, to me, is strong, but not as strong as I think it needs to be to be a singer. But, music and writing are similar, in that in both genres you're expressing yourself.

Recount for me the path that you took to get where you are today in your career.

Like I said, I did have the writing classes in high school and then I went to Howard University where I majored in journalism. I was there at Howard six years, because I worked my way through school. My parents were working-class and I had some grant money, but I also needed part-time jobs to kind of get through school. During the summers—after my second year in college—I started doing summer internships at newspapers. I really just loved those. It was my first time really traveling away from home other than my grandparents' house. I just thought, 'What a wonderful opportunity,' because the first internship I had was in Portland, Oregon at *The Oregonian*, and it was the first time I had ever been on a plane. I had sent my newspaper clips, but I hadn't heard back from them as to whether or not I had received this internship. I remember saying, 'I need to go ahead and know so I can ask my grandparents for the plane ticket money.' (*Laughs.*)

Anyway, I did get that internship and that was just a wonderful experience. A friend's mother knew some people there, and so I called them up and on weekends I would hang out with this family, this librarian. She had this wonderful beach house and almost every weekend I would go there. To be able to kind of get a taste of the newspaper experience prior to actually becoming a professional was a great opportunity for me.

The second internship was at the *Des Moines Register*—also another wonderful experience that was kind of interesting. Getting to see different parts of country—I mean, the first one was in the West, and then Midwest. Then I did a third internship at the *Montgomery Journal*, which is right outside of Washington—Montgomery County. That was kind of a fall internship, and then I did my last newspaper internship at the *Washington Post*. I grew up reading the *Washington Post* and always loved that newspaper, and so it was fabulous to actually be writing stories for my hometown paper. Of course, the *Washington Post* is such a wonderful paper with lots of resources.

Then I also did an internship at WHUR, which is Howard University's radio station because, again, my degree was in broadcast. I knew I wanted to go into newspapers, but I wanted to have the background that if I couldn't get a newspaper job, that I could also get a broadcast job—to kind of keep my options open. So I like radio as well, and I've used that background here because sometimes I have done some commentaries for WUNC—which is, of course, Chapel Hill's NPR affiliate.

What was it about newspaper early on that you really got "the bug" about?

I just think there's power in words—being able to tell someone stories, to me, just seems so powerful. I think at times I was able to express myself in print in a way I couldn't verbally. Sometimes people distract you or it's kind of hard to say what's on your mind. I've always felt in terms of writing it down, I could do that. But to me, I love reading other people's stories, I've always loved books—there's something transforming about a book. It can take you a place you've never been, whether it be in terms of traveling to another land or spiritually. I don't know, I've always been attracted to the written word.

Briefly describe for me your current job.

I am a part-time feature writer for *The News & Observer* which is the newspaper in Raleigh. I came to the paper in 1992 as a feature writer. In the past I had been a writer on the metro staff of newspapers. I worked full-time I think until 1996, but in 1994 I was selected as a grant recipient for the North Carolina Arts Council. I had a fellowship in the south of France, and I started working on my first novel there. I had been writing fiction for a while, but this was my first big fellowship. When I was in France I had three months away from work and that's when I really understood that, while I loved journalism, a lot of the love for it had kind of changed. I didn't have the passion for it I had before. It was more important to start working on my own stories. On some level, I think journalism was a rehearsal for me to become a strong writer to write my own stories.

That's interesting. What have been your greatest challenges along the path that you've taken?

I think journalism is a very demanding field. It takes a lot from you, in that I think sometimes people confuse your role. They see you as an advocate for their cause instead of a recorder of their deeds. I think that it's a lonely field in that I've often been places where I didn't know anyone.

But I think going to a place where you know no one and being able to make a life for yourself, that's a struggle, too. To be away from all your kinds of foundations—you know, being away from your church, being away from your family, being away from friends. I think, too, the thing about journalism is that every story...it's like starting over every day. It's not like being a bank teller, where you kind of count the money every day—the money is still twenties, five-dollar bills, a dollar. In journalism, you can write one story and it's totally different from the next one. It can be demanding in a different kind of way, and so you're constantly reinventing.

You're also always judged by the last story. You can do five great ones and do maybe one that's not so great, but if that's your last story you're often judged by that. It's very, very demanding. I think it's a young person's game in a lot of ways. This is a small thing, but I think another struggle has always been...a journalist has to be someone who really likes to travel, whether it be traveling from one state to the other, or just traveling around town.

Every place I've gone, you really have to be able to get in the car with a map and go someplace to cover your stories. I think you have to be somewhat broad-minded, because there will be a lot of people who are very unlike you that you're covering, but you have to be able to listen carefully so you can find their story, too.

In times of disappointment or strife in your career, what are your sources of inspiration or renewal?

It really depends on the time. I've been trying to take walks, I mean that's been important to me. Bubble baths are high on my list. (*Laughs.*) I often tell people I probably was a mermaid in a previous life. I've also had good support of friends. I've had a lot of journalism friends—older journalists—that I could call and talk about my frustrations.

I think there is a struggle being a black journalist. There are so few of us at newspapers, it seems like I tell people I probably know almost all the black journalists. Because we just seem to move around from one place to the other.

The other thing is, I think you have to really keep kind of a balanced life going. You go to work and you do the best job that you can, but you don't make it your life. I've tried never to become a wage slave. That's why in '96 I went part-time. I decided I wanted to do something a little more with my life. I wanted to have more control than working full-time and people dictating,

'You need to do this at this time and that at another time.' I think you have to figure out what is important to you and you live according to that.

For me, in '96 time became more important than money. That's been a struggle. I mean, I coupon shop, I have all these kind of discount things I do. But I want to be able, on a nice day, to go outside on my front porch at midday and have a sandwich. I think the earlier you decide what's important to you, the better off you are—because then you have to find a way of living your life according to that.

I think I've always had an appreciation for simple things. I can buy a roasted chicken and make a nice salad and put on some bossanova music and have a wonderful evening. I think it's finding whatever that thing is that, for you, is calming, and relaxing, and peaceful. I think too, I really try to do something for my personal self every day.

What are some ways that you do that?

When I was full-time I used to have this thing for a while that every Friday I would allow myself five dollars to buy something. It could be whatever I wanted, but I could only spend five dollars. So sometimes I would go and I would find some really great book that was like $4.99. I remember finding this apple book I loved, or I remember one time I found these cards by Walter Dean Myers,

who is a children's writer, but they were called *Little Brown Angels*. They were these beautiful black children that were little angels, so to speak. I collect teapots and I have all these really beautiful little porcelain teacups and things, and so sometimes it's afternoon tea with some cookies and inviting friends over. I've really gained a lot of strength from other women. I was in one writer's group and now I'm in another writer's group with three other women. The group serves not only as an opportunity to talk about my work and my writing, but about my life. I have other friends who are artists. One is a visual artist who I met when I went and had my fellowship in France. Another friend of mine, who is a doll-maker, lives in Durham. I think it's important to meet with other people who are also creative and talk about your challenges and your goals and your work. I think you have to make these networks for yourself.

What are some personal goals or personal interests that you are currently pursuing?

At this point—I haven't started, but this year—I will be doing the revisions on my first novel. I finished the actual drafting last year. Last September I was diagnosed with a brain tumor and I had the surgery last year. I was out of work for about three-and-a-half months—from September to January. I've been working a lot on journaling about that experience. I was thirty-seven years old.

I had had headaches and complained about them and the doctors told me I had sinus problems—sinus headaches. I kept thinking, 'No, I think it's something bigger than this.'

Anyway, so I've been journaling a lot about my healing process because as a result of my tumor and my surgery, I lost sight in my right eye—and I lost my sense of smell. I can't smell anything. That's really been hard for me as a writer because I used all my senses. It's really been quite an adjustment period for me.

I was told on a Wednesday evening—well, I guess it was early Thursday morning by the time they saw me in the ER—that I had a mass on my frontal lobes and the surgery had to be performed right away. There was no option other than death and that was a lot to chew on. I've always been a person that lived my life in a way where I liked options. To come to a point where there are no options is kind of hard for you. Then, on top of that, to have a six-and-a-half hour surgery...I was in the hospital for three-and-a-half weeks—recovering almost three months. That's been quite a journey for me. Eventually I'd like to do a book about my illness and my healing.

Where does that stand now—your healing?

Right now, I'm just kind of working through things. You often ask when something like that happens, 'Why me?' I thought I was doing what God wanted me to do and using my talents the way

He wanted me to use them. But I think I'm listening harder to see—what do I do with the one eye I have? What do I do now that I can't smell? How can I use my gifts even more and redefine them maybe to help others? I think this healing book...that will be important in that I think my fiction will reach a lot of people, but healing is so universal. A lot of people who had the kind of tumor I had, a meningioma—they're so much older than me. They're more like sixties and seventies. To be a young person, to have had an illness like that, and to be single—I think that's hard, too. I had help in terms of my friends and family, but I live by myself. A lot of times I remember there were things I really wished someone would do, and I looked around and it was like, 'There's nobody but you. You're going to have to do that today.' That was hard.

I don't know, I'm a person with a big spirit. I think often that when God gives you a lot of talent, he also demands a lot out of you. At this point, I just feel like I'm trying to move back into my routines. But at the same time, I really understand that I'm not the Bridgette I was before surgery. When something life-altering like that happens you have to change a little bit. I'm in the process of becoming this new Bridgette and going through an adjustment period. But also, I've had to grieve some of the things I miss about the old Bridgette.

What is the one way that you have evolved as a human being that makes you the proudest?

I'm not as judgmental as I used to be. I grew up in a household where my father was a very judgmental kind of person, and he really saw the world in a very narrow way. I think my broadening first started in college when I lived in the dormitory. That was an opportunity to live with lots of different kinds of people that had different views of the world. Often you think the way your parents think, because that's all you know. Then, through living in different parts of the country and living with different kinds of people—and when I say living, not living in terms of living in my home but in terms of this space, of the community—I think I've become a broader person in terms of my thinking about people and their experiences, and trying to see their way of looking at something instead of just my way.

What personal qualities do you consider to be of most value?

I think humor is a good one. (*Laughs.*) Even when I was sick...any time I struggle in my life I can always find humor in it. I think that's real important, to laugh. I think that's really therapy. I think honesty is a very big quality for me. I personally don't want people to soften the blow. Give me the real deal. One friend of mine said that I was honest as a razor. (*Laughs.*) I think you should be true to yourself. I've always been a person who operated—

whether it be as a reporter or in my personal life—on gut instinct. I think it's hard sometimes to follow your gut instinct, but I think that if you can do that, that's a real important quality—and an important tool for you as a person to survive in the world.

Why do you think it is so hard to follow your gut instinct?

I think because sometimes you don't want to disappoint others.

How would you disappoint others by following it?

Well sometimes people may want you to do something and you may have a problem with that. For example, I have been invited to be a bridesmaid several times in weddings. I remember one particular time a very good friend asked me to be a bridesmaid, but I never thought the marriage was going to work—and it didn't. My position was, I didn't really bear witness to this kind of farce. I felt like this person was saying to me in little ways and big ways that this guy wasn't the right guy for her, but yet, she wanted to be married. I kept saying, 'But you said this and you said that,' and she would say, 'No, well that's OK. I've changed my mind.' The marriage lasted less than three years. So, she was disappointed that I wasn't her bridesmaid—I did go to the wedding—but to me, I would have been more disappointed to have participated in something on that level, knowing in my heart that I didn't think it was

a good match.

What qualities do you possess that you think make your career a natural choice for you?

I'm naturally curious, so that's a good quality to have as a journalist. People tell me that they can talk very freely around me and they really relax—to the point that sometimes I've gotten them so relaxed they've said things they shouldn't have. (*Laughs.*)

On the record?

Uh-huh, on the record. In fact, one time I did a story in Indianapolis about this sheriff's deputy who had been involved with more police shootings than anybody else in the department. On record he called himself "Dirty Harry," and the other detectives got mad at me and said I had been so charming that he had slipped and said that. I'm a good listener and I'm naturally curious, and I really like telling people stories. I really like doing that. I think you should love what you do because it shows in the work.

Conversely, on the other hand, what qualities of yours create conflict or struggle that you constantly work to overcome as pertains to this career?

I think honesty, in a way, can be a struggle, even though it shouldn't be if you're a journalist. When I say honesty—a lot of times people present one side of something, but in actuality it's a

little different. A story that comes to mind for me is a woman who has started a literary journal. She was calling it a person's name—I won't mention the person's name because the person had been her maid. It was a white woman starting the journal, a black woman who she named it for who had been her maid. She was saying how she had admired this woman so much, and I remember when I went to interview the maid you could really see the stark difference between their lives. The maid had had a lot of health problems. She was in her seventies and yet she was still working. I remember the woman saying how much she loved her, and we were going to send a photographer to take a picture and she was saying, 'I'm going to cook for her today.' This woman—the owner of the journal—was maybe in her forties, so she was a grown woman and had known the maid since she was a child. I said, 'Well, have you ever cooked for her before?' and she said, 'No.' I said, 'Well, please don't do anything you wouldn't normally do.' I mean, don't cook for this woman you say you love, just because we're taking a photograph today. It's that kind of thing where, she painted the picture in one way and I painted it another way. Because what I could see was this woman—who I really believe couldn't even read—who she's saying this journal is for, and yet I felt like there were probably a lot of things she could have done for this woman—to help her.

Overall, of what professional accomplishment are you most proud?

Well, I guess there would be several. One thing I remember I was very proud of—sometimes I freelance for *Newsweek* magazine. My first assignment for them was to ask people were they better off than they were four years ago under Reaganomics. What happened was, I ended up interviewing a black single mom who had her son in private school. She had taken her son out of private school because she could no longer afford it. In writing her story, which was a part of a larger piece, two people wrote her and gave her son money to go back to private school.

I was so excited. I remember having them over—I have like a Christmas tree-trimmer. I interviewed her on the phone, but I actually wanted to meet this family. The woman was so proud she would only take half of the money, because for her it was important to at least contribute half of the son's tuition. I'm proud when I can write a story that can really make a difference in somebody's life. So, to me, that's really one of my favorite accomplishments.

Of what personal accomplishment are you most proud?

You know what? The fact that I really like myself. I think a lot of people don't. That's why healing from this tumor has been so hard for me, because I really grieve the old Bridgette. I loved her so much. She was interesting, she was funny, she was helpful to others—not to say the new one isn't—but her sense of carefree-ness and girlishness. I've always been the kind of girl who giggles, kind of light-hearted. I think it's real important to really love yourself. That's been, to me, one of my biggest personal accomplishments—getting to a place where I really love myself. Bridgette is my best friend. (*Laughs.*)

That's fantastic. What, if anything, would you do differently if you could turn back the clock?

If I could turn back the clock...I think that you take a lot of your senses for granted. I would have smelled more things before I lost my sense of smell. I would've seen more things—in terms of travel—before I lost the sight in that eye. I think sometimes we don't make enough time in our daily lives to appreciate things. You're working against your deadlines at work and other commitments you have, but I think you really have to take time every day to appreciate very small things that you may come in contact with that really bring a lot of beauty to your life.

How do you do that when you've got deadlines and you don't see a way to get away from the desk and go take that walk for ten minutes, or hop on the treadmill, or smell a flower?

I think what one has to realize is—for example, I had gone on assignment the day I found out I was sick. Then I went to the hospital and was there for three-and-a-half weeks. Life went on.

They still produced stories, they still got the work done. So, I think that one has to realize that you make time to brush your teeth, you make time to wash your face—beauty is just as important as those things are.

What is some of the best advice you've ever been given career-wise?

Hmmm....one thing that sticks in my mind is to get good at your current job before you move on. As a young journalist, a lot of times you have a job that you don't like. You may start off at a newspaper working night cops. It's the worst hours. Covering cops can be very depressing. I remember when I was in Indianapolis—sometimes you could cover four murders in a night. You're like, 'Man, not another dead body.' (*Laughs.*) It's depressing, you want to talk about life not death. I think you have to get good at that job. You have to find ways to make those stories the best stories you can produce, so you can then move on to something that you may like more. Some people get frustrated and they don't do a good job at the current job, and then they go, 'Well, how come nobody will give me an opportunity to do something else?' I don't know that anyone gave me this advice, but I'll give it to other people. I think the other thing is, you have to not be afraid to move on. You have to constantly look at your situation like, 'Am I learning anything new in this job? Have I come to a point where I'm not getting anything else out of this experience?' I've

had a lot of friends that get stuck because they get comfortable and it's almost like they become afraid to start over again. Because in a way, when you get a new job, you're starting over. When you move to a new town, you're starting over. I think you have to constantly be learning in your life and constantly trying new things and new challenges.

There's something my mother told me, which is very good advice. You can't live and die at the same time. I think that's so important because I know so many people who are afraid of life.

What she's talking about is, there's some people who...they don't try. I have a really good friend and every time I suggest something for her to do when she's in a rut, she has a million excuses why she can't do it. In part, Muhammad Ali, what made him so successful was he won the boxing match before he ever got in the ring. That's why he talked all that stuff. He's trying to make the opponent afraid before he even hits them. I think that's the same thing some people do to themselves. It's like, 'Well, I would apply for that job, but I just don't know. I don't know if I'm qualified. I don't know if I'm this, I don't know if I'm that.' And I think...*try*. Don't take yourself out of the running before you even start the race. A lot of people do that.

I just think, too, you really have to believe in yourself—and if you fail, so what? I remember one time I was running across the street and I fell in the middle of the street. I brushed myself off, I

laughed at myself, and then I got on the bus. I think you have to kind of be like that in your life. You can't just be afraid to not even try. If you try and you fail, so what? Brush yourself off and keep moving.

Do you have any special career advice, let's say for older women who are considering a career change?

I think once again, you have to really find out what you're passionate about, and if you're passionate about it you'll be blessed. When I went part-time, I was very afraid. I had these horrible dreams that something was going to happen to my car, because that was the one thing that I thought would keep me at a job full-time. In Raleigh, you have to have a car. But I noticed that, once I went part-time, all this work kind of fell into my lap. People will refer other people to me for freelance and I was also writing letters and queries and getting freelance work. A lot of opportunities that I didn't see prior to going part-time started happening for me.

I just think that when you're doing what God wants you to do, these blessings really do, literally, fall out of the sky. I remember I have had times when I have prayed for work. I mean, it's like, 'Wow! I need some work. Dear Lord, please send me some work.' And literally, somebody will send a contract in the mail. I'm like, 'Wow, this is just so interesting.'

I really do believe in asking and you will receive. I always tell

people, pray with your feet moving. You know, you need to be praying, but you also need to be working towards your goals. I think you kind of start small, you try a little this, a little that, and you get more aggressive with it—starting small, rather. I think you really have to have a lot of faith in yourself.

The other thing is, don't be afraid to toot your own horn. If you do something well, let people know about it. Some people, it's like, 'Oh, I do that well, but I don't want to tell anybody.' Well, please start telling somebody, that way people will know—because then they can maybe be helping you. So, that would be my advice to older women if you want to change your career. As long as you have a passion about it and it's something you love, go for it.

Do you have any dreams that are yet to be realized—whether that be professional or personal?

I hope to have a great love. (*Laughs.*) That has not been realized. Also, I always say God is going to make me patient yet. I'm not a very patient person and in my being sick I've had to be.

If you had to give me a laundry list of favorite things—and this can be books, movies, foods, sports teams, T.V. shows, you name it—what would they be?

'The Waltons.' I love John Boy. (*Laughs.*) I always tell people my ideal men are Star Fleet captains. I love how in control they

are and how smart they are. Teapots, mango tea, stationery—I absolutely love stationery. Bubble baths, rosemary, lavender, sunsets, my nephew, Russell. He is so wonderful—he's five years old and he's always spilling out some wisdom from a five-year-old's perspective. My grandmother, she was such a role model for me. I love the colors pink and yellow and reds and oranges. I love Burt Bacharach's music, Marvin Gaye...Aretha—I listen to a lot of that. I think a little grease is good for you—fried chicken. My papa, too, which is my grandfather. I think of him often. My grandparents just in general. They were just really wonderful people for me in my life. I think, too, the Mediterranean Sea. When I was in France we were right on the sea and it was just so wonderful listening to those waves. I like mountains—love mountains actually. And...did I say fried chicken yet?

You said it.

OK. That's a theme of mine. (*Laughs.*) Books, I love *Their Eyes Were Watching God* by Zora Neale Hurston. That's absolutely my favorite book. I do like *The Thornbirds* though, too—which is Colleen McCullough. Two people who've been mentors for my life would be—my high school journalism teacher, Dr. Marian Hines. She even came down for my surgery. To have a teacher that you've been in touch with that long—it's just wonderful. Also, my minister in Washington who would call every week to see how I was

doing. His name is Dean Lawrence Neal Jones. They have just been wonderful people in my life. It's really good to have good friends or people who better your life.

When I was a little girl my grandmother used to say, 'You can count your real friends on one hand.' And I used to think, 'Grandma don't know anything.' (*Laughs.*) But I really understand that now—that your real friends are few and far between. As a child I didn't. Another thing—this is kind of advice, but something my father used to say all the time. He would say, 'I'll take my bitters with my sweets.' I think you have to.

You don't always want to.

Right. My family though, they love to spew out those little sayings. They're very Southern in that kind of way. They have a bunch of them. (*Laughs.*) When I was sick, people would sit at my desk and look at all these sayings. I put them in different kinds of types and post them on my desk. One is from me and it says, 'You have to be ambitious about your dreams.' That's one of my own. Then there's one that comes from a one-woman play about this woman named Queen Bess—she was the first black woman aviator. Bessie Coleman is her name. She was going to all these aviation schools trying to learn how to fly. This was, I believe in the '30s, and everybody would turn her down. So finally she gets to this one school and they're like, 'Oh, we've been waiting for you

all day,' and she's like, 'Really?' She's so excited and then the woman says, 'Yeah, because the maid quit early this morning.' Bessie Coleman looks at her—and this is what the quote says on the desk—she says, 'I will fly over this building and your ignorance as if I was born with wings to fly.' That just takes my breath away.

Interviewed by Susan L. Comer.

"You can't live and die at the same time."
Bridgette Lacy

With David Baldwin, brother of the late novelist James Baldwin, in a
St. Paul de Vence café in France.

Bridgette *Lacy*

Bridgette A. Lacy is part-time feature writer at *The News &
Observer* in Raleigh, North Carolina and a commentator for WUNC
Radio at Chapel Hill. She's also a book reviewer for *The Washing-
ton Post*. Her work has appeared in numerous magazines includ-
ing *Attaché, Black Enterprise, Southern Living* and *Newsweek*. She's com-
pleting her first novel.

In 1998, she was awarded a grant and work-study to attend
the Vermont Studio Center in Johnson, Vermont. She also re-
ceived a Regional Arts Grant from the United Arts Council of
Raleigh and Wake County.

Her short story, "Lilly's Hunger," is featured in the anthology
Streetlights: Illuminating Tales of the Urban Black Experience. In 1994, she
was awarded a three-month fellowship from the North Carolina
Arts Council. She spent the fall in La Napoule, France working
on her fiction. That same year, she received the National Asso-
ciation of Black Journalists' feature writing award for her portrait
of peach farmer and author Dori Sanders.

María Gloria Sánchez an interview

Let's start by you telling me where you grew up and where you went to school.

I grew up in Mexico City and I came to the United States ten years ago...well, in 1989. I started college in Mexico and I finished here. I went to UNC, and I graduated in radio, T.V., and motion pictures, with a minor in French.

And if you would, tell me what it is that you do today as a vocation.

Right now, I work part-time importing books from Mexico and Central America. I run my business part-time, which is also importing books from southern Mexico. So, my company is from northern Mexico and my business is from southern Mexico. We distribute books to college libraries—the Library of Congress, Harvard, Princeton—library collections that have a Hispanic acquisitions department. Also, I work as a freelance writer for *The Herald-Sun* in Durham. Right now we're putting together a Spanish T.V. show for public access T.V. We are a team and we're getting our training, and pretty soon we'll be producing our first show. It's called *Presencia Latina*, like 'Latin Presence.' That keeps me very busy...

Well, let's go back a little bit. As a child, what career dreams did you have?

I always wanted to be a journalist. When I came to the United States I studied radio, T.V., and motion pictures because my English was not very good. I learned English here ten years ago. I was afraid I wasn't going to be a very good journalist because I wasn't going to be able to communicate if it wasn't Spanish. I was thinking to go back to Mexico, so I said, 'Well, I better learn the technical part—which is probably better here than in Mexico—so when I go back I'll know everything about producing with the best equipment, etc.' But I ended up staying here. I don't know if I'm going to go back or not—yet.

What did you do to learn to speak English? How did you go about that?

Before I knew I was coming here I took some classes in a school for nine months—intensive conversation classes. But anyway, they didn't help me that much because when I came here I couldn't understand anything. Nobody could understand me either. So, I went to Durham Tech Community College and they have a great ESL program. Pretty much that's where I learned. Only six months

after I arrived, I was able to get by and communicate and have a conversation. But the first six months were very frustrating—trying to communicate—and there were not very many Latinos around in this area. I pretty much had to speak English wherever I went.

After you graduated from UNC, what has your career path been up until today?

OK. When I went to UNC, I really wanted to get into the T.V. business, and I worked in Charlotte for NBC. NBC in Charlotte was producing a Spanish newscast that was on the air in Latin America through cable. I worked as a news writer and it was a very hard job, because I had to wake up at four o'clock to write the news for seven o'clock. I was a freelance writer, too.

Were you writing in Spanish?

I was writing in Spanish, yes. We worked together with an English newscast, a local newscast from Charlotte—and then producing a Spanish newscast. It was a permit NBC had by that time, which doesn't exist anymore. It was called *Canalo Noticio*—'news channel,' that's what it means in English. It was on for probably five years, but I think it was not productive and they cancelled the show. I worked there six months freelancing and I really wanted to be a full-time employee. But then I decided to come back to Durham, to this area. I started working at IBM as a computer consultant, and I worked there for a year. Then I was going back and forth—'I should be back in Mexico'—because you know, without the English it was the best place I had. I could probably get a job there rather than here. I was getting professionally frustrated. (*Laughs.*) I went back to Mexico and I got a job at IBM-Mexico as a Sales Manager.

How did you become so computer literate that you could do that? Had that been a skill you'd had for a long time?

Well, selling computers, you know, IBM has great training in sales and all the computer equipment. The models they were offering in Mexico were older models that they were no longer offering in the United States, so I already knew them pretty well. The operations in Mexico were very small in comparison to the United States. I already knew the models and they were coming from here—from the IBM headquarters here—and I was already trained. It was pretty easy to get the job in Mexico, and I was ready to go. Then I stayed like a month there, and I decided that the big city was not for me anymore. I was accustomed to here—to the convenience of living in a small town.

You're saying that Mexico City was not for you anymore?

That's right. Home was not home anymore. I was accus-

tomed to no traffic. Mexico City has terrible traffic and wherever you go there are lines and people always in a hurry. You know, a big city and pollution and noise, and all this stuff I really didn't like anymore. I really appreciate being in a place where you can just drive ten minutes from home and park and pull up in a parking space—pretty much do *fast* whatever you want to do because of no lines and because of the grocery stores. It's just much, much easier. I really appreciate that, so I decided I didn't want to be in Mexico. I came back here and I started working with the company I work with now. The name of the company is *Mexico Norte*, and I have worked for them—I started in probably '95—so I guess it's probably been five years. It's a very small company. There's only two other employees. They are very flexible with me and I really like that.

Do you work out of your home?

Sometimes I can bring work home. I used to travel to buy books in Mexico and I really liked that a lot. Now I have a little baby, so I can't do that anymore. It's harder to go buying books. I used to go back and forth when I lived in Mexico and now I'm pretty much more in the office. My brother and I started this business, called *Publicaciones Azteca*—Aztec Publications—and we cover all the Mexican southern states. We started it about a year and a half ago and it's doing good. Slowly but surely we're adding

new contracts. Universities are hiring us to collect materials for their collections, so we're hoping it just gets better and better in the future. While he's in Mexico, I'm running the office here. He's the one who's doing all the buying trips.

Let's talk a little bit about yourself personally. Your daughter is sixteen months old...how have you been able to balance having a child and a career?

Well, it has been quite a challenge and hard at times. But I really enjoy her. Naila really came at a good time, I think. Fortunately I have found people who support me with her—you know, who I can rely on to help me watch her and to take care of her. I really miss having my mother and my family; that would be great...that would help me a lot more.

They're in Mexico still?

All my family is in Mexico, yes. That sometimes makes it harder because I only can have her father and some friends of mine who sometimes help me to watch her. But sometimes it's like nobody can watch her and I need to finish something, and I wish my mom was here. (*Laughs.*)

Tell me a little bit about your daughter. What is she like?

Her name is Naila Parker-Sánchez, so she has kind of a Spanish last name—first the father and then the mother. She's a very

happy little girl. She keeps me very busy. What else can I tell you about her? I'm trying to raise her bilingual, because I really value that. I think it's very important to speak a second language. I especially think Spanish is a very good language to learn, because the Hispanic population is growing here very fast. It's probably the best language to learn in the United States, with the amount of business the United States does with Latin America—that's another reason. I speak to her in Spanish only, and so I want her to grow up bilingual and appreciate both cultures.

How has she changed your life?

Well, I have more pressure. (*Laughs.*) I feel like I have to be more responsible now in everything. I have to worry more about taking care of myself because I really want to be there for her, and make sure that I see her when she's a grown woman who can take care of herself. It has really made me grow up a lot in all senses. I just bought a house last year. I never thought about buying life insurance, but now I bought the life insurance. I think about what type of examples I want to give her. It completely makes me think in other terms. It's a new world to explore and to give a lot of thought.

What are some little things that she brings to your life that are positive?

I just see how happy I am, and how she makes me smile. I'm really miserable when she's not with me, when I have to go to work. She has really brought me a lot of stability and more direction, in a sense, and meaning to my life.

What are some of the ways that you relax?

I usually like to write or I go to the gym; or I just hang out in the house and watch T.V. and listen to music.

If you had to give me a list of your favorite things—and this can be books, movies, food, T.V. shows, sports teams, whatever—what would they be?

I love photography. I love producing media, even though I'm not very good at it yet. I love the T.V. business. I like being out—like walking and going to the beach. I love contras and to go dancing. I like salsa. I like cooking, too, and going out to eat to restaurants and bars. I like ethnic food.

What are some of your favorite foods?

I love Indian and I love Chinese, too.

Since you enjoy television so much, what are some of your favorite programs?

I watch a lot of the Spanish Channel. I watch the news at six-thirty, because the news in the United States sometimes has some news about Latin America, but most of the time you cannot find

that much information. So, I watch the Spanish news, which tells you what is going on in the United States and also what is going on in Latin America and Mexico, which to me is very important. I watch T.V. just like anyone else. Sometimes at night I watch some comedies, just to laugh.

What are some personal interests or goals that you're currently pursuing?

With my business, I really want to get more contracts and to be able to supply more materials to college libraries. So, maybe in the future I could possibly see moving back to Mexico, or trying to have an office in Mexico—to import books to the United States—and go back and forth. That's what I would like to do. Also with this T.V. show that we're putting together…we're going to start on public access T.V. and hopefully we'll get better at producing it, and move on to another stream where we can have more viewers. So, we're really looking into it for the future. Like I said, when we start producing something of quality, maybe we could write a grant to be able to make some documentaries—or maybe move the show to channel four, which is UNC. We may be able to sell it or air it on other channels. I always want to write, so I still hopefully can do some freelance writing.

Is there anything that's a goal just personally—that's not related to work— that you have? Any particular things you'd like to learn or that you are taking

classes in, or just pursuing as far as hobbies?

I have thought about going back to school, and I would like to go back and pursue journalism. You know, just get a more solid base, even though I'm kind of doing that right now. I'd maybe do a master's in mass communication. I'm very interested in everything that has to do with Latinos here. I'm very interested in the Chicano culture, very interested in the mixed culture of Mexicans that arrive here—the first generation of Mexicans that is developing—and how we get Americanized in this country. You know, how it's good and how it's bad, and how it influences our daily lives. I would like to write a story about it.

What have been your greatest challenges throughout your career?

Probably the greatest one was to learn English to go to college here. When I started going to college, I was not quite as fluent as I am now. I had to record my classes and go back home and listen to them again and slow down and take notes. It was hard at the beginning, but it was really rewarding to finish. So, probably that one; and the second one was overcoming my job at NBC News. It didn't turn out to be quite what I wanted it to be, and I was kind of disappointed that they didn't hire me full-time. They really didn't have the money, but I was kind of disappointed. I took it personally and it was not personal. Right now I like working with the baby and being able to do what I want and to

manage raising my daughter. It is a challenge now. *(Laughs.)*

When you suffer these kinds of disappointments, how do you inspire or renew yourself to keep going?

I'm a very social person, so I usually talk with my friends and laugh about it—you know, make fun of the situation. I usually try to keep a positive and optimistic side of the thing. Pretty much, my friends are my network of support. They help me to renew and charge my batteries, and get me feeling different and keep me going.

Well, speaking of friends, what personal qualities do you consider to be of the most value in life? These would be qualities you consider valuable in both yourself and in anyone.

Honesty and perseverance; being optimistic and positive about life. Being able to laugh at yourself.

What is the one way that you have evolved as a human being that makes you the proudest?

Well, many of the things that I have done here I have done by myself. I came here when I was twenty and pretty much, I had to figure out many things—like new English. I was married and my ex-husband (we're divorced now), he was very busy with his course and he didn't have time to help me out and help me to understand how things work in the United States. Pretty much, I found my way around doing things—you know, just to learn a completely different way of how things work compared to what I was accustomed to. I am really happy to have overcome all the obstacles and reach a position where I feel like I have an education, and I paid for it—well, I'm paying for it still. *(Laughs.)* To be able to do the things I wanted to do—I really appreciate the United States because it does have more opportunities and it's easier. In Mexico I would have a very hard time doing what I have done because the opportunities are very limited. I wouldn't be able to study and go to school. Like right now, I wouldn't be able to have a baby and work and do all the stuff I have. So, I really appreciate being in the United States; that helped me a lot.

What personal qualities do you possess that make your career a natural choice for you?

I think I'm not a shy person, and that I'm able to communicate what I want to communicate. Being here, I have learned to be more aggressive and to speak up. To learn the language is a challenge, and to be able to lose embarrassment of making a mistake in public—when you learn a language, you learn that—just to do it, and sometimes you slip up occasionally and just keep going. That helped me, to not be afraid to interview somebody and have the type of position I do. I think that's kind of important.

On the other side of that coin, what qualities do you have that create constant struggle or conflict for you that you have to work to overcome as far as your career?

I'm very impatient and I like to see results very fast. When things don't work out quite in the right time frame and I'm waiting, I can get disappointed and sometimes discouraged. I have to keep myself pushing to wait, and try, and keep doing it, until I feel satisfied that I did my best and I've accomplished what I wanted to. If I earned what I get, I at least feel that I did my best, you know? I think that's probably my big downside—that I'm impatient and I get discouraged.

Of what professional accomplishment are you most proud?

Right now I'm very happy with my business. That's one thing that doesn't have to do with what I studied. The other thing is working for *The Herald-Sun*. I'm very happy about that, because I used to work for a Spanish publication. I worked many years for a Spanish newspaper in the area called *La Vozde Carolina*. That paper was the first Spanish newspaper in the area, and I worked very close with the editor. I worked with her for probably four or five years, and the publication stopped existing a couple of years ago. That landed me the job at *The Herald-Sun*, which I see as an accomplishment—to work for a newspaper that is more well-known and has a bigger circulation. Right now I'm writing a bilingual column—it's a bilingual page—and I have a column every month, month and a half or so. All the columnists can express our point of view about our culture or living here in the United States. It's a great space that *The Herald-Sun* gave us.

It's great discovering the news of what's happening in the Spanish community. But I really appreciate more the ones where we can say how we feel about things, how we see things. Those are the ones I appreciate because it gives us a voice. And the idea that it's in English and Spanish I think is great, because it helps to bridge both cultures and understand—see and understand about the Latinos here in the United States.

Of what personal accomplishment are you the most proud?

Having my baby. (*Laughs.*) Having my baby and going through labor. Also, just living in the United States and getting by without much family support. In the beginning it was hard. Most Latinos, we are very close to family and friends and we rely on the family a lot in helping us to do a lot of things. Unfortunately, my family was in Mexico. They aren't rich enough to collect and send me dollars to help me to get by—so I've pretty much done everything since I was twenty by myself.

What advice would you give to young Hispanic or Latina women starting out in a career—or older women considering a career change?

I think I would tell them—I believe that whatever you want to do, it can be done. Especially in this country; there are a lot of resources out there, it's just a matter of finding out. I didn't find out that I could get grants and I didn't take advantage of my position as a woman who is Hispanic when I was in college. Nobody told me I was a minority, nobody told me I was a woman (*laughs*)—and how to get all these grants to go to school. So, I just went and applied for a loan and I got a loan...and I'm paying for my loan. (*Laughs.*) But there are a lot of resources to go to school. There are a lot of organizations—Latino organizations and American organizations—who provide the money if people have few resources. There are organizations that help women and minorities to do what they want in business or going to school. It's worth checking out and worth a try—it can happen. It's not like I'm glorifying the United States, but it does have a lot of opportunities to grow and get educated which we don't have in Latin America.

What aspect of your career, as it is now, brings you the most joy?

The flexibility. (*Laughs.*) When I write something, to see it published, or if I'm producing a video, to see it done. Those kinds of things—when you see something accomplished or something finished, or something printed that you wrote. That's probably what gives me a lot of satisfaction.

What message do you hope to bring to people who read your work or look at your work on television?

Understanding. The Latino culture is really diverse, and we come from very different countries with very different cultures. We're from very different races. We're black, we're white, we're mulattos—we're of mixed races. Among Hispanics, there are a lot of contradictions, and we're not a very united group. But we do have certain things we share, and I want understanding so that there's not that much racial tension and pressure. I want also to create a space where people are not afraid to talk about race and about differences; or to share and celebrate, and learn from our differences.

What dreams do you have that are yet to be realized, both personally and professionally?

Professionally, I would really like to see a Latino show nationwide in English. I don't know of any Spanish shows right now, but I would like to see a Latino show in English in mainstream T.V. I'm not saying we're going to be the one. We could be. But I would really like to be part of it. I think the mainstream T.V. is missing that audience, because they think we Latinos watch only Spanish T.V. I do watch Spanish T.V. because I don't find what I want to watch on English T.V, but I watch English T.V., too. I think they ought to listen more and more and start target-

ing these English-speaking Latinos.

I think Latinos need a lot of role models—especially young people. We need to be portrayed in the main media—not only as maids, or drug dealers, or robbers, or illegal aliens. We have a more positive portrayal of the Latino which exists, and also helps to create more role models for young people.

Would you like to write this show?

I would love to. Yeah, sure! (*Laughs.*) Give me the opportunity, I would do it.

Have you any ideas about what situations you would like to put the characters in?

I guess what it is to live in the United States in general. What it is to be here, and learning, and sharing—living everyday life in two cultures. There are so many differences. I think there are a lot of issues happening in the Latino community that can be addressed—education, health, the language barrier, human rights, immigration. Not only in Spanish; it needs to be addressed to the American public in general.

What personal dreams do you have that are yet to be realized?

My personal dream is to be able to have a house here and a house in Mexico, and be able to go back and forth. (*Laughs.*) A little house on the beach—I don't care about having a mansion—but I would really like to spend half of my time here and half of the time in Mexico, and be a lot closer to my family.

Do you feel sometimes that your heart is in another country and you're here?

Yes, I do sometimes, but when I'm there I want to come back here. I think once you leave your country and live so long in another place, you don't belong. You don't belong there, and you don't belong here either. It's very weird; you get caught between both worlds. I didn't grow up here, so sometimes I'm still learning about this country. I keep learning words, and I keep learning facts. Then, when I go back to Mexico, I don't know what's happening there, because, like I told you, I'm not every day informed of the politics or whatever social events are happening. People make jokes and people think I'm a tourist, and I'm like, 'Is that personal?' Things have changed and I have become Americanized, so I sometimes don't agree with Mexican society and their social rules. I have to fit in the middle, you know?

If you could foresee a future in this country where Caucasians and Hispanics and African-Americans—and any other group—live together peaceably and happily, what would that look like?

I definitely think we need to communicate in one language—

English. I'm not meaning that English should be the official language, but I do value my education and I do value the learning of a common language. I think United States people are afraid to talk about race—especially in the South. People in the South are not accustomed to our language. This is new to them, this new wave of Latino immigration that is invading the United States—well, maybe that is not the word to use (*laughs*)—that is *arriving* to the United States. I think whatever happened with the blacks, and with segregation, and all that history, people are very afraid to think. People tend to try to be very "P.C." when they talk about race. I think it's an issue that needs to be addressed. It needs to be talked about and people need to feel comfortable. I think that has to be a problem sooner or later, because the Hispanic population is growing and I don't see a way that it's going to slow down.

Interviewed by Susan L. Comer.

"Among Hispanics, there are a lot of contradictions, and we're not a very united group. But we do have certain things we share, and I want understanding so that there's not that much racial tension and pressure."

Gloria Sánchez

María Gloria Sánchez

María Gloria Sánchez was born in México City in 1968. In 1989, at the age of twenty, she arrived in North Carolina. At the time, she spoke little English. Since then, she has graduated from the University of North Carolina at Chapel Hill, where she majored in radio, television, and motion pictures, and minored in French. She has worked for NBC and IBM, among others.

Presently, she and her brother David run their own company, *Publicaciones Azteca*, which imports books from southern Mexico to college libraries in the United States and in Europe. Gloria is also working in the production of the first Spanish TV program in Durham, *'Presencia Latina,'* which airs on Public Access T.V. She is the proud mother of an eighteen-month-old daughter, Naila, who is raised in a bilingual and bicultural lifestyle.

Dirt Roads and Brown Dogs Rhonda Bellamy

Dirt roads and brown dogs form my earliest memories of Down South. Sitting on the front porches of my grandmothers' homes during summer visits to Wilmington, my siblings and I would laugh as cars—braving the contours of the rutted roads—would hump and bump their way to their destinations. New Yorkers by birth, we couldn't fathom what my parents meant when they talked about how much "home" had grown. And as long as we could buy brown dogs, the Southern confection made of molasses and peanuts, we didn't care. Not until Down South became home. The move was particularly unsettling for me, by now a teenager, and I cried for months.

I was the girl who "talks proper," "walks like she's stuck up" or "is one of those Greens, Sumlins, or McLaurins"—depending on who was doing the describing. The adjustment just happened to coincide with full-force adolescence, and this former valedictorian of the sixth grade class at P.S. 9/79 became a chronic high-school dropout.

Off and on for the better part of two years I'd drift in and out of school, always excelling when I went. I remember skipping weeks in a Spanish class and making a 94 on the final exam, with out cheating. With the love and expectations of my family, I willed myself through that difficult period. When I graduated from E.A. Laney High School, I was named "Outstanding Actress;" Michael Jordan was named "Outstanding Athlete."

The acceptance letter to North Carolina Central University was the ticket to a better life. My freshman year was a breeze. I made new friends, joined interesting groups, and decided to major in biology on the pre-med track. I planned to be a gynecologist. Right after my freshman year, I needed one. I was pregnant. I went back to Wilmington to give birth to my son, Rashaad. Within the year we moved back to Durham, staying in a boarding house for families across from Central's campus, and I resumed my studies. Shortly thereafter my husband-to-be joined us.

With a baby in one arm and books in the other, I juggled the responsibilities of family and school relatively well. I was encouraged to run for features editor of the school newspaper by Dr. Tom Schmidt, my English professor. I won. A *Durham Morning Herald* article revealed that many state universities, including NCCU, were actually investing in companies that did business in

South Africa. Apartheid was still the law of the land. After researching the extent of NCCU's holdings and talking with college administrators, I wrote an article for the school paper. Shortly thereafter, NCCU and other state universities began putting pressure on those companies, who put pressure on their South African interests, which I believe ultimately led to the end of apartheid. The power of the press so impressed me that I changed my major to English with a concentration in media/journalism.

Graduation was a heady experience. My favorite picture is of my son in one of my arms, his little sister, Aya, in the other—both holding onto Mommy's degree. When the realities of a stormy marriage hit home, I moved back to Wilmington with my children.

My first paying job in broadcasting was as a traffic manager doubling as a weekend talk/show host on WAAV, a news/talk radio station. Simultaneously, I began writing for the *Wilmington Journal*, joining the paper as a full-time staff writer two years later.

But the pull of radio was stronger. When Hannah Dawson Gage, the general manager of the area's two biggest stations, called to ask if I was interested in doing news, I jumped at the opportunity. I often joke that living with two teenagers, it's the only way I can get a word in edgewise. The juggling act I learned as a new mother/student comes in handy as news director/anchor for both WGNI and WMNX—among other interests.

From my first paid performance at my alma mater years ago to a stage on Atlantic City's Boardwalk recently, the thrill of bringing literature to life has been my passion. Regularly commissioned to craft one-woman stage productions from an extensive repertoire of literature, I founded Ayara Arts, with venues ranging from Barnes & Noble Booksellers to J.C. Penney. As an instructor for Dreams of Wilmington, an arts program for under-exposed youth, I'm able to share with my love of the oral tradition through Readers' Theater classes. Wilmington is increasingly recognized for its progressive arts community and, as a founding officer of the Black Arts Alliance, Inc., I'm committed to ensuring that arts lovers have the benefit of diverse cultural experiences.

Other ventures include serving as executive director of the Black Pages Publishers Association, an international organization comprised of Black Pages publishers in over sixty cities in the U.S. and Canada. Civic affiliations include serving as former co-executive secretary of the 1898 Centennial Foundation, a commemorative effort marking Wilmington's *coup d'état* in which many African-Americans were run out of town and some killed following the elections of 1898.

Spare hours (if there be such a thing) are spent serving on the boards of the Black Arts Alliance, Inc., Domestic Violence Shelter and Services, Inc., and the Wilmington Children's Museum.

But the grounding force in my life has been my family. The

expectations my parents have always had for me exceeded any I
ever had for myself. And, of course, my children help remind me
of the time when I was the girl who "talks proper"—even with a
mouthful of brown dogs.

*"I planned to be a gynecologist. Right
after my freshman year, I needed one. I
was pregnant."*

Rhonda Bellamy

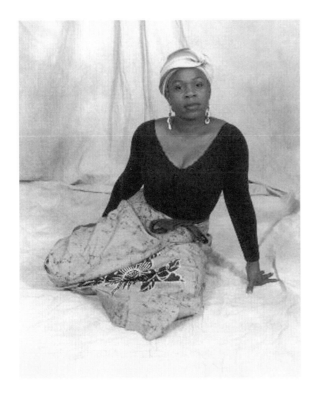

Rhonda *Bellamy*

With more than ten years of experience in print and broadcast journalism, Rhonda Bellamy is news director/anchor for WGNI and WMNX radio stations in Wilmington. She was recently recognized for "Best Newscast" by the Associated Press.

She also serves as executive director of the Black Pages Publishers Association, as founder and CEO of Ayara Arts, and as an instructor with Dreams of Wilmington. Rhonda presently serves on the boards of the Black Arts Alliance, Inc., Domestic Violence Shelter & Services, Inc., and the Wilmington Children's Museum.

A graduate of North Carolina Central University in Durham, she holds a B.A. in English with a concentration in media/journalism and graduate credits in instructional media.

Rhonda is the daughter of Ann McLaurin and the late James McLaurin and mom to Rashaad, seventeen, and Aya, fifteen.

Women In Industry: One Woman's Opinion Michele Seidman

If anything I say can make one point in all you will read, I hope it is that there is one game, and that the best person always wins...male or female.

I must admit that it bothers me if I am called a feminist. That moniker was not meant for me. I will continue to wear hidden support under my clothing and I will always be flattered to have my doors opened for me. Before you choke where you sit, I guess I will explain where I am coming from.

When I was growing up, my mom called me her female tomboy. I loved doing what the guys did and did it in dresses. I did not become a jeans woman until much later in life. I lifted heavy weights starting at fourteen and I played intramural football, much to my mother's chagrin and to the consternation of my high school principal. After all, I was the only girl who even wanted to play. Behind my parents' back, I reminded my principal of a little thing called Title Nine. This was the '70s and a woman having some equality was still too new for many. My principal had no choice but to allow me to play—and the fact I said my parents would sue did not hurt. Thank goodness he never called my parents! They had no idea that I had made that threat on their behalf.

For the record, my team won the championship, and my prowess has come in handy for many of the film and television roles I have been cast in.

That meeting with my high school principal at age sixteen was the first time in my life that I felt any power as a woman. Thank you Title Nine! I had finally made my first step in being a woman with the same rights as any man.

I had seen Billie Jean King whip Bobby Riggs. I had listened to Shirley Chisolm refer to her treatment for being a black person as horrible, but not nearly as bad as her treatment for being female. We had a voice. Our time was coming and I wanted in, but some things never felt right. After all the fighting our older sisters and mothers did, we still make thirty-five percent less money. The Equal Rights Amendment (ERA) never passed, and in many ways we are no closer to being where we want.

It finally dawned on me while shooting another male-dominated film and feeling alone on set: there had to be a way to fit in and still be me. After I rode the roller coaster from fighting for my rights in a male-like fashion to using my female charms for all they were worth, I knew I needed to find my own middle ground.

Yes, men dominate the business world to this day, in film and most other industries to boot. Not as many women are in the seats of power they should be occupying.

I have some ideas as to why. We have spent so many years fighting to be equal, we forgot we already are. We are equal *because* of our differences, not in spite of them. The game was set before we decided to play, and we want to change the rules. We each need to learn the game and where and how we fit in it.

For instance, it is a known fact that the physical and psychological testing done on both male and female potential astronauts back in the '50s and '60s showed that women were the superior candidates for the job. Why, then, were women grounded and the information on women testing better kept suppressed until the late '90s?

We have been fighting the wrong battles. We should be fighting to do what we are best at, period. Nothing else. Many women think that equal rights means they can take jobs they are not built to do from men, and then wonder why they are not treated as equals.

Don't get me wrong—some women are built well enough to handle jobs known to hire mostly men, and, as with the space program, women are suited better for some still-male-dominated professions.

Like any good starving artist I did my share of jobs, including bartending, which was long a male-dominated field. I was good, clean, fast and made one heck of a Long Island Iced Tea, but that was only part of the job. Half of the job was taking out heavy garbage pails, pulling kegs and soda canisters, plus carrying big buckets of ice. I happen to be strong enough to do all parts of a bartender's job, but when other women come in and get the guys to do the heavy work for them, they should not have the job. They have set women back a step and keep us seeming weak.

The same applies in any profession. In film circles, the stuntwomen I know get just as angry as I do about women who claim to be capable of things they cannot do. Stuntwomen are trained to take the falls and punches, and when some actress tells the producer she can do her own stunt, and then gets hurt, or slows/stops production…they just cost the production a ton of money. It is not good form in any business to not back up your claims.

⇥

We have been told all of our lives that we are the weaker sex. Science bears out that we are actually the stronger of the two sexes in the long run. It is now known that, pound-for-pound, women are stronger and have more stamina than men do.

We are not the weaker sex at all…simply the smaller sex.

Even with those facts known, women need to move forward

at a steady pace in developing their business skills and physical prowess. For women to move further faster, we must support each other's strengths and weaknesses more. Do the work you're good at! Do a job that uses your strengths! The only way to be equal in all respects is to know what your individual strengths and weaknesses are. Work with your strengths, and make your weaknesses a challenge to change or work around. That's what men do. That's the game that was always there. As I said, not a male or female game, just the game of business as it has and will always be!

⤙⊚

I think some women are pushing the limit on the sexual harassment issue. Not that there are not real cases that indeed deserve attention and judgements, but we are crying over a word and a look or a simple joke these days. That is not true sexual harassment, from what I understand of the applicable laws.

There was a film producer I once worked with (the name will remain a secret) who liked to push the limits of taste to what I call the umpteenth degree. When he became intoxicated in a social setting of fellow cast and crew, he turned to me in front of all in earshot and asked to see my tits. Just like that. "Let me see your tits." I know my face was telegraphing my complete surprise and shock.

Now, this man was producing a family film for a known family-oriented production company (now you know why I left the name out). He was far from home and maybe feeling a bit too frisky. It was the drink talking, as far as I could see, because it has never happened on the set. My job was not in peril.

Okay. I had the option of maybe slapping him across the face or verbally chastising him in front of all our coworkers; both options would have seemed reasonable for a woman to handle the situation without seeming out of line.

At first I had no idea what to say to this producer or even how to handle it. I took the moment to think how a guy would respond to a business associate making some equally offhanded remark. A man would blow it off, usually with humor. So I decided what to say, and I said it for all to hear: "Okay, you can see them, but it's triple (3X) SAG, closed set, and you still don't get to touch them." Triple SAG rate is what they pay for nudity in film, closed set means no extra crew while shooting, and the rest is obvious.

Now I had just put it back in his face, in film language, with humor, and he burst out laughing. Everyone did. He started asking me when he was sober, just to hear me say my now-prepared reply. It became a running joke, and not some noose of harassment around my neck.

Part of business is being a team, and that means sharing some things you may not completely support. I can tell a blue joke with the best of them and love to hear them myself, but I draw the line when they bring my body or me into it. I simply call the guys on it at that moment without stomping my feet. Straightforward, I tell them: I will joke with you guys all day, but don't make it personal. When the jokes are too raw for me, I simply say, wait to tell those jokes when I'm not here. Guess what...men can hear us when we don't scream, cry or freak. Men will give you that respect if you ask for it straight on, with no unprofessional outbursts. They keep the jokes in the proper perspective with me, and no man I have worked with felt he could not be straight when communicating with me.

I seem to get more information that way. Often, I am told things by male colleagues that they are not telling other women in the office or on the set. I am one of the guys, yet they treat me more like a sister or a female pal. I know it is because I do not ask to be treated differently than the guys. Women have to stop taking it in silence and speak up for themselves without all of the whining. If more women did so immediately and did not allow it to turn into a situation, over time we would not have as many men disrespecting women in work or life!

There are still a few men who are intimidated by any woman who delves into the 'man's world,' and there will always be men who call us the B-word when we fight for our rights. I still think the B should stand for Brave, as it does with men.

While working on a T.V. film, 'T-Bone and Weasel,' I was lucky enough to discuss my ideas on female bravery with actor/dancer Gregory Hines. I told him that I was tired of being told that I was a bitch, barracuda, man-eating tiger, or some equally brutal moniker, just for standing up for myself. Gregory told me something that made me feel so much better. He said he did not know one woman in the film business who had not been called one or more of those names. Not the *successful* ones, anyway.

He made another comment that stuck with me. "Michele," he said, "just remember it's those who will not be denied. They're the ones who make it." All of a sudden, I could take being called those names a bit better. Thank you, Gregory.

Each woman will have to deal with men in business, and we are not going to change anything. We must learn the game as it has been played for centuries. The women in history who gained

greatness and notoriety did not do it while stomping their feet. So why is modern-day woman stomping hers? She (and I mean myself until very recently) wants to win the game without reading the rulebook!

I have a few women I admire for their bravery in male-dominated work. The film industry is very top-heavy with men in power, and women are still working twice as hard to get the respect they deserve. My female mentors know this and work with this in mind. By watching them, I learned how to stand my ground without all of the emotions. Emotions and business do not mix. My female mentors were not afraid to say—to their faces!—when the men around them were out of line. These women give me hope and encourage my continued battle for the right to simply do anything I am capable of.

Lisa Fincannon (T.V. and film casting director), actually used to wear a badge that said she was a bitch—self-proclaimed! She did not mind the moniker and wore it with pride.

When Lisa first got into casting, she started at the bottom rung, even though she had been a documentary-maker and had been involved in the business for years. She worked it from the ground floor up. She watched her male contemporaries at work and took notes on how things were done before she took her own place as one of the major players at the casting company she is part of. Even with what she already knew, she was ready and

willing to learn more. She is diligent, thorough, a fighter, intelligent, and much more than the word capable describes. She earned her way and gets equal respect for her work right alongside the men. She did not ask for preference as a woman, but simply read the rulebook. Women like this pave the way for others. If that's a bitch, then you can keep calling me one too.

⋆⋅⊚

It can be so hard for a woman to balance her life between work and play, especially if she is single. Sometimes the work attitude carries over when we don't want it to. I know that some men I meet in social situations seem to get intimidated by me. I am not trying to do this. It bugs me greatly.

While working on the film 'Empire Records,' I spent some time with the director, Alan Moyle, discussing this very problem. (Funny thing how I keep getting all of these great insights from men.) Back to the point—after telling him how men seem to run from me at times, and how I was not sure why, he made the comment, "I have another female friend who is in the same boat as you, Michele. We finally figured it out. Strong, independent women who are single, like you and she, have not only become the women you want to be, but have not a choice but to partially become the *men* in your life."

Some men look at strong women and cannot see the female side through the independence. The men born after the women's movement seem to handle it a little better than their pre-ERA brothers do. So, single women, beware that you don't forget about just being a girl at times. After all, there is great wonder and glee in being a woman, with all her female charms, too.

MY MOM THE GUIDE

My mom was raised the old-fashioned way. Women married young, and all they could do was be a wife, mother, nurse or teacher. Anything else was unseemly. Mom had matters turn worse for her at age ten. She contracted polio during the epidemic in Chicago in 1936. Mom was actually one of the lucky ones, only being paralyzed on one side after the virus left her body. Now not only was she a woman, but a crippled one at that! Mom did the only things she knew to do: married young to get out of the house and landed in a horrible marriage for over eleven years. She tried to make it work, but eventually had to seek a divorce.

Oh my, she was a divorced woman with a child and she was a crippled woman. This was the attitude most people had concerning her. Still, she met and married my father and started having babies.

When I was three years old, Mom decided to go back to col-

lege. She was already thirty-seven years old. It was the '60s and Mom saw a chance to expand her world and to finally grow. She got her degree and reinvented herself. She became a painter and art teacher and very good at both.

Mom went to Sears one day to get something for the house. Her credit card had my dad's name on it and Mom wanted to get her own. You should have seen the reaction to her request. It was the first time I saw my mom fight like that. She stood her ground until she got her own card based on her credit and in her name. I was only about ten at the time, and somehow I knew she had just given me a lesson most women would take years to learn. Mom wanted to be treated the same based on her work and efforts as an individual, and not just as a wife to 'the man' in the family.

She looked at most things as a challenge, and even though she said she was scared to fight, she did it well. My parents retired when I was sixteen (last child at home for later-in-life parents) and we moved to the mountains. It was only two years later that my dad died. When his will went into probate, my mother again taught me much. Her money and Dad's were tied together and she could not even get to her money. I learned that the words *and* & *or* make all the difference on a joint checking account.

⇥⊙

When the will was probated, Mom decided we would need to go back to the area we were from. Being handicapped in the mountains with no man to help was going to be too difficult, especially now that I was of college age. Mom was a sharp cookie. She used the money from the will to purchase a duplex and rented out part to pay the mortgage faster, then got a bigger and better house when she sold it for a profit. She made some more changes in her life. Mom reinvented herself again and got hired to be a museum curator.

She was now in her 50s and was bringing in major artist retrospectives and the Smithsonian tours while getting much attention for it. I learned from her that it was never ever too late. I learned to stand up for my rights and the respect I earned. She told me I could learn something every day, and that there was nothing I could not do if I put my mind to it. She was right…only our minds prevent us from growing and taking on more experience and skill. She made each day a challenge just getting to her favorite chair with her morning paper and coffee without spilling any. Mom did not cry over silly things or whine about being crippled.

When she was dying from cancer and had been told of some of her tumor-induced episodes, she said, "Seems like I am going through something very interesting and I am missing it all." She was less afraid than she knew. She set me up to have more power and control in my life than was allowed in her day. She taught me to do things I want to do and can be happy doing. "After all," she said, "you're going to do it your whole life."

⟶≡◉

I hope my words can help any woman in her efforts to be the best she can be in whatever she wants to do. Find women who are doing the work you want to do. Seek out mentors and guides. Do not be afraid to ask questions or to admit what you do not know. Learn your skills, hone your craft, pay your dues. That's the real world of business and we women are showing that we *can*. Keep showing them!

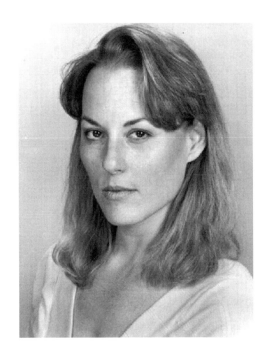

Michele *Seidman*

Michele Seidman has been acting for over twenty-six years; don't let the lack of wrinkles fool you. She started on stage at an early age, and then progressed to commercials, episodic television, movies of the week, and feature film. Her credits as an actress include Jill Hanson (former regular) on the soap opera *Another Life*; lead female Gloria Lorenzo in the soon to be released *The Cut Off*; and Queen Sabrina in *Island of the She-Devils*. Other projects include *A Short Ride, Dawson's Creek, Radio Land Murders, Empire Records, The Lost Capone, Love, Honor & Deceive, Young Indiana Jones Chronicles, Black Dog,* and *Rupan II: The Conspiracy*, to name a few. Most recently she worked on the independent films *The First Night of the Rest of Your Life,* and *Murder in My Shorts.* She is a singer and jingle artist and does a great deal of voice-over work for T.V., radio and animation.

Michele is former owner and agent of SMC Talent and Models (1993-'96). She served on the board of directors for both the Cape Fear Filmmakers Accord (1991), and the Actors Network (1995), and was the film studies coordinator and cinema symposium director for Cape Fear Community College (1998-2000). She has taught acting for over fifteen years as a private coach, and has lectured for ODU, UNCW, and CFCC as well as high schools in both North Carolina and Virginia.

Michele has the option and the rights to the film version of *Chocolate on The Outside,* and is working towards making the well-received and award-winning stage play into a feature film.

Recollections of Mining for Gold Andrea DeGette

Shots echoed through the ravine, past an old mine, and on down the only street in Nevadaville, Colorado. A high shriek was heard, then the sound of a departing Volkswagen Bug. More gunshots were fired as the car sped away down the dirt road, and then a woman yelled, "CUT!" The 'dead' gunmen got up and congratulated themselves. There was a silence, and underneath was the sound of the perpetual mountain wind that blows from peak to peak. The director rushed to meet the center of this exceptional choreography of a scripted gunfight just performed for camera, sound, cast, crew, and some few onlookers.

The director thought to herself: *Everything is coming together for me right now, just as everything is falling apart. I am finally experiencing my life as I always envisioned; that is, directing—for my own film—a complex scene with actors and a professional crew. I arrived at this moment by working hard, compromising, not giving up, and with the help of my friends. But now there is a mitigating circumstance; life has intervened, that is, my mother is dying. Now my film is not just about my sisters.*

I sold t-shirts to raise money for this film; one thousand hand silk-screened shirts. I made a draft version of this 'Sisters' film to showcase my work. Someone who saw it told me I was a pioneer filmmaker. I guess because of my work *with Super-8 or maybe because of my editing or shooting techniques. I used optical printing and other physical manipulations of the celluloid on this first version. Maybe it sounds dirty, but I enjoy stretching the boundaries of my medium. I want to create stories that people want to see, but it's hard to know what that is.*

Structuring the story of my new film has become very difficult because I am trying to write it while living in the middle of it. I don't want to offend anyone involved, but I must tell the truth about this experience. Is this fiction or autobiography? I can barely focus on what to say or show in my film. It seemed so clear before, as I wrote scenes and the black and white words on the paper revealed my story. But now I wonder what story is worth telling? I'm beginning to think that life is impossible to recreate or even to indicate within the film's frame. How will I begin to show the truth of how it feels when someone you love dies?

I remember driving my '71 dodge pickup truck, Bluebell, from NYC to the mountains of Colorado, my home state, to make this movie. With Jane, and John and Iris. And all the Crazy Mountain People. And Lisa and Ted and Barbara and Julie and Larry and Beck and the DeGette sisters. And Yvonne. And the spirit of Patricia Anne Rose everywhere, within me and within the nature around. And the crew and luck and inspiration, and some amazing

synchronicity. Now I'm here to the point of production, trying to tell a huge, long, untellable story in a short film.

The director, *a woman just like me,* was in her mid-twenties, possessing some experience, delusions of grandeur, and some sort of inspired vision.

⊷═

"What are you having for your birthday dinner?" her mother asked our director long distance from Denver to Blackhawk—an old Victorian mining town where the production was housed. "Jane made me spaghetti." The director wanted to ask her mother how she was feeling, and what was happening to her health. Her mother was so sick and no one knew what was wrong. She was afraid to ask, and her mother was probably relieved that she didn't have to talk about her worst fears. That is, a recurrence. After her lobectomy operation, the doctor assured the family that the whole, encapsulated, cancerous tumor had been removed, and had not spread. The only concern was if a cancerous cell should metastasize to another place in her body. Before the operation the mother had quit smoking, which was significant considering her forty years long, three-pack-a-day habit. This was to prove to her three smoking daughters that it was possible to stop. But now, clearly something was terribly wrong, and no one, including the mother, wanted to utter their fear.

Jane and John, assistants on the production, walked towards the director—their best friend—carrying a huge snot-green cake lit with twenty-six candles. The crew sang 'happy birthday' very slowly, and after the candles were blown out, they heaved the cake at the birthday girl and got it everywhere, all over. As she showered off, she felt a certain relief and a running down with the water of all her feelings. She had too many feelings, and she wanted to get rid of most of them. She was there, but also not there. That's what getting hit in the face with a birthday cake made her realize. She kept thinking about the film that she was finally able to make. The film was all she had, all she could call her own—but what was it anyway but a silly proposition? Some attempt to resolve family differences, with each member getting her very own "close-up?"

Still, the director knew that her mother was proud of her, and that was worth so much. Her mother had never encouraged her daughters to rush into marriage, or especially into having babies. Her girls should be able to get on in the world without anyone's help. (She had lots of help.) This was most important. Also that her children should remain close. The mother had been an actress in younger days, and she still played her 'scenes' with the precision and vitality of a star. She was a full-fledged Drama Queen who made life interesting and full, and sometimes so dark

and morbid that escape was the only mechanism for one's survival. Like moving to New York.

I have never been so in control, or so out of control, the director thought. I have my shots, my dream of a film that will be full of the life that is going on around me now. I set up scenes with the intensity of the current moment to moment infused in every frame. If this is my method, how will it be possible to construct the story? Do people respond more readily to feelings or ideas? Can they respond only to what is expected? Underneath the "why" is my impetus to get footage in the "can," whatever it is, and sew the shots together later. After I make sense of my life, I hope to make sense of my film. I think about the scene we are supposed to shoot—the scene I wrote for my mother to act in. She's to play the Old Hag. I visualize her stirring a large black kettle: "Toil, toil, boil and trouble." These lines will be a mantra for my mother's life. Then her laughter will be heard and a stream of loving kindness—my mother—will flow and this ephemeral sound will wash over my fear and sadness of losing her as she disappears into nature's embrace.

The director couldn't think about that. She needed to prepare for the day's shoot. There was a strange confusion and a feeling of murky incoherence. Not tension exactly, but a strained monotony as though there was nothing unusual about strangers with camera, grip, and sound equipment ensconced in this rather unremarkable location—a barnyard in the middle of the Rockies—with nothing to shoot. Her sisters were supposed to come up to the mountains to act their parts. The location was set and the cauldron was bubbling.

The director decided she would shoot her sisters in the exterior of the livery. Her mother's cauldron scene would come later—after a scene in the interior of the barn with the Stable Thing. These scenes would be shot after her mother recovered. At least that is what she thought at the time. Everything seemed clear to the director; a new scene just had to be written.

The director was absorbed with her thoughts and waiting for her sisters to arrive. Eventually, the familiar sound of her younger sister's red Volkswagen could be heard approaching.

My memory is a blur from the time my younger sister came until I heard my oldest sister say that Mom "was going to die." My little sister and I were standing at the payphone in the parking lot of "The Stagestop" in Rollinsville, Colorado. Her voice over the receiver said that Mother had three cancerous tumors growing in her brain. I remember how Mom thought that cancer wouldn't get her; in fact, she was "sort of looking forward to that sudden heart attack."

Our director screamed and cried in anguish at the thought that this unthinkable thing could actually be happening. How could her mother die? Go away and not come back. How could that be possible? How could she ever go on? As she cried she never thought about her little sister who was crying too. But there is no thought of others in the void when something like this becomes clear and a return to the prior perspective is impossible. The knowledge of impending death could not be ignored. There

was not one thing that mattered. How could it be that...

...she will not be seen or felt ever anymore. I can't stop thinking about the loss and I'm so much in pain and I'm crying and completely isolated in shock and sadness. I throw myself down on the ground and writhe in agony as I announce to everyone in the crew that my mom is going to die. It is all slow motion and I am unable to decide anything at all. I am an empty vessel. There seems to be no past and no future, and the present is only a frame with a buzz or a hum that links place to person to scene to scenario with its constant white noise. The crew is cast off—just like that—as I jump into the abyss of anguish.

I remember a dream from a long time ago that I had about my mother: We're in an apartment and suddenly the building begins cracking in two. Mother is striding around the room frantically. I am crawling and trying to convince her to get on her hands and knees too. I'm yelling, I'm so scared. She then flings herself into the hole—in a way, trying to jump over it and in a way, on purpose—I have no time to utter a word, but crouch motionless at the side of the chasm watching her fall down and down. She's screaming and twisting in the air as I watch every move—wishing she'd grab something to save herself. Then I move away from the hole, unable to bear it—knowing she will crash on the bottom and die.

The nurse roused our director and, after grilling her about the mother's personal habits, she finally led her into the intensive care unit that was keeping her mother alive. The young woman put on a face to greet her mother, trying to be brave, trying to be considerate. Her mother could not have been recognized by anyone outside the family, so changed was she by her illness. Her profound beauty, that almost preceded her in life, was invisible underneath the ravages of her illness. This transformation left the daughter with an intensified feeling of distance and alienation from her mother. The weeks that followed blurred in memory. The young director stopped writing notes for her film and started jotting brief entries about her mother in her journal.

"Mom said, 'Look, I'll either get well or I won't get well. I haven't decided yet. I'll let you know.' And 'Mom's hair is starting to come out in handfuls. My heart breaks as she hands it to me to throw away (I'm keeping it though). Mom said she wants to get well. Asked me this morning if she would get well.' And 'Oh, today is a hard day. My heart aches as Mom ages before my eyes. She greeted me this morning with 'I think I'm going to die. I don't think I can beat this one.'"

The months went by and the woman and her mother and sisters fought against the pettiness that surrounds such uncertain and temporary circumstances. The mother felt better for some months and without much discussion of her impending death, they all fashioned an existence together. Our director fought against the frustration of finding herself again in her mother's house with all that encompasses, and tried to squeeze the most out of the last of their days together. Together mother and daughter noticed the sunsets sometimes, and tried to ignore

the emotional and physical pain ever-present beneath the surface. Sometimes at night the mother moaned and cried in what she thought was secret agony, but her daughter could hear, and was helpless. Everyday life took on a heightened quality though the tasks and events were purely ordinary. It was the texture of life that seemed to have changed as the family went through the ordeal of saying goodbye to their present and also to their past. The future was impossible to gauge for our director as she faced the sad prospect of bringing together her thoughts, feelings, and her conclusions about the meaning of life and death onto celluloid. It was monumental to even think about creating a film that could somehow represent this time and this part of her life's journey. Later, of course, the real purpose became to define her motivation for pursuing such an impossible task. But at the time, all she considered was how to put this experience into a film so that time and distance could in some way be filled in, and her mother could live on in some legacy of filmed beauty and truth that would be a testament to her mother's strength, bravery, beauty, and love. That her film could somehow conquer death and erase the inevitable separation of herself from her mother.

I cannot bring back what is gone, but maybe with my film, I can create a kind of resolution with my sisters concerning what is left behind. Perhaps there is a way to avoid the common pitfall that accompanies so many deaths: The family torn apart by fighting over the material possessions of the departed.

"ACTION!" Four little girls walk carefully over a small stream to sit on the edge of a small rock pool with a waterfall flowing behind them. They are here to act out a scene of a ritual in memory of their dead grandmother. The girls are natural and composed as they take a dead bird, place it onto a large leaf, and carefully place the package into the swirling water that is dappled with sunlight. They watch as the leaf turns and swirls in the current. The young actresses recite their lines in unison: "Those who are not dead are never gone. They are there in the whispering shadows and in the rustling wind. The dead are not dead." "CUT!"

In turn, our director and her sisters performed the scenes that had been inspired by their recent experiences, including affecting a quarrel over the silver and the money and all that mattered in the physical realm. Perhaps this pretense worked to keep the sisters from experiencing an actual rift. Could art have the power to actually alter life? The director was careful to keep her strokes broad within the narrow frame of her "story." And though her mother was not there to play her role, another actress was found, and a scene was created. The pieces of the film were shot, edited, and eventually came together in the finished work. The sum of these individual parts were equal, in some measure, to life's actual experience. The desired legacy was eventually produced by our director, but unfortunately, there was a span of actual living that was lost in the appraisal of these moments as they fit into the work of art. The triumph of creation was to be treasured by

the artist, but the satisfaction that usually accompanies the comple-
tion of such a project would never be experienced by our direc-
tor. Such is the predicament of an artist who creates a work as an
extension of herself—without the comfortable distance that gen-
erally defines the space between the artist and her creation.

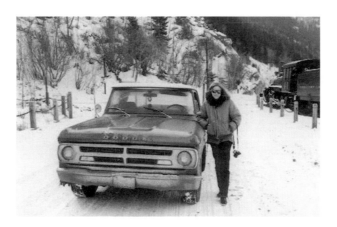

"She had too many feelings and she wanted to get rid of most of them... That's what getting hit in the face with a birthday cake made her realize."

Andrea DeGette, on herself

Andrea DeGette

Andrea DeGette is a writer and filmmaker living in Hillsborough, North Carolina. She graduated from New York University Tisch School of the Arts and is currently in the Master of Arts in Liberal Studies Program at Duke University. She has received several awards for her work, including a 1997-'98 Film/Video Fellowship from the North Carolina Arts Council and "Best Dramatic Short Film" award at the 1995 North Carolina Film and Video Festival for her film, 'Sisters From Apex.' Ms. DeGette is currently writing a novel, developing several screenplays, and completing a short documentary film.

Wendy Ewald an interview

What were your career dreams as a child?

I think I wanted to do the sort of women things like, get married, be a nun, you know. (*Laughs.*) And I don't think it was until I got into high school that I really had the idea that I could have a career that was my own. I do remember also, the week that I graduated from college, my father asking me if I was going to have a job after I got married—and being amazed that he would ask me. But that certainly was the way things were.

Where did you grow up and where did you go to school?

I grew up in Michigan and I went through junior high there, and then I went to boarding school for high school in Massachusetts and sort of followed my father with respect to my education. But, somehow, he didn't think that I would follow him in terms of getting a job and having a career.

What was your major?

I majored in art.

And did you know at that point what you wanted to do with your degree?

Yeah, I did. I took a photography class when I was in high school and then I knew that that's what I wanted to do. So I entered college knowing I wanted to be a photographer and just kept on that path. I mean, I think the *kind* of photographer I became changed—or my ideas about *being* a photographer changed, but the idea of being a photographer didn't change.

What path did you take to reach the place where you are today?

When I graduated from college, I moved out to San Francisco thinking I would go to graduate school, you know, get an MFA and teach. And everybody was moving to San Francisco then anyway 'cause it was like 1974 and so it was the place to be. And I actually *hated* San Francisco. (*Laughs.*) And only ended up staying there for about six months.

My idea of what a photographer does changed radically at that point. I moved with my husband at the time to Kentucky to work with a multimedia grassroots cooperative called Appalshop. And there, I started teaching photography to kids in the local schools—which I had done as well when I was in college in the summers—and then got together a group of photographers who'd photographed the region and I directed a documentary project for a year and a half. And I edited my first book out of that work. That was, I think, like 1978.

As I was teaching, I realized that the photographs my stu-

dents were making in three rural schools were quite remarkable, and that really no one had looked at the world in quite that way. No one had published a book of photographs made by people who were ordinary people looking at their own life. So I decided I thought that would be a good idea—and eventually I got a grant from the National Endowment for the Arts to go towards that, but then I spent the next five years trying to find a publisher. I mean, I don't know how many publishers I went to, but there were all kinds of publishers—from commercial publishers to the University of Kentucky Press and the University of North Carolina Press—that all turned it down because they'd never seen anything like it and they didn't understand whether it was oral history or photography or whatever. Then I was told about this kind of a cooperative press in London and in New York that was started by, among other people, the writer John Berger, and that was doing sort of experimental work. And finally, they said, 'Yes,' they'd publish it, and I just couldn't *believe* it at that point. Then when it was finally published, it was listed as one of the ten best art books of the year and sort of became, as one reviewer put it, 'an American classic.'

At that time, in 1983, I had been in Kentucky and I had a farm and had farmed with my neighbors for seven years. My marriage had split up at that point and I decided it was time for me to move on, but I wasn't really sure where to move on to,

because Appalachia was such an interesting place for me to work. So I applied to go to graduate school—again!— thinking that, oh, well, you know, maybe now I'd go the traditional route of being a photographer. But then I also applied for a Fulbright Fellowship to go to Latin America. And I got into graduate school and I also got the fellowship, but I was still wavering on what I should do—whether I should, you know, go off again or whether I should settle down in some city and go to graduate school. But I decided that I'd go to Colombia on the Fulbright Fellowship and do a similar kind of project—look at how a mountain community in the Andes saw itself, and make a comparison between that and an Appalachian community, which is sort of a ridiculous idea, but it was an idea nonetheless.

So I went to Colombia and lived in a village for a year and a half. And I taught photography to the fifth graders of the village school and I photographed women and recorded their stories, and in doing so, I met a woman who—well, let's see, she's sort of considered to have had the 'evil eye' or to be a witch in some sense. And she really wanted to tell me her story. She was also a strong community activist and independent woman. So I—reluctantly at first—started recording her story and then realized that she had an amazing story to tell. Over the next few years, I recorded her story, her mother's, and her sister's, and eventually put those together into a narrative and used photographs that I had

taken and that the children had taken as a *visual* narrative. And made a book called *Magic Eyes* which tells the story of her family over three generations, using both their oral narrative and visual narrative in between the chapters.

Then after that, I came back to the United States and still sort of couldn't exactly find my place, because I'd lived outside the mainstream for a long time—really, since I'd graduated from school. I lived in New York for a little bit and really liked that. And tried to go back to Kentucky and that didn't work—I had sort of gone beyond that part of my life. Then, eventually, I moved with my current husband to upstate New York—which is sort of in between an urban and a rural area—and began to use that as a home base. And I started traveling to other places to make similar kinds of work.

So the next place I went was India, but it took me a couple of years to get that sorted out—to figure out where to go, how to get the equipment into the country. And eventually I went to a village in Gujarat and lived there for seven months and built a darkroom with the people in the village and taught the children to take photographs. And most of them had never *seen* a photograph before. I photographed the village as well. And it was an amazing experience to sort of 'go back to the beginning'—to have to look at one's medium as if you had no idea what it *was* because these people didn't have any newspapers or books or anything

that *had* photographs—and didn't have photographs of *themselves*. Some of the kids didn't know what a camera was and thought that if you *imagined* a picture, it would come out of the camera. They kept also relating it to their religion because, in Hinduism, to make images is to give respect, and the only images they had were images of the gods. So they all wanted to photograph the gods.

That's interesting, the idea that making images means 'to give respect.'

Yeah, which is very different from our feeling about photography. (*Laughs.*) It's not taking something away.

But, anyway, it was a very difficult experience living there by myself, and nothing could have been more different, I don't think. But it was very important for me to understand something about images and the kind of work that I wanted to do. And, eventually, I made a book out of that called *I Dreamed I Had a Girl in My Pocket*, which is really a portrait of the village through the children's eyes. That was in '89 and '90.

After that, I moved around a lot. Well, also in '89, I started working at the Center for Documentary Studies at Duke. The one thing I had really lacked was a kind of home-base institution. I started doing a two-week workshop there, which worked well, and then we decided that, the *next* year, I would work for a semester with a group of kids. After that, it was clear that there were a lot of schools that wanted to be involved in the photography and

writing program, so I designed a Duke course which is kind of a quasi-education-sociology-photography course called 'Literacy Through Photography,' so that my students, then, as part of their coursework, could work in the schools, teaching photography and writing, and more schools could be involved. Eventually, that grew and grew, and now there's fourteen schools involved and there's lots of volunteers. I also train the teachers in learning to use photography to teach writing. And I teach workshops in the summertime, so people come from different places in this country—and outside the country, actually—to take the workshops along with the teachers from North Carolina. So Durham sort of became my *work* home base and I'm there one semester—then come and go the rest of the year.

Then I went and I worked in Mexico and in South Africa. I think I went to Mexico in '91, South Africa in '92. I would always incorporate the work that I did abroad in my classes with kids in North Carolina. So we used the situations in South Africa as a starting point to talk about race, for example. And then I went to—let's see, South Africa, Morocco, Saudi Arabia—anyway, I was sort of developing projects abroad, but then starting to work more and more in North Carolina. And I decided to use the project in North Carolina as a kind of laboratory for different ideas I had about making pictures and working collaboratively. Because as an artist, I was interested in working *with* people to make art and

that we had equal say in *how* and *what* was being produced.

I started the first of several projects I did that were based in Durham classrooms called 'Black Self, White Self,' and the idea was that the students write a self-portrait, and then write a self-portrait as another person. If they were white, they would write an initial self-portrait, and then write a self-portrait as if they were black—and vice versa—and then bring things from home to use as props in photographs I would take of them, being their white self or their black self. I made large-format pictures and I would give the kids the negatives to write or draw on to alter their persona as they saw fit. And when I started the program, there were two separate school systems that were about to merge—essentially, an African-American school system and a largely white suburban school system.

Then I worked on another project, having children decide which parts of their body they felt most represented them. I would make the picture together with them and then they would write from the picture. That's going to be published next year by Little, Brown, as a children's book.

And I did several more projects, including a religion project with the Ackland Museum, working with kids of five different faiths in the Triangle area, having them make photographs of how they considered their faith impacted their lives.

Then in the last year, I put all of the work together that I'd

done abroad and in Durham into a book and exhibition. The exhibition just opened in Switzerland and it's work from 1969-1999, collaborative projects mostly with children, although there's some with women as well. It'll tour Europe and then come to this country. And there's a book that was published as well called *Secret Games*.

I'm also working on a didactic book to explain how I've worked collaboratively and what you might want to think about if you wanted to start a similar kind of project, so that's the next thing I have to do.

How did your working collaboratively as a theme throughout your career come about?

Well, I think, deeply, it came about because I'm the oldest of six kids. I had a brother who was hit by a car when he was young and suffered some brain damage. And both my sister—who also became a teacher and artist—and I spent a lot of time working with him, trying to get his motor skills back. And so I think there was always this understanding of how to work with other people—and also understanding of the *power* of it. And as I said, when I started, no one had worked in this way that I knew of or still can think of. Because I started doing it summers in high school, I knew it was powerful—I could see that the pictures were powerful and that kept me going. But it was very hard for a long time

because other people didn't recognize their power. I mean, I knew that this was something that nobody had seen and that did something that other pictures hadn't. But it certainly became more comfortable once people did understand that there was something going on.

How do you account for the fact that nobody had done this and yet you knew you could?

Well, it was the sixties, you know. It was a climate for trying things. And I actually *had* seen—or maybe *heard* about—something that someone had done, I think, in Harlem. But it was just pictures—it wasn't anything remarkable. And Polaroid had just started giving cameras and film to people who were doing things with underprivileged kids. So it was something that was in the air, but I don't think anybody treated it *seriously*, like, 'This is a way you could *seriously* make pictures.' I mean, it was like social work, which certainly it *functions* as but it also functions as much *more* than that.

What do you consider to have been your greatest challenges along the path you've blazed for yourself?

I think just to keep going! (*Laughs.*) You know, just to keep believing that it was OK to do something that was kind of odd and not to be frightened about that.

How did you handle rejection of your projects? You must have had many people along the way say, 'What is this!'

Yeah, oh, yeah. And there certainly have been times when I've wondered, 'Well, maybe I just am not *seeing* this the right way and other people are.' You know, but then there would be the one person who *would* see it, and that would give me the energy to keep going.

When you become frustrated with a project, how do you get re-inspired?

Well, I just keep thinking, 'OK, what was it that I wanted to do here? What was the purpose of it?' I sort of go back to the beginning—to the conception—of something. If a book hasn't worked out, let's say—you know, 'Why did I want to do this book and who is it for?' And I keep trying to remember to be very flexible—that maybe the original purpose I had for something wasn't the *right* one. I mean, I guess I've seen in my life the things I thought I was gonna do, I *didn't* do, but they turned into something even more interesting. So I just go back and think, 'What is really interesting to me in this situation?' And maybe I have been trying to make it into something that it really wasn't—that what was interesting to me was actually much more profound and exciting initially than what I tried to make it into.

What aspect of your career today brings you the most joy?

Well, I think the same things as always did, and that's, one, working with the people I work with, and, two, creating something tangible out of it like a book or an exhibition. I think I need both of those things.

Tell me about your family.

Well, I'm married to a filmmaker and writer and have a little boy who's four and a half who's adopted from Colombia. So life gets a little more complicated. You know, how to *do* everything.

How do you balance family and career?

I think it's the toughest challenge, particularly because my career really started taking off when I had a child. And you can't plan those things—they just happen when they happen. So I can't say 'no,' but then, on the other hand, I *have* to do some of that. I think the thing is just to try and be as organized as I can. But it's still evolving.

What are some ways you relax?

Usually, by going away. I find it very difficult at home with the phone ringing and, you know, feeling I gotta clean the house or do something or other. So, for me, it's when the three of us go somewhere and just are together.

Do you have other personal interests or goals besides work that you pursue?

Well, I think it's sort of all wrapped up into one. I mean, I'm very interested in education and changes in education and *changes* in the art world. And I think I'm very political in my own way. But that all, fortunately, is woven into the work that I do. So I don't have hobbies. I like to cook! (*Laughs.*)

What personal qualities do you consider to be of most value in life?

I think the ability to be empathetic and communicate. And I guess to take care to do something well.

What is the one way that you have evolved as a human being that makes you proudest?

To be very interested in everything around me. I think I could've grown up to be very insular in a suburban community. I think it was *necessary*—but I'm also *proud*—that I learned how to really notice things around me. I mean, I think it was necessary for my *survival* that I do that. (*Laughs.*)

How do you mean?

I think that it really gets me out of myself, or focusing on myself, which I think can be unhealthy. And as a photographer, you have to learn to look hard, but I think *learning* to look hard has

given me an understanding of the world in which I've been able to locate myself *in* the world rather than locating the *world* in myself.

What qualities do you possess that make your career a natural choice for you? And on the other hand, what qualities of yours create conflict or struggle that you constantly work to overcome as pertains to your career?

Well, I think being a photographer is a natural choice for me because, as a kid, I was always shy and always watching everything that was going on. And I think, as a photographer, you can be part of a scene without *interacting* with it. And then I think I began to work with people because I didn't want to push my view or myself onto other people—my view of the world onto a situation. And I'm also quite *good* at working with other people. So I think the way that I work as a photographer naturally evolved out of the abilities I have.

But what I find very difficult are the same qualities that I think make me successful, and that is *not* being aggressive in the sense of saying, 'This is the way I see things and this is right,' and then pushing myself—I mean, I think I'm competitive, but I'm not *overtly* competitive. And I think that makes it difficult for me, and maybe I would have been successful earlier on if I had been more aggressive.

When you look back now, can you think of any childhood event or recol-

lection that foreshadowed that you would create this unique niche for yourself, particularly with so much world travel?

Yeah, when I was a kid, they used to have these little *National Geographic* booklets, and they came with stamps and there was one for a country. And I collected them all and I stuck all those stamps in with the little pictures of all the countries. And I would write away for pamphlets from tourist bureaus. For some reason, I was fascinated by other places. And I didn't really think about that as I was growing up. But then I also was very good early on in languages, and studied languages.

As far as being a photographer—in our house, there were pictures all over the place. And my grandfather started a very important advertising company and sort of figured out that you could use images in advertising. I mean, before that, it was mostly copy. Images were very important in our house and we always had the latest camera or movie camera or whatever. So it was all there.

Of what professional accomplishment are you most proud?

Well, I guess maybe two things. I mean, the concrete thing is I *am* proud of getting a MacArthur Fellowship and being the first woman photographer to do that. Then, also, I'm proud to have infiltrated the art world with non-art subjects, and the education world with the art world—and kind of mixing things up a bit.

And of what personal accomplishment are you most proud?

I think that I see everything as part of a whole, but I guess to have a fairly stable, happy home in what *could* be a very difficult situation.

You mean, in that you're both artists?

Yeah, yeah, and in a competitive kind of world, but to have a sane life with a little garden and a little house. And I guess I never expected to have a happy marriage, which is nice to have. I mean, I'd read a lot of biographies of tortured artists and I'm grateful to have—*not* a tortured life!

What, if anything, would you do differently if you could turn back the clock?

In a way, I had to wait till a certain time for my work to come. But I think I might have married and had a family earlier. If I could've had more confidence in myself, I think that would've made things go a little bit more smoothly. But, basically, I don't regret anything, and I think it's very important to me to feel that way.

What advice would you give young women just starting out in a career and older women considering a career change?

I think, with young women, I would really encourage them to

think for themselves and counsel them that it *is* rough and to understand that, but to keep *to* it. And with older women, to have confidence also in their own vision and to try new ideas and just to give themselves a chance to mess up and that things do take a long time to evolve. I think mostly it's just for women to give themselves a chance to find out something and not to be too hard on themselves, but just to keep going and keep trying things. Realize that it's going to be tough and to not expect things to happen quickly. But learning to understand who you are through your work is, I think, a very important thing.

What dreams do you have that are yet to be realized?

Oh, there are certain projects that I would like to do—places I would like to go. I'd like for my son to grow up to be a happy, healthy guy. And to be close to my extended family. But since I just finished this thirty-year retrospective, I sort of don't really know, 'cause it's a stage of my life finished—or maybe it's a *manufactured* stage, but it *is* a stage. I'm not sure quite what comes *next* and, so far, that doesn't scare me, but it *might* start scaring me. (*Laughs.*)

Interviewed by Susan L. Comer.

Wendy *Ewald*

As a writer, photographer and teacher, Wendy Ewald is dedi-
cated to social change and children's issues. Ewald has taught in
Appalachia, Colombia, on Canadian Native reservations, and in
Mexico and South Africa, as well as various communities in the
United States. She is currently a research associate at Duke's
Center for Documentary Studies and Center for International
Studies.

She has received numerous prizes for her work, among them
the Lyndhurst prize, fellowships from the National Endowment
for the Arts, the Fulbright Commission, and in 1992, a MacArthur
Fellowship. She is currently working in Morocco.

Kim Crenshaw an interview

Where did you grow up and where did you go to school?

Well, interestingly enough, my dad was an Air Force pilot. I was born in Bermuda, but we moved when I was very young, so I have no real memories of living there. I lived in California and Florida and the northernmost part of Alaska as a child. Actually, my first memories are probably of Florida and then I went to kindergarten, first, and second grade in Alaska, so I have a lot of memories of walking to school in deep, deep, deep snow and it being dark in the morning when you would go to school and dark in the afternoon at three o'clock when you'd come home. So that was a very exotic adventure, I think, for a small child, and I just have really fun memories of living up in Alaska.

From there, my dad got a position here in Durham. He got out of flying. After a couple of airplanes—that he was *supposed* to be coming home in—crashed and everybody was killed on them and my mother got the phone call that my dad had died in a plane crash, only to be called by *him* a few hours later saying 'I wasn't on that plane,' she said 'I can't take the stress of this' and he got into another line of work in the Air Force. He actually had joined the Air Force as a very young man, so he retired young—you know,

he had his twenty-something years in and he was in his forties. So he worked as a recruiter here in Durham for a few years and then retired. And I spent the rest of my childhood from like third grade through high school in Durham. And it was a nice city to grow up in. We lived in a beautiful old neighborhood called Hope Valley and, at that time, kids still had lots of freedom to ride our bikes and run through the neighborhood. At around twenty, I moved away from Durham and was gone out of North Carolina for twenty years.

What career dreams did you have as a child?

Well, in third grade, I absolutely knew in my heart of hearts that I was going to be an artist. I mean, there was just nothing else. I remember watching a little girl whose mother was an artist—I thought it was just probably the coolest thing—and her mother had bought her these drafting-type pens which had these super-fine little nibs on them. And she was *incredibly* talented herself and she would sit and draw little cartoon people, like of the teacher and the kids. And her little characters were so wonderful! I just remember looking at her, thinking 'Man, I wish *I* could do that.' And actually probably my earliest ideas of being an artist were of being a cartoonist. I absolutely loved the comic strip 'Peanuts' and all the Disney things. Probably until about high school, I thought I wanted to go and be an animator at Disney Studios.

And how did those dreams evolve as you grew into adulthood?

Well, I think, in junior high, I got into photography and really started loving that and had a friend that had a darkroom in his basement and played around with photography a lot. It wasn't a total passion at that point. I still think I had more of the idea, by the time of high school, that I would go into the graphic art or advertising world because that was more realistic as far as, at that point in time, it was like 'You can go get a *job* doing that.'

Were you frightened by the thought of just sort of 'winging it' in the arts world?

I think my thing was I hated high school with a *passion*—absolutely *hated* it! It was *torture* for me to be in high school. And the idea of going to a university and going through all the sciences and the maths and the things that I really just despised—I kept saying over and over, 'I want to be in a fine arts college.' There really weren't any fine arts colleges nearby and I never really had anybody help me check that out, so what happened was I married my high school sweetheart at eighteen-and-a-half just to kind of get out in the world, so to speak. I was pretty frightened, to tell you the truth, about being out in the world on my own. I just knew that I would never want to be in a typical university setting, and I didn't know at that point in time in my life how to get into the kind of college or school setting that I wanted to get into. So,

in a way, I kind of took an easy way out and got married.

And he's still a good friend, but we were married like nine years and then divorced. He was in the building industry, and I guess we'd been married about a year when I decided that I needed college of some sort, so I went to Durham Technical Institute and decided I would go into drafting and maybe, from there, work my way into architecture. And it's really amazing that, when I finally *did* get into a fine arts college years later, how many students had gone that route—had done architecture first and then said, 'No, fine art is really my dream' and had ended up in the fine arts college. I think that's kind of a way of trying to go into the corporate, more legitimate world and still do something very artistic.

So I spent a year at this technical school and got what they call an associate's degree to do architectural drafting. It was like a twelve-month course. And, from there, my husband—his name was Michael—we moved up to Washington D.C. I had spent probably a couple years right out of high school, before I had gone to college, working in a pre-school with another girl that is still my closest and dearest friend to this day. We had thirty four-and-a-half-year-old kids in this classroom. And I will say those are some of my best memories. I mean, we both had so much fun with the kids. I think we both just had such a passion and love for children.

So when we moved up to Washington D.C., I interviewed in a lot of corporate places to go and work and use my drafting degree.

And every place I interviewed, they offered me jobs. And I looked at this big city and this hour-long commute and this office space and this corporate kind of world and thought, 'Hmm, I just can't do that' (*laughs*) and went back to working at a pre-school up in D.C. for about a year.

Then from there, we moved to Nashville, Tennessee. My husband was working for Marriott Hotels, building their hotels. We lived there for about three years and that's where I had my first child, who is now eighteen. So, in Nashville, I was just doing that housewife kind of life and was O.K. with that, but there was still a huge part of me that really just didn't feel complete.

After Ashlee was born, we moved to Charlotte, North Carolina, for about six months. And then the job that my husband was working on was put on hold, so they sent him out to Dallas, Texas, to take care of a real problem property they had there and that's pretty much when our marriage just crumbled. At that point, I was twenty-seven years old, I had a one-year degree that I had *never* used—didn't even know *how* to go about using something like that at that point—and I had an eleven-month-old baby and no idea how in the world I was going to support myself or her.

And as life kind of leads you along, my sister, who is my only sibling, was living in Memphis, Tennessee, at the time, and I knew I didn't want to come back to Durham. I just knew that I was not in a place where I wanted to live in Durham—and back home—

because I pretty much knew that I would not be raising my child, but my parents would, and I didn't want that. So I moved to Memphis, not even realizing that there was an absolutely fabulous four-year fine art college there. But that's how God leads us, I guess. And I decided then that, whatever it took, I had to get a college education, because I knew that I was going to be supporting this child the rest of my life.

I started out at Memphis State University, so I *did* go into that university setting that I never really had wanted to be in. And I was going to go into interior design because I felt like that was about the most creative thing that I could really think to do within a university setting. I was in that setting for six months when I found out that there was a fine arts college in town, Memphis College of Art. And I didn't think I could get in—you had to submit a portfolio—but I got in. I got student aid and Pell and FICA grants and scholarships and lots of student loans, so I got through the four years. And it was probably one of my best experiences. It was a small college—the teachers and the students were all incredibly close. And I double-majored in graphic design and photography and loved every minute of it—and probably would've gone on and gotten a master's, but didn't have the money. (*Laughs.*) At that point, my little one was going into kindergarten and I wanted to put her in a private school and I thought 'I'd better get out and get working here.'

But that was a big, big, big, big life decision to go to a fine arts college. It was really truly about listening to my heart, because everybody in my family was just yelling at me—'How could you be so irresponsible to go to a fine arts college? You need to get a degree in something from a university so that you will be assured that you will have a job.' And I heard that for four years. And when I graduated, the clamoring grew louder to go and get a job in a corporation doing the graphic design. And, again, I had to just do an amazing amount of soul-searching to try to figure out where I really wanted to take my life. Being a single mother was a big part of that, too, because I wanted to be there on a daily basis for my child. I did not want her in after-morning care and after-afternoon care. And photography was really pulling at me more than the graphic design was. When I graduated, which was in 1987, a brand new person going into the graphic design field would be making maybe $14,000 a year—and that was tops. I figured, as a freelance photographer—if I was going to struggle and struggle—that I could probably at least struggle and make *that* much money on my own.

So with no business courses or anything—my history teacher, who was probably one of the best teachers I've ever had in my entire life, became a very good friend and she encouraged me so much. She said, 'Kim, you really have such a talent in photography. You go out on your own and you will not fail.' And I re-spected her so much because I really felt like she was one of the most intelligent people I've ever known. So even though my family was yelling very loudly, 'Go get a job. Be real,' I really, again, just listened, I guess, to my heart and said, 'What do you really, really love?' And the two things that came back to me that I truly, truly loved were being around kids and photography.

I looked around the city and there were a lot of photographers in town, but I felt like the way that they photographed kids was very stiff. You know, it was *their* idea of how a child should stand—and placing their *feet* just so and placing their hands just so. And I felt that I could probably do at *least* as good a job as *they* could, and maybe that was kind of false bravado on my part. But I guess that attitude really helped because I came up with enough money to print up a very nice postcard that had a very nice image on it. And I got a mailing list and sent them to people making over $100,000 a year. I didn't have a whole lot of expenses. I was living very, very modestly at that point. And from the very moment that I stepped out and did that, I supported myself completely. I was able to go to every single function my child had in school. I was able to go do all of her field trips—pick her up from school in the afternoon. She grew up going on shoots with me. She could literally set every piece of my equipment up and break it down. And when I remarried when she was nine years old and left the business that I had built in Memphis and moved to Kansas

City, I had the opportunity to be able to just pick my business right back up because I pretty much knew how to start one up from nothing and get working just right away. And I was able to home-school her in Kansas City.

Then we moved to South Florida and, again, started business just right the moment I hit town—you know, had business going again through mailings—and continued to home-school Ashlee. And that's when I had my other little girl, who is now five.

When we moved here to North Carolina, my oldest daughter went back to school as a ninth-grader. She wanted to kind of be with the socialization of school. And my young one was just a year old when we moved here, so I decided that I would take things slow for a couple of years because I wanted to have time to be with her.

Then a couple of years ago, I decided to advertise in a way that I had never advertised before. I had always done photography as more of a very relaxed way of working. I was not at it every single day. I would do mailings and I would be busy for a couple of months—make enough money to live for six months. Then do mailings and work another couple of months. So I was really maybe only working about four months out of the year, but making enough money to live—again, modestly. I had always thought that if I ever really got my work out to the masses, I'd actually be able to make the kind of income that would be big figures—and be very

busy. And I think I hit the right city *totally*—could not have picked a better city to do the kind of work I do. Because, being that I really love photographing kids, Cary is an area of North Carolina that my dad jokes that everybody has two-point-one children. (*Laughs.*)

What I did was I contacted two of the largest malls in the area. One of them absolutely, flatly refused to let a photographer advertise in their mall. And the other one said it was their corporate policy that they had never done that, but, after talking to me and seeing the work and seeing the kind of display I wanted to put up, he went to the head people in his corporation and pushed it through. So I really owe him a world of thanks, too. But the moment I started advertising in this mall here in Cary, I just have been blown out of the water and, literally, it's gotten to the point where I've had to hire people to come in and my husband is now working almost full-time in the business with me. I really can't keep up with the work. So it's been very, very good here.

How do you explain the fact that you had such an adventurous childhood and yet were afraid of going out on your own when you reached young adulthood?

Just never really growing up and getting a sense of being competent. My fear of being out on my own was from not having a really strong sense of self and of competency that I could take care

Kim Crenshaw

of myself. I look at my life now and I look at the earlier part of my life and I feel like it is completely two different people, because I feel like there's nothing that—if I set my mind to do at this point in my life—I couldn't do. And I totally have zero fear about taking care of me or supporting my family now. But if you'd asked me that twenty years ago, I would've told you that I couldn't imagine me *now*. I'm forty-four. So when I was twenty-four, the thought of being where I am now—I wouldn't had have the slightest clue how to go about getting there.

Describe for me your ideal shoot, one that is especially gratifying for you.

Well, it goes back to a strong belief I have that God gives every single one of us gifts—and that when we are in tune with our gifts, we can really truly feel that magic of the creative process of being just *one* with God and feeling like it's something even beyond ourselves. Like, for instance, Paul McCartney said that the music just literally comes *through* him—or when Art Garfunkel and Paul Simon wrote 'Bridge Over Troubled Water,' something that just was a creative process that was *bigger* than them. So I think when I'm doing shoots that I'm looking through the camera and I'm seeing images that I know are just going to be *perfect!* And everything—it's the lighting and the subject and the place, wherever we are, the environment, the creativeness—is just magical. It's just really, really exciting. I can be literally feeling absolutely

physically horrible, but the moment I'm behind a camera and I'm creating, it's like the whole world just goes away and it's just *that* that's right *there*. I can get that feeling working with a couple, with an eighty-year-old woman, or with a six-month-old baby. And I guess it's part of just really connecting. Part of the extreme joy I get—and people tell me this over and over again—is being able to capture that essence of that person, that personality. It's not just about recording an image, but it's about really recording *who they are*. And I have parents come in all the time and say they have struggled like crazy to try to pick one picture out of maybe twenty-five that I've given them because they see so many different aspects of the personality of that child. I consider that a gift. And when I feel like that's really happening—when I'm working with people—that's kind of an ideal, I guess.

I know you said that from third grade you knew you wanted to be an artist. Is there any childhood event or recollection you have that foreshadowed that you would end up being a photographer specifically?

My dad did have really fine cameras and there is a real artistic vein in the Crenshaw side of the family. My dad's sister is a portrait painter. She travels all over the country painting people's portraits and she's really, really good. My dad grew up, I think, in a pretty creative environment himself. And I remember him taking photographs all the time when I was little, photographing us

102

as kids. We *drove* to Alaska from Florida and drove back, so that was quite a road trip. I remember him taking pictures all the way up and all the way back. I never really looked at him and said, 'Wow! I want to be a photographer,' but I'm *sure* those kinds of things imprint on you as a child.

Tell me about your family today.

I'm married to a wonderful man. His name is Larry Henson and he's a Unity minister. In two months, we will have been married nine years. My eighteen-year-old daughter Ashlee is an incredibly artistic child herself. She should have been a little hippie in the sixties because that's truly where she lives. But she's *incredibly* creative. She is definitely going to do something in the arts. She totally has that bent and I don't know how much of that is genetic and how much of that is environmental. But she has an artist's soul. She's never going to be out there in the corporate world—I just don't ever see that happening. And she's going to UNC-G next year. One of her major gifts is her writing. She just has always had an incredible sense of being able to do that. When she was in second and third grade, every child in the school had to write a book at the end of the year. And Ashlee's, both years, were picked out to be read to the entire school, and the one that she did in third grade was put on display at the board of education. And I've had teachers all along the way tell me that I should try to get

her books published because they were so amazing. She did these huge picture books and these incredible stories that went along with them. So I would not be surprised if, somehow, some *way*, she ends up in that field. But she's very *visually* creative as well.

My five-year-old, her name is Hannah Halie Henson. It's very melodic. We never ever set out to name her with three 'H's. Her name kinda picked itself. And we call her 'Hurricane Hannah.' Where Ashlee was always a very quiet child and if you said 'no,' she would listen and was just the easiest child ever to raise, Hannah is a *fireball*. She's so full of life, it just spills out of her. She is very willful and very determined and incredibly bright. And we just look at her and go, 'O.K., she's gonna be a diplomat or something out there in the world where she's going to be getting *lots* of attention.' Because she gets it everywhere she goes. People stop and she just goes up and talks to adults and kids and engages in conversation. She's *way* beyond her five years. She's also very creative. We don't really know what Hannah's going to do, but we know it won't be quiet!

You were telling me earlier how Ashlee went with you on shoots when she was small and you were a single parent. Do you find it difficult these days to balance family and career?

I find it *amazingly* difficult. I suffer from mother's guilt on a daily basis. I'm very thankful that my husband takes up so much of

the slack. It's almost like we've done a role reversal. And I find that he actually gets to spend more time with Hannah than I do.

My teenager's pretty much out on her own these days, so there's a real spot in me that's very sad about seeing that transition take place. Being a single mother with her, we were so close. But I see her doing her own thing these days. So the guilt may be not so much *there* as with the five-year-old.

One of the things that I didn't mention is we are physically moving the house we have lived in for the last three years. It was on ten acres of land and we had a beautiful garden area we had built and a smaller home on the property that we used as a studio. So I had the perfect environment—we worked right out of our home.

The land that we're going to, we're also building a fifteen-hundred-foot studio onto the house so that you can walk out of the house through a breezeway or mudroom kind of area into the studio. So we'll continue to work and live in the same environment. And in one sense, that's really good, because Hannah's always around and people are coming in and out with kids all the time and she'll run and play with the kids while I'm talking to the parents. And she sees her dad and I everyday—we're right there with her.

The part that produces so much guilt for me is that she'll say 'Mommy, can you come and watch this cartoon with me?' or 'Can you read this book to me?' or 'Can you sit and play this computer game with me?' And nine times out of ten, my response is 'Sweetie, I'm sorry, I can't. I have to take these pictures now' or 'I have to meet with this client now' or 'I have to get this order out now.' So I *do* struggle with that. And I have yet to really learn how to get a balance where I have more time to spend with her.

One of the things we *try* to do is to take really nice vacations and just leave town where business can't be pulling at me and so, to then just give her total attention in that respect. And when things get really busy, I try to schedule at *least* one afternoon during the week that I pick her up from school and just spend that afternoon with her. It's little bits and it helps, but I don't know if there's ever a real easy place to be. I really feel like if I was being 'a housewife' where that was my job and then there wasn't really any other occupation I was doing outside of that, I would feel—I don't know if 'bored' is the word, 'cause I'm never bored around Hannah—but I think I would feel very stir-crazy in a sense.

When I've had my business in places before, I was maybe working fifteen or twenty hours a week—tops—where now it is easily sixty-hour weeks, so it's a huge difference. But when I had a *lot* more free time than I do now, I was always doing something creative. I was with Ashlee—we were always doing art projects, I was decorating the house, I was sewing. I actually—at one point, when Ashlee was young—came very close to trying to have two careers

and start up a children's clothing business, because I love designing kids' clothes as well. Somebody asked me once, 'What are you going to do when you retire?' and I can't imagine not being creative. I might not be taking photographs, but I know I will be building and making and creating something somehow.

What are some ways that you relax?

Well, one thing, like I said, is to try to take vacations. The last couple of years, one of the vacations we have found—and it's probably not *terribly* relaxing, but it forces us to *truly* leave the business behind—is to go on cruises. Because you can't get to a telephone. And last year, we actually combined business and work and took a vacation at the beach and did beach shoots. But we only did one shoot an evening at sunset, so everyday all we did was just go and sit on the beach and watch Hannah make sand-castles with other kids. And that was amazingly relaxing, to just sit and play in the sand and basically do nothing.

When I'm home, I guess the way that we relax is, Larry and I will try to go out to the movies some. We'll go to the ballet and the symphony, that type of thing.

One of the ways that *I* relax is just getting in a big bath with lots of lavender and just soaking in there, but with a very active five-year-old, she usually comes and crawls in with me after about twenty or thirty minutes. (*Laughs.*)

These days, while we're in an apartment waiting for our house to be moved, we've got a really nice tennis court here. I love to play tennis, and that's very relaxing. So we try to go out in the afternoons when the weather's nice and maybe play an hour of tennis.

What are some of your favorite things?

Well, in books, my absolute favorite author is John Irving. I love the way he writes, and I just finished reading his latest book which was *A Widow for One Year*. I love how he creates the most amazing characters.

Movies—I like movies that, when you come out, you feel moved in some way, but not depressed. I don't like going to movies that are really depressing and I really don't like the kind that have violence and gratuitous gore. I guess the movie that has struck me probably as one of the best movies I've seen in a long, long time—and it was very bittersweet; in a sense, it was sad—was 'Life Is Beautiful.'

In my younger days, I loved sailing. My first husband and I had a thirty-foot sloop we kept in Annapolis, Maryland, and we'd go out on the Chesapeake Bay every weekend and spend the whole weekend sailing. I loved that and would love to have the time and the place to be able to do that again. That is probably one of the most peaceful pastimes I've ever partaken in, but that's, unfortu-

nately, not a real part of my life anymore. Maybe *one* day it might be again.

I probably would say my biggest love is spending time with my family. Nothing gives me more pleasure than to be with them. And right now with Hannah—the age she is, I mean—Larry and I keep saying to each other, 'Well, if we had our way in this wicked world, we'd stay there and just play with Hannah everyday.'

What personal qualities do you consider to be of most value in life?

I think a sense of real integrity, to be honest in every way—you know, that a person trusts that, whatever you say, that it can be taken to the bank. I truly believe in being honest in every aspect of my life.

And I guess it's important to have a connection with something that's greater than ourselves. For me, it's a connection to God—and living from the principles of what's taught within any of the religions. There's certain truths and they're all about being loving and kind and ethical and honest. And I think if we all were able to live connected to those truths that the stress and the violence and all the stuff that's so wrong with the world wouldn't be there. I mean, I know that's really very idealistic, but for me, it's really about bringing something of worth and of joy and of value into the world and having left it a better place—and certainly not have made it worse.

So I guess those are the kind of ideals that I live from. I probably could use a little bit of lightening up in my life—could probably try to adopt the qualities of having more humor and maybe not taking things quite so seriously.

What is the one way that you have evolved as a human being that makes you proudest?

It took me the longest time to get to this place, but I think it was in my thirties that I finally truly felt like I came into myself and truly said 'OK, this is who I am and these are my beliefs and it doesn't matter what *this* person thinks about me or *that* person thinks about me. This is how *I* feel about me.' And as long as I feel that I'm coming from all those places that I've talked about and really truly being able to feel good about myself, then nothing can knock that away from me. I think there were a whole lot of insecurities that I had as a child and that I carried with me into young adulthood, so I think it was truly finding myself in the sense of seeing the *whole* of me. And kind of saying, 'Yeah, you really are a very strong person and you can do whatever it is that you set your mind to do.' And just realizing that I've made my decisions and I stand behind them—and usually try to take total responsibility for those.

What qualities do you possess that make being a photographer a natural

for you? And, conversely, what qualities of yours create conflict or struggle that you must constantly work to overcome as pertains to your career?

Well, I think the qualities that I have that make my career *work* for me is that I am totally driven inside by a desire to be creative. And I think if I didn't have that strong a drive that maybe I would, you know, sew doilies or something instead—I don't know, maybe not be very productive. So I think it's that desire to create.

And there's also a desire that I have come to understand as a big part of me that I've never really gotten in touch with until maybe the last few years, but it's a real desire to be very successful at what I do. There's a sense of satisfaction of being able to create and also be rewarded for that. So I think that's probably the part that comes together very well in me. And possibly the one other part is, like I said, when I really came into myself, so to speak—of realizing that I have a talent. I have a good friend named Kim who is probably one of the best painters I have ever seen. We've traveled all over the country, and everytime we go someplace, we go to the finest art galleries. Her work could be hanging in any of them—she is really that good. She has an amazing desire to paint. She paints everyday. She paints incredible pictures. But she has such a fear of really stepping out and becoming successful, so she never tries to show her work in galleries or sell it. And I guess that's the difference between her and me, is that I have that desire to be out there and to be producing and then getting the rewards

back for it in a monetary sense.

The part of my personality that probably really *hurts* me is I'm a real A-type personality—you probably picked that up just from this conversation. I tend to overdo, and I think that stresses out the people around me. I'm just constantly going, and there's a part of me that has not yet worked out a system of being able to hand over a huge part of the business to other people. So it's that sense of controlling, because I've got to make sure it gets done and I've got to make sure it gets done *right*. And the person that's going to do that is me. So that 'control' part of me, I think, really probably hurts.

Of what professional accomplishment are you most proud?

I don't know if I could pick out any one particular thing. I guess it's just knowing that there are lots and lots and lots of people out there that love and cherish the work that I've done for them. So I can't really say it's one particular person I've done any work for. You know, there are people that are certainly professionally very well known or very well off, but in the same sense, there are people that have struggled and saved and made payments to be able to buy a portrait from me. And it's just as important to me to make *them* happy as it is to make an extremely wealthy person happy. If I feel like I've created something that they really cherish, that's what makes me the most proud.

And of what personal accomplishment are you most proud?

I think it was being able, as a single mother, to make it on my own with no help from anyone. Ashlee's dad—like I said, we're still friends—but he never supported her through her lifetime. And as a single parent, being able to be a good mother to her and still provide a nice home for her and be able to do that totally on my own talents. That's probably what I'm most proud of.

What aspect of your career brings you the most joy?

I think it's seeing the parents' faces—or the families' faces—and knowing that I've truly given them something that brings them joy and that I know will continue to bring them joy through their lifetime.

What, if anything, would you do differently if you could turn back the clock?

Well, I can't say that I would've gone to college earlier, because going back to college at twenty-seven—I had the maturity to really get the education that it was important for me to get. And I might've just totally taken it for granted had I done that at eighteen. It's hard to say, because if you make one change in your life, that impacts everything else that would come in the future. I wish maybe I'd had the maturity not to have become a single parent, to somehow have had the maturity to work through that rela-

tionship and had a more stable life for my daughter. But if *that* had happened, I never would have had Hannah, and I can't imagine life without Hannah. So if you go back and say 'Gee, if I had changed this or changed that,' the way I've always looked at it is that it would change where you are today. And with *all* the struggles that I have gone through in my life—and there have been a number—they've made me the person I am today. I guess if there is *anything* I could change, it would've been to try to be a better parent. I don't know how that would've happened, but I guess I'm always striving and always wanting to be a better parent to my children.

What advice would you give young women just starting out in a career or older women considering a career change?

I say this to people all the time—I say it to young people as well as somebody even in their forties or fifties—'If it is in your heart, if there is something that's very strong within you, if you *believe* you can do it, you can do it.' And I always felt that, from a child. But then after really having a much closer understanding of God in my life, I believe with a passion that God gives us gifts and that if we really are listening, then they're going to speak to us very loudly. I've met a lot of people that have said, 'Gee, I don't know what I want to do.' But I think everybody—if they really stop and listen and get clear with that—they *know*! I really feel

like if you truly follow your bliss—and you *gotta* work at it; doesn't mean that you can just say 'OK, here's my bliss and so give it to me; just let it fall from the sky'—you can't help but be successful. *If* you're willing to work at it. And 'working at it' means doing whatever it takes, whether it's going to college or going and learning everything you can about it and then just stepping out there and *doing* it. So I would say if you have dreams, you have to have the faith of knowing that it will be there and then putting the action behind it to make it happen. I can't state that strongly enough, because I have found it has happened in every single aspect of my life. And I feel like you could just write that on stone.

It's just like this house that we are moving—this is a perfect example. Four years ago when we moved to this area, we had a house for sale down in Florida. It was not selling. We had a two-thousand-dollar-a-month mortgage down there. My husband took a big cut in pay to come here and I decided, for two years, that I was not really going to do much work. So we had very little income. We moved out of a big house in Florida to a half-the-size house in Cary. And my husband had been telling me for years 'Kim, you need a studio,' and I kept saying, 'No, I will never go into a storefront studio and do the same thing over and over again everyday. You might just as well shoot me.' And he said, 'Well, you've gotta get serious about your career, because you're never going to be successful unless you really know what it is you want.

So what is your dream? What do you see as the perfect place?'

And I described to him in minute detail my perfect place. It was an old white farmhouse with a big front porch with wicker and ferns. And on a big enough piece of land that would have trees all around so you would never see a neighbor's yard from any direction you were shooting. In that land, there would be beautiful gardens and enough space to build my own idea of what a studio would look like, in that I would work and live from there.

And we had been living here a year when our house was *still* for sale in Florida. And we got lost and pulled into the driveway of this house that we are moving and found out it was for rent. And we looked up there and saw this huge house and went 'Probably could never afford to rent this place.' Turned out, the owners were keeping it for an investment. Five young men had been living in it and it was nasty, nasty, nasty. It had brown nasty shag carpeting on all of the steps and all in the bedrooms upstairs. They had four big black labs that lived there. The hardwood floors were white—they had no finish on them at all—I mean, they were just colorless. And every wall was painted the color of a paper sack, and they were filthy.

And we walked in and saw the potential and the beauty of the place. We said, 'If you'll pay for the materials, we'll fix it up and sign a five-year lease.' And we thought, in five years, we would have the house sold in Florida. We had ten acres to work on, this

beautiful old house, we knew we could put our gardens in and stay there for five years and save up enough money to maybe build something in the meantime. Well, once we fixed the house up, we fell so much in love with it, we started feeling like this was our home. You know, it was like, 'I just can't imagine this not being our home.'

A year and a half later, the owners came to us and said 'We never thought that we would want to sell the land as soon as we do, but we've had an offer we can't refuse. And if you guys are willing to tear up the lease, we will *give* you the house.' So they gave us the house and, again, we got lost—and found some land. The land wasn't for sale, but it was so perfect, we found the owner, and the only reason that land had not sold years and years ago is because it wouldn't perk—they could not put a septic system on it. So we spent $8,000 getting a state approval for a very hybrid septic system that has just been invented in the last two years— and there've only been two put in in Chatham County where we're moving the house to. And there are only two people in the state that are licensed to put the septic system in. But when we found this land, we knew—we absolutely knew—that that land was our land and it was meant for us. And it took us eight months to get the state approval and it's taken us a total of $35,000 to put the septic system on this land. But it's perfect! It's three acres of land and behind and to the side of us are hundreds and hundreds and

hundreds of acres of Corps of Engineer land. So no one will ever build behind us. The house is going to be an old white-frame farmhouse and we're putting a fifty-foot-by-ten-foot front porch across it and building a fifteen-hundred-square-foot studio on the back. So it is *exactly*—to the tee—my absolute dream.

Interviewed by Susan L. Comer.

Kim *Crenshaw*

Kim Crenshaw lives with her family in a recently renovated 1920s farmhouse, where she also has her portrait studio and extensive gardens. She lives with her husband, a Unity minister, and her daughters Ashlee, eighteen, and Hannah, five. When she's not working, Kim loves to spend time with her family, garden, and travel.

Anita Mills an interview

Where did you grow up and go to school?

Well, I grew up in one of the flattest places on earth, in West Texas, in a town called Lubbock. Many people know it as the home of such notables as Buddy Holly. There is a fabulous Buddy Holly Museum there now, where they are seeking to enrich the cultural lives of people. They have got an art gallery and all that stuff that they didn't have before.

I went to public school throughout, even staying on in Lubbock to attend undergraduate school at Texas Tech University. And I would say that it was the Pollyanna upbringing bordering on the insane, you know, because of the seeming normality of it. And yet, there were a lot of really strange aspects to it. One, of course, being the absolute visual deprivation that the landscape provides. Just nothing in the way of trees or water features. Just flat, semi-arid desert land.

I think from that standpoint, growing up there was a great service to me in terms of becoming a visual artist, because I found I lived a lot more in my imagination, probably, than I would have if I had been someplace that had such inspiring landforms. Not to say that the West Texas landscape is totally uninspiring, be-

cause they did have some incredible atmospheric things going on there, and that played heavily in my work in later years.

It was an interesting place to be as a young woman because two generations ago, my grandmother traveled first to Texas—to the Panhandle—from Oklahoma in a covered wagon. And that's just at the turn of the century. So I always had a feeling that there was this legacy of 'West Texas of the high plains pioneer woman' spirit that was sort of guiding us all. And yet, in two short generations here we made the transition from horse and buggy to automobile, from hand-sewn quilts to machine-made everything, that kind of thing.

So, I always felt an incredible heritage. My greatest role models there had this o'nery woman's spirit, like, 'You say I can't do this, well, I'll show you!' If we'd believed that women weren't as capable as men, then none of us would have survived, you know. We didn't believe that, and I remember as a young girl going to the West Texas Museum and seeing all of these displays about early life on the high plains, and the dugout dwellings that people lived in and the stories about women who survived winters and dust storms and excessive wind.

Once they began to till the soil and turn it into farmlands that were then irrigated by their artesian wells, then there wasn't anything to hold the dirt down. So even as I was growing up I remember these springtime and fall dirt storms that were just of

enormous proportions. I had a real glimpse, I think, as a child, of what it must have been like in the days of the great dust bowl, which is an awe-inspiring thing. One of the earliest influences in my life as an artist was my mother's father, my grandfather, who was a rural mail carrier. But he also was an itinerant photographer. After his return from World War I, he became interested in photography. He always toted a camera with him everywhere and did large format photography as well as small. He was one of the first people in Oklahoma to have a sixteen-millimeter movie camera, which he used to document small-town rural life. One of my earliest memories of the power of visual images was, when I was about five years old, working with him in his darkroom and watching the images come to life in the development trays.

Additionally, one of his and my grandmother's earliest influences was an appreciation for artwork that is born of different cultures. It was one of the things that they did. Because he was a government employee, and worked for the postal service, he had extra gas rations and extra re-tread tires during the Depression years. So they would take off in the summertime and go on these family trips, where they set out with a total budget of eight or nine dollars, and the family would drive all the way out to Southern Colorado and Arizona and tour Navajo lands and all of the nineteen pueblos in New Mexico. In the course of that, my granddad took portraits of many of the Native American artisans that he encountered there, as well as some sixteen-millimeter film footage, and they collected the artwork of these folks. And so their house in Oklahoma was stuffed with Native American rugs, ceramic vessels that are just incredible, and baskets and kachina dolls and the like. I just remember feeling, when I stepped into their house, that I had stepped into another whole existence.

Was that very different from your parents' house?

Well, my parents had a different kind of taste. They weren't collectors. They were into reading, they were into art, they were into expressing appreciation of art. But it somehow was a secondhand transfer. My father is an architect, and he, of course, sought to surround us with excellent design and interesting things. But I think he also felt rather hampered by his environs too in terms of his own work. So, I think it was as rich in culture as we could manage, considering the remoteness of the location.

It always amuses my friends when I tell them about this phenomenon known as "The Art Train" that would come through the area. When I was a tiny girl, Lubbock was still a hub of activity for the railway industry. There were still several lines that came through there, both for passenger service and for freight. And some people out in the central or eastern part of the state decided that they needed to have some emissaries of culture...so they loaded up a couple of converted boxcars with precious objects

from the state's various museums and sent it on the road. We would go and line up and go through the art train cars.

Did you see interesting art that way?

Well, you know, as my feeble memory brings it back, it seems that much of it wasn't the most modern of the modern. They would put in things that were largely representational—things that might have had to do with the western theme or something that they figured the majority of people would be able to relate to, much more than they would abstract impressionists, or some such.

Had you always felt that you were going to be an artist?

Yes. When I was five years old, one of my earliest memories of feeling as if I would work in that field—I was sitting at my aunt and uncle's breakfast bar, working with a little tin of watercolor paints and a brush on paper. I didn't like coloring books, because I thought they were too stifling somehow. But I was working on plain paper and just making splashes and splashes of color. And my uncle came through the room, and I think he intended to be kind of skeptical. He said, 'Well, what do you think you are going to be when you grow up, an artist or something?'

I looked up from my work and I looked him straight in the eye, and I said, 'Yes, I am.' And I think he was shocked with the

certainty of that, because many kids just say, 'Well, yes, I might want to be an artist, or I might want to be...' But literally, that's all that I ever wanted to do, from a very early age. Virtually, from the moment that I began to make things with my hands and see things that I could make or do or put together, I was hooked and haven't really thought that I would love to do anything else.

What were the first steps that you took towards taking that childhood dream and making it a reality in your adult life?

Well, I thought it was enormously gratifying to be noted. We are talking about the fame, you know, of an artistic presence. I found there was a lot of ego-gratification for a little girl who could draw well. It seems like I was always distinguished, set apart, in a positive way, from my peer group for having those abilities. What I have learned since is that any child could draw if they were given the opportunity to practice and learn different techniques and tricks. Because it is just a rote activity, after all. But that was, you know, the initial thing.

It wasn't without some folly here and there. I remember my father teaching me to draw, and I was lamenting the fact that I couldn't do hands or feet on the people that I was drawing. And he said, 'Well, don't worry about that. For now, just do the best you can. And then put their hands in mittens and have them stand in buckets of water.' So I started doing that, and then, after

about a week, my teacher at school began to be concerned because all of my human beings had mittens on and were standing in pails. And she asked me, 'Now what is this all about?' This probing question of, 'What is going on at home?' you know, that kind of thing. And I said, well, I was trying to draw hands and feet, and this is what my dad said to do, so I did.

I can remember, maybe not so much having the urge to draw and paint all along, but to *make* something. I thought that was the biggest kick in the world, to make something from nothing, essentially. There was a community art center, and my parents would enroll me in their classes as soon as I was old enough to be considered. They didn't have all that many classes for kids, but I guess as soon as I was eleven or twelve and found to be *acceptable*, you know, to have appropriate behavior for an adult classroom, I was allowed to take classes there. The interesting thing about that was, of course, many of the teachers who were teaching in the community classrooms were the same teachers who were at the college where I would eventually attend. So, I virtually knew all the art faculty of Texas Tech University before even enrolling there.

I was very fortunate to have several extremely inspiring and believing art teachers along the way. These were inspirational women, as long as we are on the topic. And people who really do believe there is no limit to what you can do if you apply a little creativity here and there. They had to believe it, to work with junior high and high school children in the flatlands year after year after year, and remain inspired themselves.

One of the interesting things that I have realized, in retrospect, about my whole experience of becoming an artist and being a female growing up in that part of the country—you have to remember that, back then, females in that culture were very blatantly taught it was okay to be smart, but if you ever expected to land a husband or to lead the life that was expected of you in terms of roles, you had better never ever let them know how smart you are. So, in a way, it was a childhood of perpetually checking myself, or, 'Well, I really shouldn't say that because it might make him think that I'm uppity.' It was kinda like this culturally approved self-deprecation with regard to comparing ourselves with the males, that was annoying on the outside—but in fact, what I have come to learn since then, since having been through feminism and the women's art movement and emerged through post-feminism and beyond, is that my oppression as a female there was, in essence, my liberation. Think about it. Nobody really cared what a young woman did there. You could say you were going to be the Queen of Egypt if you wanted to. And people would say, 'Well, that's really nice, dear. You go right on ahead. Whatever you think is best.' Since it was generally believed that we would all ultimately marry and have someone else being re-

sponsible for our primary support and well-being, it didn't really matter.

Essentially, I think the fact that no one took us seriously, took *me* terribly seriously, was what in fact allowed me the freedom to do what I needed to do and to gather the skills and have the experiences that I needed to be pushed forward.

Did you accept, when you were younger, that your art might just be a passing phase that was occupying you until you were squirreled away in some compartment?

No, I knew in my heart of hearts that I had more to offer than that. I—and my female friends who were also pursuing a study of art—we knew that our seriousness of purpose was far greater than ultimately to be Sunday painters. Even as grateful as we were to our high school and junior high art teachers, we railed against the idea that we, too, would end up being art teachers. Oh, my God. That was the worst thing, at that time, that's what we fought. We fought the notion that, if you were female, you had one avenue or the other. Teaching, or homemaking, or nursing, or...

Was there a pivotal moment when you knew that you had escaped that fate, when you knew for sure that it was going to be different?

Well, what was interesting is that I had a very vivid creative visualization of getting out of there, of moving on, from about the time that I was thirteen or fourteen. But it didn't actually happen for me until I finished undergraduate school, when I was highly encouraged by one of my teachers to go on and do a master's of fine arts in studio art. And not to stick around and do that in my home town, but have a different experience. So it was then that I decided to go on to University of Texas at Austin and pursue that study.

I think, at that time, I had $400 to my name in a little savings account, and I made my application. And it turned out my application was a day late, so I had to work and take courses for a semester in order to gain formal admittance to the University.

My mother had some feelings of anxiety on my behalf. My dad was dead set against it. He said he thought it would be a far better idea if I would hang out in Lubbock and work as a secretary for a while and save my money and then go to school. But I knew if I did that I would never leave. You know, it came to this critical moment, where you go or you stay. And this was my moment of going. So I loaded all my possessions in my 1964 Oldsmobile Dynamic 88, and I said goodbye to my mother. She was tearful, but I somehow understood that with her it was sort of a nest-leaving thing that could have happened if I had gone off to some other place for undergraduate school. Then I went by my father's office to say goodbye to him. And he refused to speak to me. He had said before that he thought this was just a big mistake and

that I didn't know what I was getting myself into. And so I virtually drove from Lubbock to Austin that day, some eight to ten hours at, then, fifty-five miles an hour, weeping most of the way and thinking, 'What have I done that I can't inspire the approval of my artist father?'

Do you think, looking back, that it was what maybe he wished he had been able to do?

Well, I think that may have been a part of it. Definitely. And I know that at many times in his career he felt rather stuck being there, with the variety of projects that he had to work with and the persistent non-terrain. But ultimately he came around. When I got a job very quickly and got admitted to classes and was working with some mentors there, I was very dutiful to write home and talk about everything that was happening that was of positive note. Within a year's time he had to say to me, 'You were right to go on.' He had a hard kind of existence of his own, growing up, and put himself through school by working many, many jobs, et cetera. I think he was just interested in making sure that I realized the importance of attempting to support myself through the whole effort. Of course my mother sent me money secretly on the side every month to help.

So, after you got your M.F.A, what did you do next?

Well, I went from University of Texas at Austin straight to Minnesota to teach in one of the state universities there. It was interesting to finally end up in teaching, you know, after having resisted it for so long. I had resisted the idea of teaching all the way up until my last year of graduate school, and one of my mentors at the University of Texas, a man by the name of Kelly Fearing, practically blackmailed me into trying teaching as a teaching assistant. I was not interested in it. My prejudices about that persisted until this man, whom I trusted very much, said that he thought I had the makings of a superb teacher and that I would be disappointing him greatly if I didn't at least give it a try. So, it was then that I first got into teaching by accepting a teaching assistantship. And in these teaching assistantships, we had full charge of the classroom, so I was able to really spin out and see what I could really do in that regard. That was when I first discovered my love of teaching, that it wasn't just a career choice, or it wasn't just an economically convenient thing to do, but that I really did have a particular talent for doing that.

For me, it was the greatest reward in the world to work with people who had had terrible art experiences before. If not terrible, then less than sufficient, you know, to explore their own skills and their own opportunities for creation. That, to me, was the biggest thrill. To think that I could actually be an artist, but also had the ability or capacity to help people come into their

own being, to whatever level was going to manifest itself. And so I applied for several jobs across the country, and I got a call one day to come for an interview at St. Cloud's State University in Minnesota. I had just sent off a bunch of applications. When they called me, I had to pull out the Atlas and find out where was Minnesota, because I thought it was somewhere up north. I didn't know it was a Great Lakes state. I didn't know what bordered it or anything, but I was soon to learn. So, that's what took me to that region of the world, and I stayed there for twelve years working as a faculty member, and later, my last two years, assuming the role of department head.

So, then, how did you come to North Carolina?

Well, that's another long story. I'll try to give a succinct version of how that happened. At that time, I was involved with a woman who was finishing her Ph.D. in Exercise Physiology at the University of Minnesota. She had gone from being a physical education teacher to this highly scientific realm of studying the body and exercise. And she was keen to try her hand at a university professorship and knew that it wasn't going to be forthcoming in Minnesota. Because, as it works in academe—and I think this is really horrible—as it works there, the best way to demonstrate your worth to many institutions is to be willing to pick up and move 3,000 miles across the country to take the posi-

tion. So, her desire to do that coincided with my need to get out and do something different. And we were fortunate at St. Cloud State and the state system of Minnesota that they had a provision in the teacher's contracts—you could take what they called mobility leave. From three to five years, you could request to be away from your post. No matter what you planned to do, if you planned to go to work in private business or pursue your career as a studio artist or whatever, they believed that if you decided to return to the campus, then you would be bringing some real-world experience back to the classroom. Meanwhile they would hire two people to take your place. So I applied for and got one of these mobility leaves, and my first stint was for three years. And that's how I ended up being here, because she ended up taking a position at the University of North Carolina in Chapel Hill.

Unfortunately that relationship didn't survive the transition, but then I was still here, and enjoying being back in the South. I was really glad to be away from the bitter cold winters, in a place that was three hours from the mountains and three hours from the ocean, and had trees galore, and bumps on the horizon that I later would learn were called hills. And it was just sort of a magical place for me because of that. Not that I didn't enjoy aspects of Minnesota and all of the wonderful people that I knew and met there, but I felt like it was a homecoming. And to have that homecoming, I didn't have to go back to Texas, which was really nice.

So, in a nutshell, that's how I ended up being here. I've been here since 1989, and have really come to regard it as home. I would be loath to leave. Of course, you can't say 'never' when it comes to one's location, but I am fairly sure I will be here for a while to come.

So, how did you meet your partner Andrea?

I met her actually in 1991. At that time she was working on her master's of fine arts in creative writing at the University of North Carolina-Greensboro, and she was a friend of a friend. And we were just casual acquaintances then. Then we used to run into one another from time to time as we would attend poetry readings or exhibition openings, or other kinds of things like that around the Duke campus. But then, two years ago, we both found ourselves in the state of being single. Our friendship struck up again and we became more serious about each other and forming a family together. So it has been about two years now.

How did you decide to have a child?

Ooh, that's a very interesting question, too. It has always been her desire, she tells me, to have children. And I have to say that I had that desire once, many, many years ago, but in the context of one person that I knew at the time, a fellow that I had been seeing when I was in graduate school. As my circumstance

would have it, the people that I was involved with since were not in the least interested in having children in their lives. And when I heard Andrea speak so earnestly about wanting to have a child, or children, plural, I thought to myself, you know, one of the things that is nice about having new takes in your life, and having the opportunity to begin again, is that you get to re-examine all of your feelings and all of the issues surrounding things that you thought you might have left behind. And one of those things, it turns out, was the whole business of having an immediate family unit that involved children. Just to hear her speak as earnestly as she did about her desire to do it made me realize that, 'Hey, this door hasn't closed for me.' Even though I am old enough now that I wouldn't be conceiving and giving birth myself, it doesn't mean that I have to give up on the notion that I, too, could be a mother.

Through the early parts of our relationship we would test the idea with discussions of our age difference, which is some eleven and a half years. And also in talking about it with my friends—I think all of the friends that I have who were my age thought that I might have lost my mind, but I would just say, 'Hey, you know, middle-aged guys do this all the time.' They take up with someone who is somewhat younger, if not significantly younger, than they are, and decide to embark upon the creation of a whole new family. I don't know why I should feel so timid or intimidated for

my desire to do so. So, that's kind of how it came about.

Did you want the donor to be somebody that you knew?

Well, we toyed with the idea, and ultimately decided it was too legally encumbering to consider. Though there were a couple of men who are dear, dear friends of mine, who would have been excellent Daddy material, we ultimately decided on an anonymous donor. We just felt that we were going to face enough in the way of challenges to our family with regard to having two mothers and no father, that we didn't need that extra coordination—we didn't need extra parameters or dimensions of it.

Are your parents still living now?

Yes, my mother lives in West Texas, and my father lives in Arizona.

What's their reaction?

Well, my mother, I think, is delighted for us. My father—I wouldn't know what his reaction is, because I haven't been in communication with him since 1989, when I told him that I was going to be moving to North Carolina, and in essence, came out to him in that process. I haven't heard from him since. So, I don't know what he thinks.

But my mother has definitely been accepting. When I first said to her that we were contemplating this, I think she was supportive, but as all mothers are wont to be, she was supportive with the understanding that it would be a positive experience for me that I wouldn't somehow be ultimately dashed or hurt by it. All mothers are just that way. I mean they are as supportive as they can be, so long as they think everything is going to be fine. And then, if they start thinking about worst-case scenarios, or whatever, then they make themselves crazy.

And Andrea's parents, I think, once they are over the initial shock—parents of lesbians and gay men, somehow they just don't think about the possibilities of child-rearing or that there could be grandchildren in the picture. They somehow think that, because of gay and lesbian lifestyles, the multiple ways in which we choose to live our lives, children are not in that scene. It is not in their visualization of what it is about, or what it is like. I think that her parents—I don't want to speak for them, but I think that they had decided, 'Oh, this is not to be. Our only daughter is not going to have children herself.' So I think, on the one hand, they were completely delighted to find that she, in fact, is going to have a baby.

When you think about yourself being a mother, do you think it is going to come naturally to you, or do you perceive it as being a challenge?

Well, what's interesting is that when I taught full-time at the

college and university level, people would ask me, 'What level do you teach?' And I would say, thirteenth through nineteenth grade. It wasn't that I wished to demean the students by virtue of their age, but I did very much feel that, as freshmen in college, they needed a transition that allowed them to have more parents than just the ones who bore and raised them. And I always tried not to step into the exact role of a parental relationship with my students. But I still very much felt the responsibility to be there for them and to serve as a mentor however I could, if they wanted that to be. I always thought, when I was teaching, that for every year that I taught, it was sort of equivalent to me of having raised a child to a certain level, depending upon what degree of involvement that I ended up having. I have felt that there is an emotional crossover and relationship between teaching something seriously and parenting. I guess I am about to be able to test that theory big-time.

In an excellent teacher I think that there is a compassion, there is a desire to share and to nurture and to oversee and to protect, and all of the same basic mothering instincts. And I think this is true for good male teachers, as well. Somehow, we've all managed to tap into the best of those guiding principles and feelings and make the best use of them in our professions.

What do you think, up until this point, has been your biggest personal accomplishment?

Oh, gosh, that is really a hard question for me because even small things I tend to count as important. But, I think at this stage—and of course, I don't know what is yet to come—but I think that one of my biggest accomplishments has really been in the cultivation of an attitude which has allowed me to move back and forth between the artist and teacher, doing whatever job that I had to do in order to support myself at the time, and those have been many and varied. They have ranged from painting people's houses to waiting tables at IHOP to teaching university art courses.

I think one of the things that I count among the virtues of a skill set, being an artist, is being able to be tossed into whatever kind of situation and surviving. And I think that has a lot to do with a sense of discovery and exploration that I find to be inherent and essential in a fine life. A life that I think is worth living is one in which you take what comes and you work with it, just in the same way that you would approach a pile of collage material, a lump of clay or an unpainted canvas. You take it as it comes and you try to make the very, very best of it.

I think that in terms of achievements, the things that I am proudest of probably have been my successes in the classroom, whether they were in the very formal and academic sense at the State University of Minnesota, or currently with the adults that I teach in my community art education classes. Any time I see

someone laboring over their paintings or their sculptures or their projects and I see that gleam of recognition flash across them—you know, 'Aha, I'm making something and it's not that bad. I am loving this, and I could keep doing this forever.' And then I think, 'All right!'

Is there a way that you have evolved as a person over the course of your life that makes you the proudest, a way that you have changed?

I would say that in order to do the teaching that I have done, one of the things that I have had to cultivate in a great many ways has been an approach to people and an acceptance of people where there is not room for preconception or judgment. That is something that I think is essential if you are going to come to the process of teaching with any honesty at all. And so my attitude has been just to take people from wherever they are, whatever that place might be, and try to help them find or move toward whatever it is that they desire. And it is not always easy, because often-times we fight ourselves. We self-edit, we deny, we do whatever, to get away from the essential business of finding out who we are and what we ought to be doing with our lives. So, I think developing the non-judgmental has been a big thing. Because it is very easy to be judgmental in the world of the visual arts, or any form that has been put before society as being the desirable, the high culture, the best of the best, the most elite. It's hard being

trained in an academic environment that projects that kind of star system. It's hard to back away from that, or it was initially, and to say that everything that you learned about that elite society in college is essentially crap, you know, and that whatever people make, whatever form it takes, it is a gift. Whether it is a crazy quilt from the Plains Women, garments that they have woven and designed and constructed themselves, or whether it is baskets—Native American or traditional folkways of North Carolina—if it has been touched by the human spirit and by somebody's hands, to me it is art. I don't make distinctions between high art and low art, or fine art versus craft, because all of that...you just can't be involved with or know so many creative people and see the variety of things that are produced by creative hands and creative minds and think in a snobbish way about any of it. It's all a miracle to me. I mean if somebody has an idea and if they seek out the materials or they use the materials at hand and turn it into something that is either useful or delightful then it is a gift.

What do you think have been your greatest challenges, either personal or professional, at this point?

Probably the impulse to self-edit has been a very, very difficult thing for me. And I didn't realize that I had it with regards to my visual art until, several years ago, I began trying to write fiction. The minute I recognized in type, in boldface what are the

different ways that I will try to edit my own thoughts, or creative process, and what are the parameters that I feel bound by with regard to imagery or subject or issues? And I think that is a biggie. Just giving myself permission to go anywhere that my thought processes and my hands, hands in clay or hands in paint, lead me and not to be concerned about how other people may perceive it. I think this is an age-old dilemma that artists of any profession or any avenue struggle with. And that is, what we are taught is appropriate versus what is going to bring us the greatest satisfaction in terms of self-expression.

What led you to explore writing?

I think probably it was the really rich oral tradition from which I hail in West Texas. For one thing, the attitudes that people have there about difference, at least when I was growing up there, I found to be sort of refreshing. Somebody could be a total, total nutburger, and the people in my community would say, 'Well, that so and so is a real character.' And they would not belittle the person, but they would just take them for where they were. They allowed a space for that difference, which I thought was really great. Consequently, these people seemed to be in great abundance. At least, people felt somewhat freer for those eccentricities in their own personalities to be known or to be shown. And so I think that I have a wellspring of characters with which to

work. So much of how I define these characters has to do with dialogue and dialect and how they speak and what they do and how they choose to spend their free time, and so forth, that it seemed more appropriate that they come out that way, through writing, than through painting or through clay.

Did you find there to be significant differences in terms of the challenges you faced in writing, as compared to art?

Well, I would say that if I have a gift in the realm of writing, it is for hearing voices and recounting dialogue and creating stories around those things. My stories are definitely not complex in any sense of the word. I think they probably would be thought to be very simplistic and maybe even sophomoric, you know, by more experienced writers. But I definitely have an ear for the voice and for story and for dialogue that has come out in that way, in a narrative way, that it's not possible to bring out in a visual art form.

Was Andrea encouraging with her background in creative writing from Greensboro?

Interestingly enough, I had already made that exploration and had already written some nine or ten short stories and a small novel for the adolescent reader before we even got together and compared notes about writing. But it is a way in which I can

relate to her passionate interest, in the writing of her poetry. And it is kind of a creative bridge for us. She comes from a background that was very rich in visual arts. So, you know, it is a kind of natural bridge between them. But it is probably an area where I could learn a great deal more from her, and fortunately we have got many years to come.

What dreams do you have, personal or professional, that you would like to fulfill?

Well, let's see. I am not really glued to a career path at this point. I made a departure from that two years ago. The notion that it had to be an ever-escalating thing, that I had gone from teaching to being the department chairperson, to leaving that and starting a whole other professional interest, another career—that was in the Office of University Development at Duke, where I sought to learn as much as I could about fund-raising. At that point, my goal was just to continue moving into ever-more-responsible positions of leadership, hopefully in the art world, to lead or to direct an arts organization of some scope and size. And then, about two years ago, there came the opportunity for me to apply for such a position, and I did. And I was among two finalists for the position. But because, I believe, of differences in how I perceived the future of the organization and differences in how the other candidate perceived the future of the organization, she

won it and I did not. And that was the first position that I had actively sought and didn't get.

On the one hand it was a little bit devastating for me, because I thought, this is what I have been working toward, you know, up until now. And then, I began to think about other aspects of it, like if I were doing that work, would I have time in my life to create this nuclear family that involves small children, would I be allowed the time and the space to continue with my teaching and to continue with my art making and wherever that takes me, to indulge in the travel that I might want to do? And essentially I decided that the larger the position, the loftier the title, and the more complex and elevated the job, the greater the stress, the greater the headaches. The paycheck is big. But you are personally paying. You are paying from your health, you are paying from your creative energies.

So, I decided that shouldn't be my path for the future. That I should try to continue to teach, to do my own work, and to have a quiet or more enriched personal life that would include having children, parenting children. I couldn't visualize getting to the end of a high-powered career, and I thought I might have regrets. I really did. I began to see that there is a finite amount of time I have on this planet. And if I get out there to the far regions of that amount of time and look back, what is it that I am going to say that I regret that I didn't do?

It took about a year. But in the wake of that disappointment, I think I was able to finally to see what it is that I should be doing. I am not to the point yet that I say the search committee did me a favor by choosing the other person, but it has resulted in my taking a completely different path with my life which I am enjoying and which I feel is the path that I want to be on.

So in times of disappointment and strife, what do you fall back on to make yourself feel better?

Well, there is an inherent belief in self, I think, that's the bottom line. It is something that I wish everybody could have. I really do, because if everything else disappears, at least you still have yourself. And all of the things that you have learned how to do, all the places that you have been, all the people that you have known are still part of that essential self. I do think that I was fortunate in my upbringing that somehow, despite the isolation, despite the place or any of the obstacles or impressions that I encountered, essentially, I emerged with a feeling that I am worthy, and my ideas are worthy of expression, and I should just go for it.

Who do you think were your greatest inspirations along that path?

Well, as I mentioned earlier, even though he only was able to inspire consciously for seven years of my life, one would be my maternal grandfather. My maternal grandmother was very inspirational to me. Academically speaking, I could never say, 'Oh, you know, girls aren't supposed to study science,' or 'Girls are supposed to excel in this or that,' because my grandmother was the first woman to graduate in the sciences from what's now Oklahoma State University. She was a chemistry major, and when she taught school, she taught chemistry on all levels of junior high and high school. And then she coached their little women's basketball team at the same time. So, she was, I think, a huge example. My own parents, too, and, of course, art teachers along the way, who noted that I would be worthy of their extra time, and gladly gave it.

Teachers have been very, very important to me, and by that token, I think that in addition to the direction that they have given me through the years, they have also demonstrated to me how I might be a better teacher. When I think of my teaching, I think that it is an amalgam of all the best teaching I have had. And if a teacher disappointed me, then I wouldn't use that aspect of their methodology in my approach to my students.

In addition to that, just studying and reading and knowing about the lives of all the women artists that have gone before, I find to be extremely inspirational. And I think that is what kept me going through the development of the course that I taught in Women in the Visual Arts when I was at St. Cloud State. To me it

was just the greatest thrill, to be able to spend my days and evenings researching those women artists and then conveying as many aspects of their lives and accomplishments as I could to my own students. And among them would be some tremendous examples. I am thinking about one in particular that I know would be of interest to North Carolinians, and that is a woman named Selma Burke, who is from Mooresville, North Carolina, and was born in the early part of this century. Selma Burke started out in life as a young African American girl intent upon doing the best she could by her situation. Her choices were to go to school and study so she could teach in an all-black school setting, or to go study nursing so that she could be a nurse in a black hospital or clinic. The whole world was not open to this woman, really. But she decided that she would have better mobility and be able to keep her goals if she studied nursing. She became a nurse and she moved to New York City and took a job in nursing, and by night was able to go to art design school. Then later won an opportunity to study abroad where she studied sculpture. And then when she returned to the United States in the early forties, she learned of a competition that was being held for someone to sculpt a likeness of FDR. And she submitted her name and her credentials, and lo and behold, of all the applicants in the whole country, she won this competition to go and sculpt a portrait of FDR. When she learned of this opportunity, she didn't even have any art material

to take with her. She had to go and beg butcher paper from her local butcher. She took the train to Washington and was allowed three hours of time with the President to do this. While he was doing other things, she was stretched out sketching on the floor, I presume, in one of the offices in the White House. And it was her drawing, and ultimately her sculpture, of FDR that ended up being the image of him that is on the dime.

We don't know that; we wouldn't know that story by looking at the dime at all, because the initials that appear underneath it are "J.S.," representative of the name John Sinnock, the man who translated Selma Burke's drawing of FDR at the Mint. But that is just one example of an inspirational life story that I found with a little bit of digging. And that was hugely inspirational to me, to see the people who started out with so little and ended up enriching all of our lives so much.

Along those same lines, what qualities in people do you find to be most important, of the most value?

Well, the willingness to commit themselves to something—to an idea, a course of study. I am continuously amazed by people who get an idea which comes seemingly from out of nowhere, and they stick to it for years and years and years until their vision is realized. I think of the rich heritage of folk artists that we have in this country, people who have never had any formal art train-

ing. But one day they get an idea that they are going to weld together all this junk that is out in back of the barn and make whirligigs of monumental proportions. Or they get the idea that they are going to make a book that tells all the stories of the Bible. Wherever the idea comes, I think it has to be treated seriously, and to me the most inspiring people are those who allow themselves to have an idea and act upon it.

So if a young woman who was seeking initial direction, or an older woman who wanted a new direction for her life, came to you and asked for advice, what do you think you might say?

Well, I would try to find out from them what it is that they find most valuable in their daily business. What is it that makes them feel most alive? What is it that makes them want to get out of bed every day and go on? And even if it is something that is as basic as, 'Well, I want to get out of bed because I have got five children to take care of,' using that as a basis of measuring passion, what else brings you pleasure in this life in addition to those basic duties? If that's it, then I would encourage them highly to start a daycare facility, or their own pre-school program, or whatever. I think it is a matter of finding where the passion lies and then somehow helping to stoke that inner flame of self that people often don't have at their beck and call.

What do you think is the difference between people who have dreams but yet cannot seem to make them a reality and those who have dreams and, as you said, go out behind the barn, take the junk, and build a whirligig?

I think it all comes right back again to that issue of basic self esteem, because you can have all the ideas in the world, but if you don't think them worthy of implementation, if you have the notion that, 'Oh, this is my idea, so it must not be any good,' or if you alternatively have the idea that '100,000 people have this same idea, and who do I think I am, thinking I could make it work?'— those kinds of defeatist attitudes leave the ideas right where they were found. And it would be left to someone else to do the work, or to make the invention, or to create the artwork, or to make a difference in somebody else's life. But it all comes down to a belief in self. And gosh, if it was something that could be bottled, if it was something that could be slipped into cafeteria food, I would be the first one there mixing it in. Because to me it is the essential ingredient in getting anything done.

Interviewed by Emily A. Colin.

Ocean Vessel Series #1
Stoneware fired to Cone 5 and airbrushed
acrylics. Approx. 5" h. x 7" diam.
Ocean Vessel Series #3
Stoneware fired to Cone 5 and airbrushed
acrylics. Approx. 3.5" h. x 5.5" diam.

Andrea Selch, 1998

Anita *Mills*

Anita Mills was born in Lubbock, Texas, in 1952. She attended public school in Lubbock through her undergraduate degree, earning a B.F.A. in ceramics and printmaking from Texas Tech University. After completing her M.F.A. in studio art and art history from the University of Texas at Austin in 1977, she took a teaching position at St. Cloud State University in Minnesota.

During her twelve years at St. Cloud, she taught all levels of design, drawing, painting, printmaking, and the theory of art. For eight years she taught a two-term course entitled, "Women in the Visual Arts: An Historical Survey of Women's Contributions," wherein she and her students discovered and researched women artmakers from medieval times to the avant garde.

Currently, Anita is an itinerant art teacher and full-time artist. She teaches adults and young adults through courses offered in community education settings, now preferring to teach "non-traditional" students outside of the strictures of academe. Through-

out her career as an artist, she has exhibited her work in numerous solo and group exhibitions—both competitive and invitational, in regional and national venues.

Anita has lived in central North Carolina since 1989 and thinks of it as home. In stark contrast to the region of her birth, she finds North Carolina "has it all"—multiple climates and natural beauty—a mere three hours west to the mountains or east to the ocean. And as her good luck would have it, she's encountered just as many "real characters" here as in any place in Texas.

The Ocean Vessels are an on-going series of clay sculptures (some 40 in number now) which have been inspired by the sea life I have observed while kayaking the coastal waters of North Carolina.

Though I do not seek to make anatomical replicas of actual sea creatures, I have taken ideas about form, animation, texture, and color from them. The result for me is that I have gained a greater understanding of that biological strata—not a strictly textbook understanding. French educator and philosopher Henri Poincare said, "Through science we are able to prove, but through intuition we discover." I guess I am more interested in discovery than in proof.

Ocean Vessel Series #2
Stoneware fired to Cone 5 and airbrushed acrylics.
Approx. 4.5" h. x 6.5" diam.

Leslie Speidel an interview

Where did you grow up and go to school?

Miami Beach, Florida—South Beach, as it's known today. And I went to the University of Florida.

What career dreams did you have as a child?

Oh, gosh. Since the time I was in junior high, it was about advertising and publishing, but mostly advertising, all the way back. And, before that, I wanted to show horses at Madison Square Garden, so go figure! (*Laughs.*)

When you thought about a career in advertising as a child, what did that look like to you?

The only thing I knew back then was ads in the paper and ads in magazines. I didn't know what it looked like. I had no way of knowing. I don't know, it's kinda weird. It didn't look like anything to me other than what I thought I wanted to always do—be some Madison-Avenue type. Then, when I got out of college and interviewed with some of the big agencies up in the North, back then it was so funny—if you were female, they sent you to interview with the secretarial department; if you were male, you got to

interview with the A-E department. And so, finally, I fought my way through at one agency in Pittsburgh and, I mean, it was just so segregated. Women did this in advertising and men worked the accounts, and that was it.

Tell me about the path you've taken.

Well, for the last eighteen years, I've had an advertising agency, specializing in broadcast advertising—radio and television. My clients are all retail/consumer-type clients, although in the last couple years, I've gone into the 'dot.com' industry. I place their media, I get their production done, copy-write, creative services, that kind of thing. That's what has been my bread and butter for eighteen years.

Then about three years ago, before the web got to be really kickass like it is now, I developed both Small Business University and The Marketing Coach. I got this telephone line that holds 150 people on it at one time and I started giving marketing seminars, conferences, and training to entrepreneurs from all over the world. I've had clients from as far away as Australia and Japan, lots of Europe. And that's been a lot of fun. It's kind of taken me out of my North Carolina world and allowed me to see how business works around the globe. And, aside from being lucrative, I can pretty much go anywhere in the world right now and know somebody. It's been pretty exciting.

Let's see, from there, I started doing some research for a firm out in Silicon Valley and got kind of addicted to metrics and statistics and started being a research junkie for wanting to know what's what. (*Laughs.*) My background besides advertising is sociology, so that all fits with metrics. From there, I signed on at Duke to do Continuing Ed for 'e-commerce,' in the meantime still keeping my regular business. And I've done a lot of writing for magazines, both trade and executive newsletters—writing for them in marketing and advertising.

What made you decide to start your own agency?

It's really kind of a fluke. My first husband was in retail—he had some furniture stores and, basically, I did the advertising for the stores, which gave me, from the client's side, a perspective of buying the media, making decisions, doing promotions, that sort of thing. Then when we came down here to North Carolina, I just was at a party. It was my first week here—eighteen, nineteen years ago. I was listening to some people speaking at this cocktail party, and the fellow said to another fellow, 'I just fired my agency.' And I just kinda swooped in and said, 'What did they do for you?' He said, 'Well, not a lot. They just bought my media.' They were out of Arizona or something. And I said, 'Really?' And then I said, 'How much do you spend every month?'—I had to know that! And he told me, and I multiplied that by fifteen percent real

quick, and I just said, 'I can do it.' And he said, 'You can?' And I said, 'Yeah, I can do it,' and I gave him my background. And he said, 'Fine. Come by my office and you can start placing it immediately.' And I said, 'Well, I just moved here. I have no media credit. I know nothing.' So, would you believe, he wrote me a check for three months—ninety days' worth of media in advance! Because that's what they wanted when you were starting an agency, to have the money in advance. And I still have that client to this day. Isn't that wild!?

That is wild. What have been your greatest challenges along the way?

The changes in the media climate. In the beginning, the media representatives and the radio and T.V. stations were all your friends and they were on the same team and, you know, everybody was helping each other. Our competition had always been other agencies and other media buyers. Then things changed on the media side and the station management paid more for direct business. And all of a sudden, the competition now includes the stations themselves because of the pay structure for their employees. They pay the salespeople more to take a client off the street and work them directly and eliminate the agency, whereas they used to welcome the agency because the agency served a vital function— they got things in on time, they were responsible for their invoice payment for the client, they worked the client so that the station

didn't have to allocate employee resources to develop clients. But, with the stations began playing keepaway more often, it was harder to get clients. That was a challenge, and it still is a challenge.

The other challenges have been the outrageous costs of media that have gone so much higher than clients' budgets. And my latest challenges have been, over the last twenty-four months, keeping up and keeping ahead of my clients so that I can lead them into the 'e-commerce' side of things—so that they don't turn to anyone else.

How difficult has it been for you to adapt to the new technology?

Oh, lordy. It's been less than four years ago that I brought home a computer. And it sat here for two weeks—didn't even want to turn it on. Took it back, thinking I never had any use for it. My husband yelled, 'Go get that thing! You'll find a use.' So I went back and re-bought it (*laughs*), dragged it back home, sat here again. The first thing I did with it, since I didn't know what to do, was I e-mailed something to the President. (*Laughs.*) I didn't have anybody on e-mail that I even knew. So that's what I did, to complain about—oh, this is terrible!— to complain about the talk-shows on T.V., that I was just livid with what went on there. And, anyway, he got the FCC on me. (*Laughs.*) Thought I was a nut!

Are you not allowed to express your views?

Apparently not to the White House. (*Laughs.*) So anyway, it just sat here for a long time. I mean, I really had no application for it, but I hired a private tutor and she came three days a week and we played games! That's all we did. She taught me how to play games because that, at least, got my fingers going—learned how to work everything. And, I don't know, I just kind of took to it like a duck to water from there.

And now a great deal of your business revolves around computers?

Everything. Everything's on-line. I just came back from the technology show over at the McKimmons Center and, oh, the things people know!

Tell me about your family.

Well, I have a husband of thirteen years. And three dogs, one cat. No children. It never seemed like the right time. And when it was the right time, we were too tired. (*Laughs.*)

How have you balanced personal life and career?

I've always balanced it because I've been one of the fortunate people to have a home office.

You've always had a home office?

Well, in the beginning, I didn't. I had a fancy office and I had a number of employees and lots of overhead. But I was in between husbands at the time, so no one noticed that I was always there. And I really needed that time to ramp up the business. Then one day I saw how much money I was losing—I mean, tremendous amount of money—and I didn't know what to do. So I called my core clients and I said, 'Look, do you mind if I just not operate like this anymore?' And they said 'No. No problem.' So I started operating with subcontractors instead of actual employees on the payroll. I have regular subs that I have used for many years—a guy that writes jingles, a person that does graphics, a copywriter, a producer. I've used the same producer for ten, twelve years.

You had a home office when a home office wasn't cool!

Isn't that something!? And my mother did before me. I was so embarrassed growing up, because my mother worked a business at our house. First of all, mothers didn't work then, let alone at the house!

What year did you first have a home office?
'81.

Way before the trend!

Yeah, that's when it was embarrassing. That's when you had you to lie and pretend so that people didn't know. That's when city zoning had a fit. That's when you couldn't get a business phone in your house. It was a very different time. And there wasn't any decent office furniture. (*Laughs.*)

What are some ways you relax?

I read everything and anything, from trashy fiction to business and philosophy. Every other magazine in the world is on my coffee table—everything from *In Style* to *Wired*. When I go to the newsstand, it's so funny to see the eclectic batch of magazines I pick up.

I'm sure you're a source of wonder for the cashiers!

Oh, yeah. They'll see *Vogue* followed by *Sporting News* followed by, you know, *Fortune*!

What are some personal interests you're pursuing?

I wish I could answer that. We've had a lot of changes in priorities in the last twelve months. My husband and I owned several pieces of rental real estate thinking that that would be a really good thing to invest in, and we've just sold all of it, so we're kind of redirecting what we care about for retirement at some point. You have to start early these days. So personal interests,

what does that cover? (*With mock panic.*) I don't have any! (*Laughs.*)

(*Seriously.*) The SPCA (Society for the Prevention of Cruelty to Animals) as a board member. We're hoping to raise enough money this year to begin construction on a new facility—a state-of-the-art SPCA—because it's just so shameful here. So that's what I do for community work, serving on the board and several of their committees.

What are some of your favorite things?

Culture. Pop culture. It goes back to the sociology and the advertising and all of that. Just what culture's doing. I'm a real trend watcher, a futurist. I like to know everything first. (*Laughs.*)

The Faith Popcorn of Raleigh, huh!

Exactly. (*Laughs.*) Exactly. Yes, she is my idol.

What about your own personal favorites, though, aside from anything work-related?

Food would be chocolate mousse. Favorite movies that I have watched over and over again—there are several. There was 'The Big Chill,' 'The Usual Suspects,' just film noir—I love that stuff. 'Body Heat' was one I watched a zillion times. Books—I wish I had a favorite book, I've read so many.

Favorite author?

I have a couple—Nelson de Mille, Sue Grafton. And Salman Rushdie—I'm in the middle of one of his books now.

Since you position spots in television shows for a living, any of those you just can't miss?

I can't miss 'Ally McBeal' and I can't miss 'Friends' and 'The Sopranos.'

What personal qualities do you consider to be of most value in life?

Truthfulness. Just being factual. I have a real thing about credibility. I've found over the years through trial and error that, in choosing between being the tortoise or the hare, being the tortoise is the way to go.

How so?

In our world, there's been such big money made so easily—and made and lost, made and lost. And it's really turned people around and just put a lot of big houses out there and cars and just things. If you're the tortoise, you tend to appreciate what you get as you go along. You work for it. You have goals. You get where you're going, but there's something a little more solid about it.

What is the one way that you have evolved as a human being that makes

you proudest?

What I just said, I think. Being the tortoise versus the hare. I see so many people around me with 'dot.com' riches and 'IPO' money and going from zero to a hundred million in twenty-four hours and then losing it as quickly as they get it. And knowing that what we've built is solid and enduring and the slower you go up, the slower you fall. That's something I've always kept in mind.

What qualities do you possess that make your career choice a natural for you?

I am a very good salesperson, I am a chameleon in my ability to relate to all kinds of people, and I have a huge frame of reference so that I can talk on most subjects.

On the other hand, what qualities of yours create conflict or struggle that you constantly work to overcome as pertains to your choice in career?

I'm too strong of a personality and people are put off by that. I tend to voice my opinion when it's not requested. I seem to just throw stuff out there.

Is there any childhood event or recollection that foreshadowed that you would enter this career field someday?

My mother has always been in sales, operating a business out of the home in women's clothing and accessories. And my earliest memory is her teaching me to play 'store,' where she would take all of my toys and put them on an ironing board. And then she had this fabulous silver cash register which I still have. And she would put a bunch of pennies in my hand and have me buy all my toys and she would be the proprietor. So that's my earliest childhood exposure. (*Laughs.*) And going with my mother to the merchandise mart and watching her sell and watching her deal with clients.

In times of disappointment or strife—or even just a really bad day—what are your sources of inspiration or renewal?

I take to my bed. (*Laughs.*) First day I taught at Duke, I came home and it was a snow day and my husband was home, because his landscaping firm—you can't work in the snow. And I just started screaming, 'I'm not going back!' I went up and got in my pajamas and didn't get out of bed all day. Yeah, I'm real good at overcoming strife! (*Laughs.*)

(*Seriously.*) Actually, I am one of the most optimistic people anyone will meet because every day I'm sure is the day for something good to happen. I have been blind-sided many times and I've had terrible days many times and then the next day's another day and you never know what can happen. When you're self-employed, anything is possible.

Leslie Speidel

What aspect of your career brings you the most joy?

I'm really starting to like this teaching. It's turned me into a chronicler and an observer and I kinda like that stuff. The other thing I enjoy is the actual physical media buying. I tend to do well with data and numbers, and that is just very cut-and-dried work. My least favorite is sales, even though I'm good at it.

Why is sales your least favorite?

I don't know why. I've always had this aversion to sales.

Is it fear of rejection at all?

Probably.

But, as far as teaching, you went from not liking it so much to actually loving it?

Yeah. They kept telling me over there at Continuing Ed, 'Don't worry, it'll get easier.' And it did. And next thing I know, I really liked my people and they became like a little family. So, you know, I just took to it. (*Laughs.*)

What made it difficult in the beginning?

Well, first it was, 'Oh my gosh, what do I look like? What am I wearing? What about my hair?' You know, all the physical pieces of it, because they're looking at you. They're not looking at any-thing else—it's just you. And then came, 'Uh-oh, what if I'm making stuff up? What if they catch me? What if they ask me things I don't know? What if I'm boring? Oh, this is gonna be terrible.' And you go through that. Then, after awhile, you kind of get your sea legs and it changes. You know, it took me three weeks before I even stepped out from behind the podium. That's how scared I was. (*Laughs.*)

What kinds of things do you teach?

It depends on the sophistication of the group. This last group that I had was really sophisticated in 'e-commerce.' They knew what they were doing. So it turns out I didn't have to deal with any basics. I could not follow my curriculum because everyone there knew all there was to know. What they were interested in was marketing and customer acquisition and customer service. I'm fully prepared to start from 'A' and go to 'Z,' but with this past group, I started at 'Y' and went to 'Z.'

Of what professional accomplishment are you most proud?

The marketing teleconferences to entrepreneurs from all over the world because I learned the most. Talking and relating to people from all over the world made me feel bigger than myself and bigger than my street and my town, and it was just such a good feeling.

135

And of what personal accomplishment are you most proud?

Having a wonderful marriage. Learning about loyalty and trust and unconditional love and needing someone as much as they need me. Just the feeling of relief and being settled and knowing how things are.

What advice would you give young women just starting out in a career?

The opportunities to get money from lending sources, from the SBA (Small Business Administration)—even from credit card organizations like Wells Fargo and American Express—are so much greater than they ever were in the past. If a woman has a good idea and she's young and starting out, she should take this time to roll the dice and go for it.

And have a mentor. A lot of young people don't necessarily want to hang around someone twice their age. The ones that do will find that the experience will be so much richer in the things that they will learn and the mistakes that they will not make.

Did you have a mentor?
No.

That's why you know it's important.
Yeah, I did hard knocks.

What advice would you give older women considering a career change?

Well, there are other opportunities now for older women, because the labor market is so tight and because there are so many jobs out there—in service, retail, food service, technology. The businesses are understanding that they have to learn to keep employees on and to hire people that are a little older than they ever would've imagined in the past. There used to be a time when, if you were forty, that was it. You couldn't get another good job—you were done. You had to be where you were gonna be or forget it. Now they understand that the older the person, the harder the worker, the more loyalty, the fewer absences, the more they appreciate being there. They're just better employees. So the opportunity is there for all generations now.

What's your advice for someone forty-plus who wants to change careers?

Educate themselves for where they want to go and what they want to change to. Read all they can read, learn all they can learn—take some classes. Get their brain functioning and more active in the particular field that they're looking at. They may find they don't like it or don't want it. But do it before they leave their present job.

What dreams do you have that are yet to be realized, either personal or professional?

Want a big house. (*Laughs.*)

(*Seriously.*) I still want to be known for something. I don't know what that means. I just know that I still feel like I have to—and need to—have a contribution that will be known. And I don't know where that is.

Can you imagine yourself doing anything else in the future?

Well, it seems that every year I learn something new. This year, I'm learning how to teach. Last year, I learned how to research and write. The previous year, I learned how to become computer-literate. Every year, I add a new skill to my war chest. So I keep evolving. And I see no reason why I can't just continue to keep evolving.

Interviewed by Susan L. Comer.

"I've found over the years through trial and error that, in choosing between being the tortoise or the hare, being the tortoise is the way to go."

Leslie Speidel

Leslie *Speidel*

Leslie Speidel is a graduate of the University of Florida College of Journalism, with a B.S. in advertising. She did her graduate studies in sociology.

In 1981, Leslie founded and began serving as CEO of The Speidel Group, Inc., a media planning and placement firm specializing in broadcast media and creative services. The company has earned a forward-thinking reputation among consumer-oriented businesses in the fields of health care, retailing, franchising and shopping center advertising.

Leslie has been featured in several national publications, in-cluding *Home Office Computing*, *Entrepreneurs Working From Home* and *Home Furnishing Executives*. Her articles on advertising and marketing have appeared in trade journals and newspapers throughout the country, and appear monthly in the only business publication in the Soviet Union. America Online has featured Leslie as their marketing coach in the very popular *Business Strategies Forum*. Her online sites, TheMarketingCoach.com and SmallBusinessU.com, have been cited in Yahoo Magazine as HotSpots! Her booklet, *Successful Marketing: 78 Powerful Tips, Tool & Techniques* has been praised by *Bottomline Business*, *Office World*, and *Business '98*, to name a few. In 1997, Leslie founded Small Business University, a web-based virtual training center for business owners and entrepreneurs around the world. Her students attend teleconference marketing seminars and classes offered by the leading marketing experts in their fields.

Leslie is a member of the Board of Directors for the Wake County SPCA and a Duke University Continuing Education instructor.

Estell Lee an interview

Where did you grow up?

I grew up in Loris, South Carolina as a farm girl. We had a forty-three-acre farm and raised tobacco which is a no-no now...and cotton and corn and all of our own livestock. Living on a very small farm was trying, to say the least.

Were you working on the farm, too?

Yes. In the spring and summertime especially—because all of us worked in the fields and worked at the tobacco barns and worked getting the tobacco ready for market. Back then they didn't just pile it in sheets like you do nowadays and sell it. But it was an interesting life. I thought it was very boring because my main weekend recreation was walking up and down the railroad tracks on the rails. We lived in a very sandy area, so bicycles were out. We didn't have a paved road nearby.

How long did you live on the farm?

Until I was eighteen. Then I came to Wilmington to attend Wilmington College.

And what did you study while you were there?

Business. I have an associate's degree in business administration and, instead of going on to another college, I went to work right after school. I went to the Corps of Engineers and then went to Sunny Point Army Terminal as a secretary in the Operations Division and there...I worked for five years.

When you were younger, what did you dream of doing?

My one dream was to get away from the farm and be a schoolteacher. Why I didn't pursue that dream, I don't know. I guess leaving the farm and coming to the big city—Wilmington wasn't really that big back then, but to me it was—I decided I would go into the business world rather than go into teaching.

And so, what was your path after you got your degree?

OK. I went to work for the Corps of Engineers, as I said a few minutes ago, and then to Sunny Point Army Terminal which is at Southport. After three years I was married. My daughter was born in 1960, and the travel from Wilmington to Sunny Point and back took so long, I decided to try for a job in Wilmington. So, I went to a couple of water-related operations, because I knew the shipping industry from having worked at Sunny Point, which

is a military ocean loading and discharging facility. Got a job with a company that was a steamship agent, stevedore, and customs broker. My job at the time was working with a customs broker, so I worked with her about six months, then got my license. She left the company and I took her job. This all transpired over a period of five years. After she left and I took her job, I had about four people working with me entering goods through U.S. Customs, clearing them, and shipping them to their final destination. The owners sold the major portion of the business—which was the general cargo portion—in 1968 or 1969, and I stayed with the company to handle the bulk cargoes. The bulk cargoes are fertilizers, salt, ores...that kind of commodity which are unloaded from ships with a graft discharge, loaded onto land or into houses, then shipped back out into rail cars, barges, trucks...whatever.

In 1972, I was made vice president of the company. Then through a series of changes in 1980, I bought the company and at that time we had about one hundred employees. We still were handling bulk cargoes only through our own facility. In 1990, I sold the company and tried to retire. But in '91 I went to work with Governor Jim Martin as Secretary of Commerce. I was the first female secretary of commerce for the state of North Carolina. Did that for two years, until the end of his administration. And that's the story of my life. *Except,* in all these past twenty

years I've been on every board imaginable. Done a little bit of everything. I was the token for a long time. But in the past fifteen years, more women have become involved in business and we're no longer tokens. Isn't that wonderful?

Did you see yourself as a trailblazer at the time?

At the time, no. I just did what I needed to do to get the job done. There were times when I felt isolated because I could not belong to the Rotary, couldn't belong, of course, to the Cape Fear Men's Club—because they had the networking ability, but I didn't. But, even so, in my particular industry, I was the only female who was president of a shipping company. So, belonging to an association of shipping companies was me and sixty men. It was wonderful. They understood what I was about and what I needed, so they were actually my network. Even though they weren't here. They were all over the U.S. But they were my...would you say mentors? I don't think that word is proper. They were my networking crew.

How did your husband feel about you getting higher and higher up in the company and buying it?

We divorced in 1980.

Did you feel that it was really hard for you to juggle your career and your

personal life simultaneously?

No, I didn't feel it was. I don't think the children suffered from that, because I tried very hard to give them quality time. Maybe the quantity was not there, but I felt, certainly, the quality was. And they will tell you today that they have no regrets. They're happy that I worked...maybe I was not quite hard enough on them or something (*laughs*). But we got along extremely well. Their father and I just had a difficult time. It's hard to say exactly why but...we're still friends.

Which is the important thing.
Yeah.

How many children did you have?

I have two children. My daughter lives here and she has two children. My son lives in Florida. He's married but has no children.

Has your daughter told you that you've been a real important role model for her in terms of what she's done?

Absolutely. She keeps asking, 'Mom, how did you do it?' and saying, 'Mom, I wish I could be more like you.'

And what do you tell her when she says that? Do you have an answer to how you did it?

No. It was no big feat because along the way I did things that were necessary to enhance my job, to be a good housekeeper, a good mother, a good wife...there's just a balancing act and you just do it.

Did you find that it was difficult for you to relate to other women in your place and time who weren't working? Who perhaps couldn't identify with you working and succeeding?

No, because of my friends...most of them worked. My family, most of them did not work—my sisters and my in-laws—and I really had no problem with that. I suppose it's because I grew up so very poor and with a loving family. My parents were absolutely marvelous. We didn't have money or the niceties of life but we had the necessities.

What do you think have been your biggest challenges?

I suppose the very biggest challenge was having or getting to the point that the business community in this area, in this town, accepted me as a businessperson and not just a secretary or as a non-entity. It took many, many years. I don't know if you've heard the adage here...that it takes three to seven generations before you're a real Wilmingtonian. You know? (*Laughs.*) It isn't the number of years you've been here, but the number of genera-

tions. But that is no longer true. That was true when I came here in '53. An outsider was just that...an outsider, because it was the core Wilmington. Never in my wildest dreams did I think that I would end up owning and chairing a shipping company. That was just not my dream. I always wanted to be a teacher.

You're constantly surprised that this somehow happened to you?

Yeah. (*Laughs.*) It's just the total opposite of teaching. The shipping industry is such a different industry as compared to teaching or writing or publishing or...whatever, because it is normally a male-dominated industry. Because of the longshore—working with the longshore and the contracts and all of that kind of operation. But it's really exciting.

What did you like the best about it?

The best was getting to know the customer. We had customers from Israel, France, Germany, Holland...just from all over the world. I did have the opportunity to do some traveling—Mexico. Getting to know some of those people was really a treat for me.

What do you do now to relax? Just for you?

Oh, just for me. I love needlework. I have been an avid reader up until recently, and my eyes have said 'Hold on, wait a minute.' But I do like reading and community work. I am on, as I told you earlier, many boards and commissions and so that takes a lot of time. Reading that data, being up to date on what's happening, and networking with others in the area and across the state. So, I've been very active across the state, too, on boards such as Carolina Power and Light, Wachovia, NC FREE, NCCBI, and on and on...

What do you see as your greatest personal accomplishment?

My children. What did you expect me to say? I suppose my children because I am proud of them and happy that they're well and well-adjusted. And too, I'm proud that I've been able to give back to this community financially and of my services because I credit the community with my success.

What's the one way that you've evolved as a person that makes you the proudest?

I suppose it's my ability to meet and endear myself to people and to have people know that when I tell them something that's the way it is. Trust is a mighty function of any individual, any corporation, or any effort. Once you win the trust of an associate, friend, business associate...whatever...you've come a long way. Most people will tell you, if Estell said it, it was, to the best of her knowledge, true.

What other personal qualities do you hold in the highest regard?

My ability to work with people and to allow others to have input and to give them credit for it. I have no ego. It's very difficult to talk about myself. But I think that's an attribute that has helped me because I don't need the credit for anything.

If you had to name a few, what personal qualities enabled you to get to where you are today?

My ability to work hard and to work smart. My being goal-oriented. My belief in God, family...and in myself...and my desire to share with others.

Looking back, is there anything you would do differently if you had it to do again?

We all would do something differently. (*Laughs.*) I would probably not have sold the company in 1990. Prior to that, yes, I would have finished my college education. Maybe I would have spent more time during those years—the years prior to my retirement—for myself rather than giving so much.

If a young woman, or an older woman who was perhaps seeking a different direction, came to you wanting advice, what do you think you might say?

I would say, 'Take a look around you and find an area of need or a niche you believe you can fill and go for it.' There is, in today's world, no opportunity that's closed to women. You can be anything or anyone you want to be, so go for whatever makes you happy and work towards a goal. Set yourself a goal—I want to be here—and go for it.

Do you have dreams now—personal or professional—that are still unfulfilled? Something you want to shoot for?

No. (*Laughs.*)

You've done it all?

No, I haven't done it all. If I could turn the clock back ten years I would probably run for some elected office. But one of my favorite sayings is, 'Been there, done that, got the T-shirt.' So, I don't have any particular goal except to maybe help somebody else in their quest for a better life. Whether it's family, friend, acquaintance—and to make a difference in that way.

How did you come to have a street named after you? That's what I want to know.

(*Laughing.*) Well, it's not really a street. It's an alley. It's an alley.

OK, how did you come to have an alley named after you?

In '90 when we sold the business I gave the Chamber of Com-

merce some property and also gave the city some property. Well, when I say I gave the city—the city had about a tenth of an acre of property that I wanted that was adjacent to some other, so...the actual deal was, I swapped them about three acres for a tenth of an acre. So actually, we gave the city and the Chamber of Commerce property.

Is that strange for you?

It's weird. When I see it written—the Chamber, 1 Estell Lee Place—I'm like, 'Nawww...' (*Laughs.*) See, I didn't know the Chamber was going to do that—it just blew my mind away.

Interviewed by Emily A. Colin.

"I was the token for a long time. But in the past fifteen years, more women have become involved in business and we're no longer tokens. Isn't that wonderful?"

Estell Lee

Estell **Lee**

Estell Carter Lee was born in Loris, South Carolina. She has an AA in business administration from Wilmington College and served as president of Almont Shipping Company from 1960 to 1991. In 1991, she was named Secretary of the North Carolina Department of Commerce, a position she held until 1993. An active member of the business community, Ms. Lee serves on the boards of several companies, including Carolina Power & Light Company, Kate B. Reynolds Foundation, NC FREE, and NCCB. Estell was the first female chair of the Cape Fear United Way. She was also the first female president of the Greater Wilmington Chamber of Commerce and the first woman to serve on the Board of the YMCA.

She is a member of the First Baptist Church of Wilmington and currently lives in Wilmington. She has two children, Rhonda Lee Ottaway and Glenn A. Lee, and two grandchildren, Alyssa and Garrett Ottaway.

Rebecca Anderson an interview

Where did you grow up and where did you go to school?

I'm an eighth-generation mountaineer, born in Haywood County, grew up in Canton under Smokestack Four of Champion Paper. And went to high school there in Canton and then to Salem College and graduated from Western Carolina University. Did a little bit of post-graduate work at UNC-Asheville.

What career dreams did you have as a child?

Oh, that was very easy. Every person in my family had been a teacher for almost seven generations, so it never entered my mind that I would be anything else *but* a teacher. My mother and father were teachers, my brother is the poet laureate—and teacher—of North Carolina.

Fred Chappell is your brother? I didn't know that.

Yep! See, that's what everybody says when I tell 'em that. They go, 'Oh, God!' (*Laughs.*) But you can see now, I grew up in a household totally devoted to education. You know, all his books are about my father as this premiere teacher. And he *was*! In fact, teaching's what I majored in in college and graduated with a de-gree at Salem, which, by the way, was just named one of the three best schools for teachers in North Carolina—I thought that was great! I started out thinking I would teach high school history, English, whatever, and ended up teaching, interestingly enough, in Griffin, Georgia. I was a civil rights worker for awhile after college and taught in the all-black school system there.

After the birth of my children, I didn't teach for awhile. Then went back and started teaching first grade. So I fulfilled that dream—then got into everything *but* teaching! But teaching has always been there. And I guess if I ever wanted to do something again, I wouldn't mind going back and teaching the first grade again. That would be fun.

But when the first federal daycare programs for North Carolina came to being, sponsored by the Appalachian Regional Commission here in the west, I blithely decided I would direct the daycare program at the place I was going to church. Ended up that they hired me to be the director of the entire program. So the first job I had was to put fourteen daycare centers and homes together and run the first federal daycare program here, which I did for about five years. During that little process, I learned how to write grants, because that's what we had to do to keep our money flowing.

And I left there and went to the Land-of-Sky Regional Council, a council of governments here in the west, to be their grant

writer. Got a great education in water and sewer lines and turned out to be their community development director, learning how to do housing and public infrastructure and farmers' markets and hospitals and medical clinics and libraries—just all of those things that build a community. So I did that for about five years.

Then the City of Asheville hired me to be their downtown development director. They were beginning to start the revitalization of downtown Asheville in the early eighties. Then they merged that division with the Asheville Chamber of Commerce, and I ended up being their business director and later became their director of economic development for twelve years—industrial recruiting and those kinds of things. And at the end of that, I became convinced that we had to have different kinds of economies in our region—that we couldn't always depend on 'that big industry from somewhere else' coming in here to give us a job—and joined up with a group of folks and founded HandMade in America, which is what I do now.

Tell me about that.

Well, HandMade in America is an economic development approach to the arts—of using them to build community and to really build an economy around them, a sectorial economy. So we took the idea of the history and heritage—did a major plan for a year, with about 400 people in the region. We serve twenty-three counties here in the west. Put together our plan—and we have a twenty-year plan. (*Laughs.*) How's that for looking ahead! After being in it six years, I think we need a *forty*-year plan! But anyway, we did an economic impact study to make sure we were pretty on-target, and we found out that the handmade industry here in our western mountain region is about $122 million a year, which is very substantial—more than burley tobacco, half the total manufacturing wages of the region. So we took that bit of work and developed the first heritage tourism program of a craft trail throughout our region that's now been picked up by the State of North Carolina.

We started revitalizing the main streets of small towns in the region around their heritage and history—we're now working in eleven—will soon be twelve—towns. It's a version of the Main Street program that goes in very small communities. I have towns with ninety-seven citizens in them—that's how big my communities are. West Jefferson has twelve-hundred people, and that's the largest community we work in. So we take the Main Street program, but *really* gerrymander it down.

And then we discovered we were working in towns that had no town managers, no professional town management. So we partnered with the Institute of Government and we have a training program for citizens where we train them to become town managers of their own towns. They do a lot of project manage-

ment stuff and so forth—capacity-building. Out of that has emanated a program of greenways and creekwalks in each town—we always have those. We do a lot of environmental stuff. We've partnered with the North Carolina Arboretum here in Asheville to develop, for craftspeople, a series of gardens that they can grow themselves for their own raw material resources. We have paper-making gardens, basket-making gardens, broom-making gardens, and natural-dye gardens. That's because our craft community was beginning to buy a lot of their materials from overseas.

We have a training program going on in Graham County, along with the American Woolgrowers Association, where we're training women to weave table linens and coverlets for the homes—traditional patterns, but using organic cottons and blended wools. So it's a great combination of high-tech and low-tech all the time! (*Laughs.*)

Then we have also formed a kind of subsidiary called Energy Exchange where we have partnered with the soil and water districts and the resource conservation districts here in the west to take old abandoned landfills and build economies around them. Our first one is in Yancey County, where we're currently constructing a campus for business incubators for craftspeople. We have a glass incubator, a pottery incubator, a traditional business incubator, and four greenhouses for medicinal plants—horticultural native plant materials—and all of that's being fired by the methane from the landfill. And we're getting ready to move on and do another in Avery County, and we have two feasibility studies underway in Wilkes and Alleghany counties.

We have a component where we have partnered with the Self-Help Credit Union for the development of a bank for access to capital for the craft community. We're currently working on a self-insured program. We do workshops and seminars on business and business practices and marketing.

We have an educational component where we're working in the public school system in the 'A+' schools of the region to develop a curriculum around craft—we use it to teach math and science and language arts in the classrooms.

Next month, we are installing a permanent gateway exhibit at the Asheville airport to welcome visitors to the region as 'The Center of the Handmade Object.' And we are partnering on that display with the Southern Highland Guild and the Arboretum.

And let's see, what did we work on today? We're trying to put a series together for 'Home and Garden Television,' trying to show how crafts can be used for interior design or architectural craft or garden art—we're just playing around with that, but they're getting kind of interested, I think.

We're developing a second guidebook for Travel and Tourism called *The Garden and Countryside Trails of the Blue Ridge*, where we will take visitors into private farms, private gardens, public gardens,

farmers' markets, the whole works.

We're getting ready to jointly work with the North Carolina Department of Cultural Resources in developing and getting recognition from Congress as a National Cultural Heritage Area here in the Blue Ridge.

We have an arm of HandMade—every staff member must earn a third of their own income—where we do bulk mailing services, manage other nonprofits, and do speaking and consulting on small-town revitalization and heritage and agri-tourism.

It sounds as though you need lots of variety in your work.

Absolutely. I have more curiosity than God ought to allow any day, anywhere! I am innately curious about everything and that is my problem! (*Laughs.*) And I'm a readaholic. I can't resist reading everything that's laying around. So, you know, you just get ideas. I really, really, really like working in communities— rural communities and small communities. I am firmly convinced every community has the answer to its problems and I never have been disappointed yet by a group of citizens that didn't come up with something pretty original and pretty practical.

Obviously you've had some challenges along the way.

Oh yes!

Such as?

Always being the first and only woman in most projects. When I went to work doing the water and sewer programs for the region, I was the only woman out there. I had to learn how to be an engineer! I literally learned how much water pressure it takes to run from a tank, how much pressure factories take to meet their factory standards for insurance purposes—I learned just a whole language! When I was doing industrial recruiting, at one time I was the only woman industrial recruiter in North Carolina. And it was hard. They were not wont to let me into the back-rooms of dealmaking. It had to be done very differently.

How did you persevere? Who were your teachers and nurturers in that process?

Actually, it's really interesting. Men were my mentors. I grew up on a farm. I grew up surrounded by men all my life, so it is extraordinarily easy for me to work with them. I understand their language, I understand the *harshness* of their language sometimes, the slang of it, the cursing of it—I understand all of that. It doesn't bother me, so that was easy.

And I turned out to have two or three men who were absolutely great mentors and I am indebted to them forever! One was Ken Michalove, who was the city manager at the time. I was the first woman department head he had, and I can remember the first

staff meeting when I was the only woman in the room. And the chief of police and the fire chief and the head of the landfill and the guy running the EMS crew were all looking at me thinking, 'Oh my God, what do we do with *her!*' (*Laughs.*) But they could do their stuff and they could tell their awful jokes and I didn't care. And I assured them I didn't need to play poker on Wednesday nights—that that was *their* night and I understood all that. And they turned out to be great—they helped me do a lot of stuff.

But Ken was my mentor. He taught me how you listen to all sides of every issue before you make a decision—I wish I could remember that a little more before I jump to conclusions sometimes. He taught me how to be organized. He was a workaholic— I was a workaholic, so we understood each other. He would go into work every morning about three a.m. the whole time he was city manager—did all his paperwork. By six, he started having his first staff meetings for the day. And I went at seven—I always got biscuits at Hardee's and took 'em over there. Then I would go home and get my children and take them to school after my staff meeting with him. And so I learned a lot from Ken. I learned fairness. I learned how to be as apolitical as possible and yet let politics help you. He was great and he spent a lot of time with me. And, to this day, he and his wife and my husband and I are good friends. In fact, we're all going to Alaska together this summer.

Then the guys at Land of Sky were soooo good to me! Dennie

Martin and Bob Shepherd were my two bosses there. And they were patient and let me try crazy stuff and we began to get lots of money—they liked that! (*Laughs.*) But they were just very, very good mentors, and I will never forget them and their kindnesses and patience with me.

Was there ever a time when you just couldn't see how you would learn to do something that seemed totally foreign to you?

Yes! I can remember *crying* about it. I can remember being soooo frustrated! Oh god, I was trying to write a grant for a hydroelectric dam one time—and I never understood all the principles of hydrology and all of that stuff, yet I *had* to make this thing work! And I can remember throwing that book—or whatever the electric coop gave me—all the way across the room. I almost broke a window! And the best thing I ever learned was to walk away and let it sit for about two days—if I had that luxury— and then come back to it. But yeah, there have been lots of times when I have thought, 'I will *never* learn this!' So I give myself some space. (*Laughs.*)

What are your sources of inspiration when you're frustrated or disappointed?

Oh, that's a good question, because if you do anything that's public, you just get shot at all the time—*all the time!* The older I

get, the less it bothers me. But it still does. Nobody likes to be beat up on. And there have been some low, hard, hard times.

I guess I would rely on one or two friends, good women friends—that's where good women friends come into play. You don't deal with men too much on the personal end of stuff—I never did, but, boy, women are very good to be there—and understanding. And I always had good women friends who were maybe not in the same profession, but in tough professions. We all understood each other real well.

Or I could go—(laughs) you're gonna love this!—I could go to the foot of Cold Mountain, which is about where I'm from—or to the farm in Spring Creek in Madison County that we've always had, and sit on a rock for awhile. That always helped a lot.

But mostly, mostly, mostly—I would just start working. On the worst things that have ever happened to me, I will get up in the middle of the night and start working again. If I can get my brain in gear, I'm OK. Some of the worst days of my life I have sat and written grants—just to keep me focused.

Tell me about your family.

Oh, I have wonderful children. I have a son Alan who is thirty-six or thirty-seven now—goodness!—and a daughter Lynn who's thirty-two or thirty-three. So I have two grown children who are always a delight—I always enjoy their company. They were both 'old before their time.' It was almost like having two little adults running around! (*Laughs.*) Which was kind of fun! And then my second husband has two children, so I have four children now and they're great—all married, all moved away, all doing their own lives right now.

When your children were small, how did you balance family and career?

It was truly hard. I can remember, when I taught school, bringing my children to the classroom every Saturday. While I worked and cleaned, they played and colored. I would take them with me a lot at night. When I did daycare, I would start paperwork about eleven o'clock every night after they were in bed asleep. And they grew to be very self-sufficient. They knew that I could not get them to every piano lesson, every cheerleading practice, every after-school activity. So when they were ten years old, on their birthday, I would teach them how to ride the city bus. We would ride all over town. And they learned! And they both went away to Boston to college and they knew how to navigate Boston from a small town because they had had to be pretty self-reliant.

Where are they now?

My son is still living in Boston and teaching at Brown, and my daughter lives here in Asheville. And we have one in Detroit and one in Blacksburg, Virginia.

What are some ways you relax?

Hmmm. (*Long pause.*)

Do you relax?

You know, I love work. If I were to relax, I could go to Bakersville to the Rhododendron Festival. Now a little of that's work, but a lot of it's just fun. It's hard to go anywhere in this region that I don't know somebody! (*Laughs.*) I enjoy eating and cooking and that's kind of fun. But I don't have a lot of time. I run my family's businesses, two farms. I work here at HandMade all the time.

I met my second husband while I was recruiting industry. He brought a huge plant here, the ITT Automotive Plant. And *he* worked hard, too. I think that's what attracted us to each other. I knew that he had a hard thing, to work with a thousand employees—and in the automotive world, which is a dog-eat-dog world if there ever *was* one. So, you know, I think it was the total respect that we had for each other and the jobs that we were doing. But the most fun I have now?—is to get in the car with Ed and just ride along and look at the countryside and talk. Man, I'd do that in a heartbeat!

Do you have personal goals or interests that you pursue?

Well, everybody here is laughing at me, but I really am gonna learn to use the computer one day! I really am gonna turn one on! I have never done that. (*Laughs.*) Everything I do is by hand.

So if I send you an e-mail, you won't get it?

Oh, I'll get it, but everybody'll have to pull it up and run it for me and roll their eyes and hand it to me. (*Laughs.*) But I just know me! I am so curious that, once I do this, I'll be one of those people that, five hours later, will look up from the computer screen and go, 'Oh, wow! I didn't know it was three a.m.!' You know? That's why I don't do it *now*. I wouldn't mind going back to school, maybe learning a new language. One time I was gonna be a piano major in college—I wouldn't mind taking piano lessons again. Music's a big part of my life. My son is a musician.

What are some of your favorite things?

I love our mountains. Whether I'm riding in 'em or hiking in 'em—and we hike a lot—we live about three rocks away from the Blue Ridge Parkway and we hike the "Mountains to the Sea" trail all the time. It's one of my favorite things. So you could put me on a mountain, in a cove, in a river, and I would be happy for the rest of my life! I love Bonnie Raitt, great music—let's see, and I do read a lot. I really do like Lee Smith. I like Appalachian writers. I love my brother's work—Fred Chappell's work.

What personal qualities do you consider to be of most value in life?

My first instinct is to tell you I despise laziness—that one drives me crazy. People can do all kinds of stuff, but if they're lazy, they're really in my 'out'-book! But personal qualities of the most value? Courage. Courage in many forms. Man, courage to make a difference, to take a stand, to know you're gonna go against the grain and against the popular mentality—and God knows that's not very close to the right one most of the time.

When I was a civil rights worker, I had one of the most startling examples of courage that I've ever seen. There was a young African-American man who was a tailor by profession for a lot of the department stores—and the Klan was hounding him day and night and picketing his business and sitting in front of his business in the back of a pickup truck with a gun on him all the time. You could do that then, back in Georgia. And he would pull his sewing machine to this plate-glass window in the front of his little building and sew all day long with the sweat running down the back of his neck. And I learned courage from that man, let me tell you.

We used to picket a grocery chain because they wouldn't hire African-American folks. I was pretty pregnant at some of it, and the way everybody got back at you was to ram a grocery cart into you. People would line up way back in the parking lot and run at you with a grocery cart to try to hit you. And *every time* when they would aim at me, somebody—some young black guy—would step in front of me and take that hit. Every time! So I've learned a lot from some pretty interesting experiences.

Integrity has so many different meanings to it—I guess keeping your word. I can't remember a time in my immediate family that my mother and father didn't keep their word, or my grandparents didn't keep their word. To this day, I will still do a deal on a handshake. Now that's very seldom done in this day and time. The old gentleman that raises my tobacco and I have never had a contract—never will. When he says 'This is how many pounds I grew,' I believe him—I don't have any reason not to. And he knows I do the same with him.

What is the one way that you have evolved as a human being that makes you proudest?

I guess to look at the human condition and have more compassion for it than when I was younger, and was just irritated when people didn't do what they said they'd do or when they'd do it or *how* they'd do it. When I step back and think at what some people go through to just make it through the day, I am utterly amazed. I have never been physically incapacitated—I've never even had a headache! I'm on the board of a rehab hospital and I am in awe of people that I have met through that experience that manage their daily lives under excruciatingly horrendous physical conditions.

And then I think of people who live in such unhappy daily situations—things they generally can't get out of—and how they keep functioning. So I have learned that the human condition is pretty amazing. I used to think, 'Well, why doesn't that get done?' And now my whole attitude is, 'Man—sump'n got done!'

What qualities do you possess that you feel make your career choice a natural for you?

Energy. Energy and enthusiasm! And I think I can impart that to other people. I think I can get people excited and energized. I learned a long time ago that I was never gonna be the beauty queen or 'Miss North Carolina' or any of that stuff. But I also learned very early on that people will follow energy. People *like* energy. They're attracted to it just like they're attracted to light. And so I think the thing that I have now is unbridled enthusiasm for our mountains and for what people do here and for this extraordinarily distinct culture that we live in. It's so much a part of me. The sense of place, the culture—*energy* is what I think helps me do what I do now.

On the other hand, what qualities of yours create conflict or struggle for you in what you do?

Ahhh! I can make a snap judgment about somebody and I'm not able to hide it much. I don't ever play poker—I would never

win! Let's see, what do I do that makes everybody mad at me all the time? Let me think here a minute. I guess I always think, 'Well, I have this right answer. I don't know why you-all don't *get* it!' (*Laughs.*) So sometimes I can be judgmental. I can be *tough.*

Do you have any childhood event or recollection that foreshadowed that you would have this type of public career one day?

We had a little rule in my family when we were growing up. After we got to about the sixth or seventh grade, we couldn't come to the dinner table unless we'd read the paper that day. And so, to this day, conversation around the table with friends and family is about as wonderful a thing as I know. It goes back to my enjoyment of cooking and eating and having five people sit down at the table with you—no more than five.

During the Eisenhower-Adlai Stevenson presidential campaign, my daddy took Eisenhower's side and my brother took Adlai Stevenson's side, and every night for that campaign, they debated the issues. My love for politics—I love it!—I don't like the sliminess of it, but I like the challenge of it. And the debate, the conversation, the talk—those are probably the strengths I have, the ability to communicate. And that all came from sitting around our dinner table, debating issues. I can assure you, for all of what television does, there has never been a debate in my mind to ever equal that one that my brother and my father did for that cam-

paign. It was delightful. And it was also a very affirming place to learn you could have different opinions and that was OK, but *have* an opinion! (*Laughs.*) That was a very big learning experience for me. I've never forgotten it and it's one of my fondest memories.

Of what professional accomplishment are you most proud?

Starting a daycare program was great because that thing has bloomed and blossomed and I think there's thirty-some daycare centers and programs running around the county now. You can look around and see that.

The downtown—I didn't have a *lot* to do with that, but some. And it's booming in Asheville. And, you know, at the Chamber, we recruited seventeen or eighteen industries, put about 10,000 people to work. I like that, too.

But I think—HandMade! HandMade is probably the one I'm proudest of, in that it let me get right back into my—God, if I say 'roots,' *everybody* says that!—but back into who I am, into my culture and into my family, into everything I've grown up with, and back into community. Community's really, really, really important to me.

It sounds as though your position with HandMade ties all the different strands of your life together.

Interestingly enough, it does, it really does. (*Laughs.*) It's a great way to end your career, I have to say. You know, I'm sixty years old. And it was a unique opportunity to start something from scratch, to not *inherit* something—a little bit like our daycare when we started *it* from scratch—and put your own mark on it and think outside the box. And we do. All the time. That's what I love about it.

And of what personal accomplishment are you most proud?

Learning to read. If you don't learn to read, you can't do *anything*. And then reading is my enjoyment now. I'm a readaholic when I go to the grocery store. I have to read every label. Good lord, it takes me *forever* to go to the grocery store. I look at it and I think, 'Wow, that looks pretty interesting. I wonder what the heck's in *that*!' You know? And I start reading it! My daughter would say, 'Mom?...Mom!' (*Laughs.*) Ed looks at me and he'll say, 'Why don't I go down the other aisle while you...' (*Laughs.*) So, yeah, I think learning to read. Learning to read is a wonderful accomplishment for anybody.

What, if anything, would you do differently if you could turn back the clock?

Oh boy. I think if I could turn back the clock, I would stop looking for immediate solutions to things—be willing to wait time out. The times when I've gotten into the most trouble were when

I took the quickest way out. And I think if I could go back now, I would learn the great gift of waiting some things out and not having to jump into them and resolve them. I wish I had done that in one or two things in my life—personal things. I would've been a lot better off—and so would some other people too, probably.

What advice would you give young women just starting out in a career or older women considering a career change?

Try everything you can. Don't be afraid to do something that you may never have done or have *been trained* to do. And don't get put into a box. I never learned to type. One of the reasons I don't do computers—I knew if I learned to type thirty years ago, I would always be somebody's administrative assistant, and I refused to do that, so they had to take me as I was! And don't be afraid to be passionate about it! If you're not passionate, it will wear you out, make you sick, and make you hate what you're doing.

And the only thing I would say to them as far as an education goes—learn to write a decent paragraph! Learn good English and you can do almost *anything*. You know, I go to speak to a lot of classes that are liberal arts-oriented, and everybody says 'Why am I in a liberal arts college when I should probably be in computer science or Accounting 101?' And I keep saying to them, 'Because in a liberal arts education, you learn to read well and you learn how to write a paragraph that has a good beginning and a good ending and is concise. And you can do *anything* if you can do those skills.'

Any advice specifically for older women?

I am watching with great admiration and awe a woman who works for us here at HandMade. She's seventy-three. She runs our bulk mail facility and her energy and her enthusiasm are wonderful, but she also brings to this office the skills that very few people have now about work—being on time, being consistent, being dependable. These are big skills that very few young people understand how to value. I can always count on Lynn. I can count on her being here, I can count on her doing what she says she will do, and I have learned a lot from her. She's systematic, you know? And all the rest of us look at each other and say, 'Oh, please let us be like Lynn when we're seventy-three years old. Oh, pleeeez!' She walks two miles every day, great energy, very decisive about things.

What dreams do you have that are yet to be realized?

I would love to go to New Zealand and live for about six months, how's that? I have the proverbial dream everybody does—a little wanderlust. I wouldn't mind taking off. I've always wanted to be a cowboy, so I wouldn't mind living in Nevada or Utah or Colorado for six or seven months, just to get a feel for what that

part of the world is like. That's my big goal in life in the next two years—to just start traveling and living different places.

But then you'd have to come back to your North Carolina mountains at some point.

Oh, yeah. See, you always know where home is, but boy, you can sure have some good in-between! (*Laughs.*) And I've lived around the country some. Maine is a great place—I don't love it January the fourteenth, but I sure do love it April through August. There are wonderful places—this country's indeed extraordinary! So, yeah, I wouldn't mind that.

What aspect of your work brings you the most personal reward today?

Being in the community with people. Watching communities come back to the realization of how unique, how special they are, and how much they have to offer. I live in a part of the world that's been pretty much beaten down, and people can buy into this 'woe-is-me' and 'we're-not-nothing'—you hear that all the time. And the joy is to watch a community just really understand how rich it is in resources and come to life. We've got just the most wonderful little towns out here doing incredible things—just because they finally realized they can. So that's fun for me. I would rather be sittin' in somebody's firehouse some night at a potluck supper discussing the next step for getting cantilevered fishing piers built than anything I know!

Interviewed by Susan L. Comer.

"Men were my mentors."

Rebecca Anderson

Rebecca *Anderson*

Rebecca Anderson has twenty-seven years of experience in economic and community development work in Western North Carolina, twenty-two years in community and economic development, and five years in craft-focused community development.

As founder and Executive Director of HandMade in America, she oversees HandMade in America Foundation, HandMade in America Services, Inc., and HandMade in America Community Development Corporation. She directs board and staff activities and coordinates ten+ major projects involving 1,500+ citizens and over twenty partnerships with local, regional and state organizations and institutions. She also serves as a consultant for heritage and cultural tourism and educational and economic development projects related to arts and crafts.

Some of Ms. Anderson's previous positions include twelve years as Director of Economic Development for the Asheville Area Chamber of Commerce, Director of Downtown Development for the City of Asheville, and Director of Community Development for the Land-of-Sky Regional Planning Council.

Rebecca holds a B.A. from Western Carolina University-Cullowhee, N.C. and did her post-graduate work at the University of North Carolina at Asheville. She is married to Ed Anderson. They live in Asheville with their four children. She relaxes by reading a good book or playing the piano.

Betty Ray McCain an interview

Where did you grow up and where did you go to school?

I grew up in Faison, North Carolina, in Duplin County, which is in the southeastern part of the state. And I went to Faison High School, which had twelve grades in one building. Then I went to St. Mary's College in Raleigh to the junior college, for two years. I'm so old I couldn't go to Carolina as a freshman like they do now. I went to Carolina as a junior—most of the women back then went to Carolina as juniors unless you were in pharmacy school or nursing school or a day student. Then I went to Teachers College as part of Columbia University in New York for a master's degree in music. My undergraduate and graduate degrees are in music.

What career dreams did you have as a child?

I was gonna be the latest Robert Shaw. (*Laughs.*) The choral music was really what I was interested in. But I came back to Carolina and worked for the YWCA—I had been president of the YWCA at Carolina. And, after that, I married and worked while my husband was finishing his residency in medicine, and then we moved to Wilson. I was a volunteer for many, many years. I've done just about every volunteer job there is in Wilson at least once—and some twice!

Now, how did you go from wanting to be the next Robert Shaw to being the Secretary of North Carolina's Department of Cultural Resources?

(*Laughs.*) Well, I've always had a choir or two—although I don't have one now and I haven't had one for a long time. But I've always been very interested in politics and in the arts—well, I'm sort of interested in everything—and I'm fascinated by North Carolina. It's just the most wonderful place to live, with more characters per square inch than anyplace in the world, and I truly enjoy the wonderful people that are here. Well, there are wonderful people *everywhere*, but ours are so much fun! And so I have really enjoyed working with people in *many* capacities. I've done a lot of volunteer work with health organizations. When you move to a little town—whatever you do the best, they want you to do it, and they *need* you to do it, so you are encouraged and never squelched. So I've always had wonderful opportunities to do great things with great people in interesting times. And I have been very blessed with interesting times. (*Laughs.*)

Kind of like Forrest Gump.

Just like Forrest Gump! Forrest always had interesting times. And we have lots of interesting times where we are now. We are

in the midst of yet another series—you know, we're the world's largest bright-leaf tobacco market in Wilson—and so as tobacco goes down, we're going to have to diversify. And one of my interests has been working with economic development in the county—and downtown development. I chaired the downtown development committee—that was the last volunteer job I had at home before I got my day job up here. (Laughs.)

Wilson was a Main Street city and they've done a lot with community development grants, and so we have just many, many things going on. We had the second arts council in the state. And we have a small college in Wilson, Barton College, which is a fine liberal arts school that has a symphony. And we just have lots of advantages that towns our size usually don't have. But you have to keep working at it to keep 'em going. So I'm sure there'll be a place when I go back. (Laughs.) 'Raise a little money!'

How did you move from volunteer work to a position with the State?

Started working with Jim Hunt and in the party on the local level. I've been president of the Democratic Women of the state and chairman of the Democratic Party in the state, the first *woman* chairman. I've been to all but the last national convention since 1972 and gotten to work with Democrats across the state. And that's how I got interested in the legislature and that's why I've enjoyed working *with* the legislature so much, because I have

worked with them to get 'em elected. (Laughs.) And then worked with them with the budget, the Advisory Budget Commission. And I've also served on the board of Sprint—first with Carolina Telephone, as the first woman on *their* board, and then with Sprint.

I've co-chaired three of Jim Hunt's campaigns and that was a wonderful opportunity to meet great people all across the state *and* the nation. And then served on the Democratic National Committee from North Carolina for a long time on the Rules Committee. So that was very interesting, to help make the rules for the party. And I've served on two national commissions to work out the delegate selection for the party, the Winograd Commission and the Hunt Commission—the governor chaired one of them.

Then I had the happy job of working on the site selection committee for the National Democratic Convention in 1980. And in the Democratic Party, that's the only place that they pay your way. (Laughs.) Otherwise you pay your own way. But that was a wonderful opportunity to go to the cities that sought to have this convention and to see them put their best foot forward. We went to Detroit, Philadelphia, New York, and—I think there was one other place, Los Angeles, I believe—and saw what they could do. And you saw government at work there. So I've just had a lot of opportunities other people have not had—and I've learned a lot from them.

And the governor's always been generous with me. I've had wonderful appointments with the goals and policies committee for the state and the Child Advocacy Commission for the state. But this last time, he said, 'I want you to come up here and work with me in Cultural Resources.' And I didn't know whether I should do that or not. I hadn't worked since 1956 (*laughs*)—outside the home, you know. But he allowed me to do that and it has been a wonderful experience. I admire North Carolina and North Carolinians more everyday, and I thank the governor on a regular basis, because it's been a wonderful opportunity.

What do you do in a day?

Well, it's amazing what you get to do. It's just a gift. North Carolina is a treasure-trove. It's truly a gifted, gifted place. I don't know whether it's because of our real ethnic diversity, which we've always had, or the just sheer independence of the people, but we have wonderful arts of every kind all across the state. So, you just don't know! Every day's just a wonderful, wonderful surprise! It's the most fun job in all of state government because there's no typical day.

What are your primary responsibilities?

Well, we run the six divisions which are: the library; the art museum; the museum of history; the North Carolina Symphony,

the oldest state symphony in the nation; Archives and History, which is where all the historic sites are, all our historic publications are, all our archaeology, both underwater and on land—and we do a lot of both; and then the North Carolina Arts Council, which is all over the state. I think there are ninety-four counties that have arts councils in them, but the Arts Council works in all the counties. And they work with fiddle makers, fiddle *players*, dulcimer makers, dulcimer *players*, artists of every kind, craftsmen of all kinds. We particularly work with the pottery industry in North Carolina—we're very famous for that!—and we work with the John C. Campbell Folk School and Penland School of Crafts. And it's just amazing what's out there. I attended an opera last night that was North Carolina artists singing an opera written and staged by a North Carolinian. We have glass blowers better than any in the world since ancient Venetia. And what we try to do is encourage, inspire, keep training, keep pushing, and raise the money for all these things. And the state, you know, they cut the budget $1.5 billion after the '94 election when a lot of the long-time legislators were turned out and new Republicans came in. I will leave in January of 2001, but we're trying to have everything in good shape so it just moves right along when the money comes back.

For instance, the museum of history has three branch museums and we're building a brand new one down in Elizabeth City,

the Museum of the Albemarle. We've raised the first eight million; we've got to raise the next five. We've almost finished the Spencer Yards, you know, the huge rail yards, and that was a very expensive project. We have one more huge piece of it to finish—that's the backshop which is about a $30 million project. We've raised between nine and ten already, so we're on our way. And the museum of art is getting ready to double their space and we're gonna have to raise $40 million of that. So mostly I beg and whine. (*Laughs.*) Gotta beg and whine, all the time!

But we've been lucky in a lot of ways because this department was put together in 1971, which put anything that dealt with the arts, history, music, or libraries together in one state department. And we're organized differently from almost every other state, which keeps some state money—and, we hope, more and more!—coming all the time to the arts and to history and to libraries. The State of Virginia doesn't have any state historic sites, I don't think, under their auspices—not even the museum of history is under the state's auspices. And Mount Vernon and Monticello and Poplar Grove and all those places in Virginia, they have their own boards and they go out and raise their own money—and they do a great job, but the state *here* does that. And a lot of the things we've saved, we would not have been able to save had we not had some state help and sanction.

Tell me about your family.

Well, we just love 'em all to pieces. (*Laughs.*) We have our two children. The older child, Paul, is a civil engineer, and he has been a professor and lecturer at State until a few months ago—he's gone out on his own. And he does all kinds of training and teaches ethics in construction. He's a graduate of North Carolina State in engineering and has a master's in construction from Stanford and an M.B.A. from Carolina. So he's kind of cross-trained, and he goes all over the Southeast—and even to Egypt, to help them with big construction jobs and with preparing the personnel that build these things. He keeps 'em safe and well and alive!

He and his wife Beth—who we love better than Peter loved the Lord—have three little children. Elizabeth's nine, Emily is seven, and then Baby John is three and a half. And they live in Raleigh, so I get to see them real often.

And our daughter Eloise, who is a lawyer, teaches law at Bryan School of Business at UNC-G and does arbitration and mediation as an attorney. In fact, the Superior Court shifts things *to* her, and that's kind of a growing part of the legal business, trying to unload the court system of smaller things. So she's enjoying that, and she and her wonderful husband Robby Hassell who is a district court judge, have two little girls—Molly is nine and Bailey is seven.

And what about your husband?

My husband is a wonderful, dear, sweet, precious soul. We have been married nearly forty-five years and he is a physician. And his father and his grandfathers were physicians. And his great-grandmother was a nurse-midwife during the Civil War. So this is what he likes to do. (*Laughs.*) And he is a trained and board-certified internist and was grandfathered in as a rheumatologist. He is not a formally trained rheumatologist, but he does a lot of rheumatology 'cause there was nobody in eastern North Carolina for a long time that did it. And he does a lot of gerontology. Poor baby has just taken on a fourth nursing home 'cause the younger doctors are not as keen on nursing homes and he *loves* to do it. He enjoys the older folks, being as we gettin' to *be* those! And he goes to work every morning at 5:30 and he works about a ninety-hour week and loves every minute of it. It's amazing!

How did you balance family and career when your kids were young?

Oh, well, then, I was working as a volunteer—and we have wonderful volunteer children. (*Laughs.*) They have been everywhere! As I said, I've worked a lot in the Democratic Party and I can remember their working doors of rallies when they had to hand up the programs. (*Laughs.*) And we all love the governor, 'cause, you know, he's our home-folks and he's our beloved friend. We've worked for him since he came back from Nepal in '66, and

it's just been a privilege to work with him. When you work for Jim Hunt, you never have to apologize for anything. He's just such a capable, hard-working, straight-laced soul. And so we have had a great time working with him for all these years, and the children have, too.

What are some ways you relax?

Oh, I relax all the *time*—I enjoy everything. That's my problem! (*Laughs.*) I just have a great old time *all the time*! And of course, I love anything musical. So we just do a lot of things that are musical. I sing in the Presbyterian choir and have a grand time doing that.

And there's just so much going on. In our town, we have been able to rescue the old post office and make it into a science museum. 'Course it did have a terrible fire. We were trying to keep the iguana warm. (*Laughs.*) It set the whole place on fire. Killed the iguana. Killed all the other little critters except for one turtle, and the turtle came into his shell and managed to get through it all.

And then we have taken the old Branch Banking and Trust building which was founded in Wilson and whose headquarters have moved to Winston-Salem now—and that building is our arts council. And we took an old vaudeville theater and restored it for theatrical productions and musical things. So Wilson has a lot of

things there that we can attend and enjoy, as well as all the wonderful things here [in Raleigh].

And of course, the North Carolina Symphony is fabulous, and we're building a new symphony hall. We've just raised three-and-a-half million dollars to help with that. So, you know, there's music everywhere! (*Laughs.*)

What was your instrument in school?
Piano and organ.

Do you still play?
Poorly. (*Laughs.*) I love to play and I have a very interesting piano. *It's* a character, too. My piano is an old Hamburg Steinway which my mother gave me for joining the Presbyterian Church, since we were all Episcopalians. She felt so sorry for me, she bought me this Steinway. And it's an old Hamburg, which has a more mellow tone than the American Steinways. This piano was in the Serbian embassy in New York when Archduke Ferdinand was killed. It's had a hard life like me (*laughs*)—so we get along grand!

And our little Episcopal church at home was deconsecrated and moved to another town and rebuilt. So they sent the organ to my house without telling me they were going to, and I look out and these two pitiful men are struggling along carrying a little

Esteve reed organ. I'm having it reed-reworked right now. So there'll be a lot of wheezing and carrying on at my house very soon, 'cause you know how they gasp for breath! (*Laughs.*)

There are lots of opportunities to do wonderful things. I *love* to read and I *love* to travel and I *love* to sing and I *love* music. And I may have to have three lifetimes, like the Brahmans.

The Brahmans?
They were Indian people who believed that you come back. Only thing is—I might not come back as me. I probably would be a cow or something.

What are some of your favorite things?
Baroque music of any kind. And I like it played on early instruments if we can. On the way up here, I had a grand time. I did Handel and Vivaldi. The children even gave me 'Handel for the Highway.' (*Laughs.*) So any music.

And I love most kinds of books. I don't do Stephen King because I'm afraid of the dark. I love all the Tom Wolfe books, and I read a lot of books on tape because of commuting. I've read almost all the books on tape in our wonderful public library in Wilson. And I told 'em they had to hurry and get some new ones 'cause I was down to Danielle Steel and self-help and it was too late for *both* of them! (*Laughs.*)

I love history and I love to travel. And I love to do history when I travel. I enjoy all kinds of food—I *love* Southern food. And I love murder mysteries. And like Nero Wolfe, I usually keep three or four books going at a time. He had an appetizer and a main course and then dessert—and sometimes port afterwards!—in his books. (*Laughs.*) So I do that, too. Last night, I was just reading Ellis Peters, you know, the Brother Cadfael—do you know Brother Cadfael? Well, you'd like Brother Cadfael—he's a thirteenth-century priest. And she researches very carefully. Everything is true to the period. Everything is exactly right. And I love Antonia Fraser's stuff. She hasn't done much lately and I've got to get on her case!

What, if anything, would you do differently if you could turn back the clock?

I wouldn't eat so much (*laughs*)—and I wouldn't be quite so foolhardy, 'cause I've gotten hurt two or three times that I have to pay for every now and then. I'd try to be more cautious. And I would have a good set of eyes. *That*, I would like to have. My eyes are not so good, but you don't have to dust if I come, 'cause I wouldn't see it! (*Laughs.*)

I love airplanes—I'd love to learn to fly, but since I don't have very good eyesight, I'm not sure they'd take me on. I'd like to have better feet so I could do ballet. There are just a lot of things like that, but I don't think we can fix those though. We won't worry about it. (*Laughs.*)

Too late for the self-help.

It's too late for self-help (*laughs*)—it's too late. And I did meet Danielle Steel one time. She's an interesting character, too. We were campaigning for Jim Hunt, and every time we'd see a line, we'd get in it and talk to everybody. And I got to the front of the line and it was Danielle Steel signing her books. So we bought one so she could sign it. (*Laughs.*) I don't even remember what it was—it was a long time ago. She looks just as wild as her stories!

What personal qualities do you consider to be of most value in life?

Well, I would like to be like my parents, who were just the kindest, sweetest, finest things I ever knew. And my husband is like that, too. He's just a saintly soul. He'd *have* to be to put up with me! (*Laughs.*) I value those qualities. I've not reached it yet, but I'm working on it. Their qualities of always looking for the best in everything, being very appreciative people, and always kind to people. And, you know, when you beg and whine for a living, sometimes you get a little short—as we say, 'a little cross,' or, as they say in Wilson County, 'ill'! But anyway, I value that.

I grew up in an old house. It wasn't nearly as old as a lot of the houses back home. Our house was the newest one in town. It

was built in 1869. (*Laughs.*) But, you know, Sherman burned down Georgia and he burned right much—and half his army was quartered—in Faison where I'm from. The biggest battle we ever had on North Carolina soil was at Bentonville in Johnston County and that's just eighteen miles from my home, so a large part of the army was quartered in Faison. And they burned down a lot of the town, but they didn't burn down a lot of these older houses since they occupied them. So we have always valued the history, and we've always lived in amongst it, you know. My great-grandmother's house—built in the 1840s—is still standing. They did set her house on fire two or three times, but they put it out.

We've had lots of interesting things happen just in my little town. Our postmaster before the Civil War was Mr. Bloomingdale of Bloomingdale's. He's the one that started it. He was a Jewish immigrant that came into the Port of Wilmington. And on the Wilmington & Weldon Railroad, he came to Faison and was our postmaster in the 1850s. But when he saw war clouds gathering, he hopped upon the choo-choo train and went up North, 'cause he didn't have a dog in that fight, you know. He'd come over here to get away from that. So he ended up founding the store that we all shop in when we go to New York.

Of what accomplishments are you most proud?

Well, I think probably having the opportunities that I've had to work across the state in numerous jobs and to get to know all the people of this state and try to know what their aspirations were and try to work with the political system. I've had several jobs that took me all over the state. I mean, saw everything the state did—and a lot of the private things. The first one was as president of the medical auxiliary. I went to all the counties in the state and saw what the health needs were—and they were numerous. And we think we made some difference, and it was fun to *make* that difference. We wrote the organ donor bill on my kitchen table. For awhile you couldn't eat liver in there. (*Laughs.*) The auxiliary didn't get it through while I was president, but eventually it got through and it's on the back of the driver's license now and that'll save a lot of people's lives through the years. And we're proud of that although we had a very small part in it.

I was on the Advisory Budget Commission when it used to write the budget. Now they don't do that—they advise, but they don't write it like we used to. That was a long time ago, in the early '80s. And I was on the board of governors for the university system; you visit numerous community colleges in that process because the university system goes from Western, as you know, way down there at Sylva, up to Appalachian on the northwest, and all the way down to the coast to Elizabeth City State. And I'm on the board now at UNC-TV, which, you know, covers the whole state. And when I was Democratic Party Chairman, I got

to go to every precinct. When you do that, you can read North Carolina.

I think I've been so blessed to have these opportunities—all of which were volunteer, before I got this paying job—because I got to see and appreciate those wonderful people. My father was from Yancey County and my mother was from Duplin, which are about the two far ends of the state, so we had people we knew and loved as kinfolks from both places. You either learn to love North Carolina and try to do something about the needs—and you *saw* the needs, you truly saw the needs—or you just kinda went back in a shell and did your own thing. And I preferred the former. (*Laughs.*)

I'm proudest, though, I guess, of my children and my husband because they have excelled and that, to me, is great personal satisfaction. And I think the grand-babies will excel, too, because I tell them they're just like Mary Poppins, practically perfect in every way. (*Laughs.*)

What have been your greatest challenges?

Well, just keepin' on workin'. It's a ninety-hour week for *us*, too, and I drive myself all over the state. I have my own car that I drive, of course, and it's two years old and has 79,000 miles on it, so that's a lot of travelin'. And you get to go back into the nooks and the crannies, and the stamina it requires is hard. But luckily,

I'm from strong peasant stock, and I'm able to keep on trudging. (*Laughs.*) And then you look forward to every single day, because you may find that wonderful violinist that day or that wonderful potter that day that you may be able to give a hand up—or know whom they should see to have that hand up.

And I think I get the most satisfaction out of seeing things 'turn out,' as we say. Seeing that symphony hall be built with the fine acoustics in it that wouldn't have happened if all of us hadn't begged and whined and screamed and hollered and yelled—and it *happened*! And seeing that Museum of the Albemarle being built, which is about twenty-two counties working together. And working with Handmade in America up in the west, which is not our project but which we contributed to and got a lot of our artists to work with. And just being a catalyst is the most satisfactory thing, aside from raising your own family, I think.

In times of disappointment or strife, what are your sources of inspiration or renewal?

Well, I just go home and love to read—and, mostly, I eat! (*Laughs.*) As my husband says, 'We can eat our way out of any problem.'

And he's a doctor!

And he's a doctor! And he can keep his weight down, too!

We do have a lot of stress, because we never have enough money to do the things exactly like we want to. But then we have wonderful things happen. We couldn't dive this spring on Blackbeard's wreck because we didn't have enough money, but we have this wonderful staff, and they have gotten a private grant. And they're gon' dive next month. So you may get down, but I work around the most wonderful people in the world and I just really am fortunate. And then I go home to the wonderful husband and precious family that I love so much, so I don't believe in being depressed. It's such a waste of time. As Winston Churchill said, 'I am an optimist. There doesn't seem much use in being anything else.' (*Laughs.*)

What qualities do you possess that make your career choice a natural for you?

Well, I think I'm really finally using my master's! (*Laughs.*) I thanked my daddy, who's dead. I said, 'Thank you, Daddy, I'm finally using what you gave me.' And I think I've always enjoyed the arts—and been very active wherever I was put down to work with them. So I think having that knowledge of '*where what is*' in North Carolina and then having the opportunity.

Johnny and I have traveled a lot. We can't travel so much now because, see, we used to be in a big clinic which broke up and he's solo now, so we can't be gone long like we used to. I've

never been to South America or India, but I've been to Russia, China, Japan—all these places, the Caribbean and Central America.

And my parents were very, very generous to both of us, to my brother and myself—I have a very beloved brother who's a retired country doctor. And as much as they could afford, we had every opportunity. And so I feel very, very lucky that I've had opportunities other people haven't had. I'm very grateful for those and I think I've tried to take advantage of them and tried to bring what I learn to this job. I think that if I've been able to make any contribution, it's because of background that I've been lucky enough to acquire through the years.

And I love to read. I read everything I can get my hands on. I'll read a toothpaste tube if nothing else! (*Laughs.*) So I've been blessed to bring what little knowledge I have with me through the years.

On the other hand, what qualities of yours create conflict or struggle that you have to constantly work to overcome as pertains to your job?

Well, I get tickled at a lot of things I shouldn't laugh at. (*Laughs.*) You know, sometimes you *just can't laugh*! And I do tend to make light of some things. The John Locke society here, you know, is *extremely* conservative and they did a report on all of state government and they wanted to do away with the Department of

Cultural Resources. They said, 'You should pay when you go to the library. You should pay every time you go to the symphony, to the capitol, to the arts council.' I mean, 'You should pay your way and it should be totally privately revenue-supported by people who take part in it.'

Well, you know, we don't *think* that. We think everybody should have opportunities like this and we work very hard to do that. So when they wrote this report, I sent 'em a sassy little note and I said, 'If you're planning a new Dark Ages, we do not have enough monks.' (*Laughs.*) And the governor says, '*Think* before you write another letter!' But it was funny! You know, it gets you through lots of troubles, but you get in trouble doing it, too, sometimes. But I always had that trouble—it runs in the family.

Is there any childhood event or recollection you have that foreshadowed you would one day be in this position?

No, except that I used to love to go with my daddy to court. And, 'course, if it was a bad criminal case, he wouldn't let me go. But he would take me to court and you got to see government work and you got to see that you could change people's lives. He was always—my mother, too—very active in political campaigns, very active with the arts. My mother was, I thought, a very fine poet and an artist. She taught fourth grade, but she really was a very fine artist. She worked mostly in watercolors and she played the violin. And Daddy was so interested in what was going on and who would be elected, 'cause he kept saying, 'These people can make life so much better,' and he was just like Atticus Finch— he was bound and determined people were gon' be treated right, which made it real colorful as a lawyer because, back then, it was Jim Crow days, and he was just as good to his African-American clients as he was to anybody else. So we had an interesting time. We got to see people at their *least* tolerant and people at their *most* tolerant.

And my mother used to do the most wonderful thing. She was an expert typist. Her father was a Confederate veteran and he was fifty when she was born, and her mother died when she was four, so Mama always kind of learned to do anything. And she became a very fine typist and that was before all these new wonderful computers! She's been dead for thirty-some years. But her African-American teaching friends, if they would get a master's, she would type the master's thesis for them free. If they would get a Ph.D., she'd type their dissertation free. And that's a real nice present. And I said, 'Well, Mama, why do you take this on?' She said, 'If I can help *them*, they'll help the whole family. And if I can help the whole *family*, they may help a whole *community*. This is just one tiny step up, but it may be the most crucial one.' Because there really wasn't anybody else in Faison to do it, you know. So she taught by example.

I saw such pitiful things happen when they'd come to Daddy as a lawyer—and he would help 'em. And you realized—one person *can* make a difference. Just get in there and keep plugging! But you need an education to do it—you need that background to do it. I never *will* forget—there were seven girls in this family and they were all bright as dollars and very pretty. And Mama hounded their daddy who was a prosperous farmer until she got that first one in college—and every one of them after that. None of that family had ever been to college. And every one of them— they didn't have terminal degrees, but they had at least a master's. And it was just because of Mama. Think what a life-change *that* was for that family!

So if you see people doing like that all the time, you think you better get out there and do some good. My brother's done a *lot* of good as a country doctor in a pitiful, poor county, you know, 'cause Duplin has always been poor. But anyway, I'm a blessed person and I better do right or they'll come back and get me. (*Laughs.*)

What advice would you give young women just starting out in a career or older women considering a career change?

I would tell them they can do anything they want to do. They cannot give up, they cannot get discouraged. If they don't have the educational training, they're gonna have to go back to school

and figure out how to do it. But, luckily, in North Carolina, we have community colleges that will help them do that, and wonderful state universities, within driving range of almost everybody.

You know, I would say, 'Go to school and believe in yourself and always have some side interests that will keep your mind stimulated on other things when the troubles get too much. Be able to go and read, to go and cook, to go and play sports with your children. You have to have some relief from stress.' And some of these young mothers now, they really have my admiration because they don't have any help at home. Many of them live away from family. And it's very hard with children, when they do have to go back to work to have the confidence that they need. So we try to encourage them and we try to give everybody that we know of a leg up and help them as much as we can. So many of them go back to school and just blossom. I had a lady that helped me as a cleaning woman who was very, very bright. She had six children—most of them, she didn't get any help from the fathers. We swore out a warrant and got help for the ones we knew about (*laughs*)—my neighbor was the solicitor then, now the D.A. And then we got her in school at the Tech. She went to nursing school and was second in her class, and every one of her children has a college degree. And so if you *think* you can, sometimes somebody has to help you. And that's our job—to help 'em. And we try. (*Laughs.*)

What dreams do you have that are yet to be realized?

Oh, I have a whole lifetime ahead that I've got to think about. And since I'm gettin' on up, I've got to hurry. (*Laughs.*) I have right much traveling I want to do. One of the things I especially want to do is to go to Oxford to that two-week music course that they have. You study during the daytime and sing with the King's College or one of the college choirs at night. And it's wonderful! You can study a certain period of music that you're particularly interested in and then you get to sing with those fabulous voices. So that would be lots of fun. Everybody thinks I'm crazy when I say that. (*Laughs.*) But I have several friends I know that I can con into going with me. And then I want to be able to take my grand-children a lot of places and be with them because they're lots of fun. And they're already bucking for Europe. (*Laughs.*) I said, 'Mimi will not have a paying job when you're old enough to go to Europe. We gon' have to think about this!'

And then I've got a couple of volunteer jobs I want to do. And one of them, I'm going to have the opportunity to do that I can't talk about yet 'cause it'll be next month before it's announced. And I'm *very* excited about that. So when I get through this job, I will have fun, fun things to do!

Interviewed by Susan L. Comer.

"*I'm fascinated by North Carolina. It's just the most wonderful place to live, with more characters per square inch than anyplace in the world.*"

Betty Ray McCain

Betty Ray McCain

Betty Ray McCain is a proud native of Faison in Duplin County, North Carolina. She is a graduate of the University of North Carolina in Chapel Hill, and of Teachers College at Columbia University, with degrees in music.

Ms. McCain was appointed secretary for the North Carolina Department of Cultural Resources in 1993, a post she still holds today. She was co-chair for two of Jim Hunt's campaigns for governor, and a lobbyist for the ERA for Governor Jim Hunt in 1992. She has been active on numerous boards and commissions serving the varied interests of North Carolina.

She lives in Wilson, North Carolina with her husband, Dr. John Lewis McCain and is the proud grandmother of five "practi-cally perfect in every way" grandchildren.

McCain considers herself very blessed to have had the opportunities provided her throughout her life, and is especially grateful to Governor Jim Hunt for his leadership and inspiration.

Katie Pomerans an interview

What career dreams did you have as a child?

I think, from the time that I was a child, all my dreams had to do with fixing the world. And that may have been influenced by the fact that my childhood took place, in a great part, through World War II.

Where did you grow up?

I grew up in South America, in Uruguay, but my parents were from Central Europe, so a lot of my family was suffering through World War II.

What do you recall of those years?

On the homefront, what was happening to us in Monte Video—items were scarce and my family was extremely poor, so we didn't have access to many food items. The situation was financially difficult for our family. And what I heard from our family in Europe was that it was a very divisive time. Also, as we came to find out, part of our family went to concentration camps and died there.

Were you aware of that as a child?

Yes. In the beginning, there was no real knowledge of what was going on in Europe, except that there was a huge war starting and it was a major threat. But we didn't know what communities were targeted, and Hungary—where my family was—was not in the war from the beginning. One half of my family was Jewish and one half was Christian—so, at that point, the Hungarian community in Monte Video was a united community. As things started trickling in from Europe, there was a tremendous division in the community, and Jewish people and Christian people from Hungary would not be together anymore, because there was a fear among the Christian people that if they fraternized with the Jewish people, their family in Europe could be at risk.

Since your family was half Christian and half Jewish, did you feel this division within your own family?

Not with my family in Uruguay, but yes, with our family in Europe. My father's family wrote to us that they didn't want us to write to them anymore. They were afraid. And possibly with good reason.

Did you attend college?

Yes, in Uruguay.

What did you study?

Drama and languages. I had a Cambridge certificate in English and a certificate in French.

Did you have notions at that time of what you wanted to do as a career?

I was not a very well-defined person as far as a vocation. As I tell you, I wanted to fix the world and I had a great interest in international issues and in literature. At the time that I got married at twenty-three, I wasn't too sure what career I wanted to follow. I was an actress at the moment, since I had done drama school, but I knew that that would not be an option with raising a family.

Recount for me the path your life took at that point.

We didn't live in Uruguay after the birth of my two children. We lived in Chile for a year, where my husband got a master's in public health. My husband is a physician. And, from there, he was hired by the U.S. Peace Corps as medical director for a tuberculosis control program in Bolivia, so we lived in Bolivia for three years before coming to the United States.

What did you do during the Peace Corps years?

I had several responsibilities—among them, to keep the family together. I don't know if you're familiar with the life of fami-

lies in the Peace Corps; one person in the family may be employed, but the job is actually for the whole family. So, I was very involved in the activities of the Peace Corps in offering a home to the volunteers. I also taught Spanish to the Peace Corps volunteers. I came to the States to teach Spanish to the group for their training.

And is that how you ended up staying the in the United States?

No. After that, I went back for the remainder of the three years we worked with this group. I ended up coming to the United States in 1971 for two reasons. One was that my husband wanted to continue his studies in epidemiology at a U.S. university. He was accepted by the University of North Carolina at Chapel Hill. And the other reason was that we had to leave in a hurry because there was a change in government and the Peace Corps was expelled from Bolivia.

How old were your children when you arrived in the States?
They were five and seven.

And what was life like for you during those first years here?
Well, like all immigrants, it's an issue of survival. You do what you have to do for what is best for your family. If you have read about Latinos and how their priorities are set, you look at what is

more important for your family and not necessarily what would be best for you as an individual, so that was the first consideration. My husband was in school for the first two years and I worked at whatever I could to help support the family. And it wasn't easy to get that first job in the United States. Everybody at the Peace Corps had told me, 'Oh, you won't have any problem! You speak five languages fluently. I mean, they'll grab you!' That was not exactly the way it happened. (*Laughs.*) It was like I had just dropped in from Mars. People would look at me and say, 'Well, but, you know, which university here did you graduate from?' And coming from the university in Monte Video was not something that they could really relate to. We were living in Durham at the time, and one thing that I heard more than once was, 'We just have so many well-educated spouses here that we don't have jobs for all of them unless they are in a profession that we have a need for.' And, obviously, languages was not something that they could use at the time.

So I went to work for a retailer—I worked for Sears for seven years. And then after that, I worked for another corporation, also for seven years. And I made a good career and raised my children at the same time, so I'm very happy with the way things turned out. I perhaps would have done other things. I would have preferred to continue school. At the time, you know, I took courses here and there, but never actually had the opportunity of going back full-time to school. But it's not something that I spend my time lamenting. I had a very satisfying life. And when I decided, 'My children are now grown. They have finished their schooling. It's time for me to do something that I would like to do with my life,' I went to work for the State in a human-services type of position, using my knowledge of Spanish and my knowledge of the Hispanic community. And that's where I made my most satisfying career.

And how did you reach the position that you're in today?

Through hard work! (*Laughs.*) I was hired as Hispanic ombudsman with the Department of Health and Human Services to do bilingual information and referral for the Latino community. And I did that and realized—as the people that I was working for, I think, also realized—that there's not much that you can do as far as giving information and referral when there are no services developed for a community. The organizations were not ready to serve the new immigrants, and those services needed to be developed in an understanding of the needs of the new immigrants. So that's what I devoted my efforts to for several years, and I developed a database that the Department of Health and Human Services is using today to serve the Latino community. I also worked with different task forces and committees to improve services— or create services—for the community.

And what do you do now?

Now I'm working for N.C. State, with the Cooperative Extension Service. And I have two responsibilities—one is coordinating a program that serves farmworkers and farmers that become disabled, and we also do education for prevention of disabilities. And, at the same time, I'm Hispanic program specialist, so I assist all the programs in developing to serve the Latino community.

What aspect of what you do brings you the most joy?

People keep giving me pleasant surprises, and that is good! (*Laughs.*) You know, I'm very appreciative of the people that have impacted my life in the United States and of the life that I have been able to build for myself and for my family here. For instance, today I had lunch with the executive director of an agency that has a food shuttle to help the hungry, and she's interested in serving the Hispanic community. So she's going to complicate her life by learning to serve a segment of the community that they are not reaching. It's that type of attitude that makes my life more interesting, because I didn't have to fight my way into that to tell them, 'Look, you have people that you should be serving.' She came to me to look for better ways of reaching the community.

Can you tell me about some specific times when you've seen firsthand the

difference your work makes?

Fortunately, there have been many of those times. Because we went practically from very little—or nothing—to where, today, we do have services developed that are culturally sensitive and that are efficient to serve the Latino community. And when I'm talking of serving the Latino community, I'm talking of serving better the community at-large. But one of the things that comes to mind—I was on the task force that developed a relationship with the Department of Motor Vehicles, so that the services to the Latino community would improve. And we developed the manual in Spanish so that people could prepare to take the test—and improved customer services then at the DMV offices with interpreters to help the community.

At times when you 'hit a brick wall,' so to speak, where do you go for inspiration or renewal?

Well, you know, the first thing that came to mind is my little grandson who is two years old. When he sees somebody that's very sad, he says, 'Ohhhh, so sad. Go to the beach.' (*Laughs.*) I do the same thing. There are times when you need a little opportunity to regroup, and going to the beach does it for me, possibly because I was born close to the beach and I feel comfortable close to the ocean.

Do you have a favorite North Carolina beach?

Yes, Salter Path. It's between Emerald Isle and Atlantic Beach. It's on that same island on the Outer Banks.

Tell me about your family today.

Well, my husband is a physician, and he's changed careers within medicine a couple of times since we came to the United States. He did public health and then emergency medicine and now family medicine. And he's not a rich doctor—he likes to serve the poor, but he has a good practice. And I have a daughter who's a pharmacist and really loves her work. And that is my greatest satisfaction. You know, I wanted to see my children well-employed, and I also thought it was very important for them to do something that they loved. She has three little sons that are at this moment my greatest joy. (*Laughs.*) And then I have a son and he is in the Air Force and he's also a musician and has made quite significant accomplishments scholastically. He has a master's in business administration.

Where do your children live?

My daughter lives in Fayetteville, North Carolina, so I see her and my grandsons every week. I don't see my son that often—he is now stationed in Colorado Springs.

How did you balance work and home when your children were small?

You have to set your priorities. You have to take care of the home—there has to be cooking done and cleaning done, but the main thing is for the family to have its activities and a normal and good life.

Now that you have an 'empty nest,' what are some ways you relax?

Well, I *fill* my nest every weekend with my grandchildren! (*Laughs.*) I don't do much relaxing. Actually, I do better when I'm busy, so I divide my time between my work here for the State and my work for a nonprofit.

Tell me about your nonprofit work.

It's community work. It's a Hispanic advocacy and public policy organization called El Pueblo, and I've been president of the organization for a few years and now I'm on the executive board. And through this organization, we have had a lot of satisfactions in our advocacy for the Latino community.

How do you spend your spare time?

I enjoy reading a lot and the outdoors. I like things that are very divergent. I enjoy tremendously human company and I enjoy tremendously solitude, so I have to have some of both.

What personal qualities do you consider to be of most value in life?
Tolerance, self-sufficiency, independence.

What is the one way that you have evolved as a human being that makes you proudest?
I think I have been a positive influence on many, and I'm very proud of that.

What do you consider to have been your greatest challenges so far?
I think probably the greatest challenge in life is to be able to keep an even keel and not bore yourself to death. (*Laughs.*) I mean, you have to be able to balance making your life challenging enough and interesting enough and not lose your equilibrium.

What qualities do you possess that make your career choice a natural for you?
Well, I think my strong desire to make an impact in the community would be it.

On the other hand, what qualities of yours impede your progress or create struggle for you as pertains to your career?
Well, I need to be twenty years younger, because I have so many things I want to do that I'm afraid of getting too old before I can do them all.

Of what professional accomplishment are you most proud?
I would have to say the presidency of El Pueblo, the Latino organization that I've been with, is probably my biggest accomplishment—the fact that, from a small organization that offered the Chapel Hill area a Latino festival, we have turned it into the most influential and most active advocacy organization for Latinos in the state.

And of what personal accomplishment are you most proud?
Probably my best personal accomplishment is my children.

What advice would you give young women just starting out in a career?
Well, I would say, 'There is nothing that you cannot do just because you are a woman, but do those things that will make you feel proud of yourself.'

And what advice do you have for older women considering a career change?
Go for it.

What dreams do you have that are yet to be realized, both personal and professional?
Well, I still plan to go back to school and I'm hopefully going to do that in the next few years. That has been a dream for awhile. But I work better with plans than I do with dreams. I like to plan

things, not just to dream about them. That's the difference between accomplishing something and not accomplishing something. You know, I don't want to have a dream for the rest of my life. If I'm going to give something some thought, it will be something that I'm planning to do.

Do you know what your major will be when you go back to school?

Yes, I want to do Spanish literature because that's something that I'm very interested in.

Will you do anything vocationally with it or will it be purely for personal enjoyment?

This is really something that I want to enjoy for myself.

What, if anything, would you do differently if you could turn back the clock?

Oh, I don't believe in that. I don't ever sit back to think what I could have done thirty years ago. I just go on and do it today.

Interviewed by Susan L. Comer.

"I think probably the greatest challenge in life is to be able to keep an even keel and not bore yourself to death."

Katie Pomerans

Katie *Pomerans*

Katie Pomerans is a native of Uruguay. She has lived in North Carolina since 1971. She is immediate past president of El Pueblo, Inc., a North Carolina non-profit statewide advocacy and policy organization dedicated to strengthening the Latino community. Katie is also the coordinator of the AgrAbility Program, and Hispanic program specialist for the North Carolina State University Cooperative Extension Service. Previously, she served as Hispanic ombudsman for the Department of Health and Human Services.

She serves on numerous state task forces and boards addressing racial and ethnic issues, including the NC NAACP Board, Chair of the Governor's Complete Count Committee, Farmworker Health Alliance, and the Interpreter Task Force, among others. She was the recipient of the 1998 Latino Diamante Award for Lifetime Achievement and the first Latina to graduate from Leadership N.C.

"There is nothing that you cannot do just because you are a woman, but do those things that will make you feel proud of yourself."

Katie Pomerans

Darla Deardorff an interview

Where did you grow up and where did you go to school?

I grew up primarily in Virginia, in the Shenandoah Valley. I was born in Pennsylvania, but my father's a pastor, so we moved around a couple times during my childhood. I went to elementary school in the Roanoke, Virginia, area, and then middle and high school in a small town called Buena Vista, Virginia. Then I went on to college just a little ways farther north, at a small liberal arts college called Bridgewater College.

What career dreams did you have as a child?

Well, in second grade, I started taking piano lessons, so from that age, I had been really interested in music. But then I had a rather formative experience in that I took German classes in high school, had an excellent German teacher, went on an exchange program to Germany, and became very interested in working with people from other countries and other cultures. That wasn't the first time I was exposed to that. I remember, as a young child growing up, that occasionally my parents might host visiting foreign missionaries in our home and had always been interested in people from other cultures. The German exchange, though, was the one that really kinda clinched it for me.

One memory that really stands out from that-I remember there was a German group that came and stayed with families and attended our high school for awhile. Then later we went back and stayed with *their* families in Germany. But when *they* were leaving here, everyone was hugging and saying goodbye and it seemed like we had just so quickly become such wonderful friends. And I remember that the parents made some comment about it being amazing at how well these young people get along together, despite the fact they're from different cultures-and wouldn't it be great if maybe the world leaders would just leave the world politics up to the young people who could get along like this! (*Laughs*). Overhearing that comment just really stuck with me and gave me pause. And I thought, 'Yeah, you know, that would really be *something*, because we all do get along so well together.'

Also I would say that my own personal upbringing and background—I grew up in the Church of the Brethren, which is a small Christian denomination similar to the Mennonites, and they really stress peace and service to others. So, as a way also, then, of living out those principles, I became interested in working with people from other cultures. My initial college majors were music and sociology, but I later changed to history and political science, with an emphasis on international relations. And then in college, I had an internship at the United Nations in Geneva working

with the Human Rights Commission there. That was also a very pivotal experience for me. And ever since then, I continued moving in a direction of working with people from different cultures.

Recount for me the path you took to get where you are today.

Shortly after college graduation, I moved to North Carolina with my husband for the purpose of going to graduate school. And I spent a couple of years working at the North Carolina Center for International Understanding, first as a volunteer and then as an employee. From there, went on back to grad school, got a master's in higher education administration—but with an emphasis on international education—from N.C. State. And I am currently in the process of finishing up my doctorate there in the same area.

After working at NCCIU and then going to grad school, I have held a number of positions on the N.C. State campus. I have worked in the Study Abroad office and currently work as the programs coordinator in the Office of International Scholar and Student Services at N.C. State. In addition to that, I have been teaching English as a Second Language at Wake Tech Community College for the past five years and also teach cross-cultural courses at Duke and do a number of cross-cultural training seminars and workshops throughout the Triangle area.

What do you find most rewarding about your work?

Oh, there's so many things I find rewarding about it. One, it's being able to put my principles and beliefs into action—about bringing people from different cultures together. It's being able to *work* with people from different cultures. I learn so much from others in the work that I do. And it's just incredible how much these different persons have touched my life in the various ways that I've worked with them. It's very rewarding to bring people—particularly American culture and other cultures—together, which is what I do as programs coordinator in the office. I work with all the cultural programs, and a number of those programs are specifically designed to engage Americans with Internationals at N.C. State.

Can you give me an anecdote to illustrate how an individual you've worked with has impacted your life?

Oh, how many different names and faces come to mind when you ask that! Gosh, it's hard to pick just one incident. I guess one of the most recent comes to mind. On Sunday evening, we took a number of international students and scholars to an American family's home for a cookout and, for many of the ones who went, this was their first time ever being in an American home. And on the way home, one Chinese scholar said that attending that cookout and being with this group of folks that evening—and being

able to experience one small part of American culture while he was here—was the highlight of the year for him.

I can think of another incident when I coordinated a Thanksgiving dinner that was hosted by Americans for international students and scholars living in the Raleigh area. After the dinner, a Vietnamese lady came up to me and said something to the effect that she had felt so homesick her entire time here in the United States, but today was one day she did not. It's very, very powerful in being able to work with persons and know that these are memories that they'll be able to take home with them.

And then, in return, I can recall, two years ago, living and working in Asia and being hosted by families of students that I currently work with—and the *incredible* hospitality that was shown to me and my husband while we were there. It made me realize that what we think of as offering hospitality here didn't even come close in my mind to what we experienced there. That was a really incredible experience for me, to be able to see how their lives are before they come here.

What do you see as the greatest stumbling block between cultures communicating and feeling comfortable together?

Well, I think the international population I work with—just because of my being an English teacher—would say it would be language. But, in my experience, particularly in different countries, language is not always the greatest obstacle. I almost want to say it's in persons not truly taking the time to understand each other, that it's soooo easy to make assumptions that are incorrect, but those assumptions that we make often hinder true understanding of each other.

Do you think Americans fear other cultures?

I think how receptive or open-minded or accepting Americans might be of persons from other cultures depends on the background and experiences that they have had. I think once they've had some kind of experience working with these individuals, they're very open and receptive and want to learn more—at least, given the experiences I've had in coordinating some of the programs at N.C. State. But for those who've never had those opportunities, it can be a bit threatening to really take the time to understand persons, to try to understand where they're coming from and what their experiences have been.

What do you find to be the greatest challenge in teaching a person how to speak the English language?

I teach more on the intermediate or advanced levels and I teach primarily adults from other countries. I come out of a teaching philosophy called 'learner-centeredness'—really trying to teach what the learner needs most. And it's hard to find out *exactly* what

their needs are—is it that they need to go to the doctor and they need the words for that, or do they need to talk on the phone? So one challenge—and only *one* challenge—is always trying to discern what their specific needs are and how I can best meet those needs.

And, of course, a lot of ESL teachers would also say that a challenge simply is to work with so many people from different backgrounds and different language levels. Even if I'm teaching an intermediate class, there are certain people in there who might have fairly good speaking skills, but their writing is very, very low. And then there are others who would be just the opposite— where their writing and reading is fine, but they can hardly say two words. And they're all coming from very different backgrounds in different cultures. It's not unusual to have five to twelve different countries represented in one classroom, and trying to meet their needs when they're coming from such different backgrounds and language and skill levels is a real challenge.

What have been your greatest challenges along your career path?

I guess, initially, it was figuring out exactly which path to pursue. I knew the general field that I was passionate about, but as far as which path to take *within* that field, that was a challenge because there were a number of routes to go. At first, I thought I might go more the route of international relations in working with politics and government, and even going into law and pursuing human rights and fighting for the rights of those who are oppressed and downtrodden in different cultures. But the internship at the U.N. changed my perspective somewhat on how effective that would be, and I felt that perhaps I'd be more effective in working with people on the grassroots level—that more of a difference could be made there. I had thought about pursuing the route of anthropology and studying people from other cultures and helping people understand each other *that* way. But eventually, ended up more in the education field. So it was a challenge to discern *which* path within the larger field would be the better one to pursue and which one would be more effective in making a difference.

Any personal goals that you're currently pursuing?

A goal I've had is—try to learn some different languages. As I said, I studied German in high school and college. I have audited Spanish and Japanese classes, but would really like to learn more languages at some point. And I really do enjoy traveling. I don't always get the opportunity to do so, but when the occasion arises, that has certainly been a great joy and highlight in my life, to be able to travel—and not just as a tourist, but to actually go and learn about the culture and stay in people's homes and get to know the way people live in that culture. Photography is some-

thing else I'd like to pursue.

Tell me about your family.

My husband is a physics professor at UNC-Chapel Hill. We have been married almost nine years and we'll have our first child next week! We've both been in grad school most of our married life. And he also shares, thankfully, my interest in other cultures and in traveling and learning to know people from different cultural backgrounds. And then my family of origin consists of my father and mother, who have been married close to forty years— my father, as I mentioned, is a retired pastor—and I have two brothers.

Do you anticipate how you will balance family and career?

That's a whole new area for us! We have given it some thought, but are also trying to remain open as to how life will definitely be changed, as everyone tells me. And I would like to think that I would be able to find a balance between family life and raising a child and continuing with my work. And that's what I'm planning on now, but we're trying to remain open to see how things will work out and how things change.

It must be a very exciting time for you right now, and yet one in which you're not quite sure how to feel!

Exactly! That just about sums it up! *(Laughs.)* It's overwhelming. It's just hard to know what life's going to hold after next week, what it's going to be like. But I just enjoy what I do so much that I don't necessarily even see it as a job or as work, so I'm hoping that somehow I'll be able to find that balance. I've been able to work all this time through the pregnancy and there are times I feel so tired or just don't feel like teaching, but go to the class and then just get so *inspired* by the students that I come out feeling so much better than when I went in. It's just incredible! *(Laughs.)* The pregnancy's gone very well. The only difficulty now that I've encountered is—the baby's in breech position, so I'll need to have a C-section next week. That's how I know that the baby will definitely come next Thursday! *(Laughs.)*

Do you have a name picked out?

No, not quite, but in picking out names, we're trying to find names that would work in different cultural backgrounds possibly, at least ones that wouldn't be considered odd or offensive to people who might speak different languages. It's a challenge to pick out a name that would work in several different cultures.

When you're not eight and three-fourths months pregnant, what are some ways that you relax?

I enjoy doing some reading. I like keeping up with the cur-

rent national news. That really has its benefits in working with people from other cultures, too—being able to ask about how things are going. So being able to talk with people and be knowledgeable about what's happening in different parts of the world is important, but it *is* relaxing to just catch up on the news and read the paper. I enjoy reading anthropology-type books about different cultures.

I also play the piano. I was a piano teacher for eight years, and so music is another way that I enjoy relaxing. A couple of years ago, I started learning the harp—I have a little folk harp—and it has been fun to learn at least the basics. That has taken a backseat for now, but I wouldn't mind getting back to that sometime, too.

I enjoy listening to a lot of different ethnic music. I have a lot of collections of world music. I have quite a few celtic music CDs, but also instrumental guitar, harp—not any real specific groups, but I enjoy a group like Cusco, piano music like George Winston, David Lanz, a lot of the Narada CDs. I love ethnic foods, like Thai, Indian. We kinda alternate among different ethnic restaurants. I don't have much time to watch T.V., and when I do occasionally, I might watch a show like 'Touched by an Angel.' We try to record it sometimes, but we don't have time to watch it. Don't watch a lot of movies, but will on occasion. One of the most recent ones we had gone to see was 'Anna and the King'—

enjoyed watching 'Amistad.'

I also occasionally get involved in helping my husband with *his* hobbies. Right now, as we're speaking, he is juggling for the Durham Bulls baseball team (*Laughs.*) So juggling is one of his main ways to relax, but he also does that on the side just for fun and as entertainment for others. And I'll sometimes get involved in helping him with that. Now, I don't juggle, but I'll be support for him as he does his shows. I might videotape or do the music for him. And also kite-flying—I know a little bit about kite-flying, not a lot. So sometimes I'll get *peripherally* involved in his hobbies.

Another way to relax is that we have a pet bunny rabbit named Trixie. She's been part of our little household for about five years now. She's great fun to have around, too. Rabbits make such good pets! (*Laughs*).

How does this particular bunny rabbit enhance your life?
(*Laughs.*) Well, this one in particular is incredibly loving and she will follow us around. Whichever room we're in, she'll follow us to that room because she just wants to be with us all the time. I've never known pets who've enjoyed being with humans so much they'll just follow them around to every room they're in.

Does the joy this bunny brings ever 'multiply,' so to speak?

No, we've not allowed her that opportunity! (*Laughs.*)

In times of disappointment or strife, what sources of inspiration or renewal do you seek?

Certainly, I would say my faith plays a huge part in that renewal process—I am Christian. And relying on God and turning to God as a source of strength is the best source of renewal for me, having been brought up in that faith and having parents who are very strong in the faith as well. And family support also helps.

What personal qualities do you consider to be of most value in life?

Some of the qualities that I feel have benefited me would be creativity, resourcefulness, being able to see things from different perspectives—not just stuck in one way of thinking. Certainly personal ethics, having beliefs and principles, and being able to put those into practice and live those out. Really caring about others, I mean, showing that genuine interest in other people. Having an enthusiasm for life, for what one is doing—energy and enthusiasm. I think it's important to also be able to have a big-picture perspective of where one's headed—and just the big picture in general. That's not always easy even for me! (*Laughs.*) It's easy to get caught up in the small things and just forget the big picture. So that's something I continually work at and of which my husband reminds me.

What do you see as your big picture?

Well, that's changed really recently! (*Laughs.*)

Like in the last nine months?

Right. And it's still in the process of changing. So not an easy question to answer at the moment.

What qualities do you possess that make your career choice a natural for you?

I think a natural curiosity about others and a genuine interest in finding out, then, about other people. Also, I think, in relation to the teaching and actual program administration, just the creativity I mentioned earlier has been very helpful. The capacities in which I'm working now allow me to really be able to express myself and be myself in working with others. And that's what helps make it a natural fit, too.

On the other hand, what qualities of yours create conflict or struggle that you must constantly work to overcome as pertains to your job?

That I can often get so focused on and involved in what I'm doing that it *is* sometimes easy to lose sight of the bigger picture. And I think the baby will help put all this in perspective very soon. (*Laughs.*) I'm not changing priorities, but I guess for my husband and myself, both with grad school and then with ca-

reers, we've been fairly career-focused and -oriented. We certainly have had a very strong marriage relationship and have made that a priority but, at the same time, we've both been very focused on our careers.

So perhaps, considering your personality, that might be something you would be dealing with no matter what you had chosen as a career.

Right, right. That's true. That would be probably a given, no matter what field I was in. (*Laughs.*)

Of what accomplishments, professional and personal, are you most proud?

I just really enjoy where I'm at now. I have also been involved in our professional organization, which is NAFSA—Association of International Educators. I've held both state and regional leadership positions—regional being Southeast United States—and I'm currently being considered for a national leadership position in NAFSA. I'm also a national trainer with that organization, so I'm pleased with the professional development opportunities I've had in that way. Personally, it's working with the students in the classroom.

Your rapport with them, you mean?

Right. And the relationships that have been established and are still being maintained through e-mail, halfway across the world,

to Thailand and Japan, even after students return to their countries.

Is it tough for you when they move on?

It is. It's very hard to get to know students in the classroom and work with them for maybe a year or more and then have them move on, which is inevitable. It's hard, but I've been very glad for the numbers of them who've been able to stay in touch. And it's just so wonderful to—out of the blue, one day—get an e-mail from Colombia, from a student who says, 'Do you remember me? I was in your class two years ago and just wanted to let you know how I'm doing.'

It must feel as though you could go almost anywhere in the world and have a place to stay.

In some ways, it does. It was really interesting when we were planning our trip to Asia two years ago. We actually ended up getting an Asia air pass that allowed us to go to a number of different countries, and it *was* pretty amazing that, because of those contacts, we pretty much *did* have contacts in every place we went. (*Laughs.*) But that's what helped make it a really incredible experience, too. We ended up going to ten different countries in all, in Asia.

What doors are opened to you as a result of what you do for a living that might not be otherwise?

It certainly allows us to have those personal contacts that might otherwise be hard to obtain, so that we *could* go into a culture and have someone who could show us around. And not just to the 'touristy' sights, but show us their local hangouts and the ways of living in that country. It might be hard for someone who's just a tourist to make those kinds of connections on such a quick basis.

But it's also opened doors *here*. I think of some of the Indian students I've worked with and being invited to go to special Hindi festivals at the Hindu temple with them and being one of the very *few* white people amongst four or five hundred Indian families who are there. And feeling like, even though we were still in the Triangle, that we were in another country! It was an incredible experience, being surrounded by such colorful saris and the music and the dancing. Or being invited to a Chinese birthday party for a one-year-old. So being included in these special family celebrations, holiday celebrations—and being invited to participate in those *here* in the Triangle.

What advice would you give women just starting out in their careers?

I would encourage young women starting out in their careers to really find out how they can best put their beliefs and principles into action—and to not be deterred if one door closes, but to keep looking at the world from different perspectives and looking for alternative ways to achieve their goals. Certainly talking with others, learning from others, and hearing other stories is very helpful in doing that. Also, a very important part of my philosophy has been to make the most of every moment and opportunity that comes along. I've also felt it's very important to stretch oneself and to push oneself beyond the comfort zones we often set for ourselves. In this way, it's possible to achieve what we may have never thought possible, and whole new worlds open up.

What dreams do you have that are yet to be realized, both personal and professional?

Again, my world is in a state of flux at the moment! (*Laughs.*) So those dreams are already in the process of changing somewhat, I believe. But ultimately, pursuing a doctorate degree. I wouldn't need a doctorate in doing what I'm doing right now. But my purpose in pursuing a doctorate would be eventually to be in a position in charge of international programs at a higher education institution. And depending on the institution, that position comes in different forms or with different titles. Also being a consultant—working with different groups, different people, in cross-cultural understanding, cross-cultural training—is a route I'd be interested in pursuing, as well as teacher training, particularly ESL-teacher training. And I've already done some work on

that, but wouldn't mind pursuing that some more.

Is there anything you would you do differently if you could turn back the clock?

Not really. I'm glad for the opportunities I've had to live and work overseas. I've lived and worked in Japan, in Germany, in Geneva, and traveled to a lot of other different countries. It would be nice to have had *more* of those kinds of experiences, but hopefully there's time to come, too. And I just say that because I have found that the times that I have been in other cultures helps me relate a lot better to persons in my work, in trying to understand where they're coming from in their own experiences and backgrounds. If I've had some of those experiences, of at least what it's like to be in a very strange place and not know what's going on and having to learn to deal and cope with that, then it just helps to give that understanding that's really necessary in working with people from other backgrounds. But otherwise, I've been pretty pleased.

Do you see yourself always being in this field?

At this point, yes. Cross-cultural understanding—and ultimately world peace—is such a passion of mine that, right now, that's the field I see myself staying in.

If you weren't doing this, can you imagine what you would be doing?

If money were not a problem, simply traveling and experiencing the world on a full-time basis would be great!

Interviewed by Susan L. Comer.

Darla Deardorff

Darla K. Deardorff, of Durham, N.C., was born in Pennsylvania and raised in Virginia. She and her husband relocated to North Carolina in 1993. Darla has a strong passion for working with people from different cultures and has done so through numerous positions she has held. She is currently the programs coordinator of N.C. State University's Office of International Scholar & Student Services in Raleigh, N.C. She previously held positions in N.C. State's Study Abroad Office and at the N.C. Center for International Understanding. In addition, she has greatly enjoyed six years of teaching adults as an English-as-a-Second-Language instructor at Wake Technical Community College. She is also a cross-cultural trainer for businesses, community and non-profit organizations, and teaches cross-cultural courses at Duke University.

In addition to traveling in many countries in Europe, Asia and Latin America, Darla has lived and worked in Germany, Japan, and Switzerland, where she had an internship with the United Nations Human Rights Commission. Her educational background includes an undergraduate degree in history/political science and a master's in international education. She is currently working on her doctoral dissertation in the same field. She is married to Duane Deardorff, who is on faculty in the department of physics and astronomy at the University of North Carolina at Chapel Hill. They have one daughter, who was born in April 2000.

Brenda Summers an interview

Where did you grow up and where did you go to school?

I grew up in Davie County in a town called Mocksville, which has changed a great deal since I was there. It was very rural then and now it's pretty much a suburb of Winston-Salem. My undergraduate degree is from Carolina in journalism, my master's is from N.C. State in public administration, and my doctorate is from N.C. State in adult ed. and community college education.

What career dreams did you have as a child?

Actually, there was one career dream that probably sent me in this direction. When I was in the eighth grade—in a debate, I got up and explained how I wanted to be a lawyer when I grew up, and the teacher got all upset because girls weren't supposed to be lawyers. And the reason I wanted to be a lawyer was—the Davie County library was pretty sparse then, and all the books I read were biographies. Most of them were about men who were lawyers and political leaders, so I decided that was what I wanted to do. The teacher hauled my parents in, they had this big discussion, and, at thirteen years old, I had to take all these tests to decide what career I wanted to have. I was interested in writing, too, so they all decided that I should be some type of writer when I grew up, which I guess was more acceptable for a girl. Anyway, I went into journalism when I was in high school because, through journalism, I could still be interested in politics and cover other things and find out about a lot of things.

And all of that made me realize that there were some things girls *could* do and some things girls *couldn't* do. And that certainly prompted my interest in the women's movement when I was in college. Also, they had some books we were supposed to read before we got to Carolina—so we could talk about things—and Betty Friedan's *Feminine Mystique* was one of the books. So I read it and went around asking my mother if she knew she'd been repressed all those years. Between *that* and just the general times when I was at Carolina, which was in the seventies—when there were lots of women's movements and civil rights movements and other things going on—it all sparked my interest.

When that teacher had such an extreme reaction to your speech, what sorts of thoughts were going through your head, particularly after the meeting with your parents?

I didn't understand why it was such a big deal or why I was giving up my playground time to be sitting in there taking those tests because, at the same time, I'd been in gifted and talented

classes. And on the test, I had not done well on spatial relations, so they made me keep taking that part of the test over so I'd be in the advanced classes in high school, too. Anyway, it was all an interesting experience.

Do you think the experience planted a seed that would one day grow into this desire to help women?

Oh, I'm *sure* it did. It made me more determined to succeed, and it also made me more determined to help women, too.

Recount for me your career path.

I majored in journalism and then I went to work for some radio stations. When I first got out of school, I knew I wanted to go into broadcast journalism, because I'd already worked on the newspaper in my hometown and it was just broadcast that I was interested in, for some reason. And so I ended up working for WPTF Radio in Raleigh and, at the time I went to work for them, the woman that had been on the staff had just left. This was in news, and that was at the time where you had *one*, but you didn't have *more* than one. When I found out about the vacancy, I called the news director almost every day till he interviewed me and eventually hired me. And I primarily covered the legislature and state government for WPTF, and then left there to go to work for WBTV in Charlotte. I lived in Charlotte for a short period of time, covering the western part of the state, but then they sent me back to run the Raleigh bureau. And part of this was I was always interested in politics, which was what I was interested in in becoming a lawyer when I was much younger. So covering state government allowed me to continue my interest in politics and, as part of working for the radio station and for the T.V. station, I covered all of the debates on the Equal Rights Amendment in North Carolina, which was very interesting to me. You couldn't really take sides when you were a reporter, but obviously I was very supportive of the Equal Rights Amendment.

I'd been in television news for awhile and reached the point when you either needed to move on to a much bigger market or do something else, and I had the opportunity to work for Bob Jordan who eventually became lieutenant governor. And one reason I went to work for him was he had been a leader for the Equal Rights Amendment. I worked for him in his campaign for about two years and then I worked for him in the lieutenant governor's office. After that, I had another job working for a not-for-profit, but it was still involved in tracking issues for the state. And then, in 1993, I came to work for N.C. Equity. In my last job, I got my master's. And when I first started at N.C. Equity, I got my doctorate.

What we do now is work on economic opportunities for women and families in the state. Our mission is economic strength

for women and families, so we try to focus on programs that we think will build economic strength. And we do that through what we call The Leadership Program, which has a women's agenda program where we work with local assemblies all across the state—and local communities—to come up with a women's agenda for the legislature.

We also do advocacy training with the women in those communities and get them to focus not only on state issues, but changes they can make in their communities. And as a result of some of our work, local communities have decided to set up domestic violence shelters or women's centers. Another component of The Leadership Program is The Women of Color Program, helping them build their skills and leadership training. We have a Life-Skills Program which is a 'Train the Trainer' model, which helps women develop their budgeting skills and their job skills.

And we have a Work and Family Center which works with public agencies and the private sector to try to make them more family-friendly. We've worked with a lot of larger corporations, and now our work is focusing more on small business and nonprofits because you have a lot of women in those agencies. The national studies—and even the local studies—show that time is the key issue for most people these days, for men *and* women, so helping people figure out how they balance work and family life is the key to that. And that involves some other issues, like

finding childcare, finding eldercare.

It sounds as though you have found your niche in the law.
(*Laughs.*) Probably. And it's great meeting women across the state who are doing so many things to change things.

What have been the greatest personal challenges along your path?
I guess one of the greatest challenges was in radio, when it was very difficult for women to get into that field. I worked very hard. Sometimes I would work overtime that I didn't even get paid for just because I wanted to learn everything and prove to everybody that I could do it. And there were also some complaints when I was on the air—particularly in eastern North Carolina, you would have people call in when I would do the newscast. I mean, they weren't so concerned when I was just doing reports, but when I was doing the actual newscast, you'd get some people call in and complain—'Why do you have that woman on the air?'

It's always a challenge just getting the legislature to recognize how important some of these issues are, probably more so a couple of years ago when the legislature was less interested in women's issues. In the past two to four years, they've come around a lot more because, in part, they've recognized the power of the women's vote.

When you face frustrations and challenges in your work, what are your sources of inspiration or renewal?

Well, I have a lot of supportive friends. We have an organization called N.C. Women United which is a coalition of women's organizations, and I have a lot of friends in there who are supportive and that I can call on. And I have a core group of women friends who have been my friends since I first moved to Raleigh, so they're always helpful. And, you know, church is always a support to me, too. But the other thing—and I think this is key, too—is that women who are members and donors of N.C. Equity will tell me from time to time, 'I give you money because I don't have time to go to the legislature, but it's important to me to know you're there representing us,' and that's always encouraging.

What aspect of your work brings you the most joy?

Probably going out and doing trainings and speaking to individuals—hearing what's going on in their community and figuring out ways that we might be able to help them. I mean, we're just a small nonprofit—we only have six people on the staff and it's a statewide nonprofit—so you're limited in the number of things you can do. But we try to focus on policy issues and change issues where we feel like other organizations aren't fitting in. For instance, we will work with domestic violence and sexual assault coalitions, but we don't take the lead on those issues because they're already there. We're trying to focus on policy change and economic issues that other organizations aren't focusing on.

At the most grassroots level, can you think of an instance where you have experienced something that shows you face-to-face that what you're doing changes lives?

I guess an example would be—and this is an older one—in 1994, we had a Women's Agenda Assembly in Sampson County. Our coordinator at that time had gone down to speak to another group, but had talked about the assembly and they decided they wanted to set one up, so they did. And I went down there and spoke to them that fall. Several women there were concerned about domestic violence situations that their daughters had faced, so they decided they wanted to set up a domestic violence center.

And we went back this year and we've watched their progress from having just a part-time staff person to really getting the shelter up and running and having several staff people. Last year we went down and did the life-skills training that we've been developing here for them, so it was great to watch the whole evolution of the organization. I don't know that I can say I met one individual woman whose life was changed, but we saw a *community* that was changed.

Do you have a family?

I do not. I'm not married. I have a cat, and I have a niece and three nephews that I adore and spend a lot of time with.

What are some ways you relax?

I read a lot, and I love walking and exercising. And I have professional organizations and church organizations that I do. I'm not a person who probably relaxes a lot because I'm one of those 'Type A' personalities. I need to relax more—I just don't. (*Laughs.*)

When were you first aware that you were a 'Type A' personality?

Probably as a child! (*Laughs.*) It hasn't changed a lot since then. I do try to slow down every now and then. And a board member was just giving a lecture to me yesterday on how I needed to slow down some, because there *are* days that I worry about burnout.

Have you ever experienced any signs of burnout?

Oh, every now and then after you've worked on a Saturday, you know. Recently, I had to work like three Saturdays in a row to go to different events or for a board meeting, and usually you try to take off time during the week, but that was just a period of time where I couldn't. And I just woke up one day and I thought, 'I don't know how much longer I can do all of this.' But then you take a few days off and you're OK after that.

If you ever did decide to pursue a different path, do you have any idea what it might be?

At this point, I'm not really sure. I mean, part of the time, I would like to have my own training and consulting firm, because training is what I got my doctorate in. But it would probably be training women or nonprofits. I'm fascinated by technology, too, and my brother just bought a multimedia company in Charlotte and he keeps trying to convince me that I should go to work for him, but I never think it's a good idea to have family members working for each other.

Do you have personal interests or goals that you're pursuing or that you hope to in the near future?

Well, I always want to lose ten pounds. And I am trying to do much better—especially during some of the legislative sessions, I'm real slack about exercising, but I have a personal goal now that I do have to exercise everyday.

And are you realizing that goal?

For the most part. Except daylight-savings time sort of messed everything up, because I like to go work out at six o'clock in the morning. Somehow, losing that hour in the morning seems much harder than losing an hour at night.

I'm assuming you're a morning person.

I am definitely a morning person.

What are some of your favorite things?

Carolina men's basketball, N.C. State women's basketball. I have this book that I've read every day for a couple of years—it's a meditation book on 'Women Who Do Too Much'—because it is a daily reminder to me of how I need to put things in perspective. And I love reading mysteries, primarily those where the main character is a woman. Miriam Grace Monfredo is one of my favorite authors. But then there are tons of others also—Margaret Maron, whose characters are set here in North Carolina, that's another one of my favorites. Spending time with my niece and nephews is always important renewal to me, and I have three goddaughters, so I enjoy spending time with them, too. One of my favorite things, believe it or not, is to teach Sunday School. And, you know, just spending times with family and friends.

What Sunday School age group do you teach?

My age group, which is always a challenge. *My* Sunday School class. I do that a couple of times a year. I just did it this past Sunday, and it was on age differences.

Like in relationships?

No, it had more to do with how age differences could affect the church and our Sunday School class, but how they also affect the workplace—and our Sunday School class even has everything from veterans to Generation-Xers—and how different age groups want different things out of the church and out of service and also out of the workplace. It was also a reminder that there are a lot of people who don't remember the Vietnam War or the Kennedy assassination. I heard this guy speak recently on how everybody under twenty is a native to the current culture and everybody over *twenty* is an immigrant.

As in 'the technology culture'?

Yes. But also change, because everybody under twenty now is sort of used to the fact that change is just a constant in our lives. And for the rest of us, we're still sort of adjusting to that.

What personal qualities do you consider to be of most value in life?

Caring about other people and being willing to make a contribution to help people and change people's lives for the better.

What is the one way that you have evolved as a human being that makes you proudest?

I'm much more patient now than I used to be. I have really tried to listen to other people's concerns before I make decisions

about what sorts of changes we need here or what sorts of changes I need in my life—or with other organizations that I work with or play with.

Of what professional accomplishment are you most proud?

I think—this is sort of an evolution—but that I've had a number of different jobs that I've enjoyed in that I've grown from each one of them. I'm not one of those people who likes a lot of recognition for the things she's done, but last year, I won an Academy of Women award for Wake County for business and professions, and I think that was pretty satisfying. Personally, last year, getting a couple of bills through the legislature. Getting the gender-equity bill passed was really important to me and just getting the CEDAW (Convention on the Elimination of All Forms of Discrimination against Women) legislation through the house, too. A resolution calling on Congress to pass CEDAW was another success, because none of us thought we were actually going to do that, and I spent a lot of time working on those two issues. But there were a lot of other issues I worked on at that time, too. And just helping N.C. Equity remain financially stable and grow has been really important to me.

And of what personal accomplishment are you most proud?

I guess this sounds strange, but finding time to spend with my

niece and my nephew so I have a sense of who they are. I have a niece and nephew in college right now, so I make sure I talk to them once a week. I have two other nephews that I talk to on a regular basis and try to make sure I spend time with *just* them, as opposed to being with them when other people are around.

Are they close by geographically?

Yes, one nephew is at State. My niece is at Carolina. My other two nephews are in Winston-Salem, but for about eight years, they lived in Korea and Japan, so I made sure that when they were here in the summer and at Christmas, I took time off to do things with them. And one of the best things was—once when they were younger, we had been to play putt-putt and then to buy baseball cards. And we were riding down the road and the youngest one looked at me and he said, 'Ain't life grand?' And I thought, 'Yep, I guess it is.' 'Course now, he's thirteen and doesn't *think* it's so grand. (*Laughs.*)

What, if anything, would you do differently if you could turn back the clock?

You know, I think about that sometimes. And there are probably little things you think you would do differently. But for the most part, I don't think I would do anything differently, because I'm pretty happy with the friends I have and the job that I have

and the people I've met along the way and the experiences that have made me into the person that I am now.

What advice would you give young women just starting out in a career or older women considering a career change?

To go for it—that sometimes you have to start out with a job that isn't the job that you really want, but that you go in and select a job that comes closest to your needs, make the connections that you need to make and get the skills that you need to advance. And sometimes there are challenges, especially for women in rural areas, because they just don't have the opportunities that women in other parts of the state have.

And the other thing I recommend is that I really think it's important to do some community service or volunteer work because it gives you a different perspective on your own life. Sometimes when you're busy worrying about your own career, you lose sight of the other things that are important. So it's important for people to find a balance in their lives where there's work and play—not that I'm good at *doing* all of this, but I think it's important!

And, for younger women, it's a little easier to take risks than it is for older women because you've got more issues ahead to think about. But I think that it's important for both to be willing to take risks and be willing to change.

What dreams do you have that are yet to be realized, both personal and professional?

Oh, I think part of it is I do want to eventually have my own business. I know you have to work really hard when you have your own business, but it would allow me to probably develop some skills that I haven't developed yet because, when you're so busy in one job, you're always so focused on that, you can't do a variety of things. So I think that's probably one of the things I want to do.

And, you know, there's still a lot of places I'd like to travel to, to see how different people live. I think that's always fascinating to find out about different cultures and different experiences. And, I don't know, just to enjoy every day is the most important thing to me.

What would the eighth-grade girl who got called on the carpet about her law-career speech think about your career today?

Well, most of the time when I think about it, I think, 'Boy, you've come a long way from a little girl in Mocksville.' And especially when I was working for the lieutenant governor, and sometimes you'd be riding in a helicopter or plane—you know, he was going to give a speech and you had to do the press work— and I'd think, 'You know, when you were in Mocksville, you would've never thought about doing *this*!' And I always want to

see my eighth-grade teacher, too. (*Laughs.*)

Interviewed by Susan L. Comer.

"I really think it's important to do some community service or volunteer work because it gives you a different perspective on your own life. Sometimes when you're busy worrying about your own career, you lose sight of the other things that are important."

Brenda Summers

Brenda *Summers*

Brenda Summers is president of NC Equity, a non-profit organization that works for the economic strength of women and families. Summers joined NC Equity in 1993. Prior to that, she was executive director of the State Capital Law Firm Group and the National Resource Center for State Laws and Regulations. She has also been employed as director of communications for Lt. Governor Bob Jordan and as a television and radio reporter.

She has been involved in a number of community and civic activities. She is past president of the UNC Journalism School Alumni Association. She is a member of the Women's Forum of North Carolina, the Raleigh Professional Women's Forum and Edenton Street United Methodist Church. She also serves on the executive committee of the Breast and Cervical Cancer Control Coalition.

Brenda has an undergraduate degree from UNC-Chapel Hill in journalism, a master's in public administration, and a doctorate in adult and community college education from North Carolina State University. Her dissertation topic was "Women and the Information Highway: Gender, Access, Power and Knowledge."

Terri Allred an interview

What career dreams did you have as a child?

Well, as a child I was positive that I was going to be a ballet dancer. I danced my whole life and did gymnastics. Then as I got a little bit older, I wanted to be a teacher because I really respected the people who taught me in grade school and high school.

And where did you go to school and grow up?

Well, I grew up in Winston-Salem, North Carolina and I attended Reynolds High School, which is the big high school in Winston-Salem, and was very active there. Did a lot of after-school clubs and activities and really got the most out of my high school experience. Then I went to undergraduate at Wake Forest University. I was actually able to attend because my mother works there, and I was able to work and pay my own way with a reduced tuition. That was a really exciting opportunity for me to go to such a prestigious school and be able to pay for it myself. So, I worked—and am actually quite proud of having done this— worked my way through college. Many, many of my peers at Wake Forest did not work. In fact, most did not work. But I held down two to three jobs a year to be able to put myself through

college. I was very active on campus and that's how I actually started in my career of working in sexual violence. I helped with a peer project to educate other students about sexual assault prevention and I was a facilitator for that project, then actually became one of the leaders by the time I was a senior.

And did this come out of the blue for you? Did you not have any idea that you were interested in this area until you had this experience?

I knew I was interested in counseling and helping people and, by that point, had thought about either going into the ministry or social work. So I became both a resident advisor and a peer counselor at Wake Forest. Out of the peer counselor program my sophomore year came this program, 'PREPARE: The Policy Group To End Rape.' It was a student-initiated sexual assault prevention program, and it ended up being incorporated into freshman orientation and is still operating today. It was through my experience with that group that I started gaining skills in public speaking, and realizing that advocacy and counseling were things that came naturally to me. I felt a real passion for the issue of sexual violence because I had become a feminist, quote-unquote, during college and kind of came to terms with my own oppression as a Southern woman—and realized that gender stereotypes that I had been raised with were not accurate for who I was. The issue of sexual violence allowed me to confront violence and injustice and

gender stereotypes that I felt were keeping women in positions of submission, and potentially vulnerable situations.

If you would, go from there and recount for me the path that you took to get to where you are today.

Sure. When I left college I had been accepted to go to Harvard Divinity School and Vanderbilt Divinity School, and I decided to go to Harvard. At that point I was going to be a minister. The last week of school my senior year in college, one of my best friends died suddenly and it threw me into a real crisis of meaning and faith, and crisis about what I wanted to do in life. So, what I ended up doing was taking a year off from school, and I ultimately went back to Vanderbilt Divinity School, which is where I got my master's of theological studies. Went knowing at that point that I was not going into ministry, but wanted to understand more about how people assign meaning to, and resolve, trauma. Part of that was from my experience of the trauma of losing a close friend who was very young, and part of it, I think, came from really seeing people devastated by sexual violence and domestic violence and trying to figure out how that could happen in a world where—predominantly with Christian beliefs—where God was a good God in their faith tradition. When I got to Divinity School I majored, or focused, in feminist theology and did a lot of my focus and coursework around understanding how people resolve

the crisis of meaning that rape and domestic violence precipitates. I paid my way through graduate school by working at a rape crisis center and by doing counseling for domestic violence offenders. That was when the work that I had started in college really solidified for me, and I can remember doing an internship in graduate school at the local rape crisis center—which was in Nashville, Tennessee—and thinking to myself, 'I think one day I would like to be the director of a rape crisis center.' And...here I am. (*Laughs.*) So in graduate school was when I started thinking more about long-term career goals. Of course, I'm still only thirty-three so I've got a lot of career goals left, but at least that was the target that I set for myself.

After graduate school I stayed in Nashville and was a mental therapist for an outpatient, comprehensive child abuse program. The program did work with children, adolescents and adults—all ages—who had been sexually or physically assaulted. Actually, almost everyone had been sexually assaulted. So I was a therapist for two years there and in the course of working there, I started doing what is, I think, one of the most unique and interesting things about my career—I started working with sex offenders. Treated adult and adolescent sex offenders at this outpatient clinic. When I made that move I did it consciously, because I felt like I was not able to fully understand—I mean I could intellectually comprehend the issue of sexual violence, but I still couldn't get

my head around why or how someone could do this. I felt like if I worked directly with offenders, then I would be able to clearly understand and get a better handle on it—both for helping victims and for systemic change. So, I started working with sex offenders. It was outpatient. There were several close calls where I felt like I was in a pretty high degree of danger. I would never do it again, especially now, being a mother, but it gave me an incredibly unique handle on the issue of violence—in a way that most rape crisis advocates don't have.

Did you go into it with any outrage for these people?

Oh, yes. Absolutely. I was outraged at the horrific crimes, and I worked with pretty much every type of sexual offender—from pedophiles to rapists to exhibitionists, peeping toms—basically every type of sexual offense you could imagine. Including people who had fantasies of murder, although—I don't know for sure—but I don't think any of them had actually killed anyone. But you never know, because all you ever knew is what they actually were referred for.

How were you able to temper this outrage?

Well, that's a good question. (*Laughs.*) I did yoga and I ran. In Nashville there's an incredible music scene and I spent a lot of time going out with my friends and having fun. But I also, really

experienced some serious anxiety and trauma as a result of the work that I did. After I left the outpatient clinic I went to work for a residential treatment program and I was a therapist for pre-adolescent sexual offenders. These were eight, ten, eleven, twelve-year-old precious little boys who had committed horrific crimes and nobody knew what to do with them. So, I worked with them for two years—the same ten to twelve kids for two years—in this residential setting. That was the point at which I really started experiencing secondary post-traumatic stress disorder, which is a pretty normal thing for people in this field. It's basically being traumatized by the work that you do and the exposure to the stories. It is very similar to the primary traumatization in terms of the type of symptoms that the person feels.

How did you overcome it?

Well, as soon as I realized what was going on, I stopped working with offenders and moved to a more administrative, business-type role. That was when I got my first job as the director of a rape crisis center in Columbus, Ohio. I speak openly about the secondary PTSD, because I think it's really important for other people who are in helping fields to realize that it can happen and to know how to identify it if it does happen to you. And to understand that this work has a life-changing impact. I tell the volunteers we train that, if you choose to go through this volunteer

training, you will be exposed to things that will change your life forever—and you will be a different person as a result.

Talk to me about what it's like to be in your position every day. What is your day like?

As the executive director of a very small non-profit, I wear many hats and actually thrive on that diversity. I really like the opportunity to serve in multiple roles in one day. In any given day I may be meeting with county commissioners to discuss funding opportunities. I may be attending an interdisciplinary meeting to discuss sexual assault protocols in Durham with police officers and prosecutors and healthcare professionals. I may be cleaning the bathroom. I may be going to the post office. I may be writing checks and doing bookkeeping, or I may be fundraising, or I may be helping our board of directors govern the agency, or supervising staff or seeing clients...and so every single day brings new challenges and an enormous variety of experiences.

What portion of it is nearest and dearest to your heart?

Well, I love the systems advocacy. I love the work that I am able to do to make the systems—that meaning law enforcement, criminal justice, healthcare professionals, victims' advocates—change in a way that will better serve the needs of victims and be more sensitive to victims. That, to me, feels like I'm not just pick-ing up the pieces, I'm actually doing something to make a change that will be beneficial for everyone, whether you've been impacted by sexual assault directly or not. So, my favorite part is the interdisciplinary collaboration and the system-wide advocacy and change that I'm able to implement.

Throughout the entire path that you've taken, from college on to now, what do you consider to have been the greatest challenges that you've faced?

One of my greatest challenges has been to learn how to be a strong, competent, professional woman. To come into that identity. To be able to emerge from the gender role stereotypes and the socialization about what it means to be a woman in the Southern culture of passivity and tolerance, and to really become assertive and independent and be a strong and confident professional.

What are some things that have helped you get there?

Well, I think I have had the gift of having enormously positive supervisor/mentors. Women who have successfully navigated the waters of being professionals and being strong, but not losing who they were as individuals or who they were as sensitive women—and being able to combine those two. One of my personal missions is to offer training and mentoring opportunities to young women. That's really a lot of the reason why I'm here today, because I had strong women in professional environments

who really allowed me to become who I am today.

In times of disappointment or strife—and it sure sounds like you've had a lot of them in your career—what are your sources of inspiration and renewal?

Well, I have some personal sources of renewal. One of them is that I am the incredibly proud mother of an almost-two-year-old boy, and he is an enormous joy and continually reminds me of what is important in life—every minute. That is, by far, one of the most positive, wonderful things that is happening in my life right now. I do some of the same things that I used to do—yoga, exercise, get together with friends. And in my office I keep the pictures that some of the young children who I worked with drew for me. I keep letters from previous clients, and I keep awards for civic duties and other major projects—the impact that I've had in other communities—and they're surrounding my desk. I keep the thank-you letters and whenever I start feeling discouraged or down, I look at those things that are surrounding my desk and I remember why I'm doing the work that I'm doing. It reenergizes me.

Well, you alluded to your son and that was going to be my next question. Tell me about your family.

I have a two-year-old—he'll be two in July. His name is Dylan and he is probably the smartest, most beautiful, sweetest...funniest little boy I've ever met. I'm not at all partial. (*Laughs.*) I absolutely love spending time with him. We blow bubbles, and we play ball, and we draw with chalk on the sidewalk, and we do puzzles, and he is just an absolute delight to be around. So, much of my time that I'm not at work is spent with him. I also have a really wonderful partner. His name is Daniel Hilliker—he's got a different last name than I do. We are legally married, but I refer to him as my partner because that's a more inclusive term of who we are to each other. He is a clinical child psychologist and he works at UNC, primarily with children who are oncology patients there. I have a lot of respect for him as a person and as a professional. He is an incredible partner and father and we're just very happy. That really helps a lot with the stress of work, because work is important, but my family is what's *really, really* important.

How do you balance the two?

Well, that's hard. When Dylan was born, Daniel and I both reduced our hours. So, I'm at ninety percent and have Fridays off, and Daniel's at eighty percent and has Mondays off. I tried to do eighty percent but it didn't work. I needed that extra couple of hours. We decided when Dylan was born that we were not just going to say he was a priority, that we were going to *make* him a priority. Dylan is only in daycare three days a week, and it's with

someone who we really like. We just do a lot of juggling, and then weekends are really family time. Every now and then I will work on a weekend if there's a board retreat or some kind of community meeting, or something that I need to go to. But then I make sure that I take time off during the week to be with Dylan, if I have to do that.

What are some ways that you relax?

My favorite thing to do is to go to the beach. I love to be near the ocean. That is an immediate relaxing situation for me. My plans for retirement, or later on, are to actually live at the beach. Eventually that's my goal, but for now just going to the beach is a short enough trip. It's about three hours from where we are, so I can get there pretty regularly. That's my favorite relaxing thing to do, is to get to the coast and be on the beach and look for seashells, and just kind of *be* in the ocean air.

What are some personal interests or goals that you're currently pursuing?

Gosh, that's a good question. In terms of personal interests, I belong to a book club and enjoy participating in that. There're a lot of other really wonderful women who come together once a month to just discuss things that usually have nothing to do with sexual violence. (*Laughs.*) We are just getting ready to buy our first house—so that has been a big focus of my attention. We're

building and so we're spending a lot of time deciding what we're going to do and what that's going to look like. I really love yoga and practice and would like to actually get more involved back in classes. Since Dylan's been born, I've just been doing it on my own. Mainly my personal goals are to continue to—daily—make time and room, in what can be an overwhelming professional career, to focus on my family first. It's not a struggle in terms of it's something I *have* to do, but it's a struggle in terms of the type of helping field that I'm in. Everybody always needs something. So part of what I have to do is set boundaries on what I'm willing to do and what I'm not willing to do, and that's a constant process.

This is probably the most fun question in the interview. What are some of your specific favorite things? This can be books, movies, T.V. shows, foods, music, collectibles, sports teams…you name it. Just a laundry list, if you will.

Right. Well, I said before, I love the beach. I also love ice cream. I am an ice cream fanatic. I eat ice cream every single day—sometimes several times a day. Often before a meal. I just eat it whenever I want it. I'm fortunate that I have a really high metabolism, so I don't gain weight. (*Laughs.*) I'm able to partake whenever I want. I also love going out to eat at nice restaurants. That's a fun pastime for me—going out to eat and going to movies. I love…let's see…other types of unusual things. Gosh, I don't feel very interesting. I love ice cream, I love being with my little

boy and I love being at the beach. I'm not a big sports fanatic. My husband is, but I don't have real strong feelings one way or the other. I usually tend to root for the underdog. My favorite movie is, I think, pretty unusual given my background—it's 'Field of Dreams.' It's a baseball movie. (*Laughs.*) I like it because I like the spiritual aspect of it.

What personal qualities do you consider to be of the most value in life?

I think honesty is very important, and compassion. A sense of humor. And—I don't exactly know how to say this in terms of a personal capacity—but I think an awareness of injustice. And maybe that is part of the empathy or the sensitivity, but kind of an awareness beyond the self. I guess whatever the quality is that allows a person to see other people both as individuals and in political and social contexts.

What is the one way that you've evolved as a human being that makes you proudest?

Definitely my sense of assertiveness and coming into my own voice. Being willing to publicly take stands for what I believe in is what I'm the very most proud of.

What qualities do you possess that make your career choice a natural for you? Conversely, what qualities of yours create conflict or struggle that you

must constantly work to overcome as pertains to this career choice?

That's funny. I was just talking about this earlier this morning. OK, what qualities do I possess that make me good at this? I'm very organized and responsible and so I'm an ideal manager. I feel like I'm a steward of the community's resources and of the board's trust and of the clients' trust. I take that role very seriously. I also am very empathic. That allows me to really see different viewpoints and understand and be with people who are suffering. I think that I'm also articulate and that allows me to make a case for the need for our services to anyone who will listen. And to promote the agency in a way that is in the best interest of continuing our services and our mission. Now, most of those things are also my biggest weaknesses. The empathy that I have is very useful; however, sometimes I get so mired in being empathic that I do not react in situations quickly enough, or set limits, or create boundaries. For instance, if I'm busy listening empathically to a police officer telling me how horrible their day was—but yet they still treated the victim poorly—I'm more likely to listen empathically than to confront as effectively—because of my tendency towards empathy rather than confrontation. That's something that I struggle with. The empathy also makes me real sensitive, and I get upset very easily about the things that I come into contact with. Being really organized and responsible is fine, except for when I'm laying in bed at night thinking of the bazillion

things that need to be done. Sometimes I take that to extremes and I won't let things go that need to be let go. I'm very hard on myself when I make mistakes.

Is there any particular childhood event or recollection that would have foreshadowed that you would end up in this position one day?

I'm an identical twin, and part of being an identical twin is learning how to respect and think about the feelings of others in a real intentional way. But I think that was really fundamental in forming who I am. It has made me very tolerant and accepting of other people, and just having that close relationship—and learning how to negotiate within such a close relationship—has, I think, helped me to be more empathic. It's really helped form who I am in every way.

Of what professional accomplishment are you most proud?

That's a good question. I'm proud of a lot of different things. In several states where I've lived, I have been able to bring together disciplines to work towards unified projects. Here it's been the Durham sexual assault response team. That is our project with law enforcement, medical providers, and criminal justice and social service advocates. We wrote a protocol for response to sexual assault in our community. We have done training with all of the disciplines. We hold conferences and just do all kinds of

different things. Although many, many people contributed to the success of that project, I was really the person who made it happen. I wrote the grant to fund it and before we hired a director I served in that role. In Columbus, Ohio a similar thing happened. I worked for a rape crisis center there, was the director there, and we didn't have a crisis line. I pulled together resources and got funding for the first crisis line that's still operating today. The same thing in Nashville, I was able to pull people together to work on the issue of juvenile crime and juvenile offenders for a youthful perpetrator task force. If I were to die tomorrow, I would want somebody to remember me for the ability to pull people together for a common goal. By no means would I take full credit for any of those things. It takes many people to make that kind of interdisciplinary systems collaboration work. But I was responsible for initiation of them and, I think, leadership of the different projects that were successful. I feel really proud of being able to accomplish those things, because they impacted hundreds of people. There are very few thank-you's in this work, and part of how I feel my thank-you is to see these system-wide changes occur, and see things noticeably get better for the people who we're serving.

And of what personal accomplishment are you the most proud?

Oh, definitely going through thirty-eight hours of labor.

(*Laughs.*) Twenty-eight of those were without painkillers. There's no question that the birth of my son was the single most important, significant event of my entire life. Changed me fundamentally as a human being. I know it sounds funny, because people do it all of the time. (*Laughs.*) It's not like it's some kind of, 'Wooo-hooo! She had a baby!' But it was a real personal accomplishment for me...I mean I did hypnosis, and yoga, all kinds of stuff, in preparation for the birth and felt a huge sense of accomplishment for that experience.

To me it's a 'Woo-hoo.'

Well, people do it every day, but it took all of my mental, emotional, physical resources. It was obviously an enormous success. I didn't do that alone either. I had a lot of help. (*Laughs.*) I was definitely the one doing most of it. That is the thing that I feel the most proud of, is being a mother and having brought this beautiful child into the world.

What, if anything at all, would you do differently if you could turn back the clock?

I would recognize my own emotional and physical limits much earlier and wouldn't have allowed myself to be traumatized or burnt out. I guess "allowing myself" is kind of strong. I don't mean to condemn myself because I was young—I mean, I'm still young—but I was *younger*—and I think that it's a hazard of this work. But that, I definitely would do differently. Along the way there are many choices that I would make differently now—management decisions, interpersonal decisions. Really, taking better care of myself and being more responsive to personal limits. And setting better boundaries professionally—along my whole professional career, not just since I've had a child—would be both the thing that I would change and my recommendation for others. But I think, all in all, what I feel best about is that I have made a real conscientious effort to understand and learn from all of my mistakes. I think that has been a good gift and personal quality that I've had.

What other advice would you give to young women just starting out in a career?

My advice is, get as much volunteer and internship experience as you possibly can in any field that you think that you're interested in pursuing. It's a very different experience thinking about something and actually doing it. I have seen so many of my friends and colleagues go to graduate school and start a career, only to learn a couple of weeks later that they hate it. So, that would be my best recommendation, is to get experience prior to your professional career. And then once you're in a professional career—especially for women, I think this is incredibly valuable—

to find a mentor, to find a supervisor who doesn't just monitor your work, but really helps you grow in your skills and proficiencies.

Do you have any advice for someone your age, who maybe wanted to make a career change?

In fact, I'm thinking of that myself. Not thinking in any practical, planning ways, but I often think about how much longer I will be able to sustain this work. So, no, I don't have any advice. But I'll be interested to hear what the other women in this book say. (*Laughs.*)

I mean, I am always struggling with how much longer I can continue to do this kind of work. That doesn't mean that I'm going to leave my job. But I think it is a constant struggle that people in this field must continue to ask—when does the personal toll outweigh the benefit personally? I think that's an important question for people to ask themselves of any job, and it's a question that I constantly ask myself of this one.

What dreams do you have that are yet to be realized, both personal and professional?

This might be romanticized, but I think that I would love to have a bed and breakfast on the ocean. (*Laughs.*) Right now that's my fantasy. Professionally, my dream is to be in a situation where

I am not doing any kind of helping work at all, but instead being in more of a recreational setting. (*Laughs.*) More relaxing. A place where people come to relax and restore. And then personal fantasies...I would love to have more children. I guess that's more of a goal than a fantasy. I would love to make time to explore parts of myself that I currently don't feel are very activated, like take an art class, or take another dance class, since I haven't danced in a long time. To *make* time, not just find time—to explore how to make myself more well-rounded. So that I'm not just a mother and a professional and a partner, but I also have many other aspects of my life that bring pleasure and depth to my experience.

Interviewed by Susan L. Comer.

Terri *Allred*

Terri Allred has worked in the field of sexual violence for thirteen years and is currently the executive director of Rape Crisis of Durham. She received her undergraduate degree in religion from Wake Forest University in 1988, and her master of theological studies in feminist theology from Vanderbilt Divinity School in 1991. Her first book, *STOP: A Book for Kids with Sexual Touching Problems*, was published in 1997.

"There's no question that the birth of my son was the single most important, significant event of my entire life."

Terri Allred

A Different Path June H. Highfill

My father, who was a high school principal, used to set up lawn chairs in the backyard and wait for another family member to join him in star-gazing and sharing thoughts. Sometimes he would tell us about his life stories. For example, when he was ten years old his friend invited him to church, where they talked about somebody named Jesus. It was hard for me to imagine my dad when he didn't know about Jesus. I think he was a little disappointed that his parents had not taken him to church. But when he told his mother that he was going to be baptized, her eyes welled up, he said. She went to church from then on.

My parents' quiet, open-minded faith was personal and genuine. Their faith journeys encouraged my four sisters and me to take up our own. We've laughed about the unsophisticated blessing we said at meals growing up. But its truth has been the core of all of our theological musings: "God is great, God is good. Let us thank God..."

When I went away to college I participated in an evangelical Christian organization which taught me a lot of Bible and theology. I'll always be grateful for their emphasis on a personal relationship with Christ and the guidance of the Holy Spirit. But,

though their ministry was meaningful to me during college (and probably kept me out of a lot of trouble), in the end I could not reconcile myself to their conservative views of women, scripture, and politics.

I majored in social work because it was the closest thing I could find to church work other than the areas that were open to women in the church, such as Christian education and youth ministry, which weren't where my gifts lay. There were almost no female clergy role models in the seventies when I graduated from college. If I had been male, I'm certain I would have felt a clearer "call" early in life. Even when I enrolled in seminary I still did not think in terms of preaching and serving a church. I went to seminary because I wanted to study scripture in the original languages and because I saw at Union Seminary in Richmond, Virginia, a community of which I wanted to be a part.

Actually, I had wonderful female role models of faith and ministry, though they were not clergy. One was my mother, a high school math teacher, who not only juggled career and child-rearing, but whose quiet, introspective faith and commitment to our church was unfailing. The other was her mother. My grandmother had a wonderful way with people and was put on the church staff in order to put her considerable people skills to greater use. "Mawmaw" (as her nine granddaughters and everyone else called her) visited the sick, was a great storyteller (though she

would never have preached), greeted everyone who came through the front door Sunday morning for over fifty years, and, with the help of the kitchen staff, served up a delicious supper, complete with cake or cobbler, every Wednesday night. While I was in seminary, she would tell me she hoped I would find a nice preacher for a husband. To that I would reply, "Mawmaw, you would have gone to seminary yourself if you had been born fifty years later." Twenty in our class of sixty were women. While many of my classmates were focused on developing skills and a degree and seeking a call upon graduation, I found that I was more focused on who I was and what I believed—after all, it was the seventies! I didn't feel the pressure many men feel to become "the breadwinner" of a family, nor was I sure there was a place for me as a woman in the traditional leadership roles in the church. After my first two years of seminary, I had the opportunity to spend my intern year in Korea teaching English as a second language. The seminary's field education supervisor implored me to take a position in a church instead. He said the training would serve me well and would be valuable on my resumé. But my hankering for a new experience, that of living in another culture, won out over career considerations once again. I enjoyed the community at seminary, but when it came to conversations about degrees, church courts, pulpit positions, and clergy robes and vestments, my mind was somewhere else. Those were the trappings of forming an

identity as a minister. As open-minded as everybody at seminary was to clergywomen, for some reason, I was slow to take on that identity. The avenues I've taken to the two calls I've accepted were not the usual routes taken by my male peers. In fact, I am grateful for the willingness of "the powers that be" (individuals and courts of the church) to open up channels that might possibly have been clogged by resistance to clergywomen.

In spite of my foolhardy inattention to church politics, by the time I graduated from seminary in 1979, I was headed to Pleasant View Presbyterian, a small church in Duplin County, North Carolina. As I used to tell friends, the minister couple who took a church near mine lived "out in the middle of nowhere," and I lived twenty miles from them! And, as I soon learned, twenty miles in the other direction was a young, single, male Presbyterian minister. The first time we got together—to play tennis—I knew Matt was the one I wanted to marry. And we did marry two years later. We continued serving our churches until our son Madison was born three-and-a-half years later.

Our decision that I would stay at home with our son (and later our daughter Hannah) was made in a conversation with my mother. We were talking about childcare while we both worked, and she asked us if we had considered my not working. You would surely think that we had talked about it. But I assumed that my husband felt we couldn't afford less income, and he didn't

want to suggest an interruption in my career plans. The truth was, it was what we both wanted. During my "at-home" years he accepted two pastorates, one in Lillington, N.C., and one in Wilmington at Winter Park Presbyterian, while I supply-preached most Sundays, taught at the Winter Park Presbyterian Preschool where our daughter was enrolled, and worked a few hours a week doing pastoral counseling. Just as Hannah entered kindergarten, Pearsall Memorial Presbyterian on Market Street began its search for a new pastor and asked me to serve as their pastor until one was found. I've been here seven and a half years.

Within a month of my first Sunday, we were faced with a major fire set by an arsonist who was never caught. The congregation was devastated, but we were convinced of two things—the fire was not God's judgment or abandonment, and, in fact, God can and does work for good in all things. Our experience has confirmed that.

I'm sure I can't say that the pastor at Pearsall being a woman has not been an issue. But it certainly hasn't been a big one. A number have joined because it *wasn't* an issue for them. A few have joined *because* the pastor is a woman. We'll never know who's walked away because they didn't even want to consider it. But a given would be that there is a certain level of open-mindedness at such a church. Die-hard chauvinists will go elsewhere.

There are several ideas that regularly find their way into my

teaching and preaching:

1) God can handle our questions and doubts. If it's bothering you, lay it on the table. All God asks is that we accept God's invitation to engage our Creator in conversation. The Christian faith is not primarily about believing the right things (unless it's believing God's good will for all people), but about a relationship with God.

2) If you want to know something about God, you've got to take Jesus of Nazareth and what the church and the Bible say about him seriously. The problem is that the people who scream the loudest about biblical inerrancy and authority seem not to know the first thing about the life and ministry of Jesus. They are quick to judge and they reject people who are not like them, when the very person they claim to follow was nothing like that. My Sunday School class is reading *The Jesus I Never Knew*. The author Philip Yancey invites his readers to join him in taking a fresh look at who Jesus was, clearing away the layers and layers of misinterpretation and misunderstanding that have clouded our picture of Jesus of Nazareth through the centuries. In other words, a fresh look at Jesus is necessary for those *in* the church and those *outside* the church. To think one's understanding of God is beyond reproach is idolatry—the worship of something other than God.

3) The happiness which our Declaration of Independence

guarantees us and which we pursue so eagerly will elude us as long as it is our primary goal. Happiness results from a greater pursuit. This is a primary teaching of Jesus:

"Seek first the kingdom of God and God's righteousness and all these things will be added unto you."

"Whoever loses his or her life for my sake and for the sake of the gospel, will find life."

4) God doesn't follow our rules about who will be called to serve God in the various offices of the church. I love to tell people about a 1992 Kevin Siers political cartoon from *The Charlotte Observer* in which Mary is the first to encounter the Risen Christ at the empty tomb. Jesus says to her, "Mary! You are the first to see the empty tomb, the first to witness the resurrection! Now go! Tell the others about this miracle of redemption, rebirth and eternal life! But don't think that makes you a priest or anything!" Mary was the first to preach the good news, but how many years, how many centuries, was it before the church recognized that God doesn't have to work within our guidelines?

One of the truths of scripture is that God works wherever God works at will, and asks us to be ready to change our preconceptions about the ways in which God will work. In the Book of Acts (Chapter Ten) Peter realizes that God ignored their rule that only circumcised males could be Christians when a Gentile named Cornelius received the Holy Spirit. He didn't think it could hap-

pen, but it did. The wonderful thing was that Peter was receptive to God's continuing direction. It takes me by surprise that the early church *rejoiced* over this turn of events! The Bible is a witness to a living God, not an ancient book of rules and codes.

Not everyone in my congregation agrees with me about the ordination of homosexuals. I understand the difficulty of this issue for our society. But it's not going to go away. I can only say that some of the most devoted and knowledgeable Christians I know are homosexual and in a committed relationship, asking only that the church subject them to the same guidelines for covenant relationships as heterosexuals—monogamy and fidelity.

But I appreciated very much the time an elder defended my right and responsibility to state my views at a meeting of presbytery (the Presbyterian church governing body which directly oversees congregations), even though he does not agree with my position. His understanding of the need for dialogue, however, exemplified one of the most important truths of the church. We may struggle over and disagree as to what the will of God is for us. But one thing we do know—that the will of God is that we don't walk away from each other because we disagree.

You can't judge a book by its cover and you can't judge a church by its size. Pearsall Memorial is not a large congregation. But its perseverance and faithfulness in doing the work of the gos-

pel far outweigh its size. Four times a year we, along with Windermere and Winter Park Presbyterian Churches, open our doors to the Wilmington Interfaith Hospitality Network, providing meals and a place to stay for families who need help getting on their feet.

This congregation has also done more than most congregations of any size in tackling the problem of racism in our community. We and Chestnut St. Presbyterian Church, a congregation whose membership is African American, have gotten together on a number of occasions for worship, meals and dialogue.

I never feel the need to convince my congregation of the gifts and rights of women. Several years ago a little girl drew a picture of me and called it "preacher." (Someone else told me about a young boy growing up in a church with a woman minister who asked his mother if men could be preachers, too.) If girls and boys with experiences such as these have a broader understanding of who they or anyone else can be regardless of gender, it will be to the credit of congregations such as the one I serve, who judge people not by their gender, but by who they are.

"I had wonderful female role models of faith and ministry, though they were not clergy."

June Highfill

217

June H. **Highfill**

"I never feel the need to convince my con-gregation of the gifts and rights of women."
June Highfill

June Hicks Highfill was born in Memphis, Tennessee and holds a B.A. from Memphis State University. She received her doctor of ministry from Union Theological Seminary in Richmond, Virginia in 1979. She held a pastorate at Pleasant View Presbyterian Church in Albertson, North Carolina, and currently serves as pastor at Pearsall Memorial Presbyterian Church in Wilmington, North Carolina.

Her husband, Madison Maxwell, is pastor at Winter Park Presbyterian Church in Wilmington. They have two children: Madison, fifteen, and Hannah, thirteen.

Ann Jennings an interview

Where did you grow up and first go to school?

I grew up in Reidsville, North Carolina, which is in the Piedmont right on the border of Virginia, twenty-four miles from Danville and twenty-four miles from Greensboro, in a little tobacco town. I had a very, very, very happy childhood. I loved Reidsville. My father sold meats for Armor and Co.; during WWII, they didn't have meat to sell, and he found a job in Newport News in shipbuilding. So at Christmas-time we moved.

I was not happy in high school. It was nobody's fault but my own. I had moved from a town where everybody knew everybody, so we got to know the new people. But that was not true in a shipbuilding town that was doubling very fast. And I really was miserable a lot, but it was really my own fault, it was my own preconceived idea. I really felt not liked, because I had not been accepted in the same way I had in Reidsville.

A few years ago we had a forty-eight-year class reunion, and my husband and I went. One of the things I wanted to do was to see how much of those feelings were mine, or was it really some of the rest too? But I was invited to do things. I led the prayer at the big meal. So it really made me know that I had done this to myself. You understand this as you grow older.

I was not going to go to college because I really didn't think my parents could afford it. And my senior high school teacher said, 'You will go to college, and you need to. You have a lot of ability.' I ended up going to Madison College in Harrisonburg, Virginia, where we will have our fiftieth reunion in about a month. I went to college, came back home, taught second grade in Newport News for three years. My family was very, very close. And I knew if I didn't go somewhere else I would be right there with Mother and Daddy all my life.

I had decided this, and had already written about jobs in California. Because I knew I had to go a long way. During my third year in teaching in Newport News we went out to Denver, Colorado to an Association of Childhood Education International Conference. Had the best time. We loved Colorado. We skipped a lot of the conference just to go sightseeing. While we were there, a friend in my group said, 'Ann, are you really interested in moving? Well, if you are, we have to have an interview for our school system in Colorado Springs.' She interviewed me while I was out there and sent me an application, and in a couple of weeks I had the job. I called and accepted it when I got home from school one afternoon. Mama and Daddy couldn't believe I had done it.

Were they upset?

No, no. They knew I was doing this. They wished I had gone somewhere closer, but it was a wonderful experience—it really was. While I was out there I made the decision to go to graduate school and happened to get sick. My doctor told me, 'Ann, you are doing two jobs. Not only are you teaching, but you are so busy in our church that you've got to let one or the other go.' Well, my parents had long thought I should be a director of Christian education, but I wanted to teach. I had already been accepted at graduate school there in Boulder.

What were you studying in graduate school?

The only thing you could really go into then was elementary principal. They didn't have all these other things available. I came back and went to the Presbyterian School for Christian Education in Richmond, Virginia for a two-year graduate course and got my master's in Christian education. I was an educator in a small 450-500-member church in Richmond for five years, and then moved to Charlotte, North Carolina, where I was a director of children's work. That was a large church and I had over 2,000 children from infancy through sixth grade.

Whew. That must have been a challenge for you!

It was. We had three to four classes for every age. It was a challenge, but I had a lot of wonderful people help. And that's

where I met my husband, which was an interesting thing. The church I was in, in Reidsville, my pastor was there a long time. In fact, my parents lived with him. He was not married, and the first year of their marriage, they lived in the manse with him. It was a little town and there weren't many apartments. He baptized me and took me into the church.

My pastor is known for his matchmaking. My husband's first wife had died in January, and so my pastor decided he had a match—that since Diane, my husband's first wife, had come from Reidsville, we would have something in common. So, in July he went to my husband up in the mountains, and said, when you get home I want you to come by and see me.

Now, my husband Wes is a pastor too. And Wes thought, 'Oh, he's got a new church for me.' But that wasn't it. He had a woman he wanted Wes to meet.

So after he talked to Wes, he called me. His daughter, who I had grown up with and who was a close friend, was going to have us over for dinner. But then it turned out my parents were both sick and needed me. I had to leave early from my vacation, which was in the month of October, to go take care of Mother and Daddy. I did not get to meet Wes until the month of November. The pastor invited us out to a cafeteria one day for lunch. And just as soon as we had finished lunch, you know he had business to do. And seven months later, Wes and I were married. In the mean-

time, I lost my mother, who died in April. My father died one week after we were married.

I was forty when I got married. I've always said that I had a very fulfilling life and really had not thought about the fact that I was turning forty. It was getting to what you called the 'old maid' stage. I hadn't even thought of that, since I had a very full life. I've been very blessed. Always loved what I've done.

When I married Wes I had quite a challenge. He had three teenage daughters—eleven, thirteen and fifteen—when I married him. About six months after we were married, we moved to another church and came to Wilmington, to Cape Fear Presbyterian Church. So for about the first year and a half I spent my time with the girls and getting settled from the move and working on our family life together. And then we realized we had a daughter in high school and two others close behind. So I decided that I would go back and teach.

I didn't want to be a director of Christian education because it takes so much time. Teaching does too, but you do have more adjustable hours. I don't do anything halfway, so I knew I couldn't do it on a part-time basis. I was going to renew my certificate the first year. I was taking a course through New Hanover County Schools on Creative Teaching. And while I was doing that people kept coming to me and saying, 'Ann, will you do this?' And I said 'No, I really want to renew my Certificate first.' I had taken a

class of special education at the junior high school level. This was educable mentally handicapped. That was just coming in. The more I talked about it, I realized it was something that would really help many people. And so, I changed my mind and I went to work that year. That was in '70 I guess.

I loved it, but it was a hard job. I had anywhere from fourteen to sixteen mentally handicapped students. I had a self-contained class from the level of first grade or kindergarten up to about fourth. I taught them everything. We had some good times. I still sometimes get calls from a lot of my students who live in town.

My husband, at sixty-two, when most men are ready to retire, felt the Lord was calling him to another church. He had been here twelve years, and he took a job in Greenville at a much smaller church, which was kind of a slow-down for us. It was a wonderful five and a half years. In the meantime, we had bought a house that we never lived in, in Wilmington. We had one daughter who was not married and was living here in Wilmington, and she lived in the house until we moved back. We have now been back here for fourteen years and my life started all over again.

What are you doing now?

When we came back my husband retired. And I thought that meant that he was going to be retired. Not with preachers. He's has had six interims since then.

The opportunity came for me to be a part-time hunger action enabler with the Presbytery. It covered all the way from the South Carolina/North Carolina line, up to Morehead City and then all the way over to Pinehurst and back down. We had almost 200 churches, a lot of them very small. My job was to help them in educating them in projects of hunger and helping them become involved in missions. It was such a blessing. I worked five years in that and learned so much. I directed the Crop Walk for two or three years. Crop Walk is in connection with Church World Service. We walk for hunger. In fact, I think it was one of the first, if not the first, walks we ever had in the country. People used to collect pledges, but now they just ask for donations for hunger. And of this money, twenty-five percent stays in this community, in whatever hunger agency you want it to go to. The rest of it goes to Church World Service, which works to alleviate hunger around the world.

Another agency I learned a lot about and came to respect was Bread for the World, which is a Christian non-profit advocacy group. It was started by Art Simon, the brother of Paul Simon, who was a senator. Art is a Lutheran pastor, and he realized that there was so much that could not be done for our country and around the world in hunger because of the way things were tied up in Congress and legislature. So he started this small-scale, and it has grown and grown. Each year they have what they call an offering of letters that emphasizes one particular thing.

What do you do to relax?

You know, I used to be so that I could not sit down without doing something, but as I've gotten older I can sit down and do nothing. I can sit down and watch T.V. and read. I just don't have to have something in my hands. I guess it's just a part of getting older. I'm tired, so I just like sitting. But, you see, I have felt blessed that these things have let me carry on in retirement.

You mentioned that in high school you found it difficult to fit in and you were unhappy. How do you think that changed?

Well you know, my husband and I have talked about that some and I think that, as I have grown in life, one of the scripture verses that has meant a lot to me is, 'I can do all things through Jesus Christ who strengthens me.' I really think that's been part of my salvation. I think making the move to Colorado was the thing that helped me break away from my family to a more realistic look at who I was.

How did Christianity become so important for you?

You know, you hear people who talk about their conversion experiences. Well I can't say when my conversion experience was. I grew up with a very dedicated mother and father, though

my father was gone a lot because he was a traveling salesman. He came home every night but you never saw him. He'd come in after you had gone to bed and be gone before you woke up. So I never saw Daddy except for on the weekends. Mother was just a very giving, sharing and loving person. Christ was a part of her life. I have always grown up a part of the church and have always loved studying Scripture and teaching. I always loved to teach. So many of the things I've been involved in—even when you are in leadership, you are teaching. I chaired the Board of the Food Bank, and I've loved it 'cause I had such a wonderful chance to help educate other people to what the Food Bank is all about, and to help the Food Bank Board to understand what's really underlying hunger, the root causes of hunger and poverty.

What do you think have been the biggest challenges you have faced?

Well, I have to say, as I look back—the real challenge was raising three teenage daughters.

Did they have a difficult time adjusting?

No. We really did not. We really didn't know each other that well, and that could have been a very foolish thing. I was in love with their father. I had grown up with their mother, who was older than me. And I loved her. She was a dear person. So, I just knew the children had to be OK. We had our problems, but I don't think we had any more problems than if they had been my children. We didn't do everything perfectly as parents. It's a whole lot easier to teach about parenthood than it is to be a parent. I really think that's been one of the challenges. And special education was a challenge all along the way. It took a lot out of me. But when you see people hurting and can understand some of it...it's just a part of you to reach out and help them.

What personal qualities, either in yourself or in others, do you hold in the highest regard?

Commitment. I think some of the things that disappointed me most have been when people say yes, and then don't follow through. I feel a lot of younger people don't enter marriage with the same commitment. It's too easy today.

I don't mean to be glib. One of the reasons this stands out is because my husband and I, even being a pastor and his wife, we haven't had it ABC. We had some problems, and when we retired and came here, we got into a group the first month. They had an open meeting with the Association for Enrichment of Couples in Marriage. We've been meeting with them for fourteen years now, and we meet once a month just to work on our marriage. And we are not the oldest couple. There is a couple older than we are in the meeting. There are couples that are younger. We have seven or eight couples who work in this group together. The idea of

ACME is to help people in good marriages to make them better. If we were all willing to do this, we might not have so many divorces.

What personal quality have you had to work the hardest to overcome?

I get it done but I tend to take on more than I should. Then at the last minute I'm pushing, pushing, pushing. I'm trying to do better than that. Last night I had a good lesson. The moderator of the national Presbyterian Church is a very close friend of mine. We went to graduate school together, and she's coming to Wilmington in April, and our committee is responsible. I was going to have fifteen over for a covered-dish supper at my house. And then the next night I almost found myself saying, 'I can make Brunswick stew for the group.' And then I thought, 'No, Ann, that's two days in a row.' But I love to be involved. I love to do things. I have a husband who is very supportive. He says, 'Sometimes, Ann, I get so mad because you want me to do things with you. And I'm really not sure I want to do it, but you know after I do it, I love it. Why do I feel that way?' He's not as eager.

I call it a gift of God that I am able to be this open and free. And enjoy life. I've been lucky. I've been happy. I've never been unhappy in anything I did.

Why do you think that is?

I think it has to do with the way you look at life. You know, one of the things that has hit me recently is I've had more and more people say, 'Oh, Ann, I'm so glad I met you today. You make me feel happy. You've always got a smile.' That, to me, is something that is God-given, because Lord only knows I've had enough in my life to get depressed. And I do get days of depression. Sometimes I find myself overworked, and when it is finished I just give out for a day or two. But it's just something that's been a part of me. I've never held back. You won't believe this with the way I'm talking to you, but I was very, very shy. I would not speak out in class and things like that. I would never make a speech, even at church in our little Pioneer meetings and that kind of thing. But I took a class in drama in high school after I got to Newport News. And that freed me up so, I haven't stopped since.

If you were talking to a younger woman who wasn't sure what she wanted to do with her life, or an older woman who wasn't happy and wanted to change, what advice would you give about finding their path?

Be open to what comes to you. Look! Don't sit back and just wait for something to come. Explore this. Is this interesting? Would I like to teach school? Would I rather be a counselor? Would I rather be a secretary? Try. Take some classes. Go to night school. You can't wait for it all to come to you. You have to

be open to speaking to people.

Is there anything you wish you had done differently?

I was engaged several times, but they were a little hurried. And there's some things with our girls—I wished I could I could have been more open than I was, but it was the newness on my part. Our relationship has grown so that we are able to be open and free. And it's very obvious with the youngest child, because she was the one who needed a mother figure the most, and we've always been very, very close and still are.

You've done so much, is there anything that you want to do that you haven't done yet?

About five years ago, a friend of mine said, 'Ann, Wes ought to retire and you ought to do some traveling.' I said, 'Well, you know, Wes is a homebody, and if I were really going to travel I would love to go see some of the church work around the world.' Well, don't say something like that if you don't mean it. I had been to Haiti before, when I was a hunger action enabler. We worked with an agricultural school in Haiti. I took the first group over there, and they've been working over there for ten years. Then, within the next two years, I went back to Haiti for a week, I went to South Africa for two weeks, I went with a Presbyterian church from Greensboro and we went to visit a black Presbyte-

rian church in a former black township, which was a marvelous experience. And then I got to go with the Church World Service to Honduras.

I would like for Wes and I to have some opportunities to do this together and he's beginning to get interested. He has always loved the cathedrals. So he surprised me—he's wanted me to plan a trip, and we think we are going to go with some of his former classmates. He just had his fiftieth reunion from graduating from seminary. So we're doing a lot of celebrating.

Interviewed by Emily A. Colin.

Ann *Jennings*

Ann Powell Jennings has worked in the field of education most of her life. She was single until she turned forty. Today she is a wife, mother, and grandmother volunteering in her retirement years in many endeavors that work to empower those in need.

"It's a whole lot easier to teach about parenthood than it is to be a parent."

Ann Jennings

Ellene Van Wyk an interview

Where were you born and where did you grow up?

I was born here in Beaufort County, near Bath, the oldest town in the state. I also went to school there and had a real good life growing up with Christian parents.

What are your vivid images from childhood?

We worked hard in the fields. My dad, in earlier years, was a carpenter and helped with the land development in Terra Ceia as the carpenter and the blacksmith. So I have a rich history in the soil as well as in the home. My mother was a very devout Christian lady—an organist in the church—and we grew up in the church. My dad was a Sunday School teacher for forty-five years of his life, so we had a good exposure to that. And, growing up, there were six of us in the family. I don't remember ever being bored because we had chores to do. When we came home from school, we did our chores first. There was no trying to get children away from T.V.—as it might be today—to do a little job around the farm. We knew that was something that was necessary to be done. And when that was finished, we got the chance to play the piano. I took piano lessons in my early youth for ten years.

So we had a rich family life. We all worked together and helped our parents a lot because it was a chicken farm. We helped my dad with everything that was connected with that. And I guess about the time I was born, he decided to build a little country store. To this day, I don't know how he survived, because on almost every corner, there were other little country stores. No one ever went to town to buy anything unless it was quite needful—things that we couldn't get at the country store.

Did you work at the store?

Yes, I did. My mom helped in there, and all of the children—when our chores were done. We had tobacco fields, and I really grew up on a hoe handle, I guess. (*Laughs.*) And I still love to do hoeing in my flower gardens. I think we were all taught to work very honestly. It wasn't that parents had to keep reminding you to get that job done—you did it because you knew it was important for the family chain to survive. But, yes, I worked in the store and enjoyed that—I enjoyed meeting people. And just a very large variety of jobs that you were able to do when you grew up on the farm in those days.

What were your crops?

My dad grew some corn, and we hoed that stuff about—I

don't know—if we saw a piece of *grass*, we went through the field again. (*Laughs.*) He had soybeans and that big tobacco crop, but it involved all the children helping take care of it. And in those days, too, if you had neighbors that also had the same kind of crop, like tobacco, you swapped labor. If their children would help you, then we were encouraged to go help the neighbor families. And that's something else you don't see that much of today.

Were you also involved in the flower-growing that went on in your area of the state?

That came later in life. I've always, *always* loved flowers. I married a Dutch guy who had a flower farm—whose father was in the flower business—and we had 120 acres of a variety of flowers. So when we got married, I just went right into the flowers and helped in the fields and helped manage the crew. I always said, 'If you work along with your laborers, they do a much better job for you, because they know that they're not gonna goof off. And you won't belittle them in any way—you'll just be working along with 'em.' I thought it was an encouragement to them to keep working that way. And I enjoyed it, too. It was very nice. We started with the daffodils and the tulips and the Dutch iris and the peonies and, in earlier days, we had the glads and dahlias. And first of all, we had some greenhouses, but they were not very profitable, so we got out of that and went more to the crop-farm-

ing of the flowers outdoors—seasonal.

How old were you when you got married?
I was almost nineteen.

And how did your flower business evolve over the years?
Well, we survived with really good help—good honest help—from mostly the neighboring ladies that came to work in the flowers. This farm was originally a thousand acres and, as the parents got older, we took on more responsibility, my husband and I. When they passed away, the farm was divided into three equal parts for their children. So we kept on farming and they have their share. We rent part of the brother's land, and the sister has her own property now and she takes care of that. But we kept on with the same kind of farming.

And as labor prices increased, we just felt the need to cut down on the flower production. Everything you did had to be done by hand. The flowers were cut in the field and shipped. And sometimes, in the daffodil season, we would have like ninety-nine people on the payroll. They would pick a dozen flowers for one penny, and we would average maybe fifteen cents a bunch sent to the market in New York—and refrigerated trucks had to take them. 'Course the cost of living was less back then, so the *labor* was so much less. I think at the time we decreased with the

flowers, the labor bill was like $3.50 an hour. And, now, if you were to hire someone, you'd have to pay like $6.15, I believe it is—the minimum wage. We held on to the peonies as long as we could, and we still have an acre of daffodils that we gave to our daughter who lives most close by. She picks them with her children and holds down the labor price, and some of them go out Raleigh way. They're a little more local than the flowers that we were shipping. We'd ship like a big truckload the time of the peonies and 'course the daffodils—we had about forty acres of each, maybe twenty of the tulips. But when the labor bill got so high, we said, 'You know, we aren't making any money on it. We'd better scale back and just go to all corn and soybeans and a few cattle.' So gradually we got out of the flower business.

When was that?

I would say about twelve or fifteen years ago.

But you still farm?

Yes, we do. We still have the corn and beans, but we're getting older. My husband is now seventy-three, and I'm approaching seventy in a couple of weeks. He farmed the land with one faithful colored man who worked here fifty-three years. And when he got a little bit feeble—and later had cancer—he had to retire, so my husband did our share of the land plus the rented land from his brother which came up to like 500 acres. He did it by himself, and I don't know, to this day, how he did it. He was almost day and night trying to plant and cultivate. Back then, they didn't use as much chemicals as today. He tried to hold things together, but he just had to consider renting.

So he is growing hay more now. We have probably about fifty acres of hay that we have customers coming for—a lot of horses in the area, a lot of pleasure horses—and not as many cattle as there used to be. And we do rent out most of the farm. It just got to be quite a burden, to be that consumed in trying to keep the land tilled, and our age got with it, too. Over the years, he's made a lot of his own machinery in the way of plows and that type of equipment. And there's always maintenance to do as well, so that was one reason that he had to cut back on that type of living.

How do you spend your days now?

We have twelve grandchildren. Six live nearby, and some of those are off to college now. And I stay pretty busy. I never know a dull moment. I have been involved in music all my life—a very rich, rewarding experience helping children learn to play the piano, and also I was church organist for forty-six years. I did seven years of the music program at the Christian school that's nearby—that was a volunteer-type thing. And I led choir for twenty-eight

years at church. But I kind of scaled back. I still will do weddings and funerals.

And I am just finished with doing 'The Messiah' at the church. It actually started with our choir, and we've got over twenty churches involved in it now. I'm the overall coordinator of that, and we presented it Easter Eve at the church, so that's been the highlight of my life for eleven years. (*Laughs.*)

I also help my granddaughter with her violin lessons. Sometimes she has problems with her counting. She had a recital last week, so I spent one afternoon—five hours—helping her, so she would be familiar with the music that the pianist would be playing. Like I said, I never have a dull moment in life.

You were able to get your granddaughter to practice violin for five hours?

Yes, ma'am! She was in a crunch to get it done. She'd been busy—see, we also have a symphonia that plays with our 'Messiah' production and she had been playing in that for probably six years and was really busy with that. So the week after 'The Messiah' was finished, we went right into helping her get her recital work done. She has another recital coming up, so I guess I'll be involved with helping her. (*Laughs.*) And it's fun, you know, having the grandchildren one-on-one. I also teach piano to the other two little grandchildren that are around, so I stay kinda busy.

I enjoy baking. I enjoy my yardwork, although some of that is curtailed now with arthritis that bums in on you when you get older. But I can put in a few things, and my little grandson will come and help a little bit around the edges of the beds. I love to garden, not so much vegetable-gardening anymore—although I put a few vegetable plants here and there in the flower-bed just to feel like I've got a garden, you know—but I do enjoy pretty flowers.

So I really don't have any spare time. I enjoy doing things for the people that are sick—make a pot of soup and bring it over, or something like that. Maybe it doesn't sound like a very valuable life to some people, but to me, it's one that's been very rich—and helpful to other people. And I just hope and pray I can keep on, as long as I'm able.

Sounds like a pretty valuable life to me.

Well, sometimes when you've been down yourself, you have to look up, and you learn to appreciate what people do for you. And that way, you kinda want to reach out and help others, too. My life has always been caught up with other people, you might say. I learned it even in the store, helping out with my dad. And being in music all my life, you learn to deal with a lot of different types of people. It's been a very rich and rewarding experience to be somebody who's useful, as much as I can be.

What do you consider to have been your greatest life challenges?

Well, I think raising my three children. That's a challenge for anyone—to raise children. We worked hard to send them to a Christian school, so that was a sacrifice right there. And I was always here for my children. I think that's so important. I know today is a much, much different story, that most parents have to be out working. We were both working too, but it was a different way—we were here together.

And challenges sending all three off to college—it was a real sacrifice to do that. They had loans and some grants. And the loans, we helped the children pay them off when we got, you know, a little bit better ourselves. It always seemed like we had a very limited budget because my husband Case was working for his father, so they got a big percentage of the farm income. It just seemed like every time I saved up twenty dollars, one of the children would get sick. (*Laughs.*) And so here we go to the doctor again to take care of that.

But it's very rewarding. The children have all grown up and are able to teach. Our son teaches in Albuquerque, and our daughter is an art teacher in Michigan. Well, with her six children, she's more substituting these days and helping some special-care students until some of the children get a little bigger—she's got two in college. And another daughter lives about a mile away. She's also an elementary teacher and also has six children. Her husband passed away eight months ago—just fifty-two years old—

and she is more or less filling out the year with some substitution at a couple of schools real close by.

What is the age range of your grandchildren?

Twenty-three to five. And we have two great-grandchildren. One is almost two and the other one is eight weeks old. So we find great pleasure in the children that are around here. Of course, we keep in close touch with the ones that live away as well. That's what a family unit is all about, keeping in close contact.

When you were a child, how did you picture your future? Has life turned out as you envisioned?

Well, growing up in those days, I just took it a day at the time. And, like I say, we had a real wonderful rich family life. With six children, you're always busy. A couple of the older sisters had gone to college, and I kinda had one sister as a hero in my mind. She was a home-ec teacher, and I had always thought, 'Well, now that would be a nice field to go in,' and she had taught me a lot. You know, when you have that hero, you look up to them and think, 'Well, maybe someday I'd like to be like that.' And I still adore that sister. She's still alive.

And then I thought, 'Well, maybe, I should just go into music.' About that time, I was fascinated with the North Carolina Symphony and going to the student concerts. Then as I got older,

231

I worked for the symphony to come to the county. And I thought, 'Be nice if I could be a concert pianist,' and I got some of the works that a young girl had had. We lived in Washington—she was playing with the orchestra when she was ten. I thought, 'Well, I can do that,' and I got the work—it was Haydn's Concerto. And I did—went right through it with my music teacher. But, somehow, I don't know, I just went whichever way the Lord led me. And then, of course, when I met Case, my husband of almost fifty-two years now, then I was very fascinated with *him*, a very strong Christian boy. And I just never had any high ideals. I have tried to fulfill whatever came before me. Like you said, life is a challenge. I still am very active in music, and that fills a lot of void in anyone's life, I think, to be useful—to help with anything musical that comes along. We attend the concerts, Beaufort County Community Concert Series—we go out for that. And I just enjoy every day. I can't really describe it to you. I didn't have any further goals beyond living each day to the fullest that the good Lord gave.

Is it hard for you to believe that you're turning seventy?

I can't believe it! I think somewhere I must have slept for about twenty-five years, you know. And people look at me and they can't believe it that I'm still able to do so much. I have a lot of health problems, but I overlook it and just go *do*. And like with

'The Messiah,' too—people just can't believe that I'm able to get all that stuff organized and to still be able to do it. I say, 'Well, I'm thankful for every bit the Lord has given me and, as long as I live, I will always seek to help somebody or to help with this production as long as I can.' I think to have a good mind, to be blessed with a good mind, for so long, is really something special—it's a special gift.

What personal qualities do you consider to be of most value in life?

To live honestly. I think that's almost like a virtue, don't you think so? And to be loving to people. But I think the bottom part of anything is honesty. If you try to cover up something, you're gonna have to tell another lie to cover up something else, and I think if you were working, if you didn't work honestly, it would eventually show up. To be really trustworthy has been a goal all my life. I think I learned that from my mom and dad. We helped take care of our elderly parents for twenty-five years. I would go over to my dad's place and take care of my mother. We took turns. There were four of us helping out, but we were there day and night. And after she passed away, my dad said, 'I don't know what I'm gonna do,' and he was in tears after the funeral. And we said, 'Listen, you're still here. We will still come and help you just like we did when Mama was alive.' So we did that and he lived another fourteen years.

And, in the meantime, my husband's parents lived next door. They were getting feeble, so we helped with them—and sometimes we were helping two of them at the time. But, I mean, that too, made a big imprint on our lives—to be with them and to talk about the olden days, how *they* had sacrificed to raise us even in the Depression years. To me, it's just a life of gratitude and a deep appreciation for what's been done before *I* came along and for all my life. So that's a good summation, I would say.

Given the fact that you've been the wife of a Dutchman all these years, do you enjoy the Dutch culture?

I highly respect that. I think they have quite a heritage. But, you know, the community has changed over the years when so many of the older ones have passed away. We still have a close association with the original Dutch family that was here. We have supper with them, mostly in their homes. We will go after church and have coffee. Last night, they invited us for a little sandwich and coffee. And we enjoy talking about the older times when things were settled here and the struggles and all the years of trying to build up the community. I have a high respect and a high regard for those people that sacrificed so much—you know, they left relatives, and I think there was a space of seventeen years that my in-laws did not see their relatives during the war-time. Can you imagine not seeing your relatives that long? So yes, I

kinda grew into it. I can understand *some* of the words that they say. I don't think I would try to speak any of the words, but I would know what they were speaking about if they had a conversation.

Does your husband speak Dutch?

He can. If there are visitors in the community that stop by, he will do some Dutch. But he isn't that comfortable with it anymore.

What is your proudest accomplishment in life?

Oh, dear. I've been a faithful mother—I'm thankful for that. An honest faithful wife—I think that's a great reward. If you've ever read Proverbs Thirty-One, 'A Godly Woman,' that's been a goal of mine, and I'm not done yet. As long as you live, you've got that vision of trying to live the life of a Godly woman. And I think that gives support and encouragement in almost anything that you do.

When life's troubles and disappointments come your way, where do you go for inspiration and renewal?

I go straight to the Lord. Of course, I've got my husband to talk it over with. I'm still blessed to have him. He's been good to me all these years. And we have a real good minister who's a

strong support. And friends. I was on the phone this morning for about an hour with a lady who was disheartened. And if she gets that way, she'll call me. She'll always say, 'Oh, Ellene, I don't know what I would've done if I hadn't called you today.' And it's just to be there and to listen, a lot of times—to help friends. And they have helped me already. So that's mainly who I turn to.

How do you think you and your husband have been able to sustain a marriage for so many years?

It's only with the Lord's help. You know, not every day is a rose bed. But we have been able to talk and have a clear under-standing about things. And we're faithful in church. If we do have a problem, we talk it out. I think that's where it has to begin, right there—take time. That's such an important thing. We're here for each other, and we just thank the Lord every day that we've had these many years together.

How has your life together evolved since the days when your children were home?

It was busy then—very busy. Well, like I say, we're still busy. He still has his cattle to tend to and things around the yard—he's out working in the yard right now. And I really stay busy, but we do most of our things together. We go to town together—and we just don't run to town for any little thing that might run out in the house or something that might break down on the farm. We kinda compile our needs together and just take care of them when we go to town.

How has your relationship changed as you've gotten older?

It gets greater all the time. I mean, that trust and bond is there—it's never wavered. And I think I can say the stronghold of the marriage is our faith in God.

Is there anything that you would do differently if you could turn back the clock?

I wish I could have my children back home, if anything. (*Laughs.*) I wouldn't want to start life all over again because we've got all these pleasant memories, but I would enjoy having the children back home like they used to be. (*Laughs.*) But, you know, we've gone on with them and enjoy the grandchildren a lot, and it's a joy and a blessing to see them do well. No, I wouldn't want to turn the clock back, honey, no. Let's go on.

At this stage of your life, do you find it difficult to relate to younger generations?

I can relate to people of all ages. Most of our friends are ten years older than we are and it's always been that way. But I just take time to especially talk with the little children. I think that's

real important not to have a generation gap—to be able to relate to people of all ages and invite them into our home for coffee, cookies. And just be available to greet them wherever you see them. Our church is pretty active and close and you have a wonderful opportunity of outreach regardless of *where* you go. Wherever you meet people, be loving and friendly. It doesn't cost anything to say 'Hello,' and that kinda opens up the channel. I just enjoy people of all ages, I really do. But I have a very tender spot in my heart for widows. I try to be very loving toward 'em and, at least once a month, I'll have two or three widows over for Sunday dinner. It doesn't take much effort. They say it doesn't matter what we eat, if it's just a piece of bread—just the fellowship means a lot.

What are Sunday dinners like at your house?

Well, I'll tell you, I've changed over the years from a whole lot of cooking to crock-pot! I use the crock-pot a lot. I'll put a roast in on Saturday night and maybe roll up some potatoes in foil and stick in the pot before I go to church, because we have early services. And maybe on Saturday, I'll prepare a little salad. And a frozen vegetable. There's nothing fancy—it's just a little meal together. But we always have a good time, especially when I have the widows over.

Do your children come for Sunday dinner?

Sometimes, yes. They're kinda busy with their own activities with friends. Yeah, I invite them over, too. And of course, we're always together Christmas and Thanksgiving. It's harder to get them together when they live farther away. I never know anymore when one might walk in the door from a mile down the road, but I keep the checkers games on the table and we take time to play a game of checkers or have a glass of tea together or ice cream, you know. They're always popping in. So now you know why I don't get bored!

What has your life on the land as a farmer meant to you?

· I've always appreciated that. My husband has always said, too, that it seems like you live close to God when you're on the farm working with the soil. And I kinda feel that way when I'm out in my garden too. It's a kind of freedom—and away from all the rush and the busyness. You just take time to enjoy the beauty of nature. We have a lot of animals around the yard, especially in the bird category. (*Laughs.*) And we do not live by the busy highway—that would be a distraction for sound. We're right in the middle of the big farm. You can look a half a mile or a mile either way, and it's just beautiful solitude. And yet, you're within reach of other people. You can see the highway. But, I don't know, it's just a real peaceful life. Can you imagine living where I live?

In my yard too, there's always some kind of flower that's bloom-

ing, and the people that come up to see me—I usually share about five truckloads of multitude every year. I say, 'The more I give away, the more I get.' And there are people who are always starting new flower-beds, so they'll take along bagfuls of it. (*Laughs.*) I just sent three bagfuls up to Chapel Hill to my niece who's a doctor there, just starting a new yard. And I happened to have some flowers from my mother. I like those flowers that I get hand-downs. And I said, 'Oh, this is from Grandma. Would you like some?' 'Oh, please!' (*Laughs.*) So then I'm able to thin my bed out a little bit. But there's just always so much to share. And people always say, 'Oh, I wish *I* lived here.' But, to me, it's just been my life all these years, and I've always been very happy to be here.

What does it mean to you to be a North Carolinian?

Oh, honey, I wouldn't want to live anywhere else. We've been to visit the children and other places, but it's just heaven to get back here. And I'll have to tell you something my dad always said. He was thinking in particular of the children that have been to Michigan and made their home there, and all that snow they deal with every winter. He said, 'They know what we got here, and yet they go there and live in all that snow. They know how good it is *here*. I can't understand why they want to be *there*!' (*Laughs.*) Sometimes I feel that way, too. It's a great state—it really is. And last night, we had something on TV, and I heard little tones of the

state song-'Carolina! Carolina! heaven's blessings attend her.' Back in the schooldays, we had to learn that as one of the requirements. And it's a beautiful song, 'The Old North State,' it's called.

What are some of your favorite things?

I'm very fond of classical music. I listen to the public radio station—New Bern—just about all the time. I put it on when I get up, and if it gets a little bit out of my category later on in the day—there's a time when there's jazz; I'm not that particularly fond of jazz—I'll turn it off. But by nine o'clock in the morning, I'm listening to good music. My children know that I like CDs, so that's often the gift at Christmastime.

I like to collect little spoons—little demitasse spoons—and of course, I gotta keep 'em clean too! But that came as something I enjoyed on our trip to Holland one time. When the children were still home, we all went to Holland. And so if I see a cute little spoon, even with 'North Carolina' on it, I have collected those over the times.

I love to cook—I've always loved to cook. I love to bake. I just enjoy everything. (*Laughs.*) There's a few jobs I *don't* enjoy—I don't enjoy ironing anymore. But, I mean, that's nothing historical. You just cheerfully try to do your jobs, you know.

I have more recently enjoyed collecting little music boxes. My little granddaughter has a special interest in that and she gave

me one for Christmas. I think those are real neat little things to collect. My house is full of all things, and I always tell the children, I say, 'I didn't *buy* any of this stuff. It's all been given to me as gifts.' When you have given piano lessons for forty-five years, you're always getting gifts from students. And I put 'em up. It probably looks like a little zoo around here. And they all have to be dusted every week! I try to keep my house the best I can.

When you do something special just for yourself, what do you do?

Just for me. I don't know, I'm always thinking about others first. I would say maybe go to the nursery and get some more plants. That's what we did Friday—went and bought another rose-bush and a few bedding plants. I don't consider myself that important, to take a lot of time for my own pleasure. I want to do things for others.

That's what brings you pleasure.

I think so, I think so. I always take time in the morning to send cards out to people that are sick or had surgery, or sympathy cards. I spend a few minutes every morning just doing that and praying for friends that are in need. And it comes back to you in strength. I also send the cards for my Bible Study group. And just to think about others, I think. My own self is so insignificant.

When you have been sick or had surgeries yourself, and friends pour their love out on you, you want to somehow remember that and do the same for others. And that was a feeling I had when we were younger. We had servicemen come to our home and spend the weekend so they could go to church with us. Our churches were the only ones of that denomination in the whole state. So we would shove over and make room for a couple of servicemen to stay. I always hoped that when my children went to college, that someone in Michigan would maybe take time to give them a Sunday meal. And it did happen. So it's just a return of gratitude, I like to say.

What dreams do you have that are yet to be realized?

I see these little children and I just hope that I can be here to share my faith and to encourage them along in life, especially the ones that have just lost their father. There's a ten-year-old girl that has spent a lot of time with me and an almost-thirteen-year-old boy and then this eighteen-year-old girl just going off to college in the fall. I just pray that I'll be here to help them along—not so much financially, but as a way of showing what my life's been made up of. I know the financial part has to come too, but so far the Lord has been taking care of that. But I see such a need to help others along the way, and if I'm given the health and the strength, that's what I'll be doing—I'm sure of *that*. So that would be my goal in life, to continue, to be able to continue. And to

enjoy this wonderful world the Lord has given us here—do what I can to try to make it better.

What will you do on your seventieth birthday?

My seventieth birthday. Let me see, that's on a Wednesday, I guess. I really haven't thought that far ahead. I know I have a doctor's appointment. (*Laughs.*)

It's two weeks away, right?

(*Laughs.*) Yes! I don't know of anything significant. My two sisters-in-law usually make two cakes, and I'll have the family in. And probably I'll have some of the widows the Sunday before to help celebrate, so we'll use one of the cakes for that day. And it'll be just mainly family enjoying each other. I don't plan to go away or anything. I find great contentment with what I have and being here to share it with others. Does that sound like a birthday party? Last year I had thirty-six cards on my birthday. I'll probably get a multitude of cards again, and I enjoy that. And phone calls, after I get back from my eye appointment. I always like to plant a few flowers on my birthday, too. I can remember when I planted 'em. I usually plant some bulbs on that day—caladiums, I like to plant those on my birthday—watch 'em grow.

And do you remember which birthday the flowers were planted on when

you see them?

Not really. (*Laughs.*) 'Cause each one has its own little story to tell. But I know that's just a seasonal thing, and in the fall I dig 'em up and plant 'em again on my birthday the next year.

Interviewed by Susan L. Comer.

Ellene *Van Wyk*

"I don't consider myself that important, to take a lot of time for my own pleasure. I want to do things for others."

Ellene Van Wyk

Ellene Van Wyk was born in Beaufort County near Bath, the oldest town in North Carolina. She graduated from high school in Bath as valedictorian in a class of fifty seniors. As a child, she worked in her father's little country store and on the tobacco and chicken farm. A member of a very musical family, Ellene has been a church organist for forty-six years, a choir director for twenty-eight years, and a music teacher for seven years.

She and her husband Case are proud to head a family of three children, twelve grandchildren, and two great-grandchildren. They enjoy life on their farm in Pinetown, North Carolina, where they have lived since they were married almost fifty-two years ago.

Each day, Ellene is reminded of God's goodness and providence in her life.

Sylvia Hatchell an interview

Where did you grow up and where did you go to school?

I grew up in Gastonia, North Carolina and I went on to college at Carson-Newman College in Jefferson City, Tennessee. Soon as I finished there with a BS degree in physical education, I went to the University of Tennessee and got my MS degree in science there just the year after. I finished college in '74 and graduate school in '75.

Talk to me a little bit about what career dreams you had as a child.

Well, I've always loved sports. Even as a child I played everything, it just depended on what season it was. Of course, back then it was basically football, basketball, and baseball. Soccer wasn't that big at the time, and tennis was just coming on pretty much. I always wanted to do something with athletics, so I went to college and majored in physical education—and, of course, on in to graduate school. I actually taught classes when I was in graduate school. Then I went to Francis Marion—it's a university now, it was a college—it's Francis Marion University in Florence, South Carolina. Straight out of graduate school I went down there. They had just started a women's basketball team the year

before and it was a pretty new school. It was established in, I think, '71 and I went there in '75. It was a really good situation and I was just very fortunate to have some really good players from the very beginning.

What have been your greatest challenges along your path to get where you are today?

Well, a lot of them are the challenges of Title Nine. Now my assistant coaches, I tell them, 'Look, you know, I've paid my dues,' because when I first started coaching I used to wash the uniforms, sweep the gym floor, drive the bus—you know, if it got done, I did it. Now those things are all taken care of. We have people to do all of those things for us. But, like I said, a lot of the Title Nine challenges as far as opportunities and budgets and resources and finances—all of those types of things have been a real challenge and it's fun to see where we are now. And again, lots of times I feel like our players have too much—many times, they don't appreciate what they have.

Tell me the story of how you went from Francis Marion to Carolina.

Well, I was at Francis Marion eleven years. I was fortunate, like I said, to have some really good teams down there, a lot of good players and staff. Just good kids that worked hard. Because I went to a university that was a young school and had just started,

I actually had some advantages Title Nine-wise. Because we'd just started up, they gave the women a lot of things that the men had. There wasn't a precedent set there as far as having to take anything away from the men to give to the women. I was in a pretty good situation with facilities and some opportunities and stuff, so we were pretty good right off the bat. We played a lot of the bigger schools and we usually beat 'em. I was fortunate that we won two National Championships when I was there. We won the AIAW Division II National Championship in '82, and then we won the NAIA National Championship in '86. That's when I came to Carolina—in August of '86.

And how did that come about?

Well, we had had good teams at Francis Marion. I'd won that one championship and in '83, '84, '85—that's as a lot of the Division I schools were really starting to put money into women's basketball. I had a lot of people after me. I had a lot of bigger schools call me to come and look at their situations and all. I actually looked at Indiana, Florida, Texas A&M, South Carolina. I'd go look at them and I thought, 'Well, this is a big-name school,' but except for the budgets, my program at Francis Marion was a whole lot better. I knew I could have stayed there and been very happy. But I also knew that if I was going to stay with the game I needed to move to a Division I school, so I was actually waiting

for the right opportunity. The fact that I was from North Carolina and I grew up a North Carolina fan—this was my dream job. This is where I wanted to be. When the job came open, it was sort of like it was meant to be. Here I was at a small school and they interviewed five people when they hired me here, but the other four were all already Division I head coaches. So, the fact that I was able to come in and get this job was pretty much a miracle. But the fact was, my attitude when I came in—I wasn't negotiating for what you're going to do for me. I told them, 'Look, I just want the job. I don't care what you pay me. I want the job.' And I think my eagerness and my passion to be here is what helped me get the job.

How did you find out it was open?

Actually, whenever South Carolina was after me the year before—I had gone over there and interviewed—and one of the reporters asked me in the interview afterwards, 'If you could have any job in the country, what would your dream job be?,' and I said 'University of North Carolina.' So, whenever this job came open, it had just come over the wire, and one of the reporters—I was friends with a lot of them—one of the reporters called me at home. 'Sylvia,' he said, 'are you sitting down?' And I said, 'No.' He said, 'Well, sit down. I've got something to tell you.' So I sat down and he said, 'University of North Carolina, the women's head basket-

ball job just came open.' Anyway, immediately the next day I was talking to them and I came up and interviewed. It just seemed like it was meant to be.

What were you doing when you learned you had the job?

Well, that was a busy summer because that spring we'd won the National Championship and then that summer I was assistant coach for the World Championships and Goodwill Games. So, I had gone to train with the World Championship team and we had trained in Colorado Springs—the Olympic training center—we'd gone to Russia and played over there in the World Championships and all. We'd won and everything and then we were going to come home for ten days and then were going back for the Goodwill Games. So I came home and during that ten-day span I interviewed and actually, they offered me the job. The day they announced that I was going to be the new coach—they announced it at 4:30 or 4:00 that afternoon—and as they announced it, I was on a plane going back to the Soviet Union. So, I wasn't even here when they announced it. I was over there for another five or six weeks with the United States National Team and we played in the first Goodwill Games. I wasn't even back here until September—it was actually the first of September when I got here. It was a busy time, but just coming home during those ten days is when everything happened.

As far as coaching through the years, what is easier for you now and what's harder?

Well, I think easier...I think I'm probably a little more flexible as far as different situations and the way I handle things. Everything's not just rigid, black-and-white, my way or the highway type of thing. I think, probably, that's not from mellowing but from maybe getting a little older and wiser. Probably the hardest thing is that young people are different—they've changed a lot. I've changed because I'm getting older but I think the younger people have changed a lot, too. The hardest thing for me is, I'm a very focused person, and many times the goals and aspirations—the things I want for them—I know with just a little bit of effort and focus and commitment, these things are there for them. But the goals and the things that I want for them are not necessarily what they want. A lot of it is because of the age they are, other interests, social pressures, family situations. A lot of times it's just hard for me to accept when they don't want what I want for them. That's probably the biggest thing right there. Sometimes I just know they're making a mistake and down the road they're going to wish they had wanted the same things that I wanted for them, but I guess it wasn't the right time in their life for that. I've had many of them come back and say, 'I wish I had listened to you,' or 'I wish I had done this or that,' but sometimes you gotta let them make some mistakes. That's difficult, because I learned a long

time ago to listen to people that had been there and done that, and they can help you keep from making a lot of mistakes. I tell my players that all the time but you know, they feel like they know what's best for themselves and so sometimes you just have to let go of what you want for them.

What aspect of coaching is most gratifying for you personally?

Seeing them grow and develop—not just as players, but as people—because it's amazing. From the time they come in here when they're eighteen-year-olds to when they graduate and leave and they're twenty-two, the way they change is just incredible. Of course they improve tremendously as basketball players, but also the way they mature and grow mentally, emotionally, physically, spiritually—everything—just in all aspects of their lives. It's a lot of fun to see the differences in that four-year period that they're here. A lot of it is the impact that we have on them. Our program, the way we train them—the structure, the discipline, the priorities—those types of things that we instill in them, and the influence that we have on them is just unbelievable.

When you have disappointments, or in times of strife, what are your sources of inspiration or renewal?

Well, I'm a Christian. I mean, I'm not a fanatic, but I'm a Christian. So basically our program—I base pretty much every-

thing we do on a lot of Christian principles—but yet, they're good lessons for living. How to deal with people and how to keep your priorities in order, because you gotta have a balance, not just physically but mentally, emotionally, spiritually-everything. I'm married, I'm a mother, so I just try really hard to keep things in perspective. I just teach my players to treat other people the way they want to be treated and usually things are going to work out pretty good.

For the people who will read this who may not know very much about sports, describe for me a day in the life of a coach.

(*Laughs.*) Well, it depends on what time of the year it is, because it varies. During recruiting time you're on the road, you know, in a different state every day—visiting schools, going into the homes, getting to know the recruits and their parents and all. During the season, early in the mornings we may have workouts at 6:00 in the morning, and then usually I take my little boy to school—he has to be there at 8:00. Then I'm back in the office by 8:15 and I have usually in the mornings a lot of meetings and just a lot of office work—phone calls, reporters. I have a staff meeting every day during the season—my staff meets for an hour and sometimes two hours. Usually we finish up around lunchtime and then, again, returning those calls I had during our meeting and all. We usually practice around 2:30, so about 2:00 I'm

starting to get ready for practice. If it's weights, we have three days a week, and sometimes it's 5:00 or 5:30 before the time we finish practicing and it may be later than that if it's a lab day. I have a lot of speaking engagements. I do a lot of that at night, and also on the phone a lot at night with recruits. We have study hall for our players at night, so I'm checking on that a lot of times. I mean, there's many nights that I'm here—like last night I was here at 11:00. So, it just depends on what time of the year it is. You know, if I got paid by the hour I would be a millionaire—without a doubt. But it's got to be something that you love and have a passion for, because you're not in it for what you get out of it, really. It's not a job, it's a career. There's not any set hours, you've got to get the job done to be successful.

Well, switching gears a little bit, tell me about your family.

My husband is also a basketball coach and he is at Meredith College in Raleigh—it's an all-girls' school. They're Division III and he's an outstanding coach. They win twenty-plus games every year and he's also a professor there in the Physical Education Department. So, we have a lot in common—we're sort of eaten up with basketball. But, he also likes music and he plays instruments and he plays in a band—that type of thing.

We have one child, he's eleven years old and he plays sports, but he's not eaten up with it like my husband and I are. He plays basketball and baseball and stuff like that, but he loves music. And then we have a nanny—I have a full-time nanny that lives with us and I couldn't do what I do without her. She also runs my basketball camps—that's a good combination that we have there. We have a dog, his name is Scooter and he's a beagle. That's my little boy's dog.

Pretty basic, simple American way of life except lots of times he'll say stuff to me about wanting me to do different things. Or he'll say, 'Well, I don't have the typical mom.' And I say, 'Yeah, you're right, son. You don't have the typical mom.' (*Laughs.*) Some of his friends—he goes to a private school—some of his friends' moms are stay-at-home moms and they do a lot of different things.

So, he knows he doesn't have a typical mom but to him that's OK, because he gets to go with me and do a lot of things. This year he went with me to the Final Four in Philadelphia. He's been out to Colorado Springs with me when I coached some of the USA basketball teams. May 18th, Nike is sending my team over for two weeks to Australia, so my family is getting to go. There's a lot of benefits for him because of where I'm at in my profession and all.

We have huge camps in the summer. We have the largest camps in the nation, we have about around 4,000 girls for the month of July. My nanny, Deneene Herring, she does all of the administrative work and then my husband does all the scheduling

and planning and organizing and all of that, and I'm in charge of the staff. So, we have a really good system worked out. Like I said, we have the largest camps in the country.

Deneene was my scorekeeper at Francis Marion, when we won the National Championship in '86. So, after she graduated and I had my little boy, I talked her into coming and living with us and taking care of him. Also, as my camp grew and my situation here grew, the camps were separated from the University—they're incorporated and we actually run them from an office at our house—and she is the camp coordinator and runs all that.

Have you found it personally difficult to balance family and career?

At times. You have to really work hard to keep things in perspective. But I've found that my family, especially my little boy, helps me keep things in perspective. Like next week, he's on spring break, and quite a ways back I promised him I would spend most of next week with him. So I blocked that time off and I'm actually missing our All Sports Banquet here and missing my NCAA test—I'll have to make that up—but I've put him as a priority next week, and just told everybody else that I wasn't going to be here and I couldn't do anything. Sometimes you just have to do those things. At times it's difficult, but again, having a husband that's a coach helps, because he understands more of my situation—what I'm going through, the demands at different times

of the year.

What are some ways that you relax?

Go to the beach. We have a house at Cherry Grove, North Myrtle Beach and it takes about three hours to get down there. We're actually going tomorrow afternoon for Easter, and we'll be down there part of next week. But I love to go there. When I'm not in Chapel Hill that's where I'm at, just spending time with my family. I do play a little bit of golf—not a lot—but a little bit. I take a lot of little mini-vacations because I can't be gone for that long of a time, but those are good because they break things up. They sort of get you away and let you get recharged and that type of thing.

Besides basketball, do you have any personal interests or goals that you're pursuing?

Well, yes. I am in the process of trying to purchase 200 acres of land up in the mountains of North Carolina, up close to Black Mountain, because when I retire—and actually I'd like to get the process rolling before that—I'd like to start my own camp for kids. I want to have a Christian skills camp, where we don't just teach basketball, but sports in general. But also, a lot of character-building—just again, a balance of the mental, physical, spiritual, everything there—because I just see so many kids now that

don't have those things. Especially, they're not trained in character or respect.

If you could tell me some of your favorite specific things—books, movies, T.V. shows, foods, whatever—what would they be?

Well, I don't watch much television, but my favorite ever since I was a young child, I loved the 'Andy Griffith Show' because there's so many stories, lessons for life in those shows. For modern-day shows I like to watch 'Walker, Texas Ranger.' Movies, there's a lot of movies I like. I liked 'Fried Green Tomatoes,' that was a good movie. My favorite movie of all time is 'Sound of Music.'

Books, let's see...the book that I recently read that I liked was *Secrets of the Ya-Ya Sisterhood*. Basically I read a lot of motivational books. I probably shouldn't say this coaching at Carolina, but right now I'm reading Mike Krzyzewski's book, *Leading With the Heart*. I read *tons* of those books. I mean, I've got about five or six of them right here on my desk right now I'm going to take to the beach next week. I just constantly am trying to feed my mind with positive-type things, because I keep telling my players your mind is like a computer and what goes in comes out. You gotta keep feeding the right things into it.

What personal qualities do you consider to be of the most value in life?

Loyalty. I think that's one thing that we see very little of. Loyalty, integrity—you know, character-type things. Used to be that was pretty basic, but now it's harder and harder to find those qualities. Especially loyalty—with the people you're with every day and family and all of that. I experience that a lot with my players and the family situations that they have and again, just, you know, people that you work with and all. It's such a 'Me Generation' now, and I've always believed you get what you want by helping other people get what they want. And there's very few people that feel that way now. It's pretty much, 'Take advantage of other people before they take advantage of me.' That's the way a lot of people operate now. But again, probably the basic thing is, 'Hey, if you want to have good relationships with people, you want to have chemistry on a team or where you work, harmony—that type of thing—just treat other people the way you want to be treated.' Basically, if you do that then people will like you, you're going to have a good working relationship, you're going to be able to sleep at night...that type of thing.

What is the one way that you have evolved as a human being that makes you proudest?

I had a great upbringing or great childhood with a tremendous family, great parents—the way I was brought up—I just thought everybody was that way. But now I realize that I was one

of the few that had probably one of the most loving and perfect family environments. As I've gotten older and grown in my career and been successful, what people say to me most of all is, 'You haven't changed. You're the same as you were when you were here as a child.' Even as I go back to Francis Marion and I work with people, I'm very open, very honest. In fact, sometimes my honesty gets me in trouble, but I'm very honest—plain, simple, down-to-earth. I'm 'what you see is what you get.' Sometimes if people are successful they forget the people that helped them get there and they sort of get too big for their britches. I try to remember the people that have helped me get where I am and basically I haven't changed.

Well, this is a two-part question. First of all, what qualities do you have that make this job, or this career I should say, a natural choice for you? And what qualities do you have that create constant struggle for you as far as the job goes?

Well, I'm very competitive. Growing up I played with the boys all the time. After school, the boys would all come to my house and want me to come and play, want me to be on their team. But I was extremely competitive, especially in a day when not many females participated in sports. Now it's a pretty common thing, but when I was growing up in the late '60s—actually I was in high school in the late '60s—girls just didn't participate in

athletics that much. I think that's one reason why I'm here where I am today—because of my competitive nature.

I remember one time when I was very, very young—my grandparents lived next to us—I remember my mom said I came home and I was so mad, and I was crying and upset because my grandfather had beat me in checkers. I don't take losing well. Now, I keep it in perspective but losing motivates me extremely. That's just like, this year, we went through some struggles in January and I had a player out for a personal reason and my team went through a lot. At one point we were twelve and eleven. A lot of people had just pretty much just written us off as having a successful season and going to the NCAA's and that type of thing. We ended up twenty and twelve. We lost the ACC Championship by three points and we made it to the Sweet Sixteen of the NCAA.

I'm just extremely competitive and the more my back is against the wall, I guess the more competitive I am. My husband tells people all the time, 'Look, just *please* don't tell her she can't do something,' because I'm going to die trying to prove you wrong. I'm assertive and aggressive but I keep it in perspective. But just my desire, my competitiveness, but also the passion that I have for—not just basketball—but for athletics, to give a lot of other young girls and young women the opportunities that I did not have. All the little boys in our neighborhood were on the Little League team, and I used to go practice with them. I practiced

with them about every day. I'd field balls, I'd do different things they needed me to do at practice and I could probably do it better than any of them, but at that point in time girls couldn't play Little League. So, I would keep the scorebook.

That must have been tough.

Yeah, it was. Especially when I knew that I was better than most of them that were out there. Especially when I was eleven and twelve, I was pretty big-sized at that time and a lot of the guys were still shrimps—because girls grow a lot faster than boys at that age.

Did you in any way think that things would get to where they are today, where you would have so many opportunities?

I knew things were going to change and I knew things had to change, and that was something I wanted to be a part of. I'm glad to see where they are today. There's no question we have come a long, long way—but we've still got a ways to go. There's still a lot of double standards out there and some places are doing just enough to get by with Title Nine and gender equity and there's still some things that we need to do. I've spent twenty-five years coaching already, and it's fun to see from where we were when I started in '74 to where we are now.

What qualities of yours create conflict or struggle that you must constantly overcome as pertains to coaching?

Sometimes it's the same quality that's good, that's bad—and that's my competitiveness. Sometimes it's hard to keep things in check, in balance. Sometimes I really have to pray hard to handle situations and not to be resentful of maybe the way another coach treats me or negative recruiting. Especially being at Carolina—we have so much and we're such a great school and just our name lots of times...we can get a lot of recruits that other people can't. Or at least get them to come visit. And we get bad-mouthed a lot just because we're one of the best universities in the country and we have a great program. Sometimes that competitiveness, you have to work hard to keep it in balance.

Probably the other thing is that I'm a very, very positive person—*extremely* optimistic. I always see the glass half-full. Again, like I said, my husband says, 'Please don't tell her she can't do something.' When I see something I want to do or how I want something done, I want it done the best. Most people nowadays settle for average and I *hate* average. I want everything to be better. You may not always be number one, but you can always be around the top. That's why I tell my players, 'Don't settle for being average. And when you do something, always do what's required of you and then a little bit more.'

Sylvia Hatchell

Overall, as you look back over everything you've done so far, of what professional accomplishment are you the most proud?

Well, there's been a lot of them. There's been a lot of little things that to me *personally* have been big as far as some of the players I've dealt with, some of the situations I've taken them out of and the environment I can put them in here and seeing them graduate and what they can go on and become. Because I know that if they had not been here they could've been in prison or on the streets or a drug addict or something like that. But as far as probably basketball, probably the '94 National Championship. I mean, I won three of them, but '94 here at North Carolina was special. I don't know if you know how we won that...

Tell me about it.

With .07 on the clock, that's seven-tenths of a second, not even a full second, we were behind by two points. There was a jump ball, a tie-up, and the possession arrow was pointed in our way. We threw the ball in-bounds to a post-player, behind the three-point line—and it had to be a perfect pass and she had to be ready to catch it and launch it with less than a second on the clock—and she did. It went in and we won the National Championship.

Wow, that's incredible!

Yes, it is. It's a miracle. The reason why that championship was so special is that, when I came here to North Carolina we were pretty bad. For the first three years that I was here we were the last team in the ACC. It's hard to get things turned around when you're on the bottom. But again, we didn't quit, we didn't give up, we kept working hard and we went from last in the Conference—one of the worst teams in America—to a National Championship in three years. In '91 we were the last team in the Conference, and in '94 we won the National Championship.

That's quite an accomplishment.

Yeah. I've had a lot of coaches and a lot of people tell me that we were their inspiration because they said, 'Hey, if North Carolina can do it, then we can do it.'

Well, of what personal accomplishment are you the most proud?

Probably having my little boy. (*Laughs.*) He was born on the day that we played N.C. State.

How did you manage that?

Well, we went to the hospital that morning. We induced labor so that I wouldn't miss but one game. I went to the hospital and had him and I was back on the bench coaching on Sunday.

249

What, if anything, would you do differently if you could turn back the clock?

Probably have more children. He's such a blessing, but I was thirty-six when I had him and basically it's pretty much too late. He's such a blessing and I just wish now that I'd had more.

What advice would you give to a young woman starting out in a career, or older women who might be considering changing careers because of some passion they feel?

Well, that's the thing. You said the key word. You've got to have a passion for what you're doing. Whatever your passion is, go after it. Go for it. If you are young and you have a passion to do something, then set your goals and map out a plan and stick to it. Even if you're an older person and you're miserable with what you're doing, and you have a passion to do something else, then go for it. Life is short. The number one thing is, be happy at what you're doing. There's days I wish I wasn't coaching, but most of the time I love what I'm doing. If you can make a living at what you have a passion for and love doing, what's better? What could be better than that? Being able to make a living at something you enjoy doing and that you don't really consider work.

What is the single most difficult moment that you ever experienced as a coach?

Keeping things in perspective. This year we were picked pre-season number one and we did real good in December. Then we had some situations happen with injuries and a family situation with a player and we had some players go out—and they were our better players—and all of a sudden we lost six games in a row. You gotta keep things in perspective. You know, like, 'Why is this happening?,' and we can turn things around here—and we did. But the biggest thing is just keeping things in perspective and realizing that it truly is only a game.

Is there any one single childhood event or recollection that you have that would've foreshadowed that one day you would have this particular job?

All along, as I was growing up, I was very involved with my church's activities. I remember one time—it was a part of our church, Girls' Auxiliary—and they asked you what your goal was, what you wanted to be when you grew up. This is when I was probably eight or nine years old—and I told them I wanted to play for the Green Bay Packers. (*Laughs.*) That was whenever the Green Bay Packers—Vince Lombardi had just finished being their coach—and they were winning all the championships. But I wanted to be the best. I wanted to be on a championship team. That was the mentality I had. But all along, I wanted to be in athletics. I've always wanted to coach and teach. A lot of kids now, they don't know what they want to do and they jump around

and all of this stuff. I never had that problem. I always knew what I wanted. I was always pretty focused. But like I said, I had a great childhood. My parents, all my family was around me—my grandparents lived next door. I was very involved in everything with the church, so I just had a really, really solid upbringing and childhood. The foundation a person develops is everything.

Interviewed by Susan L. Comer.

"If you are young and you have a passion to do something, then set your goals and map out a plan and stick to it. Even if you're an older person and you're miserable with what you're doing, and you have a passion to do something else, then go for it. Life is short."
Sylvia Hatchell

Sylvia Hatchell

Sylvia Hatchell accepted the job of her dreams in 1986 and since then has posted a record of 289-146 in 14 seasons as coach of the University of North Carolina women's basketball team. A North Carolina native who grew up a Tar Heel fan, Hatchell has led Carolina to the 1994 NCAA Championship and four Atlantic Coast Conference crowns. With a 33-2 record in 1993-'94 and a 30-5 record in 1994-95, Hatchell became the first UNC basketball coach—men's or women's—to post back-to-back 30-win seasons. In 1994, she was named the National Coach of the Year by *USA Today* and *College Sports* magazine. In 1997, she was named ACC Coach of the Year after guiding the Tar Heels to a 15-1 conference record and their first regular-season ACC title.

Hatchell also has extensive international coaching experience. In August 1995, she led the U.S. to a silver medal at the World University Games in Fukuoka, Japan. During the summer of 1994, she directed the United States team to the gold medal in the R. William Jones Cup. She has been the assistant coach for five gold-medal-winning teams, including the 1988 Olympic team. She was a court coach at the U.S. Olympic basketball tryouts in both 1984 and '92 and also worked on the Olympic Games basketball events staff in Los Angeles in 1984.

Actively involved in shaping modern women's basketball, Hatchell served as president of the Women's Basketball Coaches Association during the 1996-'97 academic year and remains a member of the WBCA executive committee. She is also a member of the USA Basketball Women's Games Committee.

A 1974 *cum laude* graduate of Carson-Newman College, she earned a master's degree at the University of Tennessee.

Hatchell's husband, Sammy, is the head women's basketball and softball coach at Meredith College in Raleigh, N.C. Fittingly, the couple met at a summer league basketball game and attended a basketball clinic on their first date. They have one son, eleven-year-old Van.

Peg Bradley-Doppes an interview

Why don't we start with where you grew up and went to school?

I grew up in Cincinnati, Ohio. I am one of nine children, eight girls and one boy. Went to high school at St. Ursula Academy, which was a small all-girls' private academy with a wonderful environment for women because it really empowered them. It was an academy where graduation class was maybe sixty; small classrooms; very, very strong faculty made up of Rhodes Scholars and people that really pushed women to excel. Then I went to the College of Mount Saint Joseph, again a private, all-girls' college. As an athlete it probably was not the college of my choice.

Back when I graduated from high school, which was 1975, athletic scholarships were just becoming a reality, and I was recruited by numerous institutions—Kentucky, Ohio State—big-name institutions. My father was very involved in the decision-making process, thinking that my education was most important, and if I really was that gifted an athlete, that I would be a star anywhere I went.

I guess it is important to note that athletics was not emphasized or acknowledged or supported in my family. Academics and the arts were, but with having nine kids—my father was in

politics; my mom was an incredible role model, but kind of kept the whole thing together. I was a three-time All American before my parents had ever seen me play. So truly, athletics was my outlet to be a little bit different from the family.

So how did you get involved in athletics in the first place?

I think I fell into it. The fact that I went to a Catholic grade school—there was CYO, which is Catholic Youth Organization. They had a lot of teams, and it was a way they could get the kids off the street to play. When I was in the seventh grade, I was out doing some yard work, and a gentleman pulled up and said, 'Hey, aren't you Peg Bradley?' And I said, 'Yep.' And he said, 'I have watched you play softball. You are a wonderful softball player. Have you ever thought about doing any other sports?' And I said, 'Oh, yeah. I want to do volleyball, kickball, your basics.' But he felt that I had great potential. His name was Jerry Bullen, and he was the executive director of Williams YMCA. They had a traveling volleyball team.

So, by the time I was a freshman in high school, I was weight training and playing with a team of women that were much, much older than myself, and training with men. And I think that gave me a competitive advantage throughout high school and then through college. I got to play throughout the United States. I played a little bit internationally. And I think because I had trained

with a different environment—you know, I am a woman, but I trained with men—that my style of play was different. Not *better*, but because people weren't used to seeing it, I was much more effective.

I never thought I would go into coaching. I thought I would be a poor man's lawyer and advocate for causes, similar to my father. But because of my successful athletic career, my senior year in college I had the opportunity to go over and train in the Soviet Union in Moscow. This was in 1979, and if you remember, we boycotted the 1980 Olympics. I am one of the few American National Team players that studied, trained, and competed in the Olympic facility. I came back, just recently graduated from college, thinking I would take the LSAT, and was going to kind of stall for a year, get a master's. I didn't even care what in. I wanted to do well on the LSAT because of family pressure. My dad's a lawyer, my only brother is a lawyer, my sister is a lawyer. And I felt like if I was going to do it, I had to do it right.

I had a few graduate assistant offers, but when I came back from Russia, Miami University in Oxford, Ohio, a great academic institution, called me up and asked me if I would be interested in being the head volleyball and head softball coach. I had never coached a day in my life. I thought they were crazy. I went up for the interview, and my biggest concern was, how could I justify this to my parents? So I took the job on the condition that the

pay wasn't that great, but I could get a free education—free master's, and start working on a doctorate. I coached at Miami, head volleyball coach, and head softball coach, and it was great, because Oxford is only about forty-five minutes away from home, but just far enough that I could stretch my wings.

How did you figure out how to coach? Was it a difficult transition between playing and coaching?

I tried to keep everything in balance. My philosophy is that athletics enhances your life. It can't *be* your life. It's just a game. But I tried to take some of the discipline, either from academics or from studying piano, which I studied for years. You may not be as gifted, but you can be smarter than your opponent, and in order to excel, you have to release your body. And also release your mind, and just enjoy it.

At Miami, I trained the team the way I trained and really kept things competitive but light. I would never, ever criticize anyone for doing anything aggressive, anything in the affirmative. I felt very good about freeing women up to express themselves. So anybody that ever expressed themselves in any way, in an aggressive or take-control manner, I applauded.

In athletics, very much of what we do is a psychological game. And, if you think you can, you do. You win. At Miami, my first year being head coach we were thirty-eight and eleven, the best

program they've ever had in their history. I had no idea what I was doing, but it was fun. I just shared how much athletics had enhanced my life.

Softball also had tremendous success. There were things I couldn't coach in softball, because I didn't know how to. I didn't know how to bunt. My gosh, look at the size of me. You know, all I could do was hit and hit harder, so that when we would play against an opponent, no outs, one on first, you'd know you were supposed to bunt. Of course, the opponents would sneak in on the corner. The kids would get out of the batter's box, look at me, and I would give them the signal to hit them in the head. (*Laughs.*) So it was unorthodox, but it was wonderful. The athletes had a great experience. They loved it. It was fun for me.

I did that for five years. Got a master's degree and was working on the EDD, and then had an opportunity to explore coaching more. First offer I got through softball was from N.C. State, and they offered me a job in 1982. I came down; was there for a week. It was a wonderful job offer—full-time volleyball coach, nice salary. It was in 1983, I guess, because Jimmy Valvano just won the national championship, and he was the AD. Rose Casey was just getting out of the business. During that time, innocently enough, I took a car and drove over to Chapel Hill. No map, nothing. But, if you look at Miami's campus and Chapel Hill's campus, aesthetically they look very similar.

Really?

Yes. Same architecture, so that you have the campus community, a very safe environment. I ended up declining the offer from N.C. State, but as luck would have it, eight months later Chapel Hill called, and I went down there to be the head volleyball coach.

You were there for seven years?

Seven years, where I taught, and I coached. Loved it. I had great success. And that's when I fell in love with this area, the State of North Carolina. And then, Michigan called and asked me to be their head volleyball coach, but also their women's athletic director. Now by this time, because I started early, I was the youngest coach ever in any sport to have 300 Division I victories. And when somebody says to you, 'Would you like to be an athletic director?' and you are a coach, that is an insult. So I was more offended by Michigan's offer. Like, 'No, I'm really a good coach, you know.' Just by the luck of God, I have learned how to do this, and it's fun.

They asked me to be their women's AD, and their programs had really struggled. When Title Nine was passed in 1972, the University of Michigan was the largest and the most vocal opponent to Title Nine.

When you went over there, was the situation hard for you to work with, or

was it better for you to have a challenge?

I think it was better for me to have a challenge, and I made it very clear that they knew what they were getting. They had done a national search, and they didn't find anybody to be the women's AD. But when they asked me, the president of the University, Dr. Duderstadt, a brilliant man, said, 'I want you to think about this, and what would it take?' We weren't talking salary. We were talking philosophically.

I took a few weeks and put together a master plan. And I wanted complete fiscal control. I wanted to make sure that all of the coaches—and this was ten years ago—were computer-literate, had computers in their office; that the two separate departments—women's and men's athletics—had to merge, because you don't have two separate fine arts programs, or two separate chemistry departments. As long as we were separate, we were not equal. I wanted us to merge, so that I could show them concretely that we were equal. The Women's Program back then at Michigan was not a successful one. We had one competitive program, and that was in swimming and diving. I talked about being able to hire and fire the staff. Setting the bar higher. Letting them know it was going to be a turbulent time, but that an institution of that magnitude, with the type of intellectual minds that they could attract, it would be easy to build a dynasty. And, within five years we dominated the Big Ten on the Women's Program. You know,

we went from having one Big Ten championship team to two, to four, to five. There was a period when we would have more championship titles than anyone else in the Big Ten. And a lot of that was just done on design, kind of a long-range plan of what we needed.

We had never been competitive in the Sears Cup. As of two weeks ago, Michigan is second in the country this year's cup with the Women's Program carrying the bulk of that.

So, it was wonderful. It was a great opportunity. I thought I would be there for a while. You know, at that time I was Women's Athletic Director and Associate Athletic Director, and then finally Senior Associate Athletic Director. I oversaw most of all the day-to-day operation. But as fate would have it, people that knew me knew I loved this area, and when this job opened up, I had a few people call: John Swofford, the Commissioner of the ACC, Dick Baddour, the Athletic Director from Chapel Hill. They knew that Gary, my husband, and I had bought land down here. We had built a summer home down here. The quality of life, the people here, this is where I wanted to be. It just so happened this job was open.

And then they had 140 candidates. Never in a million years did I think they would hire a woman. I don't think *they* thought they would hire a woman. You know, when they brought me in—a great story—they had four candidates, and I was the last

one. And after being in this business, you can tell when somebody is interested in you, and when you are filling out their candidate pool. I purposely would never try and leverage my position at Michigan for more money. I don't believe in that. But I am smart enough to know that they weren't serious when they first asked me to come down. It was so they could say they had a complete search. Even the first day, I was a token. But, by the beginning of the second day, you could see there was a different reception.

What do you think really made that difference for you?

I think the fact that I was very candid. I certainly was blessed with much more experience than any of the other candidates. You know, as far as being an athlete; being a coach; being at major Division I institutions with the magnitude of responsibility—my responsibility at Michigan was a $20 million budget, and a staff of a couple of hundred. Certainly, if I worked I could meet the challenges here. And I think, also, that I wasn't afraid. I was competitive enough that I said to them, 'I may not take this job, but I am here to get the offer.' Because, as an athlete, I was damned if they were going to use me. And as a woman, I felt that I needed them to see that I was very, very capable.

My biggest challenge was, I didn't want them to say I was one of the best *women's* athletic directors in the country. My challenge is to be one of the best athletic directors, and somehow get people past the fact that I am a female athletic director.

Well, you are the first full-time female athletic director in the CAA (Colonial Athletic Association), aren't you?

I am. I am.

Do you feel that carries with it any sort of role model responsibilities?

My management style is to be inclusive, but to take control; to make sure that I operate on facts, not emotions. And everyplace I have been, I have taken the best from the best people, so that I am evolving as an administrator and as a person. Hopefully that would complement the rest of the ADs in the CAA.

Do you think, as a woman, there has ever been a time when you faced prejudice or stereotyping that you had to overcome?

Sure. But my way of dealing with that is, I understand that in going into this world, I am a minority. There were times where it could have been very uncomfortable. A great example was the first year I was Women's Athletic Director of Michigan, I was included on things that women had never been included on. For example, we would do fundraising swings. We would go to Palm Springs; we would go out to Phoenix; we would go out to California. We would play golf with ninety people. After that, we would

have dinner and then we would talk about how great Michigan was, and are you going to endow a scholarship?

What we forgot to mention was that the ninety people we played with were all men, and that the only time you would see women would be the waitresses at these resorts, who were dressed to make it obvious that they were women. The first time I played, I was playing with three wonderful men, but they had no idea they were going to be playing with a woman. I walked up and a wonderful gentleman who was in his eighties saw my legs and looked and said, 'Oh my gosh! What a great distraction!'

Now, I could have been offended, but I tend to use humor to make people feel comfortable, because I believe that they don't care how much I know until they know how much I care about doing a good job. And instead I said to him, 'Good God, you're blind. So, I am going to have to watch your ball. Otherwise you are never going to be able to find it.'

What did he say?

He smiled, because he didn't mean to be attacking me. And then ultimately everything was OK, once they could see that I could hold my own. It happens all the time. You know, we go into a meeting and people will presume that I am support staff. 'Could you get us some coffee?'

What do you do?
Certainly I could, but you are capable as well.'

How do they react?

They are fine, because I try and make it very, very light. Especially down in this area, I will speak to groups that will be a roomful, a churchful, of men; and it is very uncommon for them to see a woman in this position. But once we get past that—it takes about five or ten minutes—they can see I can talk football with anybody. So that once they see I know that world, then they forget the fact that I am a woman. You know, we talk about basketball. I can talk about basketball with anybody. I tend to think if I can make people comfortable, then they're much more receptive. And, if they are receptive, then they are much more supportive.

How have you been able to balance your personal life and your career? Has that been a challenge?

Oh, gosh yes. It's a huge challenge. Probably the biggest disappointment is that I can't have children, and always wanted to have children. So, as blessed as I have been, I am this focused and this passionate, not only about my job, but I am this way about my housecleaning. I am this way about my church. I am this way about eating, music—so that this, to me, is something I

enjoy doing. I have had the luxury of never having to go to work and not enjoy it. But, who knows when that day will come, when I will wake up in the morning and say, 'Oh, not today.' Because then I would have to make a change—if this felt like a job, or if my career consumed me so much that I became one-dimensional. So there is a balance in that.

You know, my husband and I have a consulting business. He travels Monday through Thursday. We leave notes at the airport on our windshields. I have missed more family gatherings. You know, we played on Friday (*the Seahawks' men's basketball NCAA tournament game*). I couldn't tell anybody that I was in a wedding Friday night—my sister's. Thank goodness we got to play the first game. So we played the first game, I had a flight to Cincinnati at four o'clock, I was in a wedding at seven o'clock. I had a return flight, because I was sure that we were going to win.

It certainly sounds like it would be a great challenge, but also, it sounds to me that what you have learned in your professional life has enhanced your personal, and vice versa, and that they really complement each other.

They do. And I think we don't take anything too seriously, you know. I am not finding a cure for cancer. I wish I was. My job is to have our athletic department enhance our university; have our student athletes graduate—which we do; we graduate the highest in the entire Carolina system—that we field competi-

tive teams; and that we do whatever we can to enhance the academic mission. It's that easy.

You know, I think where people go crazy is, they think it's something more. I can remember when I was at Michigan, every home game was 111,000 people. Now for most of those 111,000 people, the world stopped on Saturday afternoon. For me, it was, 'I hope we win this game. But, God, it is a beautiful Saturday afternoon. Look, the leaves are changing.' So it was much more of a kind of global perspective.

Were your parents happier with what you were doing once they saw your level of success, or was it difficult for them to adjust?

Well, it was great. Even after I was at Miami the whole time—a great school—and then went down to Carolina, to put it in a nutshell, once my mom and dad came down for a surprise visit in August. And for coaches, your base salary is not that great. You make your money doing camps and clinics. And so I did forty day clinics throughout the entire state and then I would have three weeks of camp at Chapel Hill.

Mom and Dad came into Carmichael (*Auditorium*) as I was having one of my overnight camps—275 young kids sitting in the gym. It's ninety degrees, ninety percent humidity, and I look up and here's my mom and dad. And Dad's way of dressing down is Bostonian. Mom is in three-inch heels. *Isn't this a nice surprise?*

I'm thinking, 'Oh, my God, my parents are here.' I was probably twenty-eight or thirty at the time, but again, it was a fun job for me. You know, they would say, 'What are you going to do when you grow up?'

I went upstairs and I said, 'Mom, come here.' Dad looked down, and Michael Jordan was speaking to my camp. Now, Michael wasn't speaking to my camp because we were friends; he was speaking because he did every year for free, because he would come back and play. He dated some of my athletes. It was more of a friend-thing to do. My dad said, 'You must be a great coach, if Mikey Jordan works for you.' And I looked at him, thinking, *they have no concept. Mikey* Jordan, *please,* works for me. My God.

I giggled, and I didn't say anything to him for a few hours. Then I said, 'Dad, I have got to tell you. Michael doesn't work for me. He is his own person. He was doing that just to be kind. He always helps the coaches out.' But I think at that time, there was an acceptance of, Well, oh, my gosh, maybe this is something!

And they got to know a lot of the athletes who have since then graduated, have had children of their own. When you are in this world, somebody who has that type of effect on your life, they stay in contact with you forever. So, over time, they thought it was great. And they thought I had the best deal going. I loved my job, got to travel. I have been around the world through athletics, and have enjoyed every moment.

And your brothers and sisters? Were they accepting, too?

Yes. But nobody is jealous. At Michigan we would go to a Bowl every year, and there would be times when Gary would say to me, 'I'll meet you there game day.' Well, I had to be there a week early. I would take a sister, you know, to go with me. For them it was a great trip. They treat you like gold. But they would say, 'Do we have to go to the game?' They have no concept.

Here's a true story about my sister, Julie, who is two years older. At the time I was at Michigan, I was in charge of all marketing promotions, corporate sponsorship, had just signed Nike to a seven-million-dollar deal. It never had been done. My sister came in, and she is wonderful and innocent. But we had my assistant taking me around on the golf cart saying, 'OK. We are going to take you up to the Pepsi Corporate tent. Here are the people.' Had to give me a prep. 'Remember so and so and so and so. Make sure you say hi to them. We are in the eleventh hour trying to get negotiations with them, so just five minutes here. Then I need you to go over to the Nike tent. There are going to be photo ops there, because now it's a done deal.'

My sister is listening to this. We get to the tent. I say, 'You just go get some food. Don't say anything to anybody, and I'll be with you in ten minutes, and we will go to the game.' And I am kind of apologizing to her.

So we take the pictures. Everything is great. And the Nike

people, Steve Miller, Bill Nice, they give me a Nike swoosh, because now it's official. So I have a Nike swoosh on my Michigan maize jacket. As we are walking out and the people really feel great. This is a big deal.

My sister is twenty feet away, and she says, 'Peg, what's that check for? Is that for AIDS?' And I go like this (*shaking her head*), I say, 'Don't say it—*no!*' 'Breast cancer?' She has no idea why the Nike people start laughing. Because for the rest of the world, the commercialization of their swoosh is so legendary. They tell that story everywhere.

I think that shows in a nutshell, my family thinks it is a gas. They think it is fun. Yet they can't believe I get paid for it, you know. But they are lawyers and doctors, nurses, and teachers. Doing some very meaningful things.

And your husband, is he into sports?

He is a computer geek. His specialty is financial software. But in my first year at Michigan, we go to the Rose Bowl and win. We go to the Final Four for basketball, the Final Four for ice hockey, and they ask us to go on a one-night trip for free to the Grand Canary Islands on the tip of Africa. And Gary says, 'You've got the best job in the world.' Now, he forgets about the other side. The lawsuits, the hiring and firing, the stress of trying to keep this enterprise afloat. But for him, he loves the excitement of it.

So what do you think have been some of your greatest joys?

The greatest joys are the people I have gotten to work with; the coaches, and especially the kids. I love the fact that we are given this unique opportunity to deal with young men and women going into adulthood. And we have a vehicle to help mold their lives in a better way; to instill discipline; to help them with goal-setting, expectations. To make sure that they understand the importance of winning or losing, and I am not talking about athletic competition, I am talking about life. You know, winning's not everything, but striving to be the best you can, that's something. And I love that part of it. I feel that that part, the people part, is probably the most important part of the job.

And the greatest challenges?

To make sure that we keep the commercialization out of it. This is amateur athletics, and so when people get upset because we lost last Friday, because Cincinnati played a great defense, and they camped out on Brett (*Blizzard*), they forget that Brett's a seventeen-year-old young man, doing the best he can, going to school full-time. And you know, he is representing not just himself, not his family, not only our institution, but I think the best America has to offer. I think we forget that. And then sometimes we think they are professional athletes, and this is their job. It's not their job. And if it was their job, everybody would probably be fired,

because we are not doing very well, you know. Don't take your-selves that seriously.

So the commercialization, I think, is scary. And that goes in line with the gambling of intercollegiate athletics, the corrup-tion. I love the fact that our kids are good kids, and agents aren't camping out here. Now, I don't have rose-colored glasses. I keep my eyes open. When we went to the NCAA, I didn't stay with our fans. I stayed right there in the hotel room, because I wanted to make sure none of the evils sneak in here.

So those are it. And the other challenge is, I think, to make sure that we are an active part of the University community. You know, this isn't Trask Sports Complex. This is the Athletic De-partment of the University of North Carolina at Wilmington, and I think our role is to make sure that we are a part of the University.

And when you are not here, what do you do to relax?

Wow. Love the arts, love to travel. Like to play golf. We love to entertain. Love to do family stuff. With nine of us, and Gary is one of nine, we have family visiting non-stop. So I love to do that. And, I think I am blessed. My life is very full outside of this. There's a good dose of church. There is a good dose of the social. That's very important to me. I think by keeping that part balanced, it makes me feel full, so that the challenges of this job don't overwhelm me.

And if a young woman who's just starting out and trying to figure out what she wants to do, or an older woman considering a change in lifestyle, came to you and said, 'Now, what's worked for you,' what advice do you think you might give?

I would tell them to find someone and latch on. I truly be-lieve I am here because people took chances on me. Look at Mr. Schrieder at Miami. I was almost twenty-two, and he saw some-thing I certainly didn't see. John Swofford at Chapel Hill. Chris-tine Grant at Iowa. Chris Fultz at Minnesota. Those are mentors for me.

When I was at Michigan, I would take two women a year, and they would come as interns. And some would come for abso-lutely nothing. Others would come for hourly wages, just for the chance to get their foot in the door. And I would share every-thing with them. Not only budget, hiring, and firing, but I let them go to the lawsuits meeting with me when I was being de-posed, I'd let them come in so they could see the big picture. I think giving people the opportunity to feel this, experience it, they will either decide, 'Yep, this is what I want to do, or maybe not.' But I think that the answer is that there is plenty of opportu-nity. You just have to get yourself at a place where you are willing to be with someone and learn and open up the doors.

You don't say this to graduating classes when you're talking to them about fulfilling their dreams, but I truly believe that all

you've got to do is just keep plugging away—do an honest day's work, and doors will open for you. You know, sometimes you have got to force the doors yourself, other times people help open them up. But you have got to get to the doors.

Do you have any dreams, either personal or professional, that you want to work toward?

I would like to make a difference, but I don't know what that means. I have been asked lately to take an active national leadership role and have been very involved in the NCAA and NACWA, because I believe in that. But I don't know if—not being morbid—but if I died today, would there be a void? I don't think so. I think there would be a body in here tomorrow, and people would miss Peg, but I don't know if I have left any legacy at all.

You know, when my father passed, there was a legacy. He made this world a better place. I need to find out how I am making it a better place.

You don't think taking all those kids to victory—what that means in their hearts, even beyond the field—will be a legacy to leave?

Hopefully, I can continue to do that. In a way, I am an educator more than anything, to teach life skills and make kids believe. As a former coach, I don't know if I really taught physical skills, I think I taught mental skills. The game itself is easy. What you have got to do is *believe* me that it is easy. You know, you have got to trust yourself. And with that, maybe over time. But I think I am as good as I was yesterday, and over the test of time, twenty years from now, I think people will say: 'She is honest, she is fair, she works hard, and she cares about the kids.'

I think I am harder on myself. I really want to be able to say that either UNCW is a better place because of what I've done, or I have made a difference in our community, whatever community that is.

Interviewed by Emily A. Colin.

Peg *Bradley-Doppes*

Margaret (Peggy) Bradley-Doppes is the third athletic director in the history of The University of North Carolina at Wilmington. She comes to the Port City after serving as Senior Associate Athletic Director and Senior Women's Administrator at the University of Michigan in Ann Arbor, Michigan.

In addition, Bradley-Doppes has been a member of the board of directors of the National Association for Collegiate Women Athletic Administrators (NACWAA), USA Volleyball, North Carolina Special Olympics and the National Kidney Foundation State Board. She also serves on the NCAA Committee on Women's Athletics, the NCAA Peer Review Team Certification Committee, and the NACWAA Finance and State Farm Classic Committee.

Bradley-Doppes ranks as one of only eighteen female athletic directors among the NCAA's 300-plus Division I institutions. She is also the first full-time female athletic director in the history of the Colonial Athletic Association and one of only two currently in the sixteen-school UNC system.

Bradley-Doppes received her bachelor's degree in health and physical education from the College of Mount St. Joseph in Cincinnati, Ohio, in 1979, and completed her master's from Miami of Ohio in 1981. She and her husband, Gary, are proud to be members of the Seahawk family.

Peggy Kirk Bell an interview

Where did you grow up and where did you go to school?

I'm from Findlay, Ohio, which was a wonderful town to grow up in. We must have had fifty kids living in a three-block range. Marathon Oil was the big industry in town, and they took good care of the townsfolk. The executives' kids went to public schools, and they made sure the teachers were top-quality and well-paid. The public schools were very good. I graduated high school in 1939, and I went to Sargeant's Physical Education School in Boston (now a part of Boston College) to study for a career in teaching. Then, my second year, the northeast was choking in a blizzard, and I visited Florida over spring break and said, 'What am I doing there in the snow when I can play all year in Florida?' So I transferred to Rollins College in Winter Park before the 1941 school year. There was no girls' golf team, but I played every day at noon. I graduated from Rollins in 1943.

Briefly describe for me what you do now as a vocation.

Essentially, I'm retired now, but I still teach in our 'Golfaris,' which is a name I came up with years ago for the women's-only golf schools we have at Pine Needles, the golf resort that my fam-

ily owns and operates. It's a take-off on the word 'safari,' and we call it a 'week-long excursion into golf.' We have eight of them a year, most in the spring and fall, and I'm there every day. I give a few private lessons, but not many these days.

My husband's given name was Warren, but he was known since a kid as 'Bullet' because the kids around Findlay marveled at how fast he could swim. I'd known him since grade school, and we were married in 1953. For thirty-one years side by side, we ran Pine Needles, watched it grow, raised our family and hosted thousands and thousands of people every year. I played some golf on the LPGA Tour in the 1950s, 1960s and 1970s, but essentially I taught golf at Pine Needles and Bullet ran the resort. He died in 1984. Since then, my three kids and their spouses have taken over and are running the resort.

What career dreams did you have as a child?

Since I was twelve years old, I wanted to be a physical education teacher. I was a tomboy growing up, I played every sport I could, played a lot with the boys and tagged along with my brother, David, who was eighteen months older than me. I was pretty athletic, and sports came naturally to me. I loved watching sports, too. We weren't far from Cleveland, and I can remember some neighborhood kids getting together, hopping on the train and riding into Cleveland to see the Indians play baseball. Players

like Bob Feller and Hank Greenberg, I really put them up on a pedestal. We could leave in the morning, see the game, ride home, and spend about three-and-a-half dollars. Golf was never a factor. I didn't play golf until I was eighteen years old.

How did those dreams evolve as you grew into adulthood?

I was studying to become a teacher in college and was playing more and more golf and improving each year as I went along. I never had a thought of being a golf professional. There was no money in the game then, there were hardly any women pros, and, how do I say this, the position of a golf pro back then just wasn't held in that high a regard as it is today. For a long time, pros weren't even allowed in the clubhouse.

But my good friend, Babe Zaharias, had a dream of making women's pro golf a big thing. She recruited players. She'd talk about how we were going to do great things with the LPGA. She'd be on the phone talking to a promoter, who'd offer her a certain amount to come do an exhibition. She'd say, 'You sweeten that pot and I'm bringing my friends, and we'll play a tournament for you.' I'd been playing amateur golf for a number of years and had realized my goal of making the Curtis Cup team, which I did in 1950. I was set on remaining an amateur. But Spalding offered me $10,000 a year to play their clubs and give a few exhibitions, and Babe was pulling me, so I said, 'Okay, I'll turn pro.'

Recount for me the path you took to get where you are today.

I had some success playing amateur golf and then the pro tour from the end of college through 1953. I won the Titleholders at Augusta in 1949, and that was a tournament considered the as the ladies' equivalent of the Masters. And I made the 1950 Curtis Cup team. But there was a part of me that wanted to settle down and raise a family. Bullet was an avid golfer and wanted to go into the golf business, to own a course somewhere. He scouted around, and eventually we talked to the Cosgrove family about a run-down course in Southern Pines. 'Buttons' Cosgrove was a good friend of mine from playing amateur golf, and her family owned Mid Pines, just across the street from Pine Needles. She married Julius Boros, the great men's tour pro, and I'd visited Mid Pines many times over the years.

Tragically, Buttons died in childbirth in 1951. But Julius was still involved at Mid Pines and he had some money after winning the 1952 U.S. Open. Maisie Cosgrove said, 'Peggy, let's us, Julius, you and Bullet go in and buy Pine Needles.' So we did and boom, we're married in August, 1953, and immediately we're part owners in a golf course.

There's an interesting story behind both Mid Pines and Pine Needles. Both were built by the Tufts family, the founders and owners of Pinehurst, in the 1920s. Both courses were designed by Donald Ross, the great Scottish golf architect who took up

residence at Pinehurst in 1900. Mid Pines was created as a private club, Pine Needles as a resort. The original Pine Needles Inn is that beautiful old building that's now the St. John's of the Pines rest home. But the Depression hit right after they opened, and the Tufts and their investment partners lost both properties.

The golf shop was located in the old inn when we bought the golf course in 1953, and we had an old Army barracks left over from World War II, when troops were trained and housed there before going to war. Men would ride the train down from New York, sleep on cots in the barracks, play golf for thirty-six holes a day and go home. It cost them $15 a day—room, board and golf. We were just leasing the barracks and the pro shop, and eventually we had to move out. We wanted to buy some land on the other side of the golf course, where the resort is today, and build our own lodgings and facilities.

To make a long story short, I sold some property in Findlay my dad had given me, we got some loans from family members, and we eventually borrowed the rest from the bank to buy the land and start building. We built four small lodges first. Then we built half of what is the clubhouse today. We didn't even finish the upstairs because we couldn't afford it. Bullet and I bought out the Cosgroves and Julius. We gradually added on over the years whenever we had the money. Bullet inherited some money, and that was the swimming pool. I sold an airplane and that was the

bar. We just kept growing until we have what you see today. In 1994, we had the opportunity to team with some investors and buy Mid Pines, which the Cosgroves sold in the early 1970s. It was a great move to get that wonderful old inn and golf course in our family.

What have been your greatest challenges along that path?

Growing Pine Needles in the early years was very difficult. Money was hard to come by at times. In 1957, we had just bought out the Cosgroves and Julius and had no cash. But our lease was coming up in the inn, and the owners didn't want to renew it. We had to build our own lodging. What good was a resort golf course if you had no place to sleep people? The local bank turned us down for the $100,000 we needed. We were getting desperate. By pure luck, we ran into a friend in the insurance business, a man named Jimmy Hobbs. He saw our spirits were down and asked what was wrong. We told him. He told us he knew someone who might help. Well, Jimmy introduced us to a man named Frank Houston, from Occidental Life Insurance in Raleigh. He came down, looked at the place, saw the blueprints Bullets had drawn himself. And he loaned us the money! So that got us going. Now we were in the hotel business, and all we'd ever wanted to do was run a golf course.

In times of disappointment or strife, what are your sources of inspiration or renewal?

I've prayed a lot over the years. I believe that God really does have a plan for your life, if you'll just let it unfold. Too many people try to force things. They don't realize that the Lord is in control. My dad used to say, 'Girl, that worrying will kill you.' So my Christian faith has been a bedrock. I've cherished my involvement over the years with the Fellowship of Christian Athletes. We've had an FCA group here every year for as long as I can remember.

What aspect of your career brings the most joy?

I'd say seeing people learn the golf swing, improve their games, get more enjoyment out of golf. The sport has been so wonderful to me and my family. I want to see others get pleasure from it.

Tell me about your family.

Well, I've told you about Bullet. He was a great guy, a tireless worker, a great host. His dad died when he was young, and he grew up in modest surroundings, so he was always motivated to take nothing for granted, to build for a better future for his children.

Bonnie was our first child. She was born in 1954. Babe Zaharias wanted me to name her "Babe." She said, 'Peggy, it'll be great. I can see the headlines now: *Babe Bell Wins the Open.*' Peggy Ann was next in 1958, and our son Kirk was born in 1962. All of them are good golfers and have been involved in the resort over the years.

Bonnie's husband, Pat, was a PGA Tour player for over ten years. In fact, they met when Pat stayed at Pine Needles, when the Tour Qualifying School was held at Pinehurst in 1977. Peggy Ann met her husband, Kelly, at the University of Alabama. Kelly's now our general manager and is a wonderful amateur golfer himself. Kirk went to Alabama and wanted to try politics when he graduated. He worked in Washington out of school and there he met Holly, his wife. They moved here after getting married. And I have six grandchildren, ages fourteen through infant—Blair, Melody, Michael, Kelly Ann, Scotti and Gracie.

How have you balanced family and career?

By combining them! Seriously, our family has been a part of our life at Pine Needles, going back to the beginning. We put the kids to work. Bonnie used to joke that it probably looked impressive to potential guests to get brochures addressed by a twelve-year-old. Bullet and I were here all the time. Our house is on the eighteenth hole. If we were going to present a family atmosphere to our guests, our family had to be involved.

What are some ways that you relax?

I watch 'Walker, Texas Ranger,' every night he's on. That's my favorite T.V. show. I watch pro football, a lot of basketball, I watch golf when it's on. I really don't have much time to sit around.

What are some personal interests or goals that you're pursuing?

Getting my golf game back in shape. I played so poorly this winter down in Florida. It was driving me crazy! I was about to throw my clubs away. I was saying, 'I'm too old, I can't play.' One of our instructors, David Orr, said, 'Let's have a look at you.' He's really a sharp young man, a very good teacher. He showed me where I was breaking down my left side through impact, that I wasn't swinging through the ball. He gave me some drills to work on. Now I'm hitting it great! I'm so excited.

What are some of your favorite things?

I've always had a passion for anything you can ride in—bicycles, cars, airplanes. I even had a motorcycle one time in the 1970s. I picked my daughter up at school one day on this motorcycle and she just about died. She told me to pick her up around the corner next time so no one would see her mom on a motorcycle.

We grew up about three blocks away from a small airport in Findlay. Every Sunday they'd have what amounted to an air show, with the pilots doing all kinds of stunts. One of the pilots could land a small plane on a moving car. I was fascinated by those airplanes. I grew up wanting to learn to fly one. I eventually did and even bought my own plane when I was playing the golf tour. It was a great way to travel. Then one year I was in an awful snowstorm and I said, 'Please, God, let me get this plane down safely and I'll never fly again.' I made it and then sold the plane.

What personal qualities do you consider to be the most valuable in life?

Well, like I said earlier, I was blessed with my family, with the values they instilled in me. Hard work. Discipline. Honesty. Caring for your fellow man.

What is the one way that you have evolved as human being that makes you the proudest?

I'm not really sure. I've never thought about that. I guess that anyone who teaches well has got to sincerely *care* about the student learning. I wanted so bad for every one of my students to hit the ball, to get to where they understood the swing and the basics. Not long ago a man in one of our golf schools said, 'I learned more in two hours here than I have in forty years playing golf, because now I understand the fundamentals.' It would drive me nutty sometimes when I'd hit a wall with a student and they just couldn't get it. You live for the moment when that light bulb goes

on. Caring about that happening is very important.

What qualities do you possess that make your career a natural choice for you?

Doing something that involved physical activity and exercise was natural for me because I was so active, so sports-minded, as a kid growing up. I was fortunate that golf was the game I finally chose because it's something you can do for a lifetime. It's hard to play baseball or softball for a lifetime. And I've always been good around people. So teaching and running a resort were a good fit for me.

Conversely, what qualities create conflict or struggle that you must constantly work to overcome as pertains to this career choice?

Everyone's got faults, that's for sure. I've got my share. If someone's parked in the wrong place at the club, I get aggravated. Like anyone who gets a few years on them, you look back and say, 'Why can't things be like they used to be?' I look at our resorts and all the employees we have. I say, 'Why do we need all these people?' Bullet used to do everything himself. He'd make beds, handle reservations, check you in and out. But it's the next generation's turn. I need to remember that. And they're doing a great job.

Of what professional accomplishment are you most proud?

Well, in playing golf that would be making the Curtis Cup team in 1950. Like I said, that was a long-time goal. In the golf business, just watching Pine Needles grow from what we started with and what it is today is mind-boggling. We started with an Army barracks and guys paying $15 a day. Now we're getting ready to host our second U.S. Women's Open. That's something.

Of what personal accomplishment are you most proud?

Seeing my family blossom like it has. I get such a thrill watching the kids take over the business. My son-in-law, Kelly, is the general manager and is doing a great job. I tell him, 'Bullet's watching you.' Pat and Bonnie teach golf. Kirk and Peggy Ann are here every day for lunch. Kirk's wife Holly is our advertising and sales director. This place is their life, just like it was mine and Bullet's.

And I love seeing the grandkids getting interested in golf. I have six, and three are old enough to learn to play. The youngest is Kirk and Holly's baby, Gracie. When she was born, I saw her big hands and I said, 'You don't know it yet, but you're going to be a golfer!'

What, if anything, would you do if you could turn back the clock?

I'd win the National Amateur. I wanted to be the best, and that was the ultimate at the time. One year I lost and an aunt of

mine said, 'Peggy, that's a blessing in disguise.' What she meant was that if I'd won, I'd just have chased more golf titles. I might never have married Bullet and had what I have had. I've had a full life.

What advice would you give young women just starting out in a career, or older women considering a career move?

Set goals. I tell kids to set their sights on being a fireman or policeman or ballplayer or whatever—it can change, but have something in your mind to work for. It kills me these kids going to college and not knowing what they want to do. I decided right when I started playing golf that I wanted to be on the Curtis Cup team. That was like the Olympics—playing for your country. Every ball I hit for years on end was with that goal in mind.

Thank you for your time.

It's been a pleasure. Now, if you'll excuse me, I'm going to go hit balls. I've got to work on what David Orr taught me this morning.

Interviewed by Lee Pace.

"I believe that God really does have a plan for your life, if you'll just let it unfold. Too many people try to force things."

Peggy Kirk Bell

Peggy Kirk **Bell**

sporting goods manufacturer.

Peggy Kirk Bell was born in Findlay, Ohio, in 1921, the youngest of three children of Robert and Grace Kirk. She began playing golf in 1939 and her game took major strides in 1941 when she transferred from a northeastern college to Rollins College in Winter Park, Florida. There she began playing golf on a daily basis and within years had become one of the top women's amateur golfers in America. Peggy Kirk won the Ohio Open in 1947, 1948 and 1949; the Women's North and South Amateur at Pinehurst in 1949; the 1949 Titleholders Championship at Augusta, which was the day's women's equivalent of the Masters; and was an alternate on the 1948 United States Curtis Cup team. Two years later, she realized a decade-old dream of competing in the Curtis Cup. In September 1950, she turned professional, competing on the fledgling LPGA tour and representing the Spalding

Peggy Kirk became Peggy Kirk Bell in August 1953, when she married longtime sweetheart Warren "Bullet" Bell. They immediately purchased part interest in the Pine Needles golf resort in Southern Pines, N.C., and over the coming years bought out their partners and expanded the resort. Bullet died in 1984, but the resort remains a family operation, with Mrs. Bell teaching golf at the resort's famed "Golfari" golf schools and her three children and their spouses involved in the operation of the resort. In 1994, the Bell family teamed with investment partners and purchased the seventy-three-year-old Mid Pines Inn & Golf Club, located across Midland Road from Pine Needles. Pine Needles and its 1928 golf course, designed by famed Scottish golf architect Donald Ross, achieved their crowning glory in 1996 when the U.S. Women's Open was contested there. The Open returns in 2001.

The Ultimate Challenge *Mia Hamm*

I believe setting goals genuinely helps a person's growth and success. Otherwise, how can you really be sure what you are training for, why you're asking so much of yourself? Most people have a vague idea in their mind about the future, and that uncertainty impedes their ability to achieve greatness. Write your goals down or articulate them. This process will give you focus, and help you determine whether you need to set new ones. Setting out without a direction will lead you nowhere, and dreams without follow-through are just that—dreams.

For too long, society has imposed restrictions on girls and women, telling us that when we achieve something we are not supposed to show excitement and emotion. We are expected to go about it in a quiet, dignified way, be thankful, and not call attention to ourselves. It's time to break this stereotype of the passive woman, and one of the best ways I can think of to do this is to raise a ruckus when you stick the ball in the back of the net. Goals are so difficult to come by that when you get one, you should mark the occasion. Run with joy and salute the fans, sprint to the team bench and make a dogpile, do a little dance with the corner flag, a Shannon MacMillan slide on your stomach, a Tiffeny Milbrett dance, or a brisk jog for the T.V. cameras.

I have always been uncomfortable talking about my personal accomplishments, but I must say that scoring my 100th career international goal was surprisingly emotional for me. When I really stop and think, I have to admit that I'm a bit in awe and even thankful for the opportunity to play enough times for my country that I could score so many goals.

For a school or team to retire your number is the ultimate compliment, and being there with Kristine Lilly made it even more emotional, if that's possible. My number was retired at halftime of Duke vs. Carolina basketball game. Basketball is a huge social and sporting event in North Carolina to begin with, but when interstate rival Duke is the visiting team, the 'Dean Dome' takes on the raucous trappings of a championship game. To have the ceremony at halftime of the Duke game underscored how much the university cared about us and our achievements.

-→≡⊙

I would hope that young girls now know that it is okay to be

tough, to be competitive, and to defeat an opponent. Girls should be encouraged to fulfill their athletic potential and to be winners. One of the most gratifying aspects of being part of the U.S. Women's National Team is that we are constantly showing that women can be hyper-competitive and super-tough while still being positive role models.

How many times have our parents trotted out the tired old line, "Winning isn't everything," and how many times have you rolled your eyes and thought to yourself, "Yeah, sure?" The next day or the next game we might agree with our parents, but right after a loss, it sure seems like it's everything. If winning isn't everything, why is it that we fight so hard to achieve it and feel so empty and miserable when we don't? It's the feeling of knowing you were the best on that day and conversely, when you lose, it's the painful awareness that you just didn't get it done that sticks with you for so long. I've got to admit that I'm addicted to winning and have been fortunate enough to win a lot of games in my life. The truth is, early on, when my brother Garrett used to whip me in backyard games of one-on-one, I developed a keen distaste for losing and dedicated myself to not letting it happen too often. If you want to be a winner, it starts with this determination to strive for victory—fairly, squarely, decently, by the rules—but always to win.

As much as we value winning, my teammates and I also cher-ish the process. We love the challenge of being the best, yet still striving to become better. We love the fact that the pressure is on us to win every game and that every team is gunning to knock us off the top of the world. We love wearing the colors of our country at home and on foreign soil. We love the kids who scream for us and young players who want to be like us. We love playing every day, and we love that we finally can make a living from the sport of soccer. In short, we love the game.

The soccer-playing girls of the United States have lacked role models for too long. You will see a ten-year-old girl on a basketball court dribble behind her back and then try to finger-roll the ball into the hoop. Where did she learn that? By watching Michael Jordan and his friends on T.V. every night and, more recently, the WNBA. Young European kids can watch professional soccer players on T.V. every day. Now it's time for American girls to have soccer role models of their own.

Young players today are able to look up to our team. Our team does a good job of being available to the fans. We stay after every game as long as possible to sign as many autographs as we can. When we are out there playing, we play hard but with respect because there are young players out there watching. When the U.S. Women's National Team takes the field, we love looking into the stands at the sea of young girls in their team uniforms, chanting our names. It's a lot to live up to, serving as someone's

example, but it's a great source of pride to us. I guess the main reason we feel that way is because when we were growing up we had very few female role models in sports. If you ask most of the veterans on the team, most of our sports idols either outside of soccer or were men.

I personally shadowed my older brother Garrett, an incredible athlete himself, wherever he went. My parents adopted him when he was eight, and he became my instant role model. More than any other sibling, he shared my love of sports and competition and nurtured that important part of my life.

Garrett passed away in 1997 from complications arising from a bone-marrow transplant he underwent to combat a rare blood disease. It was an extremely difficult time for my family and me, but I was able to persevere through the pain and sorrow with the support of my teammates and the very lessons in courage and fortitude he helped me learn. Garrett was, and always will be, my inspiration.

Next to Garrett, coach Anson Dorrance has probably been the most influential person in my life. In my early years on the National Team and then all through college, he was the driving force behind my growth as a person and a player. When I arrived at North Carolina, Anson quickly became a father figure for me. As I was only seventeen and my parents were in Italy, he became my legal guardian. I grew very close to his family and soaked up

every insight, every piece of advice I could. For four years of college, I pretty much picked his brain about soccer all day and learned how to build and maintain my confidence, which has always been a challenge for me.

⤏

Sportsmanship should be the bottom line no matter what the situation or score. You should never avoid shaking an opponent's hand after a game, even if you are hurting from the loss and the sharp kick to the shin she gave you in closing minutes. Sportsmanship is being equally as gracious in defeat as in victory. When you win, never forget how the players on the other team are feeling, because we have all been on the other side of a 7-0 rout or have lost a heart-breaker in the final minutes on a penalty kick. As you feel the elation of victory, surely you must celebrate, but don't lose sight of your opponents, and whatever you do, don't rub it in. If you do, it will come back to haunt you, I promise.

I will never forget the aftermath of our agonizing semifinal defeat to Norway in the '95 World Cup. After the final whistle, the Norwegian players got on their hands and knees and formed a conga line, a kind of dancing human worm, that crawled around the field in celebration. It was easily the longest ten minutes of

my soccer life, and I can assure you I haven't forgotten it because none of us looked away. We forced ourselves to watch through tear-filled eyes as Norway basked in the glory of their victory. We swore we'd never feel that way again and that the next time we met, it would be us in a pile of happy, sweaty bodies at the final whistle. Even though we later beat them en route to an Olympic Gold Medal, we still have a bone to pick with Norway.

⊸⟢

Don't forget that to win on the field, your body needs every edge it can get off the field. That means eating good foods, staying hydrated by drinking water, juices and sports drinks, and of course, avoiding drugs, alcohol and cigarettes. Learning what foods work for you, how much rest your body needs, when you can push yourself to your hard work and training. But after you've, say, run the stadium stairs, done your forty-yard sprints, and lifted weights for an hour (in other words, done a half-baked Carla Overbeck workout), remember to take time for yourself. The real winners have balance in their lives. When training camp gets too intense, I recommend doing what we do—goof off. That means playing hearts for Oreo cookies, cruising the local mall, and watching a tape of any Adam Sandler movie.

If you are not having fun, something is wrong, because soccer is all about enjoyment, no matter what level you play. If you are a casual player and you stop having fun because your interests go to other activities, it's not a big deal. But for those of us who live the game, sometimes the fun disappears, and that is a problem.

Golf is my second favorite sport, and it is extremely humbling. It's fun to see the improvement, and it's fun to laugh at yourself when you mess up. But it doesn't really care what you did four weeks ago or what awards you've won. I enjoy golf, and right now, I'm just having fun with it. It's recreation, and if it stays that way, it won't be as frustrating. There are a bunch of us on the team who play golf. I'm fair. There are some days that are better than others.

You get to go to beautiful places, and it is very relaxing. The only downside is that a round is four to five hours depending on the day. Usually, you are out in beautiful weather and beautiful surroundings.

⊸⟢

I understand the pain of bone marrow disease firsthand. As I talked about earlier, in 1997 my brother Garrett died from complications related to aplastic anemia. Last April we helped stage an all-star exhibition game to raise awareness for bone marrow diseases. At halftime we brought together marrow donors with recipients for the first time. It was clearly my most satisfying mo-

ment away from the field

Needless to say, I would not have had the life experiences to date without other pioneers who worked tirelessly to provide opportunities for women in sport. Although I am encouraged by the growth of opportunities for girls, I am committed to continue the progress made in the last decade. It is my goal to help further the development of programs and initiatives for young women in sports.

I am very excited to dedicate my time and energy to the Mia Hamm Foundation. The Foundation represents two causes very close to my heart. Separately, these two issues have had a profound effect upon me as an individual and I am committed to raising funds and awareness for them. My goal is to leave a positive and lasting legacy in the research of bone marrow diseases and for every female athlete to have the opportunity to play the sports they love.

The Mia Hamm Foundation is a reflection of my life experiences. I created this foundation to benefit important issues that have directly affected me throughout my life. The foundation is focused on providing support for two important causes: raising funds and awareness for bone marrow diseases and continuing the growth in opportunities for young women in sports.

If you are interested in making a donation to the Mia Hamm Foundation or would like to share your thoughts with us, please

contact us at:

Mia Hamm Foundation

P.O. Box 56

Chapel Hill, NC 27514

Tel: 919-544-2150

info@miafoundation.org

Soccer has been a part of my life for as long as I can remember. It has helped me grow as an athlete and as a person. I've made lifelong friends, learned to embrace competition, and gained self-confidence, all the while having a ball. I feel like I'm the luckiest woman in the world.

Mia *Hamm*

As one of six siblings, Mia grew up a 'military brat,' moving many times throughout her childhood—from Selma, Alabama to Monterey, California, to Florence, Italy, to Annandale, Virginia, to Wichita Falls, to San Antonio, to Lake Braddock, Virginia, and eventually ending up in Chapel Hill, North Carolina. Mia played on a couple of all-girl teams, but mostly played with the boys. This molded her competitive edge and combative spirit that has her widely regarded as the best women's soccer player of all time.

Mia fell in love with soccer while her father was serving in Italy. By the age of fourteen, she was dominating women's soccer in Texas and attracting attention from around the country. After a scouting trip to watch Mia play, coach Anson Dorrance made Mia the youngest member of the national team at age fifteen.

Following an All-American high school career, Mia decided to continue to play for Dorrance at University of North Carolina. She led the Lady Tar Heels to NCAA championships in all four years she played, while setting conference scoring records as the all-time leading scorer in goals (103), assists (72), and points (278).

Mia is a three-time All-American; the first-ever three-time U.S. Soccer athlete of the year; a member of the Gold Medal-winning U.S. Women's National Team at the 1996 Centennial Olympic Games; and the first player named U.S. Soccer's Female Athlete of the Year. In 1995, she was named Most Valuable Player of the Women's World Cup in Sweden, and in 1996, she led the U.S. team in scoring with nineteen goals and eighteen assists.

Paula Miller an interview

What career dreams did you have as a child?

I guess probably to be an athlete to start with, but that quickly went by the wayside. (*Laughs.*) I pretty much knew that I always wanted to do something in the science field—unclear as to what it was. And it got a *little* bit waylaid by the fact that I got married to my high school sweetheart early and ended up going in a path that wasn't the initial path I would've thought. I mean, I thought about going from high school to college to medical school, but it didn't quite happen that way.

How did it end up happening?

Well, I went to high school, to college, got married my sophomore year, ended up getting a degree in medical technology, and then went on to go to med school two years after I finished the medical technology degree.

Where did you grow up and go to school?

I grew up in Greensboro, North Carolina and went to UNC-Greensboro—undergraduate. I actually went to my freshman year at Wake Forest University and then I transferred to UNC-Greens-boro.

Recount for me the path you've taken to reach the place where you are today.

Well, let's see. After I finished my undergraduate degree at UNC-G, I went on an extra year to get a B.S. in medical technology. After that, I worked for a year at Moses Cone Hospital in Greensboro as a laboratory tech, then came down to Chapel Hill and worked as an assistant supervisor in the microbiology labs for a year and a half, and then went to med school. And I was twenty-six when I started med school. I did my four years of medical school, which was colored by the fact that my high school sweetheart that I'd married left me two weeks after I started—he also was in medical school, two years ahead of me—and moved in with an operating-room nurse. Made it a little difficult for the first two years because he was there and she was there and I was there, and so we would often cross paths. But, after the first two years, it was OK.

I finished in '83 and went back to Greensboro to Moses Cone Hospital to do a residency in internal medicine, which I finished in '86. After that, I spent two-and-a-half years in the Air Force as a medical officer in the Medical Corps. And that was in Valdosta, Georgia, at Moody Air Force Base. And then I came back to UNC to do a three-year cardiology fellowship which I finished in '92,

and that same year, I joined the group that I'm with now.

When did you first decide you wanted to be a cardiologist?

That was my second year of residency. I was working with a very nice group of cardiologists in Greensboro whom I'd worked with in my internship year and then I came back for a second month with them in my second year. I had two months of elective time, so I took it, and we ended up writing a project together to look at catheterization intervention and people having heart attacks. So if you came in having a heart attack, we would take you straight to the cath lab and try to open up the artery that was involved in the heart attack. We collected 125 patients over a two-year period, wrote a paper, and got it published. And so they got my interest up in cardiology. It started back in '84, and from there, they wanted me to stay to try to do this fellowship with them, but you have to have a *fellowship* program, which they didn't have—and they couldn't really get affiliated with UNC quickly enough for me to be able to stay—so I went on and did my Air Force time and came back. And initially, I thought I would go back to work with that group and actually got a job offer from them. But in the interim of all this, I had kids, and nobody in the family wanted to move back to Greensboro but me. (*Laughs.*) So I was outvoted—we stayed here, which is a good thing. This is a good job.

What is a day in the life of a cardiologist?

Well, let's see. Our *normal* days vary from day to day—but to come in around eight, and to see anywhere from fifteen to twenty patients, and then be home with my family between six and six-thirty. And during the day, we may or may not have emergencies, so the day may or may not get longer. In the spring, I tend to try to finish a little early because I have two boys who play baseball and I try to get out in time to go see their games if I can. I'll often come in and work a little earlier and get out of the office a little earlier so that I can see 'em play.

Can you recount for me just one instance where you've been able to make a tremendous difference in someone's life?

I can tell you one that just happened about two weeks ago that is pretty incredible. I help proctor the end of the second-year medical-school exams. And what happens at the end of second year is you have to do part of a physical diagnosis in front of a professor. So I was the person in blood pressure, which is obvious because of cardiology, and the guinea pig was a first-year student—a young guy who had graduated from Florida State. We were talking and he said he had a heart murmur and I said, 'Let me listen.' Once I listened, I knew that it was a bad heart murmur, and I said, 'So what did they tell you this is?' And he said, 'Oh, they didn't tell me. They just heard it in Physical Diagnosis class.

And my pediatrician had said I had a heart murmur as a child, but it didn't really make any difference—wasn't anything to do.' And I said, you know, trying not to be alarming to him, 'Why don't you come on over to my office this week and we'll take a look by ultrasound and see if we can figure out what's going on?' So—took a little convincing. I guess this was Saturday—he was over on Wednesday. And he had a hole in his heart between the two top chambers, which had already started to enlarge his heart—I mean, it was *damaging* his heart. So we got him into surgery the following Tuesday and he's fixed and he'll be fine. But if he hadn't been in that room with me—or with another cardiologist or somebody who could listen to him—he could've had bad heart failure within three or four years.

And on top of it, he's a weightlifter. To the layperson, that doesn't mean a lot, but a weightlifter with a hole in his heart—what happens everytime they lift is they bear down like they're having a bowel movement and it forces the blood from one side of their heart to the other side through that hole and it makes the hole bigger and it also puts them at high risk for a stroke. So he was lucky in all different kinds of ways! But I've kept in touch. He's at Duke, and I've e-mailed him. He came through the surgery with flying colors and, actually, he'll go home tomorrow.

That's pretty amazing.

Yeah, it *is* pretty amazing. I told him I was beginning to feel a little bit like Jessica Fletcher because, this past Tuesday, I was teaching Advanced Cardiac Life Support down in the emergency room and they called me and said my best friend's mother was on her way in with a heart attack. I'd been taking care of her for twelve years. So she came rolling into the ER and I was there waiting for her. And we had her in the cath lab and fixed and opened and up in the CCU all within about an hour, which is pretty good timing for something like that. (*Laughs.*) But they were saying, 'You know, wherever you go, Paula, somebody seems to be getting sick!' So, it's kinda like, where Jessica Fletcher goes, people die? But I'm hoping that this is over!

Is there any childhood event or recollection you have that foreshadowed that you would be a doctor someday?

No, except my mother said I used to take care of everybody. I wanted to make *everybody* happy. (*Laughs.*) I was pretty much always taking care of *me*. My mom was a schoolteacher and my dad was in the Navy when I was born, but went back to college when I was three and graduated and went on to be an engineer. So there was never really anybody home with me—well, up until I was seven, my great-aunt lived with us and she took care of me. But, after that, I was kind of a latchkey kid and came home in the afternoons and took care of myself.

I've always had this need to *help* people—help around the house or help other people do the right thing, just sort of always your general 'Little Miss Helper.' But I was also very strong in science and math in school—and got science and math awards, and, I think, in high school, knew that some career like that was going to be what I needed to do.

How do you balance family and career?

It's hard. (*Laughs.*) I think I discovered about, oh, early '90s, that I had to say 'no' to some people to do things that I would *like* to do, but that I also needed to forego in order to take some time for myself. I try to be very organized and keep a calendar and know where I'm supposed to be at any given time. And my family comes first—I always try to make time for them. I go through my schedule and mark off time to make sure that I'm at all these events—and then schedule around them. So if my sons are having games, then I know that I can't do anything else.

Tell me about your family.

I have a husband who is a lawyer here in town. I met him about the day that my divorce was final from my first husband—at a volleyball party. He was in the school of public health and I was in med school. And he actually was a good friend of one of my roommates. We kind of laugh about it. I lived in this house

when I was in medical school where it was three other guys and myself, and I did the grocery shopping and the cooking and they did all the cleaning. So it started out with the four of us there. Then, as people learned about being able to eat there, people kept bringing other people home. So he came home with my roommate all the time to eat with us and ended up just not ever going home one time. (*Laughs.*)

You must have been a really good cook!

Oh, no, they were very easy to please, believe me! We were all in our mid-twenties, and they were very happy with spaghetti and lasagna and soups and things that you could make easily for groups. And it was very cheap living. We had four of us and we could live in a fairly nice four-bedroom house here in Chapel Hill for about $350 apiece a month. And I just did all the shopping for all the groceries once a week, and they would just eat what I had or what I fixed—they weren't very choosy. (*Laughs.*)

So I met Steve and we ended up getting married my fourth year of medical school, and Jackson—he's my oldest, he's sixteen—was born two months into my internship. Which made the internship a little bit more interesting. I took two months off and then went back to work, so Steve was with him two out of every four nights because I had to spend the night at the hospital every fourth night. He was the person who did the midnight feedings

and took care of him two out of every four, so he got to be very close to him.

And then about two-and-a-half years later, we had our second son Nate, which was right before I finished my residency. So he was three-and-a-half months old when I finished my residency and went into the military. As I mentioned, we were stationed in Georgia—or I was stationed in Georgia and Steve went with me, but his job was here in Chapel Hill, so he commuted back and forth. He would be with us most of the time and came up here about a week out of every month. Then we moved back to do the fellowship in '89, so my sons were two-and-a-half and five when I came back—and have been in Chapel Hill schools and been in the same place since we got back and it's been great for them. They've got lots of friends and are good kids.

What are some ways you relax?

I swim four miles a week and play racquetball and do walks with my friends here in town. And my swimming is what keeps me going, I think. It's a time when there's no beepers and no phone calls and nobody can get to you unless they get in the pool and stop you from swimming. (*Laughs.*) And I can do a mile in about forty-five minutes and it's an easy hour—then I reward myself with a little bit of time in the steam room. But I also do yoga once a week, which I think has been very good, as far as—if I get really stressed, I can spend five or ten minutes relaxing with some of the yoga breathing techniques, and it makes a big difference.

What are some of your favorite things?

Well, my favorite thing is swimming. I love to swim, I love to get in the water, I love the way it feels, and I love how I feel when I finish. I like spending time with my family outdoors. I love to travel. My mother would tell you my middle name is 'go.' And I love to read and keep up with the medical journals. I like to read just for pleasure as well. On our trips in the summer, I usually take novels and I average five novels while we're gone. They do a lot of fishing and I do a lot of reading. I'm not a very good writer! My papers, when I write 'em, I give 'em to my husband and he edits them—he's a good writer. Doctors don't write in complete sentences.

My favorite food is probably Mexican. And I'm not a vegetarian, but I do like black beans—any kind of Mexican food, I can eat. My favorite music is rock 'n' roll—which is probably not every cardiologist's—old-timey rock 'n' roll like the Doors and Jethro Tull and Led Zeppelin. I just grew up in that era and I still like 'em. When Jackson was about five, we took him into the nursery school where he would be going, and the teacher was showing him around and we got to the record player, and she said, 'Jackson, what kind of music do *you* like?' And he said, 'I like

rock 'n' roll!' Steve said, 'He's not my child!' He listens to a lot of classics and jazz, and I like jazz too, but I *really* like rock 'n' roll— still one of those old hippies, I think.

What are some personal interests or goals that you have for yourself?

Well, my goals are mostly through my family. I want to see my children finish school and get into good colleges and find something to do that they really like, because I really like what I do. And I think if you talk to people about—would they do those things in their life all over again and do the same kind of career, I would do everything that I've done over again, including marrying my ex-husband because I think I learned a lot. Being married at nineteen, you learn to stand up for yourself pretty quickly. So my goal is to get them into where they're very happy and then to spend more time with Steve and to be able to continue my job, maybe in a different way. We've fantasized about this—I don't know that it's really a fantasy because I think we could probably do it—in five to ten years, maybe be able to spend the summers working on the Blackfoot Indian reservation in Montana as a summer medical officer. Then come back here in the winters to work. I'd like to do something more than just be an office doctor. I'd like to go out and help some of the more underprivileged places. The Indian population is so in need of help.

How did you become interested in that particular population?

Well, we've traveled. One of the things we do to keep our sanity is, every summer we take a very long vacation, usually between two and three weeks and sometimes a little longer. We've gone to the Southwest, and when we went to New Mexico and Arizona and Colorado, I really got interested in it down there because the Navajo population is so poor. They don't have any resources, they don't have clinics, they don't have *anything*! You can just go for miles and miles and see just these shanties and *no* towns and *no* clinics. So I started looking into the United States Indian populations after that.

We then decided to go north, so we've been up in the Montana area and Washington and in Canada for the last three summers. But the same thing goes for those populations—the Blackfoot reservations are probably the poorest Indian reservations up there, and it's much like the Navajo. They're very happy, but they suffer a lot of health problems and I don't think they get the attention that they need.

We met an interesting guy who carried us on a tour of the Ute Indian Reservation. In Arizona and Colorado, there are three major populations—the Ute, Navajo, and Hopi. And the Ute is probably the least wealthy of the three. So we went to tour their reservation with a guide and, as it turns out, he was born on the Ute reservation as one of a set of twins given away at birth by the

birth mom. Well, his twin was adopted by a Ute family, and he was adopted by a Norwegian family who lived in Montana, so he comes back in the summers to do these tours on the Ute reservation. He's in perfect health, owns 300 acres of land in Montana, is very articulate, and looks to be very healthy. And his twin, who was taken by the Ute family, is on dialysis—has diabetes, hypertension, and all the health-risk factors that you see in the Indian population. And I just think that's fascinating that you take twins and separate them and that their health is so different.

So I got interested after meeting him and have just tried to look into what's available for them and what kinds of things would be available for us to do in the summers. There's also some legal services with the government that Steve could do. And maybe we would just volunteer our time. Sounds pretty weird, doesn't it? (*Laughs.*) My kids say, 'Mom, I think you're crazy.' But I don't think I'm crazy. I just think that, if you learn a lot and you know a lot and you can do something to help somebody, you should.

Would your sons help, even if they do think you're crazy?

My oldest son has panic disorder and he is very interested in helping. What he wants to do in college is to be a sports psychologist, to help athletes who may have the same kind of disability that he has. He actually plays on the varsity high school baseball team, and, in fact, this past Monday, pitched the very

first no-hitter in school history—although the school's only four years old, so, I mean, it's the first one, but there will be others. But he had a panic attack in the first inning and was able to work himself through it and to go on to pitch a wonderful game. And he wants to be able to understand why he has them and understand what he could do to help other athletes that might have them and not be able to live up to their athletic potential. So I think, in that respect, he's got a little bit of me in him.

What personal qualities do you consider to be of most value in life?

I think that you have to be a good listener. I think women physicians do more listening than male physicians—I don't mean that to be a sexist comment. I just mean that I think women, by their nurturing with children and their families, tend to listen more and listen with a better ear. And I think that to be a good person, you really have to be able to listen to other people and not dwell so much on yourself and to help those that are less fortunate. It sounds trite, but I don't mean it to be. For instance, we do an AAU baseball team with our youngest son and we've raised enough money that we have several minority kids on there who wouldn't be able to play if we didn't raise the money for them.

What is the one way that you've evolved as a human being that makes you proudest?

That I've been able to develop a sense for my patients and their care and medicine, and that the people I take care of will say very nice things about me and say that I listen and that I don't discount anything that they say—that I always take it to heart. And that I'm a good caring physician. And that's what's important to me—it makes me feel very good that the people I take of are happy with my care. And that my kids love me. And they'll tell me that every now and then. (*Laughs.*)

I guess they're at the age where that's happening less for the moment?

Less and less. (*Laughs.*) Although the fourteen-year-old still gives me a hug every now and then. But when they're hurt, I'm the person they come to. I think their father would faint—he's not good with blood.

What qualities do you possess that make your career choice a natural for you? And, conversely, what qualities of yours create conflict or struggle that you constantly work to overcome as pertains to being a doctor?

Well, I think's it's sort of the same thing. For the first part, I really am a good listener and I try to accommodate the patients as best I can and work around their schedules and their illnesses and make myself available to them. And then that's the other part, too, is that what I need to overcome is not being able to say 'no' and not being able to not be there at some of the times when people call. I always feel like I have this inner conflict of 'I need to go see them, but I also need to spend time with my family.' And it's a struggle. It's hard sometimes.

That's funny, how our strengths are also our weaknesses.

Yes, it is. And I think that, in this situation, it's so true because I really love all my patients and would do anything for them, but they do call me at home and they do call me in the middle of the night and even when I'm not on call. And that's O.K., because I really feel like I'm the one that knows them the best, but you end up getting sleep-deprived. And they call you on vacation, too. (*Laughs.*) But, in the long run, it's not a problem. I mean, I do need to learn to say 'no' and, as I've gotten older and gotten more involved with community and things going on outside work and home, I've had to say 'no' to more things. Like I play racquetball with the mayor of Chapel Hill and she has asked me several times to do different town committees and I have been able to say 'no' to that so far. I usually pawn 'em off on my husband. But also I've been president of the board of directors of the 'Y' and I've been president of the Faculty Club, which is the swimming and tennis club associated with the university employees—twice now. And so I like to do some things, but I also get asked to do a lot of others that I have to turn down.

What aspect of your career brings you the most joy?

I think just the patient contact and knowing that I can make a difference in whether some people live comfortable lives and enjoy *their* families and enjoy their existence as opposed to *not* having somebody that they know they can talk to or ask for help. The patients aren't just numbers—they're really faces and names to me.

How do you handle losing a patient?

Well, I usually go in my office and cry. (*Laughs.*) Or I cry wherever I am. I'm a pretty emotional person. It's hard. I beat on myself generally. And I go to my husband. He's very supportive. I think the most recent thing that happened that really was the hardest for me is my nurse who has been my nurse now since '92—her husband came in earlier this year. He had respiratory disease anyway and I sent him out by ambulance. As he was going out the door, he said, 'Please don't let me die in the hospital,' and this was a Monday and he died in the hospital on Friday. And I knew intellectually when I sent him out of here that he wasn't going to go home, but emotionally I didn't know it—or I didn't *want* to know it. So when he died, they called me at five in the morning and I got up and went up there. And my nurse Gwen— who is a good friend as well as nurse—was devastated. She hadn't been home since he went in, and I just felt incredible guilt—and

still do—because I didn't keep my end of the bargain, even though I *know* I couldn't. He would've died at home or died here in the office if I hadn't sent him to the hospital. But those are hard times. And my husband's great. He lets me rant and rave and he listens to me and helps me reassure myself that I'm doing the right thing. But there are times that even he can't understand and I just have to go away and spend some time by myself, go swimming—that's what I usually try to do. It helps clear my mind.

What do you consider to have been the greatest challenges to reach the place where you are today?

My greatest challenge was to finish medical school after having to go through such an emotional first year. Your husband leaving you two weeks into it and medical school being such a change anyway and having been out of school for three years when I went back—it was a challenge to not let my emotions really get me to such a place that I couldn't finish. I got very depressed. I was treated for depression with an anti-depressant. I lost about thirty-five pounds and went down to like ninety-eight pounds—I'm normally about 125 to 130. But had very good support from all my friends around here and was able to sort of fight my way back. And I think that was probably the biggest challenge I had—didn't know it was going to be a challenge like that when I started (*laughs*), but turned out to be. And finished OK.

Of what professional accomplishment are you most proud?

I think my involvement in the cardiac rehab program that I work with. It's a community program that started out very small. I started as the director in '91, and we've been able to grow into a pretty prominent community program and recruit lots of good people and have lots of patients. We've made a name for ourselves in the community. We take patients who have had cardiac disease or who are at *risk* for cardiac disease and teach them about risk factor reduction and about psychological stresses that go along with it—about dietary and exercise intervention. And we try to keep them exercising three times a week. Most of them exercise *with* us, and we monitor blood pressure and heart rate and well-being and guide them in the direction of which exercise they should be doing. And we've developed a good program over the last eight or nine years.

And of what personal accomplishment are you most proud?

My kids. And my marriage.

What advice would you give young women just starting out in a career?

To make some time for themselves. If you don't, you will quickly get burned out with what you're doing in your career and you won't be able to continue without suffering a big setback. So I would say, 'No matter what you do, take that hour, two hours—two or three times a week—to just do something for you.' I learned that a little late, but I've learned that it's probably one of the most important things.

Do you have any advice for older women considering a career change?

I have quite a few friends doing that now. Life is too short to be unhappy with *whatever's* going on. If you think you can do it, if you're *eighty*, you should be able to accomplish it.

Do you have any professional dreams that are yet to be realized?

I would like to make associate professor. (*Laughs.*) I'm still an assistant clinical professor. And that's just on paper—there's nothing that goes along with it. It would just be nice to have that. But it doesn't really matter. Professionally, I would like to be able to make a difference in some of the medical students' lives, so maybe to be more involved in the teaching. But, I don't know, I'm pretty happy with where I am right now. I really do love what I do.

Interviewed by Susan L. Comer.

Paula *Miller*

Paula Miller was born in Memphis, Tennessee. She went to high school in Greensboro, and then to Wake Forest University for a year. After spending a year at Northeast Mississippi Junior College (her parents' alma mater), she attended UNC-Greensboro, where she received a B.A. in biology and a B.S. in medical technology. From there, Paula attended the UNC School of Medicine, after which she held a three-year residency at Moses Cone Hospital. After a fellowship in cardiology at the UNC School of Medicine, she served as a captain in the U.S. Air Force for three years.

Currently, Paula serves as an assistant clinical professor of medicine at the UNC School of Medicine and as a partner at Chapel Hill Medicine, where she practices cardiovascular and internal medicine. She is married to Stephen Miller and has two children, Jackson and Nathaniel.

"My swimming is what keeps me going… It's a time when there's no beepers and no phone calls and nobody can get to you unless they get in the pool and stop you from swimming."

Paula Miller

Lorraine Perry an interview

Why don't we start at the beginning...where you grew up and where you went to school?

Well, I was born in Hell's Kitchen, which is a part of New York that was known for brewing alcohol during Prohibition. My parents were artists. My mother was a designer of clothing and had a shop in Greenwich Village. My father was a cabinet-maker, but really a designer of furniture. They had six children in five years. I'm the oldest.

Where did they put all of them?

In a ninth-floor walk-up. When the twins were born, which were the last two, they decided they better move to Westchester County, where there was going to be some green grass.

How could one be pregnant and walk up nine floors?

Oh, she was a trouper, I guess.

Wow. That's amazing.

Yeah. That's a lot of pregnancies to do it in, too. Up and down. I remember there was the top floor, which is where we lived... We had a little escape to go to the roof, and I remember playing on the top of the apartment roof as a little playground.

How long did you live in New York?

At age five, I started public school in Westchester County. Went through public school and then to Sarah Lawrence College in Bronxville, New York. Got an undergraduate degree in fine arts and art education. Left during the end of my junior year for a summer abroad with Sarah Lawrence in the South of France. It was a special art history program.

I met a Frenchman there that summer when I was horseback riding. He was the owner of the horses that Sarah Lawrence College used for their students. I fell off the horse and he stopped the other horses and riders and came to me and I thought I had died—just flat on my back. I was startled to wake up and find this Adonis face in my face, speaking to me only in French and telling me to get up. I thought, 'Well, I must be in heaven,' because of these incredible blue eyes staring at me. 'If this is an angel I'm supposed to do what he says.' So I just got up and got back on the horse.

I fell in love with the country and the people and with him. But of course, I had to go back to school and finish my senior year, and I never thought I'd see him again after that very romantic summer. But I did. He sold all of his horses. He flew to

Paris—the first generation of many, many generations that lived in the South of France to ever be outside of the Provence—sold his belongings to go to Paris and then to the United States.

It was very romantic, and after I finished school I went with him back to France and I got pregnant and had a baby and lived in France for four and a half years. But the marriage did not work out. The more French I learned, the more I learned about myself as a young woman, the more I realized that it was not an ideal relationship. I went home with a young baby.

My parents, in the interim, had sold their home in Yonkers, New York and had purchased land in Hampstead, North Carolina and built a house on the Intercoastal Waterway. So they said, 'Home is no longer New York. If you're going to come home with a toddler, you're coming to Hampstead.' And actually, Hampstead was not so different from rural Provence. Both agrarian communities, sea coasts...and I adapted very easily.

I got a job with the Parks and Recreation Department in Wilmington to be a visiting artist and with the school system to do art education in the schools. Through the visiting artist program I was initiated into a network of agencies that needed art. There were mental health centers, prisons, nursing homes... And everybody that was using the art—even though I was presenting it in a very academic, curriculum way—what I noticed was that they were using it in a very *un*academic way, which was just to express themselves. They didn't really require the kind of academia that I was using in the school system.

That fascinated me, especially when I was working in the mental health center. I had chronic schizophrenics—mostly street people—who were there to get medication by day, and I had them producing silk-screened Christmas cards. Well, word got out that these people who were considered very low-functioning were producing Christmas cards and selling them to the staff. The mental health nursing staff told the hospital nursing staff about it, and the hospital wanted to meet me and start an arts program right in the hospital.

When I got into the hospital setting I realized that I needed more schooling. So, I went back to school and got a second degree in psychology and then pursued graduate school in art therapy, but there were no graduate schools here in North Carolina. I interviewed and looked at schools in other states, but realized that I didn't want to be out of the state.

By this point, I had remarried and married an Englishman. My little French boy was now adopted by this Englishman and I had a family, so I chose not to pursue graduate school. It's something that I may do some day, but not right now. I've been with the hospital for nineteen years.

How did the program evolve?

Well, the oncology nursing director saw the horticulture therapy program and the arts and music that were being used in psychiatry, and asked if such a program could happen for cancer patients. The Oaks, which is a psychiatric facility, said, 'We will send you Lorraine as a consultant. During her consulting period, she can help you identify needs and establish a program and maybe interview a potential therapist.' But I fell in love with the patients and the staff, and the difference between ego-healthy patients who were suffering from physical illnesses that were causing depressive symptoms—very different from the guarded patient-clients that I was seeing in psychiatry. I was very relieved to be able to do work with people who had good ego strengths. I decided to stay and run the program myself.

While running the program, I realized that there were many more physicians throughout the house—on other floors, other units—that wanted similar services. Especially when I produced a photography show by the patients and I had photographs enlarged and matted on the walls. It became very visible through those photographs the kinds of interaction, therapeutic relationships, and the kinds of modalities that I was using. It became apparent that this was something exciting and unique and wanted by more and more people. There was only one of me. So, I decided that I would write a grant and hire on other practitioners who could provide similar modalities or things that I was not even capable of providing, like music therapy.

I wrote a grant that was accepted by the hospital itself and they gave me an initial one hundred thousand dollars to initiate the program. I was able to hire a full-time music therapist and many practitioners that would provide things like horticulture therapy, dance therapy, massage, yoga, progressive relaxation techniques...as well as visiting artists who would not come in as therapists but as professionals in their own right, providing music and quilting and visual arts at the patient's bedside, as well as storytelling. So, a program developed and we called it The Healing Arts Network. It is truly a network between the community, artists and practitioners and what the needs of the individual patients are.

What do you think have been the greatest challenges for you in developing the program?

Educating. Educating people who had a set idea of what the medical model is and what it should be, and encouraging people to look outside of that box.

And what do you think your greatest triumph has been thus far with the program?

Probably the fact that over 220 different physicians in the last two and a half years have written orders for the Healing Arts

Network. Of those 220, many of them continue to write repeated referrals. Also, having met over a thousand patients' needs in a relatively short period of time after a very dubious beginning.

So, being so busy with this, how did you come to be involved with Habitat for Humanity? Can you talk a little bit about that?

Sure. There was another nurse who was on the Habitat board that I worked with here in Oncology and she came to me and said, 'Lorraine, you would be a perfect Habitat board member.' I said, 'I think I have enough things to do, thank you very much.' And she said, 'No, no, no, Lorraine. You don't understand. I know that you *should* be a board member of Habitat because of your sense of community and the way that you do things up here with all different kinds of people in different walks of life.'

So, she begged and nagged and begged and finally I said, 'I know nothing about building but I'll do it.' So, I got on the board and didn't really work on houses themselves, but became very involved with the selection committee, choosing families that are in need that would be most appropriate for building their own house with a group of people. Then I got very involved with the partnership committee, which is where you actually partner with a homeowner who is about to receive a home because they've completed the sweat equity hours and they're going to pay their mortgage payment. You couple with them to help them under-

stand the responsibilities of being a homeowner.

For all of these people, they are the first generation of their families to ever own a home. So they have no real inkling about those responsibilities. It's kind of scary and they need a little reassurance and sometimes motivation. That's what the partner does. I remember trying to figure out with this new partner why these border plants had perished. She's watering them and she gave them some fertilizer and they looked...these little azalea shrubs looked terrible.

Well, she went back in the house to do something and her little boy came out and sat on their new porch railing with his feet dangling over, and he's eating his cereal and as he got to the bottom of the bowl of his cereal, he poured out the rest of the cereal over the plants and the shrubbery. I watched this scene, and I realized all that milk and sugar and leftover Cheerios were on the leaves and on the ground. And I said to this little boy, 'Do you always eat your breakfast out here?' And he said, 'Oh, yeah. I like eating on the porch.' And I said, 'And when you finish your meals you always put the leftovers on the ground?' And he said, 'Oh, yeah.'

I said, 'Well, I want to show you something.' And I said, 'Let's look at this bush and let's look at the one on the far end. I've been trying to figure it out...and I'm a master gardener and I figured I knew all the horticultural answers...but this bush doesn't stand a

chance because bushes don't like Cheerios and milk and sugar.' He understood that and he was a little miffed that maybe I was complaining or reprimanding him. And I said, 'We've just learned something here. You've been conducting an experiment. And the result is this bush and this bush and what have we learned?'

So, sometimes what you assume or take for granted as common knowledge is not necessarily common knowledge for people who are in a brand-new situation, a brand-new territory. A different way of living where there isn't a custodial staff or a governing body telling what and what not to do with your home. There really is no set of rules that you're given. So these things have to be learned and taught and...we go from there.

How did the women's housing endeavor come into being?

Well, I had heard about a women's built house in another state. It intrigued me and I knew that this was a fast-growing, up-and-coming town for developers. I was on television to promote The Healing Arts Network and the person being interviewed just before I went on the air was a young female contractor who was setting up her own building firm and had received an award as Businesswoman of the Year or some title like that.

When she finished speaking on the air about herself I made a mental note of calling her. After I did my segment she was still there, I got up with her, and she said, 'Oh, yeah. There are sev-eral female contractors in this town.' So, that got the wheels going.

I have friends who are pretty industrious in their own right and creative and would love the project of building a house, but they don't necessarily have the licensure or the certification to do such a thing. So, I called a meeting—a focus group—between friends and people who knew female contractors—and I got on the phone and called every female contractor that I could find in the book. We got together and we had a big brainstorming session and figured how best to organize it. The YWCA was willing to collect all the volunteer data so that I was able to hold a full-time job and help organize this. I was able to get two lead female contractors who would be the kingpins for the construction—which I know very little about—and lots and lots of friends who were willing to come out every Saturday morning and help build. So again, it was another networking thing.

That's wonderful. With all of this stuff going on, how have you had the ability to balance your personal and your professional lives?

I stay very busy. I start my day with reading the newspaper and being aware of our community. Then I work approximately nine hours here at the hospital, nine to ten sometimes. After work I go home and have a quick dinner with my husband and then it's usually a meeting after dinner or enjoying a show. You know,

Cinematique or a creative arts endeavor in the community. I enjoy museums, St. John's Museum of Art, and take in the openings. I enjoy the theater, Thalian Hall. So, whether it's meeting because it's a community endeavor or it's because I'm the recipient of something artistic that's going on in the community, I make a point to be involved.

Does your son participate as well?

He went to school to study biomedical photography and did an internship at Charleston Medical College, but there was not an opportunity for him to work in that practice after he graduated. So, now he's going back to school to study radiography as a technician. He doesn't show so much of a penchant for the arts, as he's more technically oriented.

What do you see as your greatest personal accomplishment?

I guess I'm pretty adaptive and flexible. That has allowed me the success of integrating with many different types of people and many different types of situations. I believe in a sense of community. I believe that networking is a way of accomplishing a lot of those goals that we need to accomplish for our community.

I guess I see the family as a big picture. Maybe it's because I'm the oldest of six. I think my parents' values and mores have to do

with assisting and looking at the big picture, looking outside of the immediate family.

Who do you see as your greatest heroines, either growing up or now?

I was always fascinated by people like Margaret Meade and anthropologists. I have a great uncle who was a pretty famous anthropologist. I have a sense of wonder about the development of human beings and human nature. So, I guess, people who have been in the field of tracking and being inspired by humankind. Both men and women. I think of Carl Jung being in that category.

What's the one way that you've evolved as a person throughout your life that makes you the proudest?

(*Laughs.*) I don't know. I still have a lot to learn.

Are there particular facets about yourself that you think enabled you to be so successful?

Probably being open to the possibility of change. Looking beyond the box. Growing where one needs to grow and not saying, 'Well, it's been done this way for eons, therefore we should continue in that vein.' Maybe a little stubborn or tenacious about knowing that things are going to change, things are going to evolve, so why not push and encourage it? And being patient

enough for others to catch up.

What dreams or goals do you have that you still want to fulfill?

I'm open to learning, I guess. That may come through travel, being better educated, and looking forward to meeting people who are going to influence me and continue to mentor.

If a young girl or an older woman seeking direction came to you, what advice do you think you might offer?

Probably to get them involved. Not so much to tell them that this is the way it is, but to say, 'Come and try it with me. Get your feet wet. Don't wait to make sure that you're going to do it right before you do it. Learn from your experiences. Learn from your mistakes. Let's go and pursue it.'

Are you thinking now specifically of what you've done, or also as a general philosophy?

Well, in this realm...in the realm of working in a safe, controlled environment where there is a lot of predictability, it's easy for me to say, 'Let's go do it,' because everything's in place and that the patient is going to teach us how to do it better each time. I don't know if I would make the same statements about society in general because we are very vulnerable to many, many factors.

What advice do you think you might give to someone who had dreams of starting a program the way you did—about reaching that goal, fulfilling those dreams of starting something up, managing it, watching it grow?

To be aware of one's own vision. To repeat to oneself in the course of every day what that vision is and verbalize it out loud or in writing to other people, and converse about it so that it actually comes to fruition. It's not an idea and then a thing on its own merit. There's a process. So you have to have a very clear idea of what it is you want to bring about and you have to be very active *daily* about what it is so that it can begin to develop—begin to materialize. That doesn't happen in a vacuum. It's about people networking with other people and engagement. So this dialogue creates a team, and then the team goes forth and puts it in place. This house isn't going to be built by one person. The job here at the hospital isn't any one person's, because if the patients weren't here we wouldn't be here.

Interviewed by Emily A. Colin.

Lorraine Perry

Lorraine Perry works as an expressive therapist and holds a B.F.A., as well as a B.S. in psychology. She initiated and developed the Healing Arts Network as a pilot/grant funded program, now an official program of the New Hanover Regional Medical Center. As a resident of New Hanover County for twenty-one years, she has attempted to promote community interest in the arts by implementing innovative programs using horticulture and the fine arts.

Recently, Lorraine presented a keynote address at the annual conference of the International Society for the Arts in Health Care in Michigan. She is a Board of Trustees member at the New Hanover County Arboretum, and serves on the Board of Directors for the Habitat for Humanity.

She currently works as an expressive therapist at the Coastal Cancer Center's Oncology in-patient division. Lorraine is a Hospice volunteer and a facilitator for the Karen Joe Smith Breast Cancer Support Group.

The Urban Ecologist Samantha Lefko

Well, so here I am today, a sustainability activist, a boat rocker, an environmentalist, a passionate urbanite, a wife, a mother to-be (expecting on Thanksgiving), co-founder of an innovative non-profit called CitySeeds, which has created the first system of edible public parks in the United States, and even I wonder how I got here. My life has been no more extraordinary than most people's, but where I ended up and what I want out of life may be different than the majority of people I meet. I overcame few obstacles in my childhood to get where I am today. In fact I have dropped a few economic classes in order to accomplish the things I have.

I was born into a fairly privileged suburban life with all the amenities. As a teenager there was a car for each member of the family. Today, my husband and I share a vehicle by choice. We've designed our lives so that the majority of places we need to go we can get to by foot or by bike. We live inside the City of Asheville, only a mile from downtown. We believe that cities are the most sustainable forms of settlement because services are concentrated, less land is used for development, and greater amounts of farm and wilderness areas can be preserved if our settlements are dense

and clustered rather than linear and spread out as is all too common today in suburban and rural development. We can walk to the bakery, the animal hospital, the video store, a convenience store, the pool, day care, four restaurants, and an art store in under five minutes. In a mere fifteen-minute walk we can be in the heart of Asheville's thriving downtown.

As would be expected of my suburban upbringing, I was never influenced politically, and I was never taught to be aware of social causes. In fact to this day I am unsure if my parents were Republicans or Democrats. To this end I have no idea where my political and social conscience came from. It seems that if my social and political awareness were to be a result of my upbringing, I would be interested in little more than big houses, pretty cars and all the obligatory "stuff" of suburban life. Instead I value community, environmental and social ethics, and family above all other things. Even though today I am pursuing a master's degree in accountancy, my goal is not to be a chief financial officer somewhere making six figures. Instead I continue to want to apply my skills in the non-profit sector, making far less than what I am worth in the corporate market.

What I have learned, from watching family and friends, is that you can't buy quality of life. And I don't intend to try. Except for the rare millionaires, I have not seen an instance where working harder and longer at the expense of self and family has improved anyone's quality of life. And let's face it; none of us will probably become millionaires.

Perhaps, one of the decisive moments in my life was attending a senior year high school program in Yorktown, New York called Walkabout. The program's academics were solidly ecology-based. It was my first awakening to a world that was fragile, finite, and could be impacted by my actions. That is not to say that I became a raging environmentalist. I have never had that extreme streak in me. Instead I have always approached most things rationally and logically. I have never wanted to tie myself to a tree or be a participant in a human barricade. Thankfully there are other people out there who will do those things so I don't have to. Yet it wasn't until I arrived to college in Boone, North Carolina in the early 1990s, that I began to understand the economic implications of environmental problems. It was at that point that my life started making sense, my seemingly scattered and fiery beliefs began to fall together. I had discovered a rational and logical approach to understanding the impact of environmental problems through economics. If we continue to spend the earth's resources with wild abandon and no concern for the future, it is going to cost us all money. And we all know that when people get hit in the pocketbook it hurts, and they take notice.

Finally, in college, I was exposed to a field of study called permaculture. The word permaculture is derived from the words permanent and culture. It is a methodology that can be applied to all things from sustainable agriculture to the sustainable design of cities. Its very basis is derived from Von Thuenen's—a famous economist's—concentric circles. It is from permaculture that my husband and I came up with the idea for our non-profit organization, CitySeeds. The edible public parks are nothing more than a rather straightforward idea from permaculture called forest gardening. In forest gardening we simply accelerate the first few phases of natural forest succession by planting the seven layers found in every forest ecosystem. The layers include the canopy tree, dwarfing tree, shrub, vine, herbaceous plant, ground cover, and root layers. After minimal maintenance for the first three to five years, the forest system will then become self-sustaining, producing food, shade, recreation and pleasure for decades to come. By mimicking the development of a natural forest system, we are able to produce a natural system that needs little maintenance, no chemicals, and provides for human needs. We simply took this very basic and old idea and applied it to the public realm. My motto is, money doesn't grow on trees, but food does. In our

endless campaign against hunger, it seems that this is what we have forgotten. If you are curious about permaculture, you can just type the word into a search engine on the Internet and you will have more information than you know what to do with. CitySeeds' mission is to **educate the public through the implementation of model projects, which promote ecologically sustainable urban development.** If our cities can become wonderful places to live, there is far more hope for the preservation of our farm and wild lands.

In the latest chapter of my life I have begun to learn that you have to find balance in your life. No matter how much money you make or how much good you do for others, you will hate your life if you make no time for yourself. I can't wait to become a mom in November and I have struggled with not accepting jobs or chasing opportunities for next year. Next year is set aside for my child, my husband and myself. I will never get this time back and I must be careful that my ambition does not overshadow the real pleasure of living. So do good things, commit your life to meaningful work, and don't chase big houses and shiny cars. Always remember that there are precious moments in life that once gone, can never be recaptured. So make plenty of time for living. Good luck.

"No matter how much money you make or how much good you do for others, you will hate your life if you make no time for yourself."

Samantha Lefko

Samantha *Lefko*

"*As would be expected of my suburban up-bringing, I was never influenced politically, and I was never taught to be aware of social causes.*"

Samantha Lefko

Samantha Lefko lives and works in Asheville, North Carolina. She has been active in helping to bring attention to the field of urban ecology and the value of sustainable urban development through her involvement in the non-profit organization, CitySeeds, which *educates the public through the design and implementation of model projects which promote ecologically sustainable urban development.* Samantha is married to Jonathan Brown, co-founder of CitySeeds. They are expecting their first child this Thanksgiving.

Marcia Lyons an interview

Where did you grow up and go to school?

I grew up in Needham, Massachusetts, which is about fifteen miles west of Boston, went to college at University of Massachusetts, and got a bachelor's degree in wildlife biology. They didn't have a coastal lab then, but I just sought out as many professors as I could that did coastal courses. That had always been a very keen interest of mine, since I was young.

Can you briefly describe for me what you do now as a vocation?

I have been with the Park Service here at Cape Hatteras seasonally since 1976. And I worked three seasons as a temporary and then on permanent. Since 1995, I have been a natural resource management specialist. It is a mouthful.

It is quite a mouthful.

I know, so I very often just say, 'field biologist.'

When you were a child, what career dreams did you have?

When I was a child I knew I wanted to work with animals, and when I was really little, I used to think I was going to be a farmer. And then I was eaten up with sharks. I suppose that is a terrible way to say it. I used to read constantly on sharks. So that was my dream when I was little, to be what I called a shark authority. I didn't know what else you would call it.

And then as you grew into adulthood, how did those dreams evolve for you?

Well, I still knew that I wanted to deal with some sort of wildlife and conservation. That was something that was, I think, near and dear to my heart. I was always in awe with the wild world. So I pursued wildlife biology at school, not knowing exactly what I was going to do. I graduated in 1976, and back then the wildlife biology departments were predominantly male. I was one of the few females. It has changed so much now. I am so happy that there are so many more women in wildlife biology or wildlife management. Back then they dealt with game animals and management of game animals: rough grouse, spring neck pheasants, and white tail deer. It was really very much game-oriented.

Actually, I thought that when I graduated, I'd take a year off, and then go back and study entomology. I was very much into insects, social insects in particular. And then, in my summers through college, I had done volunteer work—which I really advocate for people, because this is a competitive field now—and it really helped me. I worked at the New England Aquarium in

Boston. I worked at the Manomet Bird Observatory on Cape Cod. Again, these are all internships that I did. Probably what got me my first seasonal job here was the fact that I had worked at the Manomet Bird Observatory and they needed someone to deal with birds here. Initially I was hired on as an interpretive naturalist. And they needed someone to do bird walks, so they grabbed me because I was the only one, like I said, who applied that had mentioned that. And then I had done an internship also through the Student Conservation Association at Cape Cod National Seashore.

Can you recount for me the path that you took to get where you are today? You graduated, and what happened?

And then what happened? Then I did what everyone did in the Seventies. I got in a VW Bug and drove cross-country with a friend, writing applications for summer jobs with every National Seashore in the country for seasonal work, because again, I knew I was most interested in coastal ecology, coastal systems. I guess I was on the road for two-and-a-half months, and then the minute I got home I heard from Cape Hatteras National Seashore.

I had known about Hatteras because of an old surfer boyfriend, and also I had taken as many coastal courses as I could. It just so happened that the coastal ecologist at University of Massachusetts did most of his fieldwork at Cape Hatteras and Cape

Lookout National Seashores. One of my roommates had worked with him for a summer, so I kept hearing about Cape Hatteras, Cape Hatteras. And when I started my cross-country trip, we came straight south to Hatteras from Massachusetts and then went west, because I really wanted to see what this place was like that I had heard so much about. And I really liked it. I even fell in love with one special part of the seashore where they have the maritime woods, and the ocean right next door to each other.

So when I arrived back in Massachusetts, I got a phone call from Cape Hatteras asking me if I wanted to be an interpretive naturalist for the summer months, and so I jumped into that. I really was very, very fortunate being at the right place at the right time, because when that summer job finished, they wanted to have someone stay on in the wintertime, which they had not had before. So I got a nod to extend one year. I kept getting these long-term seasonal positions. And then finally after doing three years of that, they were phasing out my seasonal position, and I had to compete to get on a—well, actually, it was a part-time permanent job. I worked thirty-two hours a week. But I was considered a permanent employee with benefits. So, I actually took a cut in pay when I became permanent.

Did you find that there were many women working in your same field?

When I started with interpretive work, yes. There were a lot

of women who were interested in environmental education. But I would still say that the park service definitely had more males than females. And more females were in administrative or clerical work. There weren't as many female law enforcement rangers. But as far as summer work goes, there were a lot of females that did work here at Cape Hatteras as interpretive naturalists or interpretive historians. I worked with that until 1995, and I think I kept very, very close ties with the park biologist, who is up at our headquarters office in Manteo. And what I concentrated on in my interpretive work was to try to educate people about better island ecology, but also talk about issues and talk about research that was being done. So I always had a very good relationship with the park biologist, and I had some supportive supervisors who knew I really wanted resource management. When I had my other work done, I was allowed to help on projects, like some bird census thing or doing the closures for nesting birds, things of that sort. And, then I would again try to keep this good relationship with the biologist because I wanted to get the information out to the public.

I was always big on interpretation. Besides the one-on-one with people, we did a lot of writing. We wrote a lot of pamphlets for the public. We worked a lot with the local schools. We wrote press releases for the local papers, so I was the main person who always tried to make sure that what was going on in the park was known in the community, as far as research issues or developments, or things of that sort, from endangered species to hydrology studies, to whatever.

And then in 1995, we had a contract with N.C. State University to do some shorebird work, including the Piping Clover, which is threatened along the Atlantic Coast. When that contract finished up, they wanted someone to help out with overseeing the Piping program, monitoring the program for the 1995 breeding season. So just out of the blue I was called up and asked by the park biologist if I would consider leaving interpretations for the summer. I would oversee their project, which I jumped at.

Then we got a change of superintendents, and the new superintendent was very concerned that this park had no real resource management division. We only had the park biologist, who was overwhelmed, and would just rely on the law enforcement rangers to do resource management projects as needed. But they were already overwhelmed with everything else they had to do, with visitation increasing. So, at any rate, this new superintendent decided to create a resource management division, and he permanently placed me in that division. So we now had two people. It was the smallest division, of course, in the Park Service at that time.

We have always relied on the Student Conservation Association. We have been getting SCAs to do turtle work, to help out

with the nesting bird work. And that was great because, again, there are so many young biologists out there trying desperately to get field positions. I always joked that I we were the only division who could really rely on volunteerism. I don't think you get people who are just dying to volunteer to collect fees or dying to pick up trash along the side of the road, but there are a lot of young students that are just dying to get some field experience in the biological sciences. So we always get a very good pool of people from the Student Conservation Association. And now, besides that, this will be our second year that money was funded to have bio-techs to help me out on the fieldwork. So I now have a bio-tech again this spring, summer and fall at Ocracoke, two at Hatteras Island, and one at Bodie Island.

Along this path that you have taken, what do you think have been your greatest personal and professional challenges?

I guess the challenge that I see is the mandate of the Park Service. The Park Service has a double mandate to be here for the enjoyment of the American public and future generations, but at the same time, to preserve and protect the resources for future generations. And in our enabling legislation it says that 'Cape Hatteras National Seashore is set aside for the enjoyment of people who would like to pursue fishing, sailing, swimming,' things along that line. But no development can be 'injurious to the flora, the fauna, or the topographical features of Cape Hatteras National Seashore.'

It is very, very hard to try to balance this double mission, and that has probably been the most challenging thing for me. And because the number of people are increasing in the National Seashore, where we have now hit near three million people a year. It used to be just a summertime place, and that's why I stayed here in the seventies. As soon as Labor Day rolled around it was empty, and I didn't know there was any place left on the coast like that. You know, coming from Cape Cod, I didn't know that there was any place that was still so isolated and had such a short season. So the fact now that we have a much larger visitation, we have many different interests groups than what we had when I first started out or when the park first started out.

You know, four-wheel drives are allowed on our beaches here. But back then it was mainly it was during the fishing season, and there were mostly these old beach buggies. There weren't that many. Now, you know, with the economy doing well, everyone has sport utility vehicles and so now you get people out there who aren't fishing. They just want to take their vehicle out there to be on the beach so they will have all their chairs and their grill, all their extraneous fun toys. You get people out here windsurfing. It is just awesome. People just love to be out on the beach just to use their car to go shelling, or to go birding.

We own the whole beach—seventy miles of beach. But behind are these villages which have been here since the 1700s, and when the park came, they didn't take all the land from the villages, or weren't given all the land. The land was acquired in all different ways. And development in the last fifteen years has really, really increased. Even in areas where there's not four-wheel drive, there is a very heavy day use for pedestrians.

So, therefore, you are trying to balance people who want to recreate in the park with what I feel my job is to try to protect the resource. It is very challenging when you are out there, because not all visitors agree with you. For the last two weeks all I have done is put symbolic fencing around areas where birds traditionally nest—our early season birds, which would be the Piping Clover and the American Oyster Catcher. Some of these same areas, by next month, they will be used by large groups of colonial water birds, the terns, the skimmers, etc. So, what I try to do is get out there early, and this has changed over the years, because there was not a field biologist to really be out there and get things done in a timely manner.

Some people say the Park Service is closing more beaches than they ever used to before for all these birds. And yes, it is true that they are, because we have never had a resource management division. And so, therefore, we are doing a better job of protecting the species that are at risk.

Is it a challenge for you to separate your personal and your professional life?

Yes.

How do you juggle that?

I don't always do it very well. And I have got to learn. I think I am known in the community because I have lived here for so long, so sometimes I get the 'Oh, my, she's doing this again!' 'Oh my, she is doing that again!' I and my supervisor are trying to let people know that it is not just Marcia. We have a mandate, and it is the Park Service, as a whole, who is making these decisions. I don't willy-nilly go out and close an area off or make some decision about the use of a certain area.

How do you relax?

How do I relax? Well, often I spend a good part of my days off in the park. I live right in the village of Buxton here. And even my house abuts right on Park Service property. So I find myself in the park a lot. I love to go birding, and I love to hike. And so I am through the maritime woods a lot. We have the largest maritime woods left in North Carolina. Between the Park Service and the state of North Carolina, with the National Coastal Reserve System, two-thirds of the woods are protected, and it is really beautiful maritime woods. I love reading, I love gardening.

I keep bees, which I enjoy. I keep chickens. That's a little bit of the early part of wanting to be a farmer. And then I do love to take trips if I can. My husband and I both love the outdoors, and we have taken quick trips to Alaska. Last year we went to the Bahamas, to Abaco, to Scotland, to Ireland.

Does your husband work at Cape Hatteras, as well?
My husband is an elementary school teacher.

How did you meet?
I met him down here my first fall.

And is it a challenge for you to balance family and career that way?
The job is real demanding, and I have one child, who is now fifteen years old. I loved it when I worked thirty-two hours a week on that first permanent job, because that's when Teal was born. And so I thought I had sort of the best of both worlds, that I could get what stimulus I needed at work, but still have three days a week at home with him. And my husband's days off always overlap with my days off, so we felt that we had at least four days a week that our son was with his parents.

So, has it been really wonderful for him to be able to grow up right next to the park?

Everyone jokes that Teal was mixed up at the hospital.

Is he a city boy?
Since he was in second grade, he's been putting computers together. I would have to drag him outside. I would say he HAD to go for walks with me. You know, I remember when he was really little I used to take him birding and I would have these great pictures of him standing with dead basking sharks and looking through spotting scopes at peregrine falcon, and stuff like that. But then when he started to get more of a mind of his own, academics were really important to him, and technology. So much so that—we were very happy with his elementary school here, but we have had to make a decision, and this was one of the hardest decisions I have ever made—because of his interests he wanted to go away to a private school. He felt that he wanted more challenges than what he was getting here. So this is his second year away. It's very hard to say goodbye to a thirteen-year-old, especially if he is your own, but he lives with his grandparents in Norfolk, Virginia. That's my husband's parents. And he is attending Norfolk Academy.

Was that particularly hard for you? It seems like in many ways the environment where you are living right now is where you would have loved to grow up, in terms of being able to wander, look at the birds, and hike.

Yes. My husband loves to fish, hunt. Before his knees gave out he was on the surfboard all the time. So, yes, for both of us, what we loved was getting away from the fast pace and being in just a beautiful surrounding. We both chose Cape Hatteras as the place that we would like to live and then bring up our child, as opposed to a more urbanized or suburban-sprawl type area. So it was very hard for us to accept, but then, we just finally had to realize he was his own person, and this is what was important for him. And it wasn't worth going through battles of trying to get him over to our side. We had already gone through that. And still, he is only fifteen. Who knows what is going to happen? With this going away to school—he is definitely getting exposed to things that he wouldn't have gotten exposed to down here. At Hatteras, he was so into computers and he even helped the school run their computer system—I was afraid that he would see nothing else but that.

What do you think is the way that you have evolved as a human being that makes you the proudest?

I have always thought that dedicating your life to a humanitarian cause or an environmental conservation and preservation cause, to try to hang onto the things that are good and try to make the world a better place—it makes me feel good that I am in this field. I probably would feel very despondent if I found my-

self behind a cash register somewhere, because that is just not what I care about, about the consumptive parts of life. But just preserving what is here.

Do you have a particular personal accomplishment about which you are the proudest?

Well, I guess as far as work goes, it probably is that I felt like we started with just one person who was trying to look out for 30,000 acres. And so, I just feel good that I have been a part of allowing the resource protection to develop in this park, and I feel like I have been part of putting us on that path that I think we will continue.

What advice do you think you would give either young women just starting out in a career, or older women concerning a career change?

When I worked at Cape Cod, one biologist said to me, 'Being a biologist is not a career, it is really a way of life, a way of thinking.' And I think that if people have that feeling, they should pursue it. I don't think we can have enough advocates for the earth, and even if people can't do it full time, there is still so much that they could do with their local government, their local community, to try to bring about an awareness and change. I think with young students or people who are changing their field—I really found that because it is a competitive field, I can't say enough

about how important volunteerism is. And, also another thing is to at least get your foot in the door, and to try to be as proactive as you can in trying to get as much experience under your belt.

Do you have dreams that you haven't realized yet, either personal or professional?

Well, when I was an interpreter, I learned a great, great deal. I learned so much about dealing with people, about public speaking, about writing and all that kind of stuff, that has helped me so much in this position here. I wish we had more help, because I feel like everyone in our division is doing more than what one person can do, and that can get overwhelming. That is something I haven't figured out how to do, is to say NO. Some things have to slide, or else you just stress yourself out.

I would say that as far as my professional work, I am where I want to be. My personal dreams—I get despondent when I feel that everything is geared towards consumption in our society. And the economy is doing so well, and so it's growing, it's growing, it's growing. But, at what cost is it growing? Not just in our country, but globally. I would like people to come to some realization that they do not need all these physical things. That it is so much more important to be satisfied with less and protect what we have got.

Interviewed by Emily A. Colin.

"I was always in awe with the wild world."

Marcia Lyons

Marcia **Lyons**

Marcia Lyons is a resource management specialist at the Cape Hatteras National Seashore. She holds a B.S. in wildlife biology from the University of Massachusetts. In 1976, she moved to Hatteras Island to work as an interpretive naturalist for the Seashore.

Since 1995, she has worked in the Park's resource management division. Much of the work involves protecting and monitoring threatened/endangered as well as other sensitive coastal species.

Marcia lives with her husband and son in Buxton's maritime woods.

"I get despondent when I feel that everything is geared towards consumption in our society... It is so much more important to be satisfied with less and protect what we have got."

Marcia Lyons

Composing a Life with Children and a Career: Can It Work? Victoria Thayer

I hung over the tank, my ten-year-old arms dangling as I watched the dolphins swim by. Their sleek, pewter bodies leaped and cavorted in front of me. How did they stay underwater so long? I was hooked, and I wanted to know more.

My introduction to bottlenose dolphins was at a place called Theater of the Sea in Islamorada Key, Florida. I was there to visit my grandparents with my mother and five-year-old brother. My parents had gotten divorced five years before, and we hadn't seen my father since. We couldn't go to school because there had been a mononucleosis outbreak in the local school, so my freckled sibling and I were gleefully free from academics for three months. We walked the beaches, adopted a pet hermit crab that could be coaxed out of his shell with a pelican feather, and punctured the hundreds of turquoise man-of-war that had stranded dead along the high tide lines. My mother was depressed, and was there to relax and hopefully feel better, so my brother and spent most of our time alone. We visited a retired man who created pigs out of small coconuts and shells. He bestowed gifts of

giant starfish on us and made us feel as though we were the center of his universe at those moments. I fell in love with the ocean, the palm trees, and the salt air, and returned to my fifth-grade class a different person.

Growing up in the seventies, environmental concerns became a central theme in my life. Acutely feeling the injuries and injustices wrought upon the environment and its creatures, I went to the University of Connecticut and studied Natural Resources Conservation. Graduating after studying for a year in France, I obtained my master's degree in environmental management from Duke University. I studied loggerhead sea turtles and documented that vehicular tracks on the beaches can prevent turtle hatchlings from getting to the ocean. Subsequently, the National Park Service closed many areas of the Cape Lookout National Seashore to vehicular traffic during turtle hatching season. Still, my passion was marine mammals.

As I was writing my master's thesis at the Duke University Marine Lab, Dr. Richard Barber, a biological oceanographer, asked

me to assist on an oceanographic cruise from Peru to Panama. Dr. Barber knew me from a seminar course I had taken with him and apparently I seemed to be a likely candidate for such an adventure. I took an instant liking to the sea and cruises, and saw many species of dolphins, whales, and seabirds on each cruise. We were at sea for thirty days at a time, and the ports were as varied and fascinating as the Galapagos Islands, Tahiti, and Hawaii. On one cruise in 1982, we were the first research ship to identify that a major El Niño event was taking place. The winds had died, and the eastern tropical Pacific appeared eerily calm—almost lake-like. The normal potpourri of seabirds and marine mammals was absent. The water was five degrees warmer than normal and the equatorial current was flowing toward the east instead of the west. I called via satellite to tell Dr. Barber. No research ship had had previously worked in El Niño at sea as it was setting in. He pronounced, "You're out there on the edge of science."

I went to sea to do research frequently over the next three years. Keith, my boyfriend, and I then decided that it was too difficult to be apart for so many months each year. Keith and I went out one night and sat by the water and talked about our dreams and what we wanted from life. We wanted to be together, to stay as healthy as possible, and to study dolphins. Since we had moved to Beaufort in the late 1970s, we had seen bottlenose dolphins each time we sailed our Hobie Cat catamaran. We started taking photographs of their dorsal fins.

Each dorsal fin is unique—its shape, size, scars, and notches. We started a catalogue of the fins and soon could recognize many individual dolphins from their distinctive fins. Very young dolphins sometimes have completely smooth fins and are not distinctive enough to be identified, but most fins have some notches or scars.

We knew it would be extremely difficult to make a living by studying dolphins, but we were young and determined. Keith also had a master's degree from Duke in environmental management, and we shared a passion for our work.

We were married on the beach in 1985 and began working at the National Marine Fisheries Laboratory in Beaufort as research technicians. After a few years, an oceanographer friend from my previous cruises called and told me of job opening in La Jolla. The job entailed organizing and conducting biological oceanography on marine mammal cruises designed to gather data on spotted and spinner dolphins. Soon we headed west, to spend almost five months a year on research vessels in the Pacific. Keith was hired as a marine mammal observer, and quickly became one of the very best. Finally we would be on cruises together.

In an attempt to estimate the numbers of spotted and spinner dolphins, the cruises hosted an array of scientists and their gear.

As the biological oceanography coordinator, I was in charge of collecting seawater samples from these twin 171-foot government research vessels. We analyzed the water for productivity and chlorophyll levels, to learn if the dolphins were preferentially choosing more productive waters.

Spotted and spinner dolphins were important because of tuna. Fishermen caught and killed thousands of spotted and spinner dolphins in their purse seine nets each year as they fished for tuna. Pressure was on the National Marine Fisheries to come up with some baseline data of how many species inhabited these waters. So each summer, two research ships would leave port and cruise to the eastern tropical Pacific. Observers would work during all daylight hours, scanning the waters with giant binoculars to find and count all marine mammal species. It was a dream job. More interested in marine mammals than seawater now, I became frustrated by the oceanography aspect of the job and asked to become a mammal observer. My boss was shocked. "But it would be a demotion, with less pay!" he exclaimed. "I know, but I really want to spend hours looking through the binoculars every day," I explained. He went along with the idea, and I became an observer.

We saw twenty-six species in all on those cruises, and the ports were wonderful. Elusive beaked whales, breaching humpbacks, thousands of common, spotted, spinner dolphins, false killer whales, killer whales, and enormous blue whales. Giant squid, flying fish and sea turtles were not uncommon. We would fish for tuna and mahi when the ship was stopped. One boat had a helicopter pad and aerial observers went up and took pictures of the huge spotted and spinner dolphin schools to calibrate our observer estimates. We stopped at Cocos Island, Clipperton Island, and the Galapagos. Panama, Costa Rica and Mexico were regular ports. By the time we got back to San Diego after all those months, we were unsure of getting in our cars and driving on I-5.

One morning I woke up at sea and had a revelation. I wanted a **baby**. I was ready. After years of saying that I would never want kids, my biological clock had gone off with a resounding ring. Keith tried to dissuade me from being too hasty, but I wouldn't hear of any reasonable excuses to wait any longer. I was thirty-three years old and it was time.

I became pregnant almost immediately. In fact, I was in the galley of the ship one evening and was literally eating pickles from a jar, when my friend Greg came in. He took one look at me puckering up from the sour dills and quipped," You're pregnant!" I thought he was nuts. As a sworn bachelor with not even one commitment molecule in his entire body, what did he know about pregnancy and how could he tell from my eating habits? Of course, he was right.

I couldn't tell too many people on the ship because I wanted to tell my boss back in La Jolla first. This would definitely change my plans for the coming year. We got back, I told my boss about the pregnancy, and he was understanding and supportive. Probably stemming from his own three little children, he knew what joy and fulfillment children meant. He also knew that I would be out of commission after the baby arrived, and maybe for a long time after that, depending on how long I wanted to stay home with the new little one.

We decided to move back to Beaufort. We had had enough of the fast-paced southern California style. Although we worked with some wonderful folks, there were still too many people all wanting to do the same things at the same time, and they each wanted to look really good doing it! My boss tried to entice me to stay by offering a raise, and mentioned that I could apply to Scripps graduate school for a Ph.D., but Keith was homesick for Beaufort and we wanted to slow down. Probably the nesting instinct had kicked in along with all those wonderful pregnancy hormones.

Beaufort is a wonderful place to raise kids. It is safe, beautiful, and has wonderful opportunities for doing things on, in, and around the water. Protected by two barrier islands, it is a cozy little harbor for many sailboats that are headed to or from the Caribbean islands.

We had to get back to our own bottlenose dolphin studies. While living in California we had flown east several times to take some dolphin photos and check on our house, but we knew if we were going to make something out of this study we had to be in Beaufort. It was tough getting a job when I was obviously pregnant and showing more and more. In my infinite wisdom, I went out and got a Great Dane puppy. There we were, neither of us had jobs, about to have a child, and I brought home a six-week-old puppy that was as big as a cocker spaniel, who promised to weigh more than I did (even pregnant) in no time. "River" became an instant part of our tiny family. Frequently, I would try to keep her from digging holes the size of large graves in our tiny yard. Neighbors would bicycle by, glancing at a very pregnant woman wrestling with a pony-sized puppy, often to no avail.

I had a wonderfully easy pregnancy. I loved being pregnant, felt better than ever, and was in or on the water constantly. I was very lucky. We were teaching a School for Field Studies bottlenose dolphin course which involved living with, being responsible for, and teaching eighteen college students during two four-week sessions, including providing all meals and going out in boats almost every day. That first summer we camped with the students out on a marsh on some friend's property. River ran right through several tents, not seeing the screen. She was confused about why that wasn't a good idea—it seemed like such fun!

While I was in labor, one of the other instructors came into the delivery room with several students, and started asking Keith a whole bunch of questions about the Evinrude outboard motor. I grunted at Keith in exasperation, and Keith got the message and finally asked Sherman to leave. Our first baby, Olivia, was born at the end of July.

When Olivia was a few months old, Keith proposed to the Maritime Museum that he would design some programs out at Cape Lookout. He would use the abandoned Coast Guard station that was maintained by the National Park Service. The Park Service was happy to have an organization that would use the facility and help with the maintenance, and knew that the exposure would be help with public relations. The program was a success, and after Keith replaced the diesel generators with solar panels and a wind tower, we could have running water and lights at night. We lived out there the first three summers of Olivia's life. It was hot, mosquitoey, and rustic, but we all loved it. It was a shock to come back into town —to civilization, to feel air-conditioning again.

One reason I believe that Olivia weaned herself at eleven and a half months is because it was too hot to breastfeed—for both of us. I cried—the rejection made me sad and I knew an important bonding time was over. We had hired a live-in nanny, but I was torn between spending time with Olivia and giving the students attention and help with their projects. I was only teaching half-time, but living with the students full-time and found that I never felt that I could do enough mothering or teaching.

In their student evaluations, many of the young women wrote about how important it was for them to observe my attempts at balancing parenting and work. They felt that it was possible to do both! In their eyes, they had learned not only about dolphin biology and behavior, but also some valuable life lessons.

After three summers of teaching, we felt that Olivia needed to stay at home during the summer and play with friends her own age. I was working at a veterinarian's office about twenty hours a week during the non-summer months. One day a colleague from the west coast called me. She was working with a marine mammal curator from the Smithsonian. They were bemoaning the fact than there was no one in North Carolina responding to marine mammal strandings. When dolphins and whales and porpoises become sick or die, often they end up stranded dead on the beaches. These carcasses provide a plethora of information to scientists. The Smithsonian offered to pay my expenses if I would respond to strandings and report back to them. I was thrilled, not having any idea what I was getting myself into.

North Carolina has more than 100 strandings of dead marine mammals each year. I became the North Carolina NMFS Area Representative for marine mammals strandings, which meant that at any hour of the day or night, I was called about whales, dolphins and porpoises that had washed up on the beaches of North Carolina.

One day when my four-year-old daughter and I were at home on a Saturday morning, I was looking forward to a peaceful weekend. Keith was out at Cape Lookout for the weekend. Then the phone rang. It was the Park Service at Cape Hatteras, two ferry rides and about four hours away from Beaufort. There were eleven harbor porpoises on the beaches, along a ten-mile stretch of beach. I knew I had to go get them and bring them back to our lab's walk-in freezer so that we could perform necropsies on them. Olivia wasn't allowed in our lab vehicles, so I had to drive my station wagon. We strapped two big coolers on the roof and headed north. After a few hours, we arrived at the ranger station. The ranger eyed me with one raised eyebrow as I asked, "Could you please drive us out to the dead harbor porpoises so that I can pick them up and take them back with me?" The ranger agreed, and off we went with our coolers down the beach.

I held Olivia on my lap, and within fifteen minutes, she was vomiting all over the inside of the ranger's truck. This was not a popular event with the ranger, as we hadn't even reached the putrid-smelling porpoises. We cleaned up the mess, I apologized profusely, and Olivia felt much better. Soon my brave four-year-old and I were putting on gloves to pick up the porpoises and dragging them to the cooler. She loved being my "assistant" for the day. On the way home, though, I heard a small voice from the back seat say, "Mom? I think you and Daddy should get another job, because these dead things are too stinky." From the mouths of babes...

The stranding network evolved into a true network of volunteers. The Park Service continued to be an enormous part of reporting, transporting and support. Many of the rangers and naturalists within the Park were extremely knowledgeable and generous with their time. However, my job was still a temporary job. The Fisheries Lab had not made it a permanent position. I decided to apply to graduate school, figuring that maybe with a Ph.D., I would finally get a permanent position, or at least be able to write proposals that were large enough to help support us.

We were also trying to have another child. During a period of two and a half years, I had four miscarriages. I was feeling responsible, as though it was somehow my fault. We had almost given up, but we wanted Olivia to have a sibling so that she could commiserate with someone about her childhood, and so that when it became time to make tough decisions about our care at some

point, she wouldn't have to do it alone.

As luck would have it, I became pregnant AND was accepted to graduate school. I thought either one or the other might work, but not both! My advisor joked with me that I was on the fifteen-year plan to graduate. "Don't rush me," I warned.

When I was about seven months pregnant, a fourteen-foot beaked whale stranded dead on Atlantic Beach during the early summer. A talented assistant, Katie, and I were performing a necropsy, which involves measuring the carcass, removing some organs, and collecting samples of many others. A well-meaning woman in gold shoes came down the beach and saw us working. It was obvious I was pregnant. "You really shouldn't be doing this!" she chided. I wanted to say, "But who will take my place if I don't?" but I didn't. I wore double gloves and was very cautious. I asked Katie, "When ARE they going to design attractive maternity stranding clothes?"

That July, River's health suddenly went downhill. Great Danes, and other giant breeds, don't have long lifespans. River was seven when she died, and Olivia was heartbroken. She was sad because she missed her lifelong, velvety-eared companion, and because she knew that her new little sibling would never meet the enormous-hearted River.

Lindsey was born at the end of August, between two hurricanes. A curly-haired, exuberant child, she and the dramatic, sensitive Olivia are great pals. Olivia was seven when Lindsey was born, and upon seeing her new sister, pronounced, "She looks like a cross between a monkey and a worm!"

Typical mornings now begin like this.

"Don't forget your lunch!" I remind my daughter, Olivia, who has reached the philosophical age of almost-eleven.

"You don't have to remind me!" she retorts, her dark eyes scolding me. I hoist three-year old Lindsey to my hip, and swing my backpack and lunch over one shoulder.

"Lambie!" Lindsey pleads and I bend down so she can grasp Lambie with one pudgy hand. We head toward the back door.

"I want my La-lee-dah, too!" Lindsey chirps. She's referring to her stuffed baby doll, named La-lee-dah for reasons only toddlers can understand.

"Lindsey, you already have Lambie. We can only take one toy," I answer.

"Mom, can you ask me some of my vocabulary words? I have that test today," Olivia asks.

Lira, our slightly neurotic Golden Retriever, displays her intention to join our entourage by barking. "Sorry, Lira—we'll see you this afternoon. Good girl. Patriotism, Olivia."

"What?" Olivia asks, emerging from her adolescent fog.

"I want my La-lee-dah!" Lindsey asserts.

"Patriotism, your vocabulary word," I remind her.

"P-A-T…"

"Mommy, Lira wants to go to school," Lindsey explains.

"What, 'Liv? I can't hear you. Lindsey, climb up into your car seat."

The dog continues to race around, wagging every muscle in a rave but vain attempt to convince us she should come along. Finally, all three of us end up in the car. I fasten my seat belt and take a deep breath. My watch says ten minutes before eight, and I need a nap.

Our dolphin photo-identification work continues. We have identified over thirty dolphins we believe to be mothers. Just as female human mothers spend time with other parents with children the same age, we see some of our known female dolphins with other females with similar-aged calves. Dolphin moms are known to form a circle while the young ones play in the center, sort of a playpen arrangement. Perhaps it is beneficial to have more individuals watching for predators, or maybe like us, they're trading stories about weaning Junior.

I continue to push the envelope regarding being a part-time student and older mom. Most universities aren't used to it, and are not that thrilled about it. Most employers I've had wanted me to work full-time and I've refused, although the money would have helped. I feel it is important for our children to have someone at home at least part-time. I love the days I pick up Lindsey at 12:30 and spend afternoons with her. I know it is important for me to be there to help Olivia with her homework after school and take her to lessons or sporting practices and games. Would they be fine if I worked full-time? I'm sure they would. But I would be miserable.

So, it continues to be a trade-off. We women want to have a career, and yet we want to be nurturing, involved mothers. Can we do both—succeed at home and in the workplace? I am going to keep trying.

Victoria *Thayer*

Victoria Thayer was born in Wakefield, Rhode Island and grew up in New England. She graduated from the University of Connecticut in 1978 with a major in Natural Resources Conservation. While at the University of Connecticut, she spent one year in Paris and Rouen, France, and earned a degree from the University of Rouen in 1977. She moved to North Carolina in 1978 and graduated with a master's degree in environmental management from Duke University in 1982. Since 1982, she has worked as a biologist for Duke Marine Lab. She also works for the North Carolina National Marine Fisheries Service Marine Mammal Stranding Network at the laboratory in Beaufort, North Carolina.

Victoria is currently a Ph.D. student at Duke University. Her husband, Keith Rittmaster, works for the North Carolina Maritime Museum as curator for the Cape Lookout Studies Program. Victoria and Keith have two daughters—Olivia, ten, and Lindsey, three.

about the *Editor*

Emily A. *Colin*

Emily Colin grew up in Brooklyn, New York, where she played the violin, read a lot, and gallivanted with her oversized white boxer, Buddy. She migrated to North Carolina via New Zealand, and graduated from Duke University in 1997, with B.A.s in literature and psychology. Since she was never a big-city girl anyhow (and since, post-graduation, she realized that she had developed a distinctly un-New Yorkish predilection for barbeque and open spaces, as well as an allergy to smog and unsweetened tea), she elected to remain in North Carolina and pursue a career in publishing. Three dogs, two cats, and one 1918 bungalow later, she is happily on her way to...well, to something, anyway. Emily lives, writes, and renovates in Wilmington, North Carolina, where she is an editor at Coastal Carolina Press.